CAMBRIDGE STUDIES IN FRENCH 56

Surrealist collage in text and image

Surrealist collage in text and image

Dissecting the exquisite corpse

ELZA ADAMOWICZ

Queen Mary and Westfield College
University of London

PUBLISHED BY THE PRESS SYNDICATE OF THE UNIVERSITY OF CAMBRIDGE
The Pitt Building, Trumpington Street, Cambridge CB2 1RP, United Kingdom

CAMBRIDGE UNIVERSITY PRESS
The Edinburgh Building, Cambridge CB2 2RU, United Kingdom
40 West 20th Street, New York, NY 10011–4211, USA
10 Stamford Road, Oakleigh, Melbourne 3166, Australia

First published 1998

Printed in the United Kingdom at the University Press, Cambridge

Typeset in Dante 11/13 [SE]

A catalogue record for this book is available from the British Library

Library of Congress cataloguing in publication data

Adamowicz, Elza
 Surrealisrt collage in text and image: dissecting the exquisite
corpse / Elza Adamowicz.
 p. cm. – (Cambridge studies in French: 56)
 Includes bibliographical references and index.
 ISBN 0 521 59204 6 (hardback)
 1. Surrealism – France – Paris. 2. Arts, Modern – 20th century –
France – Paris. I. Series.
 NX549.P2A53 1998
 700'.41163'0944361–dc21 97-13546 CIP

ISBN 0 521 59204 6 hardback

QUELLE EST LA PLUS NOBLE CONQUETE DU COLLAGE?
C'est l'irrationnel. C'est l'irruption magistrale de l'irrationnel dans tous les domaines de l'art, de la poésie, de la science, dans la mode, dans la vie privée des individus, dans la vie publique des peuples.
Max Ernst, 'Au-delà de la peinture' (1936)

Le collage est peut-être une technique, l'amour aussi, vous savez, ou le suicide.
Louis Aragon, *Ecrits sur l'art moderne*

Contents

Illustrations

Acknowledgements

I should like to thank Malcolm Bowie for his encouragement and support for this project from the outset. I am grateful to Roger Cardinal, Peter Dunwoodie, Michael Sheringham and former colleagues of the French Department of Birkbeck College, London for their critical support. Queen Mary and Westfield College, London have provided financial assistance towards the cost of the illustrations.

Early versions of some parts of this book have appeared in books and journals. I am grateful to *Mélusine*, Polity Press, l'Harmattan and University of Keele Press for permission to reproduce the material here, and to all colleagues and students in surrealism who have provided a forum in which to develop my ideas.

Abbreviations

Louis Aragon

C *Les Collages* [1965], Paris: Hermann, 1993
PP *Le Paysan de Paris*, Paris: Gallimard, 1926

André Breton

En *Entretiens* [1952], Paris: Gallimard (NRF Idées), 1969
OCI *Œuvres complètes* I, Paris: Gallimard (Pléiade), 1988
OCII *Œuvres complètes* II, Paris: Gallimard (Pléiade), 1992
SA *Signe ascendant* [1947], Paris: Gallimard (NRF Poésie), 1968
SP *Le Surréalisme et la peinture*, Paris: Gallimard, 1965

Max Ernst

E *Ecritures*, Paris: Gallimard, 1970

Beyond painting

L'importance stupide donnée à ces 'genres': huile, gouache, crayon, confiture, cirage, marbre, sable, 'collage', etc., interdit selon moi que l'on en fasse état, désormais, dans un catalogue et dans la conversation.

René Magritte[1]

'Enfin Max Ernst vint . . .'[2] Ernst's first Paris exhibition was held in May 1921 at René Hilsum's bookshop and gallery Au Sans Pareil. A full-page advertisement (figure 1), published in the May issue of *Littérature*, the Paris dada group's ironically titled journal, announced: 'LA MISE SOUS WHISKY MARIN / se fait en crème kaki & en 5 anatomies / VIVE LE SPORT . . . / EXPOSITION DADA / MAX ERNST'.[3] The exhibition was reviewed in the contemporary press less as an artistic event than as a provocative dada spectacle. The tone had been carefully orchestrated by the dadaists themselves who had sent out press releases qualifying Ernst as the Einstein of painting.[4] The private view, held on 2 May 1921, was staged as a dada event. Jacques Rigaut stood at the door, counting in a loud voice the rows of automobiles and pearls drawing up in front of the gallery. Visitors – among them André Gide draped in his voluminous cape, Kees Van Dongen and René Clair – were greeted by insults hurled at them from inside a cupboard, while strange sounds, absurd phrases and flashing lights emerged through a trapdoor from the bookshop cellar. Louis Aragon impersonated a kangaroo, André Breton munched matches, Philippe Soupault played hide-and-seek with Tristan Tzara, while Benjamin Péret and Serge Charchoune shook hands for an hour and a half. A photograph of the dada group, taken outside the gallery on the opening day, shows Breton, Hilsum, Péret and Charchoune grouped around Soupault, who is standing on a stepladder holding a bicycle, and Rigaut hanging upside down.[5] Ernst, who had been refused a visa by the occupying powers in Cologne, was not able to attend the event in person.

Fifty-six works were exhibited, numbered with bus tickets. The

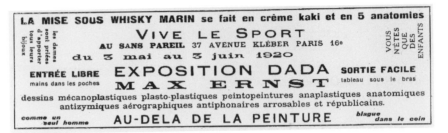

Figure 1 Max Ernst, advertisement for exhibition *La Mise sous whisky marin*, Paris, Au Sans Pareil, May 1921

announcement in *Littérature* lists the works as follows, using Ernst's words: 'dessins mécanoplastiques plasto-plastiques peintopeintures anaplastiques anatomiques antizymiques aérographiques antiphonaires arrosables et républicains'. In fact, the works exhibited were produced in a wide range of media – oil paint, watercolour, gouache, pen-drawing, cut-out engravings and photographs. The techniques used included stamped and rubbed drawings, overpaintings (*Übermalungen*), 'fatagagas' ('FAbrication de TAbleaux GArantis GAzométriques', collective collages made in Cologne in 1919–20 by Ernst, Hans Arp and Johannes Baargeld), a sculpture and twelve 'collages-découpages'. The term is Ernst's, who lists the following works:

> 1° *C'est le chapeau qui fait l'homme.* 2° *Un peu malade le cheval.* 3° *Le cygne est bien paisible.* 4° *Déshabillés.* 5° *La chanson de la chair.* 6° *Aérographie.* 7° *Le massacre des innocents.* 8° *Petite pièce à huit mains.* 9° *Le rossignol chinois.* 10° *Ingres gazométrique.* 11° *La Suisse, lieu de naissance de Dada.* 12° *Le vapeur et le poisson.*[6]

Materials were cut out from various sources – encyclopaedic plates, anatomical treatises, engineering diagrams, commercial catalogues and advertisements – and pasted together in new combinations. Many of the works have titles or inscriptions in English, French or German, often forming an integral part of the work.

The advertisement – indicating 'ENTREE LIBRE mains dans les poches/SORTIE FACILE tableau sous le bras' – qualifies Ernst's works as 'AU-DELA DE LA PEINTURE'. Those journalists who did actually mention the works themselves in their reviews, were largely dismissive. For André Déhal, who reviewed the show for *L'Ordre naturel*, Ernst was a rather mediocre artist whose paintings 'sont un mélange de mysticisme mythologique, de médecine, de géologie, d'érotisme surtout, mais bien peu de peinture y rentre'.[7] The *Daily Mail* reporter found the exhibits quite distasteful. 'In the window there are things you see in a lobster salad nightmare', he wrote. 'Nobody knows what the images are intended to convey. There are faces, and

fishes, and animals, and scientific figures, and hats all jumbled up together. The result is . . . Dada.'[8] However, although dadaist in their use of non-artistic materials and their cavalier disregard for artistic codes, Ernst's works cannot be reduced to strategies of negation or playfulness. At least two journalists underlined the import of the works as a radical departure from mere icono-clastic gestures. Jacques-Emile Blanche suggested that the exhibits were less remarkable for their pictorial qualities than for their poetic resonance, result-ing from the unconventional use of familiar elements.[9] And Pierre Deval, in his enthusiastic review of the exhibition, celebrated the poetic quality of the works:

> AU DELA DE LA PEINTURE . . . Des dissociations constantes, un mélange infini de matériaux: tout ce qui n'est pas de l'art, et – *de plus en plus fort* – tout l'Art, servant, désagrégé, découpé, une partie formant le tout, transposant, recollé, amalgamé encore, en haut le bas, aussi en haut le haut. Beauté des collages: point de départ nouveau, lyrisme, liberté. Quelques phrases folles et magnifiques servent d'indicateur toujours renouvelé de la direction sentimen-tale.[10]

The Paris dada group acclaimed Ernst's works with unqualified excitement.[11] 'L'exposition des collages de Max Ernst à Paris en 1920', wrote Aragon, 'est peut-être la première manifestation qui permit d'apercevoir les ressources et les mille moyens d'un art entièrement nouveau.'[12] In 1941 Breton was to recall the impact of Ernst's collages on the dadaists: '[j]e me souviens de l'émotion, d'une qualité inéprouvée par la suite, qui nous saisit, Tzara, Aragon, Soupault et moi, à leur découverte – de Cologne ils arrivaient à l'instant même chez Picabia où nous nous trouvions' (*SP*, 64). In the same article Breton claimed that surrealist art was already 'en plein essor' in Ernst's early collages. Later, in a 1952 radio interview with André Parinaud, he stressed the visionary power of the works: 'Il n'est pas exagéré de dire que les premiers collages de Max Ernst, d'une puissance de suggestion extraordinaire, ont été accueillis parmi nous comme une révélation.'[13] Such enthusiasm, reiterated thirty years after the event, testifies to the seminal role of Ernst's collages in the elaboration of surrealism.

An embryonic surrealist poetics is outlined in the texts written by Breton and Aragon on the occasion of the exhibition.[14] In his preface to the exhibition catalogue, titled 'Max Ernst', Breton states that with the invention of photography traditional modes of pictorial expression have been rendered redundant, just as automatic writing, defined as 'la photographie de l'esprit', has disrupted the verbal field.[15] The pictorial possibilities opened up by pho-tography and film anchor the collage aesthetic in radical forms of representa-tion based on the transformation of pre-existing elements, 'l'image toute

faite d'un objet (cliché de catalogue)'. The innovatory character of collage, however, lies not so much in the words or images used as in their combination, affirms Breton; and the value of the encounter between disparate realities lies primarily in its effect, namely its capacity to 'nous dépayser en notre propre souvenir' or disorientate both producer and viewer. Breton's choice of lexical terms, whether referring to the material used ('réalités') or to the effect of the encounter ('étincelle'), grounds collage as a general aesthetic principle which would subsequently be applied to both pictorial and verbal modes of expression.

Aragon's text, 'Max Ernst peintre des illusions', written in 1923, analyses Ernst's work, from his early *Fiat modes – pereat ars* (1919) and the mecanomorphic paintings (1919–20), to the works produced for the Paris exhibition and the 'collage-paintings' of 1922 and 1923. Aragon distinguishes cubist *papiers collés* which, he claims, have a realistic or formal function, from Ernst's poetic use of printed or photographic images: '[l]e collage devient ici un procédé poétique' (C, 25). Ernst is engaged in the magical transformation of real elements: '[t]oute apparence, notre magicien la recrée. Il détourne chaque objet de son sens pour l'éveiller à une réalité nouvelle' (C, 26). Like Breton, Aragon seizes on the analogy between pictorial and verbal modes of expression, highlighting the metaphorical function of collage: '[t]ous ces éléments serviront à Ernst pour en évoquer d'autres par un procédé absolument analogue à celui de l'image poétique' (C, 25–6). He extends the notion of collage to the texts which accompany Ernst's works, referring to them as instances of 'collage intellectuel', and arguing that they function in a similar way to 'collage plastique' (C, 27).

Both Aragon and Breton, when distinguishing Ernst's use of collage from cubism's *papiers collés*, foreground the importance of strategies of selection and combination of pre-formed elements, whether photographic reproductions or engravings, as a critique of realism; and both invoke magic and the marvellous when referring to the transformation of reality effected in collage. For Aragon and Breton, Ernst's pictorial practice is based on an aesthetic which is not medium-specific but encompasses both pictorial and verbal modes of expression. While Breton focuses on collage as a combinatory or syntagmatic practice, Aragon foregrounds its paradigmatic or metaphorical mechanisms. And while Breton engages subjectivity in his analysis of *dépaysement*, seen essentially in terms of the effect of collage, Aragon's approach, more technical, analyses the mechanisms of the semiotic process based on the *détournement* of images. Lastly, their positions diverge on the finality of collage. Breton considers collage as a dialectical structure: 'la faculté merveilleuse . . . d'atteindre deux réalités distantes et de leur rapprochement de tirer une étincelle' (OCI, 246). This contrasts with Aragon who considers collage in oppositional terms: deconstructing the so-called

'illusion' on which Ernst's images are built, Aragon emphasizes the alternating vision between reality and appearance, or between the literal and figurative levels of the pictorial metaphor created.

The importance of the exhibition *La Mise sous whisky marin* lies essentially in its role as an initiatory surrealist experience. Rosalind Krauss refers to the exhibition as 'a kind of originary moment, almost, one could say, surrealism's primal scene'.[16] For the future surrealist group, Ernst's works were not only a locus of fascination as a source of the *merveilleux*, but also the occasion for a tentative formulation of the surrealist aesthetic. For me, the initial encounter with Max Ernst's collages was also a 'revelation', and the point of departure of this book. After the initial wordless *jouissance* which their encounter first provoked, their contemplation raised a number of questions. How could my fascination be verbalized without my resorting to an inarticulate pointing,[17] or the stammering of an emotional effect, the 'zut, zut, zut, zut' of Proust's young narrator? How could I analyse works characterized by fragmentation without cementing the fissures through my own discourse and thereby reducing the alterity of collage? How could I define the workings of a practice which encompasses both pictorial and verbal modes of expression, often within the same work, without blurring the specificity of each medium? The present study explores some of these questions.

Collage and automatism: cutting and flowing

Max Ernst's 1921 exhibition was in fact the second of two seminal events for the early elaboration of surrealism, which took place at the very heart of Paris dada activities. The earlier event was the publication in 1919 of the first automatic text, *Les Champs magnétiques*, written by Breton and Soupault.[18] The spontaneous verbal flow – and later the graphic gesture – which characterizes early automatism on the one hand, and the deliberate cutting up and assembling of disparate elements specific to collage on the other hand, were to be elaborated as the two essential modes of surrealist production, breaking away from traditional codes of mimesis and the aesthetics of coherence, and exploring the language of the irrational and the chance encounter.

Automatism and collage are presented in Breton's *Manifeste du surréalisme* (1924) as two distinct techniques for producing a surrealist text. His definition of the surrealist image is based on the encounter of disparate elements: 'C'est du rapprochement en quelque sorte fortuit des deux termes qu'a jailli une lumière particulière, *lumière de l'image* . . . La valeur de l'image dépend de la beauté de l'étincelle obtenue; elle est, par conséquent, fonction de la différence de potentiel entre les deux conducteurs' (*OCI*, 337–8). Although applied here to an exclusively verbal medium, this definition, and

its poetic formulation, echoes and develops Breton's account of collage in the preface to Ernst's exhibition discussed above. It also presents an extreme reformulation of Reverdy's concept of the poetic image whose notion of surprise is radicalized by Breton in the metaphor of the spark produced by the disparity between the two elements brought together. Breton presents two methods for producing a surrealist text. Firstly, under the title, 'SECRETS DE L'ART MAGIQUE SURREALISTE COMPOSITION SURREALISTE ECRITE, OU PREMIER ET DERNIER JET' (*OCI*, 331) – a parody of popular literature on magic – detailed instructions are provided for writing an automatic text. The poet, in a passive-receptive state, writes without any preconceived idea, and without exercising any control over what he writes; the text produced is claimed to be a direct transcription of the 'fonctionnement réel de la pensée' (*OCI*, 328). Secondly, Breton proposes a formula for writing a collage text or 'POEME': 'Il est même permis d'intituler POEME ce qu'on peut obtenir par l'assemblage aussi gratuit que possible . . . de titres et de fragments de titres découpés dans les journaux' (*OCI*, 341). This is followed by an example of such a text (which I analyse in chapter 3). The immediacy, however illusory, of automatism or 'la pensée parlée' (*OCI*, 328) as a play on signifiers, appears to contrast radically with the mediated discourse of collage: while the material for the first is the linguistic code (*langue*) or the graphic impulse, collage material involves the recycling of ready-made messages, whether pre-formed linguistic entities (*parole*) or iconographic fragments. In addition, the material fluidity of automatic production contrasts with the dryness of the collage process.

Although the *Manifeste* presents collage and automatism as two distinct modes of textual production, Breton grounds his general definition of surrealism on the overarching concept of 'psychic automatism': 'SURREALISME, n. m. Automatisme psychique pur par lequel on se propose d'exprimer, soit verbalement, soit par écrit, soit de toute autre manière, le fonctionnement réel de la pensée. Dictée de la pensée, en l'absence de tout contrôle exercé par la raison, en dehors de toute préoccupation esthétique ou morale' (*OCI*, 328). With such a definition Breton appears to assimilate automatism as a principle ('automatisme psychique') with automatism as a technique ('écriture automatique'), and indeed throughout the 1920s the term 'surréaliste' is held to be largely synonymous with the restrictive use given it by Breton as an automatic mode of production. Hence, for example, the rubric 'textes surréalistes' in *La Révolution surréaliste* (1924–9) comprises exclusively so-called automatic texts. And in the pictorial field Breton privileges the graphic automatism of Joan Miró and André Masson – in a footnote to his 1924 *Manifeste*, which contains the only reference in that work to pictorial modes of expression, he refers to Masson as 'si près de nous' (*OCI*, 330) – alongside Max Ernst's more premeditated collages.

Breton's programmatic or theoretical texts of the 1920s are dominated by the engagement with automatic means of production. To Pierre Naville's claim that surrealist painting does not exist – 'Plus personne n'ignore qu'il n'y a pas de *peinture surréaliste*. Ni les traits du crayon livré au hasard des gestes, ni l'image retraçant les figures de rêve, ni fantaisies imaginatives'[19] – Breton counters with his essay, 'Le Surréalisme et la peinture' (1925), initially published in instalments in *La Révolution surréaliste*, where he privileges gestural automatism and automatism of the dream.[20] As a technique collage itself is rethought in terms of automatism, an appropriative gesture evidenced in Breton's analysis of Ernst's work in this same essay. Breton stresses the importance of chance in the manufacture of collage, referring to the encounter between objects 'préalablement disqualifiés et *tirés au hasard*' (*SP*, 27), which suggests that collage is the result of an automatic process. In 'Au-delà de la peinture' (1936), Max Ernst, in line with Breton's discourse on the primacy of automatism, models his own account of collage on the mechanisms of automatism:

> je fus frappé par l'obsession qu'exerçaient sur mon regard irrité les pages d'un catalogue illustré . . . J'y trouvais réunis des éléments de figuration tellement distants que l'absurdité même de cet assemblage provoqua en moi une intensification subite des facultés visionnaires et fit naître une succession hallucinante d'images contradictoires. (*E*, 258)

Collage (and by extension frottage), tapping the resources of the unconscious mind, are considered processes parallel if not equivalent to automatic writing, in their capacity to stimulate the hallucinatory powers of the artist and generate a flow of multiple, contradictory images, as in hallucinations or visions of half-sleep. Ernst's intervention is minimal, reduced to a passive gesture, 'en ne faisant que reproduire docilement *ce qui se voyait en moi*' (*E*, 259), to fix the hallucinatory mental images set in motion by the pages of the catalogue. Privileging the mental activity instigated by the collage elements, Ernst stresses the flow or continuity between the images of the unconscious and their projection onto the page, glossing over the production stage of collage. Several critics too, following Breton's emphasis on automatism, consider collage to be a feature of automatic production. J. H. Matthews, who promotes a view of surrealist collage which encompasses all allotopic utterances, equates the collage effect of automatism, as the expression of the fragmented inner voice, with collage as a deliberate process, when he refers to the speed with which Benjamin Péret wrote his poems, 'in which verbal collage is of course a sign of the unrestricted play of free association'.[21] In his analysis of automatism, Michel Murat dismisses collage as a post-automatic stage in the montage procedures of a number of texts of *Les Champs*

magnétiques, or as an abortive genre in Breton's early poetic development: 'Le découpage-collage est une pratique poétique qui a failli se développer en un genre de *Clair de terre* aux textes relégués de *Poisson soluble*.'[22]

While collage did indeed suffer a momentary eclipse after 1924 in Breton's critical and theoretical texts, following his hortatory exegesis in favour of automatism, it was very present in other surrealist programmatic texts, as an innovatory mode of perception or production. Pierre Naville, in the text quoted above, proposed an alternative to automatism in his celebration of the fragmented images of modern life:

> Mais il y a *des spectacles*.
> La mémoire et le plaisir des yeux: voilà toute l'esthétique . . .
> Le cinéma, non parce qu'il est la vie, mais le merveilleux, l'agacement d'éléments fortuits.
> La rue, les kiosques, les automobiles, les portes hurlantes, les lampes, éclatant dans le ciel.
> Les photographies: Eusèbe, l'Etoile, Le Matin, Excelsior, La Nature, – la plus petite ampoule du monde, chemin suivi par le meurtrier. La circulation du sang dans l'épaisseur d'une membrane.
> S'habiller, – se revêtir.

More important, collages continued to be produced, as testified by their significant presence in surrealist publications, journals and exhibitions throughout the 1920s. Literary collages include poems made partly or entirely from ready-made materials (Péret, 'Hier en découvrant l'Amérique' 1926 (figure 10)), collage elements in prose works (Aragon, *Paysan de Paris*, 1926), and collaborative collages such as surrealist games or 'L'enfant planète' (1926), a montage text by Robert Desnos and Benjamin Péret. Towards the end of the 1920s, once the disruptive and poetic potential of appropriating and combining ready-made material without modification had been explored, such experiments were abandoned in favour of techniques which rework earlier texts, as in Aragon and Breton's *Le Trésor des Jésuites* (1928) or Breton and Eluard's *L'Immaculée Conception* (1930). In the artistic field, Tanguy, Magritte, Miró and Ernst are among the many artists who produced pictorial collages in the latter part of the 1920s. Yves Tanguy integrated collage elements into his oil-paintings of 1925–6: *Le Phare* incorporates a cut-out cardboard lighthouse, steps made out of pasted matchsticks and a child's folded paper boat, *Le Pont* includes metal wires, and *Le Bateau* cotton-wool smoke. Between 1925 and 1928 Magritte produced approximately thirty collages made of pasted paper with gouache or watercolour. He sometimes produced two versions of the same image, one as an oil-painting and the other as a collage (such as *Le Goût de l'invisible* and *Le Ciel meurtrier*). Miró produced

very few paintings between 1928 and 1930, his main output being works exploiting collage and assemblage techniques. In 1928 he made a series of object-pictures (for example, *Portrait de danseuse* and *Danseuse espagnole*), where figurative elements are suggested by objects pasted onto the canvas, such as sandpaper, feathers, a nail, a hatpin or a draughtsman's triangle. In the summer of 1929 he produced a series of about twenty *papiers collés*, where irregular shapes have been cut out or torn from coarse paper, such as sandpaper or wrapping-paper, and pasted onto the canvas, with a few lines added in charcoal. Ernst, who after 1922 turned to collage-paintings (1922–4), then frottage and grattage techniques, went back to collage in 1929 with his first collage-novel, *La Femme 100 têtes*.

Collage and its cognates, photocollage and photomontage, are also very present in surrealist journals towards the end of the 1920s. In *Le Surréalisme en 1929*, a special issue in June 1929 of the Belgian publication *Variétés*, edited by E. L. T. Mesens, several collages and photomontages were reproduced: six works by Ernst, including two plates from *La Femme 100 têtes*, Miró's *Portrait de danseuse* and *Danseuse espagnole*, Mesens's *Je ne pense qu'à vous* and *L'Instruction obligatoire*, Paul Nougé's *Carte postale éducative*, and four *cadavres exquis*. Aragon and Breton's *Le Trésor des Jésuites* (1928) also appeared in the same issue. The last number of *La Révolution surréaliste*, dated December 1929, includes paintings integrating collage elements by Dalí (*Les Accommodations du désir* and *Les Plaisirs illuminés*), three collages by Ernst (*L'Esprit de Locarno*, *Nostradamus, Blanche de Castille et le petit Saint-Louis* and *Jeanne Hachette et Charles le Téméraire*), photomontages by Magritte (*L'Opéra de Paris* and *Je ne vois pas la [femme] cachée dans la forêt*) and Albert Valentin (*Monument aux morts*), as well as several *cadavre exquis*. The same issue also contains Magritte's text 'Les mots et les images', Breton and Eluard's 'Notes sur la poésie', and Buñuel and Dalí's scenario for *Un chien andalou*, texts which mark a move towards more consciously constructed modes of production. This change of focus in literary production, from the so-called spontaneous mode of automatism to more deliberately (re)worked texts, corresponds to a shift in interest among the surrealists from Lautréamont's *Chants de Maldoror*, generally considered to be the paradigm for Breton's elaboration of automatic writing, to *Poésies* – 'un immense monument élevé avec des collages', according to Aragon (*C*, 110) – the model for 'Notes sur la poésie', which is a rewriting of a text by Paul Valéry.[23] These experiments in collage and related techniques coincide with a critique of automatism, which, towards the end of the 1920s, was in danger of becoming reified as the 'poncif surréaliste' whose very principle Breton had rejected in his 1924 *Manifeste*. In *Traité du style* (1928), Aragon launched an attack on automatism as a mere gimmick:

[L]a légende règne qu'il suffit d'apprendre le truc, et qu'aussitôt des textes d'un grand intérêt s'échappent de la plume de n'importe qui comme une diarrhée inépuisable. Sous prétexte qu'il s'agit de surréalisme, le premier chien venu se croit autorisé à égaler ses petites cochonneries à la poésie véritable, ce qui est d'une commodité merveilleuse pour l'amour-propre et la sottise.[24]

Collage is also codified in a number of texts, which suggest through their very titles – 'La peinture au défi', 'Au-delà de la peinture' – an alternative to the more traditional pictorial experiments of a Dali or a Magritte. In 1930 the first retrospective of *papiers collés* and collages, held at the galerie Goemans in Paris, exhibited forty cubist, dada and surrealist works. Aragon wrote the preface to the exhibition catalogue, polemically titled 'La peinture au défi'. In a later, self-laudatory critique (1960), Aragon refers to his preface as a seminal text, 'probablement le premier texte systématique qui ait tendu à faire l'historique de cet art nouveau en notre siècle' (C, 75). He underlines the importance of collage practice while deploring the general absence of critical interest in this activity: 'Il est curieux que presque personne n'ait semblé prendre garde à une occupation singulière, dont les conséquences ne sont pas encore toutes appréciables, à laquelle certains hommes se sont livrés ces temps-ci d'une manière systématique qui rappelle plus les opérations de la magie que celles de la peinture' (C, 37). Aragon sets out to remedy this situation by outlining a history of collage over the past twenty years, from cubist *papiers collés* (Braque and Picasso) to dada (Duchamp and Picabia) and surrealist collage. Ernst is once again the initiatory figure, but Aragon's overview also encompasses the works of Arp, Tanguy, Masson, Magritte, Picasso, Miró and Dali. He enumerates the various functions of surrealist collage: its metaphorical and dramatic use in Ernst's work, its representational or 'anecdotal' role in Tanguy, and its function as a critique of realism in Dali's paintings. This exhibition and Aragon's text contributed to the increased visibility of collage as a mode of production, and to a further elaboration of the poetics of collage. The following year Tzara published a key text, 'Le papier collé ou le proverbe en peinture', which constitutes yet another challenge to traditional painting and literature: 'Le papier collé, sous tant de différents aspects, marque dans l'évolution de la peinture, le moment le plus poétique, le plus révolutionnaire, le touchant essor vers des hypothèses plus viables, une plus grande intimité du provisoire et des matières temporelles et périssables, la souveraineté de l'idée.'[25] In 1936, Ernst wrote 'Au-delà de la peinture', where he relates his discovery of collage ('Histoire d'une histoire naturelle') et discusses the mechanisms of collage ('La mise sous whisky marin'), drawing parallels between pictorial and verbal collage and linking the dialectical structure of collage to the concept of identity ('Identité instantanée').[26]

During the 1930s two main tendencies can be charted in collage produc-

tion. Firstly, there was an important renewal of satirical collage, notably in the use of photomontage, a technique which had been favoured by the Berlin dadaists in the early 1920s as a polemical instrument. In the context of the surrealist political agenda, collage, disrupting social order, is a powerful instrument for a critique of the doxa. In 1933, *Le Surréalisme au service de la révolution* reproduced two photocollages by Breton, *Un temps de chien* and *L'Œuf de l'église (le serpent)*. Around 1935 Eluard produced several collages, including *Le Bon Bourgeois* and *A chacun sa colère*. Ernst's second collage-novel, *Rêve d'une petite fille qui voulut entrer au Carmel* (1930), is an anti-clerical satire, while his third collage-novel, *Une semaine de bonté* (1934), includes a satire of militarism via the main protagonist of the first chapter, the Lion de Belfort. Secondly, collage, as it was developed in the 1930s, was linked with an interest in the surrealist object constructed from found materials, which often integrated fetish objects and had strong erotic or sadistic connotations. In collage, the fetishistic appeal of part-bodies and the elliptical erotic narratives of advertising images and slogans are underscored even further by the surrealists' cutting and pasting practice. The erotic connotations of such fragments are brought out by collagists – who were not all trained artists – Nusch Eluard,[27] Paul Eluard (*L'Amour*, c.1935), Georges Hugnet (*La Septième Face du dé*, 1936) or Léo Malet (*Le Rêve de Léo Malet*, 1935).

This rapid overview of surrealist collage in the 1920s and 30s shows that, as a mode of perception or production, it is at the very centre of surrealist activities and thought. Collage and assemblage, manipulating already existing signs, are a privileged mode of creating the surreal. 'Pour qu'il y ait surréalisme, il faut qu'il y ait réalisme,' writes Michel Leiris, 'il faut qu'il y ait une réalité à manipuler.'[28] Collage effectively anchors surrealist activities in the real, thanks to the 'reality effect' of its processes, which unmask, critique and renew the perception of utilitarian reality and modes of representation and expression. Disrupting the accepted order of reality, it constitutes a critique of artistic and social codes. Magritte, referring to Ernst's use of old-fashioned engravings in his collages for *Répétitions* (1922), produced in collaboration with Eluard, claims that traditional pictorial techniques have been superseded thanks to collage procedures: 'Les ciseaux, de la colle, des images et du génie ont remplacé, en effet, les pinceaux, les couleurs, le modèle, le style, la sensibilité et le souffle sacré des artistes.'[29] Collage is also a material practice which deliberately subverts traditional models of representation and bourgeois value systems, through strategies of displacement and perversion. Thanks to its conscious manipulation of the *symbolique*, collage is a radical deconstruction of the language of the father, unlike automatism which claimed, at least in its early stages, to privilege the *sémiotique* or presocial language. Further, as a mode of creating new realities, collage can be linked to the concept of the *merveilleux*, central to surrealist doctrine, based on a

rupture in the order of reality. 'La réalité', writes Aragon, 'est l'absence appar-
ente de contradiction. Le merveilleux, c'est la contradiction qui apparaît dans
le réel.'[30] While mimetic models of representation mask their own processes
of construction, collage visibly disrupts the normally seamless surface of
reality by smashing the mirror and importing the other into its cracks. '*QUELLE
EST LA PLUS NOBLE CONQUETE DU COLLAGE?*' asks Ernst: 'C'est l'irrationnel. C'est
l'irruption magistrale de l'irrationnel dans tous les domaines de l'art, de la
poésie, de la science, dans la mode, dans la vie privée des individus, dans la
vie publique des peuples. Qui dit collage, dit l'irrationnel. Le collage s'est
introduit sournoisement dans nos objets usuels' (*E*, 264). Finally, collage is
associated with the notion of *hasard objectif*, defined by Breton as the point of
intersection between inner desires and external reality, in a confrontation
between '[la] représentation intérieure avec celle des formes concrètes du
monde réel'.[31]

Critical assessments of surrealism have tended to focus on Breton's pre-
scriptive, indeed often proscriptive, writings, and the analysis of surrealist
works has been largely filtered through his own critical discourse. Recent
reassessments, however, have shifted the focus from (an ideal form of) auto-
matism as the dominant mode of surrealist production, privileging spon-
taneity, to more consciously constructed modes of production, such as
surrealist narrative, photography and the arts of assemblage.[32] In addition,
reevaluations of surrealist writing have served to revise earlier identifications
of surrealist discourse with so-called automatism. With a growing interest in
genetic criticism and the publication of, or readier access to, surrealist manu-
scripts, recent analyses have revealed that, far from being the product of a
spontaneous 'flux de la pensée', automatic texts are complex structures which
often encompass collage procedures in their appropriation of earlier texts,
thus calling into question Breton's early opposition between automatism and
collage, outlined above.[33] In addition, recent trends in art history have tended
to focus on the work as process rather than finished product, so that
'unfinished' works, as well as works which are a comment on image-making,
are attracting much critical attention.

The present study continues this reassessment, with the aim of
(re)instating collage at the centre of surrealist practice. Paradoxically
perhaps, Breton's own assessment of the automatic process as an ideal model
reveals that collage modes of production are at the heart of automatic texts
as pragmatic objects: 'Comment s'assurer de l'homogénéité ou remédier à
l'hétérogénéité des parties constitutives de ce discours dans lequel il est si
fréquent de croire retrouver les bribes de plusieurs discours; comment envis-
ager les interférences, les lacunes . . . etc.?' (*OCII*, 380–1). A study of collage
involves precisely the analysis of the 'bribes de plusieurs discours', the very
'interférences' which Breton seeks to eliminate in the automatic text, the

débris of iconic or literary references, narrative topoi, visual memory traces or simply clichés, which inhabit the text, and which in fact constitute its specificity. The surrealist text, whether verbal or pictorial, *is* fragmented, disparate, multiple, as Claude Abastado argues: 'Le "lieu" du texte [surréaliste] est celui d'une hétérogénéité radicale; une infinité de textes en interrelation, toute une culture, une conscience foisonnante et incohérente du monde surgit dans les "bribes de plusieurs discours", les "interférences", les "lacunes".'[34] This study aims to contribute to the analysis of surrealist verbal and pictorial production as the locus of multiple and divergent discourses, a construct of pre-formed messages, the parodic reworking or poetic transformation of earlier texts or iconographic fragments.

Towards a definition of surrealist collage

Miró's *papiers collés* and Arp's *papiers déchirés*; Ernst's *collages-découpages* and Hugnet's *poèmes-découpages*; the anatomical chart and the advertising slogan, the Romantic print alongside the sales catalogue, the telephone directory and the poem; Dali's disguised collages, false collages, stone collages; the lugubrious game, the definitions game, the hypothesis game; surrealist journals and exhibitions, walks, letters and advertisements; Breton's collage texts on Ernst or Ernst's texts on Ernst; Magritte's mental collages or Ernst's painted collages; Eluard's photocollages and Valentin's photomontages; monsters, masks and machines; bachelor machines, hundred-headless women, disarticulated dolls; the meeting of a cardinal and a monumental nude, or corpses and a sewing machine on a battlefield; Loplop, Perturbation, Germinal and other exquisite corpses … Such variety seems to defy definition. As a practice, surrealist collage encompasses a wide range of activities, from encounters with defunct objects at the fleamarket to the transcription of the multiple voices of the unconscious, the fragmentary images of the dream and all modes of production which stage the clash of disparate elements. As a pragmatic act, collage englobes various complementary or conflictual functions – critical, poetic and political – which cohabit throughout the 1920s and 30s. As a technique, collage is a material mode of cutting and pasting distant elements – or indeed a simulation of that process. As a subversive act, it is an instrument of *détournement* of pre-formed messages, 'une machine à bouleverser le monde'.[35] And as a creative act, it involves the transformation of these messages.

The collage principle has been considered by some critics as the fundamental structural model of the twentieth century, not only in the field of aesthetics but more generally in social, scientific and philosophical thought. The surrealists' concerted exploitation of the accidental, the aleatory and the

chance encounter, makes collage an essential agent in the grand epic of the rout of rationalism following the 1914–18 war. New concepts of space were elaborated in non-Euclidean geometry, while quantum physics explored the nonsequitur, and the irrational and the fractured subject were charted in Freudian psychoanalysis. In art-historical terms, the collage principle has been read as the principal *actant* in the history of modern art, from Manet's *Déjeuner sur l'herbe*, through cubist *papiers collés*, dada photomontage and surrealist collage, to the combine-paintings of American postwar artists and the strategies of appropriation, recycling and generalized cannibalization which characterize the art of the last twenty years. In the literary domain, the increased fragmentation of the modern text can be traced from Rimbaud and Joyce to Burroughs and Butor. Finally, collage, or its cognates assemblage and montage, privileging such concepts as heterogeneity, play, transgression and marginality, has been considered as the paradigm of the (post-)modernist aesthetic.

The problem with such grand narratives is that any mode of aesthetic construction involving the juxtaposition of disparate realities can be subsumed under the umbrella term collage. Herta Wescher refers to such an extensive coverage of collage: 'It has been customary to apply the term "collage" to all works in which components belonging to separate intellectual or perceptual categories are combined, even when, as in many instances, nothing has been pasted or glued.'[36] In their introduction to a special issue on collage in *La Revue d'esthétique*, Groupe MU refer to the dangers of extending the term indefinitely within the visual field: 'Ses frontières ne sont pas seulement floues mais prises dans une mouvance perpétuelle . . . on parle de collages tantôt comme d'une activité artistique précise, tantôt comme d'une métaphore approximative, quand on n'en arrive pas à la généralisation extrême du "tout est collage".'[37] Bert Leefmans proposes a 'metaphysics' of collage which he defines as 'the overt association of fragments not explicitly connected'.[38] And for Florian Rodari, the creation of collage-illusionism without using pasted paper 'demonstrates the metatechnical validity of the collage procedure'.[39] Such extended definitions englobe almost any surrealist activity or product, from Jacques Vaché and André Breton 'zapping' from one cinema to the other, or Alberto Giacometti's chance encounter with a gas mask at the Paris fleamarket, to Leonora Carrington's pictorial *sphynges*, Ernst's verbal *phallustrade* and Diego Rivera's (real) *singes-araignées*. The concept of 'tout est collage' can be extended to all modes of aesthetic production, where collage is identified with the principle of intertextuality. 'Cas limite d'intertextualité,' writes Henri Béhar, 'le collage considère l'entier de la littérature comme un discours clos, fini ou finissant, dont les éléments peuvent permuter à l'infini.'[40] All surrealist texts, from manifesto to automatic text, from poem to 'papillon', are inhabited by fragments of earlier

texts, and would therefore be included within the category of collage in such a generalized sense.[41]

One is led to conclude that the collage principle as defined above is so general that it cannot account for the specificity of surrealist collage. It is essential therefore to start by situating the notion historically, taking as a point of departure collage as a combinatory technique, namely a material mode of cutting and pasting pre-existing iconic or verbal messages. In the pictorial field the surrealist model is provided by cubist *papiers collés*, while in the literary field Tzara's 'Pour faire un poème dadaïste' is the founding recipe for the practice of collage.[42] Hence, while it can be claimed that all discursive practices, whether verbal or pictorial, are characterized by the discrete dissemination of prior discourses, since all texts intersect with other texts, the specificity of surrealist collage is to have drawn attention to the intertextual process itself, by its deliberate *mises-en-scène* of diverse and often divergent verbal and pictorial texts, which reveal the mechanisms of the assembling process by displaying its breaks. In contrast to traditional expectations in aesthetic production of material finish, semantic coherence, seamless narrative, and the integration of parts into the body of the text, leaving smooth contours, in surrealist collage the scars left by the grafting of spare limbs remain visible. The appropriation and assemblage of disparate fragments, in aggressive or discreet juxtapositions, are inscribed in surrealist collage as a visible gesture or a performative act – which explains the recurrent motif of the pointing hand, the frame within the frame, the theatre set or podium – in the overt staging of seams, material tears, semantic incoherence, iconographic anomalies or narrative nonsequiturs. This characteristic assimilates collage to the technique of montage with its connotations of the machine, stressing the intentionality of the process and the visibly constructed relation between elements. 'Monter, ' writes Denis Bablet, 'c'est choisir et assembler pour construire, mettre en rapport pour exprimer.'[43]

The combinatory process can be more or less overtly signalled in collage. In pictorial collage it is visibly inscribed when the material heterogeneity of its elements is foregrounded or when iconographic anomalies are present, such as shifts in scale or incongruous juxtapositions. These visible breaks which characterize collage – material, syntactic or iconographic – are sometimes parodied or mimicked, as in Dali's 1929 oil-paintings with collage, or Magritte's 'collages entièrement peints à la main' (E, 266), discussed in chapter 3.

Clearly, in verbal collage, which can also mask or mimic its sources, the encoded intent is often less visible than in pictorial collage. One of the problems which has arisen in the course of researching this book and establishing a corpus, is the invisibility of some verbal collages. 'Est-on condamné, en matière de collage littéraire, à une perpétuelle cécité, alors que dans les arts

plastiques il s'affiche comme tel par un ensemble d'indices formels?', asks Béhar.[44] The seams between verbal collage elements can be materially imperceptible. Michel Décaudin expresses his misgivings about the very possibility of elaborating a poetics of verbal collage, because of the elusiveness of its corpus: 'Dans le domaine littéraire . . . les éléments collés n'interviennent généralement pas en rupture; ce sont le plus souvent des mots et des phrases qu'on colle au milieu d'autres mots et d'autres phrases; le fil du discours peut être plus ou moins perturbé, le code de la lecture ne change pas.'[45] The levelling process often at work in verbal collage means that the hypotext is not always recognized as imported. Décaudin concludes on a rather pessimistic note: 'Une théorie du collage, dont l'élaboration ne serait pas impossible en peinture, aboutirait ici à un système réducteur incapable d'embrasser tous les aspects du phénomène.' According to Décaudin, this might explain why Aragon, who relegates to a footnote his intention of undertaking one day a systematic study of literary collage (C, 41), left his project incomplete, limiting it to two examples: the appropriation of the text of Hamlet in Tzara's Mouchoir de nuages, and an analysis of the 'thème secondaire' in his own novel La Mise à mort, hence identifying collage with the broader category of intertextuality. In the absence of material evidence of the collage process, such as that provided by the manuscript or the writer's own statements, the encoding intent of verbal collage can only be recognized indirectly: extratextually through the introduction of an alien fragment, intratextually through a break in the discursive logic, or intertextually with the identification of appropriated texts. Unless the decoder has the necessary competence to identify the collaged text, there is no difference between an actual collage text, and a text which exploits collage-effects, such as an automatic text, where the multiple voices of the unconscious, memory fragments and ready-made phrases are allegedly heard. These pseudo-collages, where the cutting and pasting process is simulated, are clearly limit-examples of collage. Insofar as they engage clashing iconographic, discursive or semantic elements to create the illusion of collage, they are relevant to the present study.

Defining surrealist collage essentially as a material technique serves to establish it as papier collé (or texte collé), but does not distinguish it from other instances of twentieth-century collage, such as cubist or futurist collage; after all, as Ernst claims, 'si ce sont les plumes qui font le plumage, ce n'est pas la colle qui fait le collage' (E, 256). Magritte also attributes little value to the glue of collage:

> En pensant à la question du 'collage', il me semble que le collage peut être non indifférent – comme le tableau peint à l'huile – dans la mesure où la colle (et l'huile pour la peinture) ne joue aucun rôle dans l'appréciation qu'on en fait.
> . . . L'importance stupide donnée à ces 'genres': huile, gouache, crayon,

confiture, cirage, marbre, sable, 'collage', etc., interdit selon moi que l'on en fasse état, désormais, dans un catalogue et dans la conversation. (Sinon pour en dénoncer l'absurdité.)[46]

Surrealist collage cannot be reduced to a cutting and pasting technique, a material practice of collating distant realities. It is also, and more essentially, a creative act of *détournement*, through the subversive manipulation and creative transformation of ready-made elements, forging the surreal out of fragments of the real, suggesting the *merveilleux* through the combination of banal and defunct images, clichés and rewritten texts. It is essentially a semiotic practice of transforming pre-formed iconic or verbal messages.[47] We saw above that this aspect is underlined by Aragon, who refers to the elements in Ernst's collages as signifying units, distinguishing them from the elements in cubist works which function as a direct quotation from reality or as formal units. Hence, both the encoding and decoding stages are central to an analysis of collage, which is not only defined as a formal category, but also, and more importantly perhaps, as a mode of perception.

The corpus analysed in the following chapters covers surrealist verbal and pictorial works where the cutting and pasting mechanisms are visibly or discreetly encoded, or where they are simulated. Widely different types of texts and images are considered under a single category. Materially, collage encompasses a wide range of media, from woodcut engravings to prints, photographs, feathers, paint, sand, playing cards, literary quotations and newspaper fragments. Collages are also technically diverse: the pasted element can be a minor component of the text or painting, as in Magritte's works of 1925–8 which often combine gouache, watercolour and drawing with a single collage element, or in several of Dali's paintings which incorporate minute, scarcely visible collage elements; or the entire work can be made up of collage elements, as in Breton's 1924 collage-poems, where there is not a single 'original' line, or Jindrich Styrsky's collages composed solely of ready-made iconographic elements. These collage elements can be 'pure' or imported ready-mades with no modification; or they can be transformed through processes of permutation, addition or deletion, involving the process of rewriting in literary collage, as in Breton and Eluard's 'Notes sur la poésie' which inverts Valéry's text, or the modification of iconographic images, as in Ernst's collage of the Venus de Milo in *Paramyths* (1949), analysed in chapter 7, where a butterfly head has been added to an engraving of the statue as in a rectified ready-made.[48] The corpus thus includes a clearly defined core of verbal and pictorial works, in which the actual cutting and pasting process can be identified either materially through actual traces of the glueing process, genetically in cases where manuscripts or an original *maquette* are available, semantically or iconographically in the presence of

anomalies, or paratextually by statements made by the surrealists themselves, such as Aragon's annotations to his earlier texts. Incorporated also are the nebulous frontiers, which include simulated or false collage, as well as 'collage intellectuel' or 'collage référentiel'.[49]

Collage is frequently invisible in another way, simply because, as an essentially ephemeral mode of production made of frail materials, it is difficult to track down. 'Le collage est pauvre', writes Aragon. 'Longtemps encore on en niera la valeur. Il passe pour reproductible à plaisir. Chacun croit pouvoir en faire autant' (C, 49). It was sent as letters (Breton's collage-letters to Vaché and Aragon, Roland Penrose's letters to Lee Miller) or personal gifts (Ernst gave *Rêves et hallucinations* to Aragon who in his turn gave it to Sylvie Danet), or produced as a source of income (during World War I Vaché made collages from bits of cloth and postcards of scenes of military life or elegant women, which he sold for two francs apiece in Nantes (C, 47) or as a game (*cadavres exquis*). Collages are often hidden in private collections or museum and library archives: for example, the Musée d'Art et d'Histoire at St-Denis houses Georges Sadoul's *Portes* (c. 1925), an unpublished fourteen-page booklet composed of collages made from magazine illustrations, newspaper fragments, photographs, postcards and drawings; a collage by Théodore Fraenkel is inserted between the pages of the Bibliothèque Nationale's copy of *Littérature*. Such discretion is compounded by the fact that surrealist collage is often difficult to decipher because it can be highly idiolectal, articulating the socio-cultural and personal minutiae of group and individual interaction. Moreover, collage has only recently been recognized as an art form on a par with so-called finished works. The large number of exhibitions devoted to collage in recent years is a sign of that shift: these include *The Golden Age of Collage: Dada and Surrealist Eras 1916–1950* at London's Mayor Gallery in 1987; an exhibition of 200 of Max Ernst's collages at the Kunstmuseum in Berne and the Kunstsammlung Nordrhein-Westfalen in Düsseldorf (1989); *Collages. Collections des musées de province*, organized by the Musée d'Unterlinden of Colmar (1990); *Collages surréalistes* at the Zabriskie Gallery in Paris (1990); *Rencontres. Cinquante ans de collages* at the Galerie Lusman in Paris (1991); *Collages, décollages, images détournées* at the Musée d'Ingres in Montauban and the Musée des Beaux-Arts in Pau (1992). Recent surrealist exhibitions have also given collage a more prominent place: at the 1989 Miró exhibition *Joan Miró: Paintings and Drawings 1929–41* at London's Whitechapel Gallery, preparatory collages for the artist's *Paintings made after collages* (1933) were displayed alongside the oil-paintings; at the Max Ernst retrospective in 1991 (Tate Gallery, London, Staatsgalerie, Stuttgart, Kunstsammlung Nordrhein-Westfalen, Düsseldorf), an entire room was devoted to collages; in the 1991 exhibition *André Breton. La beauté convulsive* (Centre Georges Pompidou, Paris), a number of collages were exhibited for

the first time; an exhibition of Claude Cahun's work in 1995 (Musée d'Art Moderne de la Ville de Paris) displayed a large number of photomontages; another 1995 exhibition, *Dessins surréalistes* (Centre Georges Pompidou, Paris), included numerous *cadavres exquis* and other collaborative collages. Yet, while collages are now being acquired by museums, many remain in private collections, and are rarely, if ever, exhibited. This very invisibility, both as a discrete mode of production and as an ephemeral genre, presented a challenge to track down collage in order to reposition it as a central mode of surrealist production.

Methodology

'Est-ce que telles toiles de Max Ernst, de Magritte, de Brauner intéressent moins la poésie que la peinture?' (*En*, 220) asks Breton, suggesting that pictorial compositions can be read in poetic terms. For the surrealists, pictorial and verbal modes of expression, far from being distinct surrealist activities, engage with 'la poésie', a notion which englobes a Mallarmé sonnet, an advertisement, a Magritte painting or a mode of life. However, Breton also grounds pictorial expression in more specific poetic terms: for example Ernst's collage activities are situated in an essentially literary tradition, of which Rimbaud and Lautréamont are claimed to be the founding fathers: 'le surréalisme a trouvé d'emblée son compte dans les *collages* de 1920, dans lesquels se traduit une proposition d'organisation visuelle absolument vierge, mais correspondant à ce qui a été voulu en poésie par Lautréamont et Rimbaud' (*SP*, 64). Max Ernst is given multiple literary ancestors in Breton's writings, from Rimbaud to Apollinaire, through Young, Lautréamont, Baudelaire and Jarry, treating the *jamais-vu* of the artist as analogous to the *inouï* of the poets. Max Ernst's own references to his collage activities are largely based on analogies with literary devices, echoing Breton's discourse, rather than on the cubist (essentially formal) notion of *papiers collés*. 'QU'EST-CE QUE LE COLLAGE?', he asks. '"L'hallucination simple", d'après Rimbaud, "la mise sous whisky marin", d'après Max Ernst. Il est quelque chose comme l'alchimie de l'image visuelle' (*E*, 253). Aragon also draws a parallel between pictorial and verbal modes of expression when he observes that Ernst's collage elements evoke others 'par un procédé absolument analogue à celui de l'image poétique' (*C*, 26).

Jakobson, basing his analysis on the principle of pictorial production as a system of signs, tentatively adumbrates a surrealist rhetoric within the framework of a general semiotics:

> Celui qui étudierait la métaphore chez les surréalistes pourrait difficilement passer sous silence la peinture de Max Ernst ou les films de Luis Buñuel, *L'Age*

d'Or ou *Le Chien Andalou* [*sic*]. Bref, de nombreux traités poétiques relèvent non seulement de la science du langage, mais de l'ensemble de la théorie des signes, de la sémiologie (ou sémiotique) générale.[50]

Groupe MU, extending Jakobson's work, reformulate traditional rhetoric through semiotics to encompass both verbal and pictorial forms of production, and notably collage.[51] Pictorial collage invites a semiotic analysis, since the cutting and pasting mechanisms which characterize collage define all semiotic utterances: 'faire (ou lire) une phrase, c'est toujours faire jouer le double mécanisme de sélection paradigmatique et de combinaison syntagmatique, c'est donc, toujours, opérer par collage'.[52] While the components of the sentence are drawn from the linguistic code, collage elements are drawn from pre-formed messages. Selection and combination also characterize the rhetorical mechanisms of metaphor and metonymy. More recent contributions to the study of twentieth-century collage have used the semiotic model, which challenges the mimetic model of aesthetic production.[53] My own approach, based on the notion of collage as the recycling of pre-existing signs, draws essentially on modes of analysis which are both structuralist, focusing on the process of sign-making in the structural relations between collage elements as signifying units, and poststructuralist, notably in the analysis of the surrealists' citational strategies, the parodic appropriation of literary and art-historical codes and fragments, and issues of context and intertext.

However, in opposition to the essentially reductive descriptions or theories by Breton, Aragon and Ernst, who stress the common denominator between verbal and pictorial modes, this analysis aims to chart the dialogue between two similar though quite distinct modes of production. It sets out not only to find points of contact in the analysis of similar procedures, but perhaps more essentially to find points of conflict. Pictorial and verbal modes of expression in surrealism have often rather hurriedly and quite uncritically been considered as equivalent processes, a tendency initiated by the surrealist poets and artists themselves. Breton, for example, conflates the two media by using general terms (such as 'réalités', 'images', 'éléments') to cover both verbal and iconic signs, and by resorting to metaphorical language to evoke the effect of the encounter of disparate terms ('lumière', 'étincelle', 'choc'), which can be applied to both iconic and verbal media. In addition, by giving priority in his 1924 *Manifeste* to isolated images rather than their elaboration in the poem, in his stress on the immediacy of the surrealist image, Breton circumvents the essential differences between the sequentiality of the linguistic medium and the simultaneity of the pictorial medium. The surrealists' own discourse thus needs to be deconstructed in order to differentiate between the ways in which iconic and verbal images function. An analysis of

pictorial and verbal collage involves attempting to define the workings of similar modes of production, while trying to avoid the dangers of a reductionist poetics which would erase the specificity of the material, whether image, object, word, or a combination of these. Rather than reducing one practice to the other, the boundaries and interfaces between verbal and pictorial media will be explored. This study will show, for example, the ways in which traditional modes of reading verbal and pictorial texts are subverted in collage, where the frontiers between the simultaneity of the iconic media and the linear elaboration of the verbal text are confused, as shown for instance in the strategies of spatialization used in verbal collage, the incorporation of verbal elements in pictorial collage, or the introduction of temporality in pictorial collage (as in the collage-novel and collage series). The surrealists thus continue, in the modernist tradition, to undo Lessing's claim in his *Laocoön* (1766) that poetry and painting are incompatible modes of signification. From a more general perspective, fragmentation is more acceptable in a perceptual than a verbal space; to borrow the words of Laurent Jenny: 'la sémiotique s'autorise à trouver des fractures dans le visible, parce qu'elle les y attend, et néglige les lézardes du discours'; indeed, the eye can '*balayer* un champ optique'[54] without the need to decipher, whereas the juxtaposition of words or syntagms generally calls for a rationalizing process, 'un balayage dynamique en quête d'unité(s) de signification'.[55]

The systematic estrangement and coupling of disparate elements in collage invite a reading which takes into account the complementary acts of production and reception. The initial stages of this study focused essentially on the encoding of collage and issues of representation. However, as the study progressed, the notion of *dépaysement* as used by Breton, for whom the term refers primarily to an effect (or an affect), called for an analysis of issues of readership and spectatorship.[56] The absence of pictorial cohesion or semantic coherence in collage disturbs the viewing or reading subject; information seemingly withheld frustrates and thus implicates the addressee, inducing her active engagement in constructing the work. The imaginative activity triggered by the gaps between the collage elements is seen as an integral stage of the collage process itself. Such an aesthetics of effect or collage *ethos*,[57] grounded in the convergence between text and reader, complements and completes the study of the encoding of collage. To adequately chart such a process requires a pragmatic analysis, which examines the role of the addressee in the hermeneutic activity. Such a reading can be seen as an integral part of the semiotic approach, since it takes as its premise the active cooperation of the reader, who fills in the spaces in the text or image, identifies sources or intertexts, or simply inhabits the gaps. The centrifugal, dislocated imagery can indeed make the reading of collage difficult, but it presents a challenge for the critic to read these works, 'non pas malgré leur illisibilité,

comme une énigme à décrypter, mais dans cette illisibilité même, comme un processus à réactiver'.[58] Aware of the dangers – and attractions – of eclectic methodological approaches and *bricolage* analysis, I propose an analysis of surrealist collage which encompasses both a critical reading, where specific collages are dissected and analysed, and a theoretical reflection on the collage process, as a mode of signification within the context of surrealism, in relation to questions such as the creation of the surreal or the *merveilleux*, the structure of enigma, the concept of *hasard objectif*, the aesthetics of *beauté convulsive* and the relations between part-bodies and totalities.

The displacements and condensations of collage configurations; the nonsequiturs and fragmentation of collage narratives; the simulation of the simultaneous jarring discourses of the unconscious in the multiple voices of the text; the dissolution of identity in the dislocated photomontage portraits, the re-enactment of primal fantasies, the fetishism of part-bodies: these characteristics of collage could be subjected to a psychoanalytical reading. The enigmatic signifiers of collage might well point to fantasies of seduction, primal scenes or castration, as Hal Foster for example has quite singlemindedly argued.[59] However, such a reading is beyond the scope of this study, which focuses less on the hermeneutics of collage than on its semiotics, namely the analysis of the mechanics of collage as a citational strategy. In this optic, psychoanalysis is less relevant as an interpretive code than as a discourse among others, exploited as ready-made material, to be analysed as a social construct whose models the surrealists manipulate and transform in their conscious and often parodic reworkings of fragments of psychoanalytical discourses and models. Hence, while Foster distinguishes between dada collage as 'transgressive montage of constructed social materials', and surrealist collage as 'disruptive montage of conductive psychic signifiers',[60] I argue that the discourse of psychoanalysis also enters surrealism as fragmented, distorted or displaced social material in collage. The recycling of images distances them from their original meanings while retaining the traces of these meanings, and invests them with new meaning, so that the psychic material is recoded in ludic manipulations. Such aesthetic or sublimatory recodings are considered here as the dynamic reworkings of the 'signe ascendant' rather than the fixed traces of a trauma, in a juggling with fragments which are signifiers unhinged from earlier meanings and exposed to the play of difference. My own critical approach purports to account for images which both invite and resist interpretation, and for the irreducible heterogeneity of collage fragments, which might be erased or bypassed by applying the explanatory model of psychoanalysis. This approach focuses on the mechanisms of collage, the breaks and fissures, rather than cementing them over in a clarified reading.

This study deals essentially with works produced between 1919 and 1940 by the surrealist group around Breton, with some incursions into the 1940s and outside the Paris nucleus. The historical limits chosen have deliberately ragged edges. The reference to the seminal 1921 Paris exhibition of Max Ernst's works showed how it is quite impossible to draw a line between the end of dada and the start of surrealism. Without wishing to reduce dada to a pre-surrealist phase, it can be said that the two movements are historically interwoven. Breton compared dada and surrealism to alternating currents: 'Dada et le surréalisme – même si ce dernier n'est encore qu'en puissance – ne peuvent se concevoir que corrélativement, à la façon de deux vagues dont tour à tour chacune va recouvrir l'autre' (*En*, 62). The decision to restrict the study essentially to collages of the first period of surrealism is primarily strategic, and is not intended to minimize the important renewal of surrealist collage from the late 1940s, notably among the Czech surrealists (Heisler, Kolar, Svankmajer . . .), but also among younger French artists (Benayoun, Elléouet, Nicole . . .). Although the conclusions I have drawn are applicable to later collages, the social, cultural and aesthetic conditions after 1945 were so radically different from those of the interwar years, that surrealist collage of that period would require a separate study.

The approach adopted is synchronic rather than diachronic, privileging principles and structures rather than forging a linear narrative. I should like to propose a reading of collage as a semiotic process, where tendencies and networks across the twenty odd years under scrutiny will be delineated, while underlining the links between specific aspects of collage practice and the aesthetic, philosophical and political activities of the surrealist group. Further, the focus will be less on biographical material than on works, while recognizing that the history of collage could also be written as a story of individual artists and writers. For example, Jacques Dupin has given an account of Miró's collages in the late 1920s and early 30s in the light of his 'assassination of painting' phase, a narrative which has been challenged by Anne Umland who constructs the story of a dialogue between painting and collage in Miró's work.[61] While giving considerable attention to the work of Ernst and Breton, my analysis also covers less well-known figures and works.

Geographical limits have deliberately not been imposed on the study. Whilst recognizing Paris as the nucleus of surrealist activities, collage activities in Prague, Brussels and London are also considered. The mobility of surrealist ideas, communicated through journals, visits, conferences and exhibitions, and the numerous personal contacts and collaboration between artists and poets, make of surrealism an international community of discourse. For instance, while still in Cologne, Max Ernst collaborated with Eluard in producing *Répétitions* and *Les Malheurs des immortels* (1922). Roland Penrose, who lived in Paris from 1922 to 1935, provided an essential link with

artists working in England. As for the Brussels connection, Magritte's first contact with the Paris surrealist group dates from 1927. Magritte, along with Paul Nougé, Camille Goemans and E. L. T. Mesens, went to Paris in 1927, and while Magritte returned to Belgium in 1930, Mesens settled in London from 1938 where, as director of the London Gallery, he acted as mediator between the surrealist groups in Paris, Brussels and London. Similarly, there were numerous contacts and collaboration between the Czech and Paris surrealists before 1935, the year Eluard and Breton went to Prague.

The analysis which follows will focus initially on the mechanisms of collage production or the 'cut-and-paste' technique. The surrealists favour cut-out materials which are trivial or outmoded, marginal or ephemeral; these collectors' pieces are considered less an exhaustive inventory of the textual and iconic elements selected than an exploration of types of material used in collage. The combinatory process is explored in an analysis of the various syntactical structures of verbal and pictorial collage. 'Cocking a snook' examines the processes of semantic transformation effected in collage as a result of the *détournement* of words and images, both as a parodic activity and as a metaphorical strategy, as outlined in Aragon's text on Ernst quoted above. This is followed by an analysis of the effect of collage on the reader / viewer, identified by Breton as *dépaysement*. The mechanisms of *détournement* and the *ethos* of *dépaysement* are analysed in semiotic terms as the structure of enigma. Attention is thus shifted from the production to the reception of collage. 'Between Fantomas and Freud' proposes an analysis of narrative codes and, notably, the parodic reworking of stereotypical narratives. Strategies involved in the reading of collage are discussed: when we read collage narrative texts or view collage-novels, is our role similar to that of the detective – or his *alter ego* the psychoanalyst – piecing the fragments together as in a rebus? Or are the mechanisms of collage narrative closer to those of the dream, which invites us to inhabit the enigma and accept the fragmentation of oneiric experience? The following chapter, 'Masking', takes as its starting-point an analysis of the mask in surrealism, in order to study the question of identity in relation to otherness as it is raised in collage practice, in intertextual strategies and in photomontage (self-)portraits. 'The future of statues?', focusing on representations of the body in surrealism, analyses some of the iconoclastic and iconographic motifs of collage: exploring the surrealists' deconstruction of the opposition between classical and modernist modes of representing the body, it shows how the unity of classical statues is eroded in collage. The issue of fragments and whole bodies raised in that chapter is developed in the concluding chapter, 'An impossible mosaic', which returns to a question already alluded to earlier in the present chapter on the finality of collage: are part-bodies finally resolved dialectically in the total body, as suggested by Breton, or are they experienced as contradictory fragments, as claimed by Aragon?

Rather than attempt to give a comprehensive survey of surrealist collage, this study undertakes to identify its basic principles through the analysis of individual collages. The corpus chosen is thus representative rather than exhaustive. I propose a reading which considers surrealist collage as a process rather than a product,[62] an experimental mode of textual and pictorial production more than a fixed genre, a disruptive activity, not a static form. My reading stresses the importance of collage as a paradoxical structure: its visibility as the collation or copresence of disparate elements, and its legibility as a configuration of signs, in a dynamic process of multiple meanings and hovering significations constantly reactivated, eliciting both the addressee's cultural competence in decoding iconic and textual signs, and her openness to the free play of collage. In addition, as my subtitle indicates, the clinical dissections of the critic's discourse does not preclude the paroxysms of melodrama, hysteria and desire encoded in *exquisite*, and experienced as an integral part of the disorientation effect of collage. Above all perhaps, collage is a cosmogonic game, 'le jeu de patience de la création' (*SP*, 25), a playful activity and hence a liberating force, freeing collagist and addressee from perceptions blunted by clichés, codes and causality, those banal arrangements of apples and pears, and from expectations dulled by academic concerns for coherence and linearity. Jolted out of our visual habits and rationalist mental moulds by chance encounters between a sewing machine and an umbrella, between Shakespeare and an advertising slogan, a pharmaceutical formula and a lyrical development, we are propelled into collage space and invited to explore its 'paysages dangereux' and exquisite corpses, uncovering new perceptions grounded in the mechanisms of objective chance and linked to the workings of desire.

Cutting

Quand Max Ernst vint, ces différentes données étaient outrageusement simplifiées. Il apportait avec lui les morceaux irréconstituables du labyrinthe. C'était comme le jeu de patience de la création.

André Breton[1]

'Rêves et hallucinations'

A cardinal sits gagged, his crucifix replaced by a flower, his feet resting on the photograph of a military scene, while his gloved hand points downwards to an advertisement for *Articio*, 'l'apéritif ami du foie aux vins de France & extraits d'artichaut' (figure 2). To the right of the dignitary, pasted at an angle, an advertisement for *Smoko*, 'pâte dentifrice des fumeurs', displays the bust of a gentleman in top hat and dinner jacket, smoking a cigar. Below this advertisement, and partly covering the military scene, the fragment of a third advertisement, composed of the words 'CHAUD – LEGER / ELEGANT – PRATIQUE', is placed above the image of an elegantly dressed male figure facing the soldiers. Behind and above the cardinal towers the bust of a woman in a bonnet, whose profile is mirrored on the right of the collage in the cut-out photograph of a bombed cityscape. Superimposed on this photograph is an advertisement for 'l'inimitable FAINEUF / S^TE G^le des cires françaises à Montluçon', while a handwritten slogan for the same product – '*Tout ici est à neuf . . . Grâce à Faineuf*' – is pasted at the top centre of the collage. Beneath this slogan are the printed words 'REVES ET HALLUCINATIONS', on what appears to be the title-page of a book forming the ground of the collage. The author's name is almost fully concealed – only the last two letters (-NN) are visible – by the cut-out engraving of a gloved hand or gauntlet, placed above the cardinal's hand, gesturing in the direction of the photograph of the

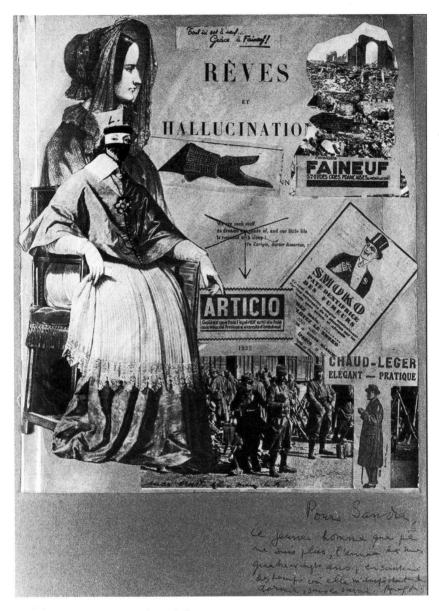

Figure 2 Max Ernst, *Rêves et hallucinations* (1926)

ruined city. The epigraph – 'We are such stuff / As dreams are made of, and our little life / Is rounded in sleep!' – attributed here to Carlyle, is crossed out in ink, while an arrow points down towards the *Articio* advertisement. The collage has two handwritten dedications: one on the photograph of the military scene, which reads '*Max Ernst 26 pour L.A.*' (these initials also appear on the cardinal's mitre), the other at the lower right of the collage: '*Pour Sandra,*

ce jeune homme que je ne suis plus, l'année de mes quatre-vingts ans, en souvenir des temps où elle m'empêchait de dormir sans le savoir. Aragon.' This collage, entitled *Rêves et hallucinations*, was produced by Max Ernst in 1926 and sent to Louis Aragon, who in turn gave it to Sandra Danet in the early 1970s. It was acquired in 1989 by the Musée d'Unterlinden in Colmar.[2]

The work displays the devices of its production in the visible tears, seams and textures of its materials. The materials, drawn from different media and registers, include newspaper advertisements and photographs, as well as art-historical images (a photographic reproduction of Philippe de Champaigne's painting, *Le Cardinal de Richelieu*), printed material (the title-page of *Rêves et hallucinations*), graffiti and handwritten texts. The black and white photographs, the brown printed paper of the advertisements, and the book title-page which forms the ground present clearly defined contrasts in colour and texture. The irregular edges of the fragments are visible, and images of differing scales and registers overlap at various angles as if they had been casually assembled.

The assembling of materials from various registers and sources challenges traditional notions of hierarchy in a process which treats the fragments without discrimination. High and low art, the poetic verse and the advertising slogan, the graffiti and the printed word, artistic and institutional icons cohabit in a single space, in a levelling process which frees the constituent elements from their original fixed meanings and functions. By juxtaposing apparently incongruous images, the collage stages different modes of interaction between signs, and thus invites various readings, whether parodic, poetic or simply playful. The arrangement of the collage elements seems to present a rebus, challenging the viewer to solve the enigma of their juxtaposition by combining the disparate elements in a coherent reading.

Ernst's appropriation of texts and images can be read as a social critique of the discredited values of the ecclesiastical, military and literary establishments. Photomontage as a critical cutting and pasting activity was already a privileged vehicle for political satire among the Berlin dadaists. Ernst's work is similar to dada photomontage both in construction (the overt display of fragmentation, the combination of graphic and pictorial elements) and iconographic motifs (the use of images from the military and ecclesiastical institutions), and can be read as a socio-political statement. The bourgeoisie, the army and the church, recognized by their uniform(ity), are seen to be thriving on the ruins of capitalism, caused by the bourgeoisie, carried out by the army, and blessed by the church. The juxtaposition of war photographs with advertising slogans debases the significance of the former and calls into question the function of the latter. Hence, the advertisement for *Faineuf*, presumably a make of furniture wax, placed below the photograph of ruins, becomes a satirical caption for a scene depicting the destructive-constructive

effects of war, while the slogan '*Tout ici est à neuf . . . Grâce à <u>Faineuf</u>*' can be read as a derisive comment on postwar reconstruction programmes.[3] The church's authority is presented as handed down to, but also supported by, the coercive element of the military establishment. The cardinal appears to tower over the military scene, his hand pointing down in a negligent gesture as if blessing its protagonists (perhaps with *Articio* apéritif?) and hence patronizing the destructive machinery of war. The gauntlet and the cardinal's limp hand, inverting the cliché of the iron fist in a velvet glove, overtly display the *rapports de force*, unmasking the usually covert ideological under-pinnnings of the system. A similar attack on the collusion between the dominant powers is enacted in George Grosz's photomontage *My Germany* (1920), where the connections between the military establishment and capitalism in the Weimar Republic are overtly articulated.[4] In addition, the graffiti-like markings on the photograph of the cardinal – the gagged mouth, the initials *L.A.* on the mitre, the flower – which recall Duchamp's acts of vandalism on established icons, challenge the inviolability of the masterpiece, reducing it to a commodity on a level with the frayed fragments of advertisements. The dedication to Aragon, casually written over a photograph presumably cele-brating war, displaces a social message by using it as a ground for a personal missive. Finally, the traditional poetic text forming the epigraph is crossed out and an arrow points to an advertisement for *Articio*, suggesting in a graphic form that the central position of consecrated literary language is being chal-lenged, ousted by the new lyricism of advertising language.[5]

Yet this work cannot be reduced to a satirical reading. It functions as a kind of palimpsest, where other strata, partially obscured yet deliberately dis-played, remain operative, serving to dislodge any fixed meanings and to promote a multilayered signifying process. The collage, intended as a gift for Aragon, appears to constitute a personal dialogue with him: the title echoes Aragon's text *Une vague de rêves* (1924), while the elegantly dressed gentlemen in the advertisements might allude to Aragon the dandy, and the pasted advertisements recall the collaged elements in Aragon's *Paysan de Paris*, pub-lished in the same year as this collage, and celebrating the 'merveilleux quo-tidien'. Another level of image-making is visible in the elements of a *cadavre exquis* suggested by the assemblage on the left. The bust of the woman in a bonnet appears to be continued in the figure of the cardinal encompassed within her body, his robes forming her voluminous skirt, her two tiny feet just visible, shared with one of the soldiers in the photograph beneath the figure. With gloved hand, in a gesture which almost repeats that of the cardinal, she seems to be addressing her mirrored silhouette.

Yet another instance of the stratification of meanings is provided by the ground of the collage, consisting of the title-page of a book whose epigraph and title, *Rêves et hallucinations*, bear witness to Max Ernst's fascination with

dreams and the hallucinatory power of images. The book, published in Paris in 1925 by Vigot Frères, was written by Dr Schatzmann. Like the surrealists, Schatzmann values dreams as 'une révolte contre la tyrannie de la raison' (p. 324). He claims there is a continuity between images perceived in a waking state and hypnagogic hallucinations, an idea which echoes Breton's analysis of dreams in his 1924 *Manifeste*. In his book Schatzmann proposes 'une autopsychanalyse' of 149 of his own dreams; Breton was later to engage in a similar undertaking in *Les Vases communicants* (1932) in an equally meticulous and naïve manner. Ernst's inclusion of the Cardinal de Richelieu is also significant in this context: it was known that the Cardinal suffered from self-delusion or *pseudologia fantastica*, and would sometimes gallop about and neigh, believing he was a horse.

Ernst's use of the title-page of Schatzmann's book suggests a further level of meaning, namely a reflection on the collage process itself as a strategy of appropriation. The gloved hand hides the name of the author, suggesting that the language of dreams and hallucinations, like that of collage, is anonymous – *NN* – or collective. A similar (mis)appropriation is made of the language of poetry: the epigraph, wrongly attributed to Carlyle on the original title-page of Schatzmann's book, in fact comes from Shakespeare's *Tempest*. Perhaps Max Ernst knew this when he integrated this title-page into his collage and crossed out the quotation? Moreover, the slogan '*Tout ici est à neuf – Grâce à Faineuf*' can be read as a comment on the collage process, which purports to 'make new' old images. The history of this particular work also testifies to the status of collage as a form of collective property and a mode of migration of signs. Ernst appropriates images and texts in a work which he dedicates to Aragon, who in turn appropriates the collage through his own dedication, on the collage itself, to Sandra Danet, thus displacing once more its meanings. The nomadic character of collage is underscored by its status as a type of ephemera, made of poor materials on a paper support, sent unframed as a gift to a friend who continues to circulate it. Local patterns of meaning can thus be constructed from the collage elements, creating multilayered signifying patterns, yet each element ultimately remains autonomous, a migrant sign hovering between original context and novel configurations, never fully liberated from the aura of its origins, never fully absorbed into its new context, never yielding a global coherence.

It was suggested in chapter 1 that surrealist collage, as a pragmatic object, should be considered essentially as an act of production rather than a product, to be analysed from a double perspective: as a text/image-making act and as an act of reception. The analysis above of *Rêves et hallucinations* sketched out the stages of this double act, by focusing attention firstly on the mechanisms of the work's production, and secondly on the issues of reading the work. Moreover, three stages can be identified in the collage-making

process: an initial stage of selection of elements, followed by the assembling of these elements, which are transformed in a third stage to create a new entity. Groupe MU identify these three stages as follows: 'La technique du collage consiste à prélever un certain nombre d'éléments dans des oeuvres, des objets, des messages déjà existants, et à les intégrer dans une création nouvelle pour produire une totalité originale où se manifestent des ruptures de types divers.'[6]

Collage is firstly a material process of selecting and cutting up material, where, according to Breton, words and images are 'considérés d'abord élémentairement et presque "rendus" selon leur figuration du dictionnaire' (*SP*, 29). The raw material of collage is already cooked. In his preface to Max Ernst's 1921 exhibition, Breton states: 'Il est . . . stérile de revenir sur l'image toute faite d'un objet (cliché de catalogue) et sur le sens d'un mot comme s'il nous appartenait de le rajeunir. Nous devons en passer par ces acceptions, quitte ensuite à les grouper selon l'ordonnance qui nous plaira' (*OCI*, 245).[7] While the first sentence refers to the necessity of accepting words and images as ready-made entities, the second sentence focuses on their assemblage, the real site of their rejuvenation, which suggests that the act of collage privileges less the materials themselves than their combination. The importance of the combinatory process is underscored in Breton's definition of the surrealist image where he focuses on the bringing together of distant realities in incongruous juxtapositions, '[le] rapprochement en quelque sorte fortuit [de] deux termes' (*OCI*, 337). Both collage and automatism subvert normative relations between elements through the concerted or spontaneous displacement of words and images. Breton gives as an example the physical removal – or literal *dépaysement* – of a statue from public square to ditch: 'une statue est moins intéressante à considérer sur une place que dans un fossé' (*OCII*, 305). Thanks to the imaginative re-ordering of signs through processes of displacement and assemblage, which break with the codes of mimesis and coherence, images and words are freed to create new configurations. Breton refers to this stage of the process as follows: 'L'objet extérieur avait rompu avec son champ habituel, ses parties constituantes s'étaient en quelque sort émancipées de lui-même, de manière à entretenir avec d'autres éléments des rapports entièrement nouveaux, échappant au principe de réalité mais n'en tirant pas moins à conséquence sur le plan réel (bouleversement de la notion de relation)' (*SP*, 64).[8]

What are the characteristics of the 'rapports entièrement nouveaux', those new configurations which are created in the third stage of collage: a semantic effect or an emotional affect? While Aragon examines the process of *détournement* as essentially a semiotic act in his analysis of the metaphorical transformation of elements which he charts in Ernst's collages, Breton's discussion of *dépaysement* – of the reader/viewer this time – focuses on the

affective resonance of such encounters. Whether concentrating on the semi-otics of *détournement* or the *ethos* of *dépaysement*, critical attention shifts in this third stage from the production to the reception of collage, where the reader/viewer is actively engaged in the transformation of words and images and the elaboration of meanings.

The three stages of collage-making – collecting, collating and configuring – will be analysed in the following pages. The rest of this chapter and the next will focus on the encoding process or cutting and pasting mech-anisms, while chapters 4 and 5 will explore collage decoding strategies, namely rhetorical and narrative reading processes.

Cutting: collectors' pieces

> Puis j'ai placé sur ma fenêtre un aquarium. J'y conservais un scalp aux cheveux d'or, un très bel exemplaire de papillon à l'œil bleu et aux tendres veines aux tempes. Mais plus tard, j'y ai jeté tout ce que j'aimais: des débris de tasses de café, des épingles à cheveux, la pantoufle bleue de Catherine, des ampoules, des ombres, des mégots, des boîtes de sardines et toute ma correspondance. Ce monde a fait naître un grand nombre d'animaux étranges. Et je me considérais comme un créateur.[9]

This quotation from Styrsky illustrates the diversity of materials used for collage. Personal fetishes and banal débris, images from commercial or pedagogical catalogues, nineteenth-century popular science journals and illustrated novels, neo-classical statues and Second Empire ornaments, turn-of-the-century prints and postcards, advertising images and slogans, proverbs and *faits-divers*: surrealist collage materials include the ephemeral and the defunct, the outmoded or the stereotypical, high and low cultural fragments. In contrast to the cubists, who used a restricted range of materials in their *papiers collés* – newspaper or wallpaper fragments, tram tickets, bottle labels or other printed matter – the surrealists selected their collage elements from a wide range of sources. And while the cubists subjected their collage frag-ments to the formal aesthetic demands of their compositions, the surrealists were drawn primarily to the semantic potential of already constituted signs or artefacts. Important exceptions, however, do exist, particularly with the return at the end of the twenties to the technique of *papiers collés* – as in Miró's compositions, such as *Danseuse espagnole* (1928) – which integrate collage elements chosen essentially for their formal qualities. Some of these collage sources are explored in the following pages. My aim is not to identify in the source images and texts a covert interpretant which would explain the works by identifying their textual or iconographic sources, draining them of their mystery by labelling their constituent parts; nor is it to privilege the

selection process of collage over its assembling and semiotic processes, thus reducing the import of the later stages of collage production. The aim in this section is to draw up a typology of collage elements, and not an exhaustive inventory, in the context of the surrealist encounter.

Collage materials are the fruit of the discerning ragpicker – Aragon refers to 'la personnalité du choix' (C, 43) – rather than the result of random pickings as in dada hat-tricks. Less an aleatory agent of production than a subjective engagement, the surrealists' selection of collage materials is informed by desire, determined by an encounter which has the characteristics of objective chance and the impact of a revelation. 'To collect', writes Roger Cardinal, 'is to launch individual desire across the intertext of environment and history. Every acquisition, whether crucial or trivial, marks an unrepeatable conjuncture of subject, found object, place and moment.'[10] The *trouvaille* or found object is situated at the point of intersection between an inner desire and its manifestation in reality. 'C'est en elle seule', writes Breton in *L'Amour fou*, 'qu'il nous est donné de reconnaître le merveilleux précipité du désir' (*OCII*, 682), and he gives as an example Giacometti's discovery at the Paris fleamarket of a metal half-mask whose encounter allows the artist to complete a sculpture he was working on at the time, *L'Objet invisible*. Associated with the artist's desires and anxieties, the mask strikes Giacometti as the crystallization of an inner voice, and its function as a catalyst allows the artist to overcome an obstacle experienced hitherto as insurmountable.

The encounter with the object, responding to inner desires and provoking associations, thus invites interactions and appropriations. Ernst explains his fascination with commercial catalogues by the hallucinatory qualities of the images of objects lined up on their pages. Tracing his 'discovery' of collage back to a legendary rainy day in 1919 – and it is significant that collage was allegedly discovered by chance and not invented – Ernst recollects his fascination with the obsessive quality of 'les pages d'un catalogue illustré où figuraient des objets pour la démonstration anthropologique, microscopique, psychologique, minéralogique et paléontologique' (*E*, 258). He draws some of his early collage material from teaching-aids catalogues such as the *Kölner Lehrmittel Anstalt* (1914), where images of pedagogical materials – ranging from alphabets and animals to geometrical forms and anatomical charts – are assembled in rows on the page, sometimes portrayed in widely differing scales and drawn from very divergent contexts. Each object, rendered in clearly legible form for didactic purposes, is isolated against a white ground, as if suspended in space. Ernst also recycles material from commercial catalogues such as *Le Catalogue du Grand Magasin du Louvre*, *Le Magasin des nouveautés*, *Le Magasin pittoresque* and *Les Attributs de commerce*. He uses this material in a series of collage-type works produced in 1920-1 which he calls *Übermalungen* (overpaintings), produced by choosing a page from a catalogue and painting over or subtracting some elements, thereby

inverting the additive process of collage. Several of the works shown at
Ernst's 1921 Paris exhibition exemplify the technique of overpainting, some-
times combined with collage: for example, in *L'Ascaride de sable* (1920), dis-
cussed in chapter 4, two rows of ladies' hats, set at an angle, are overpainted
with yellow and blue gouache, to form a ground which suggests a desert land-
scape.[11] In the overpaintings, Ernst's intervention is often reduced to a
minimal gesture:

> Il suffisait alors d'ajouter sur ces pages de catalogue, en peignant ou en dessi-
> nant, et pour cela en ne faisant que reproduire docilement *ce qui se voyait en moi*,
> une couleur, un crayonnage, un paysage étranger aux objets représentés, le
> désert, un ciel, une coupe géologique, un plancher, une seule ligne droite
> signifiant l'horizon; pour transformer en drames révélant mes plus secrets
> *désirs*, ce qui auparavant n'était que de banales pages de publicité. (E, 259)

In the seemingly arbitrary alignment of clearly defined images on the page,
Ernst detects a hallucinatory quality similar to that of dream images. Minor
changes, such as the addition of a horizon line or ground, help to bring out
the marvellous in the images. Ernst sometimes adds to these collages and
overpaintings a text, handwritten as in a classroom primer, often itself a
collage of fragments, which continues, often through paradox, the imagina-
tive resonance of the pictorial elements. Ernst's statement suggests that the
charm of these objects lies not only in the memory of their past functions,
but perhaps more essentially in their role as catalyst of as-yet unarticulated
desires.[12] Estranged from their utilitarian function, these images appear to
crystallize, in a graphic form, the desires and anxieties of the unconscious
mind.

Miró also used commercial catalogues as a source for his collages, but
with a totally different result. In October 1933, the Georges Bernheim Gallery
in Paris exhibited eighteen large oil-paintings based on collages, executed by
Miró in the spring of that year. Miró cut out from sales catalogues and
advertisements engravings of banal objects such as kitchen utensils,
machines, tools or a battery, which he arranged and pasted onto large sheets
of Ingres paper. The pasted items, in a very reduced format, are surrounded
by large areas of white paper. The collages served as a preliminary stage for
Miró's paintings; 'I did not copy the collages,' comments Miró in an interview,
'I merely let them suggest shapes to me.'[13] He used them as a point of depar-
ture for his imagination, which transformed the original objects into organic
shapes or signs suggesting figures, creatures and plants, which recall the
figures of his earlier 'dream paintings', floating on dark or blue-green
grounds which evoke the nocturnal or aquatic space of dreams. Like Ernst,
Miró was fascinated by the hallucinatory potential of images lined up on the

page, but whereas Ernst's appropriations involve minimal displacements which leave the image itself largely unchanged, Miró totally metamorphoses the collaged images from sharp-edged manufactured objects to floating bio-morphic forms. 'Between the collage and the finished canvas', writes Jacques Dupin, 'there has been a complete change of realm, the mechanical image has been transformed into an organic reality, and the neutral, inert arrange-ment of the collages has become a prodigiously rhythmic composition.'[14] Although Miró kept the original collages, he chose not to exhibit them, since they were designed solely as preparatory works, designed to be superseded by the paintings.

Both Ernst's use of objects lined up on the pages of a commercial cata-logue, and Miró's pasting of tiny images on to large sheets of paper, testify to the power of the isolated sign to provoke associations. Freed from a specific context which would limit its resonance, and set adrift in a space which acts as a screen for the projection of subjective associations or formal manipula-tions, the isolated sign is favoured not only in pictorial but also in verbal collage, where the surrealists often integrate single phrases, quotations or titles. It is thus significant that Breton's poetics are grounded on the single image rather than the sustained text, as is evident in his list of isolated images in *Le Manifeste du surréalisme* (OCI, 339), or in his notes on *Les Champs magné-tiques* where he underlines individual images in red.[15] Indeed, he tends to con-sider poetic works as an anthology of images; for example, in 'Forêt noire', he quotes a line from Rimbaud's poem 'La rivière de cassis' – '*que salubre est le vent*' – signalled in the text as a separate unit by the use of italics and iso-lated typographically on the page.[16] Significantly, this line is already isolated in its original context, thus enhancing its poetic resonance. Breton later lists this line among those which give him 'un trouble physique caractérisé par la sensation d'une aigrette de vent aux tempes' (OCII, 678). Freed from the support of a diegetic elaboration, these isolated images appear more arbi-trary than they were in their original context; presented in isolation, their associative resonance is enhanced. This partly explains the surrealists' predilection for recycling titles of earlier works, as we saw earlier in this chapter in the case of Ernst's collage, *Rêves et hallucinations*, whose title is appropriated from a work by Dr Schatzmann. Similarly, the title of Camille Bryen's *Les Quadrupèdes de la chasse* (1933) was 'found' in a bookshop window. 'Ces mots', writes Bryen, 'soustitrant un ouvrage de vénerie, s'imposèrent.' Spatially, and hence semantically, isolated on a book-cover or a title-page, these words act on the imagination of the poets in a manner similar to the hallucinatory appeal of catalogue images for Miró and Ernst. Cut out and pasted as a title in a new paratactic context, the collage fragments continue to resonate with multiple and indeterminate meanings.[17]

'Aucun phénomène de la vie moderne n'a gagné autant d'étroits

rapports avec l'esprit, que cet étrange monstre: la réclame', writes Tzara.[18]
The surrealists were alert to the verbal energy and visual impact of com-
mercial signs in the streets of Paris and in the pages of newspapers – shop-
signs, giant billboards, advertisements.[19] From the turn of the century,
advertising had radically modified the make-up of the cityscape. 'Démesuré,
hallucinant, le panneau s'impose partout . . . Il surgit comme une cathédrale',
writes Louis Chéronnet in an enthusiastic celebration of the hallucinatory
appeal of the billboard.[20] Advertisers attracted the eye by isolating or enlarg-
ing their products on billboards and media pages, such as the enormous
Mazda lamps to which Breton refers in *Nadja*. Chéronnet claims that the spec-
tacle offered by the street in the quick succession of advertisements is more
exciting than the music-hall: 'Un garage entier est sorti un jour de la plus
grande baignoire du monde comme une boîte magique. Une lampe de T.S.F.
pour réception planétaire éclate un matin et aussitôt apparaît une bouteille à
quoi pourra enfin s'abreuver Gargantua.' In *La Liberté ou l'amour!* (1927),
Desnos exploits the dramatic potential of these giant images by staging a
mock-epic struggle between Bébé Cadum ('l'archange moderne') and
Bibendum the Michelin Man, with the tyre finally winning over the soap-
bubble.[21]

Advertising provided the ground for a new pictorial and literary aes-
thetic articulated as early as 1913 by Apollinaire in his poem 'Zone': 'Tu lis les
prospectus les catalogues les affiches qui chantent tout haut / Voilà la poésie
ce matin et pour la prose il y a les journaux'. While the Berlin dadaists' aggres-
sive cutting up of ready-made images often reveals a satirical treatment of
media images and language, the surrealists' own attitude appears to be more
wholeheartedly enthusiastic, echoing the fascination of Chéronnet or
Apollinaire. Breton's predilection for advertising language as a source of
poetic invention is expressed in a letter to Aragon in 1919: 'Belles quatrièmes
pages des journaux. Tout le lyrisme moderne.'[22] The following month he sent
Aragon a handwritten copy of his *poème-affiche*, 'Le Corset Mystère'. This text
accompanied one of the many collage-letters Breton was to send friends over
the next four years: these are composed of ready-made documents, drawings,
fragments of advertisements and newspaper articles, a visiting card, some-
times with a few manuscript lines added.[23] The surrealists often found in
advertising language or imagery the concise slogan or visual fragment which
articulates desire. The journal *Proverbe*, produced by Eluard in 1920–1, pub-
lished montages of short pseudo-aphoristic sentences, reworked proverbs
and fragments of advertisements, polemical or poetical in tone. In the first
issue (dated 1 February 1920), the last page, which would normally be devoted
to *petites annonces*, is headed 'LISEZ ATTENTIVEMENT', and consists of a
series of short texts with a typographical layout similar to that of advertise-
ments. One text, possibly a collage, signed P. E., reads:

TOUT SEDUIT

———o———

Acrobate des plates,
Amoureux des filles à l'étroit,
Il jette sa main et son bras sur toi,
Bas
Légère à prendre
Mais lourde à garder.

Théodore Fraenkel produced similar collage texts, combined with pictorial elements, such as 'Une séance historique' and 'Femmes qui souffrez' (1920), composed of strips of text taken from advertisements:

Femmes qui souffrez
Dans les Wagons-Lits
Emotion factice
remplace avantageusement
LE PRIX DE LA DOULEUR . . .

The erotic charge of the original slogans is heightened when these are combined in elliptical narratives which appear to articulate desires, as in Georges Hugnet's *Le Sang en proverbe* (figure 24), discussed in chapter 7. Advertising techniques of persuasion which exploit the codes of desire in isolated fetishistic images and arrested narratives are thus appropriated by the surrealists who simply reroute them for their own ends. Hugnet was alert to the violence encoded in advertising imagery as well as in the language of *fait-divers*. The sadism implicit in advertising and sensational headlines is often made explicit in his photocollages through the juxtaposition of images of women and fragments from *fait-divers*, such as: 'LES PETITES DE LA NUIT DERNIERE SONT EN DANGER DE MORT'.[24] Similarly, Bryen's *Expériences* (1932) includes collage texts made up of headlines and fragments from sensational newspaper reports. One such poem, composed of cut-out strips of text, with the pasted head of a woman and a portrait of young Goethe, starts:

Un train déraille
La mort de la jeune infirmière
à coups de hache.

le sang travaille

UN TAILLEUR DE CLASSE

· · ·

Such examples demonstrate how the potential for recycling fragments of quotations or titles is facilitated to a large extent by their isolation from their original diegetic context, analogous to the isolation of banal objects from their utilitarian context when lined up on the pages of a commercial catalogue. Spatially isolated, such verbal or pictorial elements are freed from fixed meanings, and resonate with multiple potential meanings. Indeed, for Paul Nougé, the resonance of an object is in direct relation to its very banality: 'Mais comment conférer à l'objet pareille vertu de fascination, pareil charme? Ici, l'opération nous a paru être l'*isolement* et l'on pourrait se laisser aller à exprimer une sorte de loi: isolé, le charme d'un objet est en raison directe de sa banalité.'[25]

Objects and verbal fragments which are isolated temporally are also favoured by the surrealists. In a programmatic poem 'Que faut-il pour faire un collage?', E. L. T. Mesens lists the necessary ingredients: 'Quelques vieux disques: soleils ruinés, astres pourris, lunes de mauvaise fréquentation'.[26] He is thereby echoing Rimbaud's inventory of 'vieillerie poétique', the outmoded and clichéd objects and images that he favoured: 'la littérature démodée, latin d'église, livres érotiques sans orthographe, romans de nos aïeules, contes de fées, petits livres de l'enfance, opéras vieux, refrains niais, rythmes naïfs'.[27] The surrealists are attracted by images already cut off from their original cultural space, images which are defunct or devalued, past or exotic, ephemera whose meanings are eroded through distance, whether topographical, historical, ethnographic or utilitarian. According to Walter Benjamin, Breton was

> the first to perceive the revolutionary energies that appear in the 'outmoded', in the first iron constructions, the first factory buildings, the earliest photos, the objects that have begun to be extinct, grand pianos, the dresses of five years ago, fashionable restaurants, when the vogue had begun to ebb from them. . . They bring the immense force of 'atmosphere' concealed in these things to the point of explosion.[28]

The search for such indeterminate signs takes the surrealists to the spatio-temporal margins of signifying spaces in their exploration of the outer edges of the city: the arcade about to be demolished evoked in Aragon's *Paysan de Paris*, the fleamarket where Breton among others went in search of 'ces objets qu'on ne trouve nulle part ailleurs, démodés, fragmentés, inutilisables, presque incompréhensibles, pervers enfin' (*OCII*, 676), objects such as the half-mask discovered by Giacometti and discussed earlier, the 'Cinderella spoon' which Breton himself found on the same outing, or masks and objects from 'exotic' cultures. Like Baudelaire's ragpicker, the surrealists carefully select among the rejected and broken objects of society: 'Il compulse les

archives de la débauche, le capharnaüm des rebuts. Il fait un triage, un choix intelligent; il ramasse, comme un avare un trésor, les ordures qui, remâchées par la divinité de l'Industrie, deviendront des objets d'utilité ou de jouissance.'[29] The surrealists' fascination with such images and objects derives from their interstitial status as 'objets qui, entre la lassitude des uns et le désir des autres, vont rêver à la foire de la brocante' (OCII, 699). The surrealists tap the collective memory of society's fleamarkets and junk-heaps in their search for objects whose functional and sensorial charge has been almost erased. Such exhausted objects, marooned in the present, are revitalized by the artist's imaginary projections and material jugglings. As Tzara wrote: 'J'aime une œuvre ancienne pour sa nouveauté. Il n'y a que le contraste qui nous relie au passé.'[30]

Ernst selects much of his collage material from popular nineteenth-century scientific journals such as *La Nature*, whose images were already old-fashioned in the 1920s; his choice focuses essentially on mechanical contraptions such as early cycles, optical instruments and experiments in 'physique amusante'. Many of these images already have a surreal quality, and often Ernst made only slight additions to them. Their spatial isolation on the page of the journal is conjoined both with the formally outmoded – wood-engraving was a mode of reproduction which had become outdated by the end of the nineteenth century and had been superseded by photo-mechanical reproduction techniques – and with a temporal palimpsest of meaning, traces of earlier strata from a past, both historical (in the partly eroded cultural signs) and individual (in the repressed images of childhood). In his introduction to Ernst's collage-novel *La Femme 100 têtes*, Breton refers to the adult's fascination with the children's books and popular illustrated books which Ernst uses as sources for his collages, and which still retain traces of the decisive influence they exerted on the child, a diffuse evocative appeal characterized by Breton as 'un singulier pouvoir de frôlement' (OCII, 304). Their auratic register is linked to the – almost – defunct character of such images, which carry the memory of former meanings. Such images occupy the space of the uncanny, which has both an individual dimension as the recovery of childhood memories, and a historical dimension in the traces of former cultural images. Yet they remain fundamentally ambivalent images, caught between the rigidified traces of their original meanings and the fluctuations of potential dramatizations.[31] Already displaced as enigmatic fragments cut off from their original function, these old menu cards and posters, masks, obsolete manufactured objects or early scientific instruments are signs in flux, *disponibles* for further subjective investments, inviting the collector to pursue further displacements.

An erotic theme is often encoded in many turn-of-the-century sentimental popular prints, as in the advertising images and slogans discussed

above. Around 1935 Eluard made a series of collages based on popular prints. In one of these (untitled), two naked young women are portrayed in the foreground, playing in a somewhat provocative manner with an anteater, against a romantic landscape with rocks, deer, a cupid with butterfly wings and a seascape, while a cuttlefish hangs upside down in the sky evoking a heraldic shield.[32] Styrsky also uses turn-of-the-century prints in his collages, as in *La Baignade* (1934) (figure 8), analysed in chapter 4, made up of a cheap print of a bathing scene with two semi-naked young women; onto this bucolic scene have been pasted fragments from anatomical plates which suggest a gross mating. By modifying sentimental prints Eluard and Styrsky bring out their latent sexual associations, displaying what was often only covert in the original image.

A more humorous erotic note is present, mixed with the nostalgic, when Miró incorporates in his drawing-collages of 1933–4 popular postcards of lovers, landscapes, fashionable ladies in plumed hats, as well as children's transfers – snails, starfish, flying fish, butterflies, a female stockinged leg or hats, as in *Collage (Prats is quality)* (1934) (figure 9), analysed in chapter 4, cut out from commercial catalogues. These images were pasted onto large sheets of drawing paper, then outlined with charcoal lines which suggest schematic figures. Breton's collection included *La Plage*, composed of photographic cutouts of three female bathers in outmoded swimming costumes and two figures outlined in charcoal. The nostalgic character of the pasted elements used gives these collages a fragile appearance. 'Autrefois', writes Anatole Jakowski about them, 'il y avait des sentiments et des gestes. Il n'y a plus rien. Une couleur, une tache, une ligne, c'est tout. C'est la beauté fragile des fragments. C'est la petite beauté des souvenirs qui sont parfois plus grands que la vie.'[33]

We have seen that it is often the very banality of images which triggers the desire for surrealist appropriations, disrupting the surface of quotidian reality to reveal the desires and violence, the fears and anxieties underlying the everyday. The clichés of everyday language are transformed through the cutting and pasting process, revealing their critical or evocative potential. This is foregrounded in Aragon's reference to the first poetic experiments of Breton, Soupault and himself in transposing pictorial collage techniques into poetry: 'la forme essentielle de cette obsession est le *lieu commun* qui est un véritable collage de l'expression toute faite, d'un langage de confection, dans le vers' (*C*, 99). Among pictorial clichés, we have already considered the surrealists' appropriation of old-fashioned prints; they also recycled popular postcards, revealing their potential to create the *merveilleux*. In 1933 Eluard published in *Minotaure* an article entitled 'Les plus belles cartes postales', illustrated with a montage of turn-of-the-century postcards, '[t]résors de rien du tout', portraying lovers in parks, *femmes-fatales*, young girls and children,

Easter and new year cards. Many of the postcards in Eluard's collection are themselves collages or photomontages, such as assemblages of heads made up of nude female figures in an Arcimboldesque style, or photomontages of the head of the *Mona Lisa* pasted onto various figures.[34] The surrealists often use banal postcards of Paris views onto which they paste disparate photographic fragments, as in Magritte's photomontage *L'Opéra de Paris* (1929), which combines the Paris Opera with a field of cows, creating a cohesive representation where the material montage process is hidden.[35] In the summer of 1937, Roland Penrose developed a collage technique using postcards representing tourist views of Paris or the south of France. He transformed these clichéd images through processes of doubling and juxtaposition. In *Papillon magique* (1938), for example, six identical postcards of the Eiffel Tower are arranged in a manner to evoke the body of a butterfly, and in *Miss Sacré Cœur* (1938), two cut-out postcards of the Sacré Cœur church are pasted onto a female figure to suggest breasts, in an irreverent pun on the title.[36]

Thanks to the evolution of printing techniques in the course of the nineteenth century (from wood-engraving to lithography then photomechanical reproductions), by the beginning of this century élite cultural icons also entered the domain of the mass-produced image as widely available reproducible commodities. Hence the levelling process discussed in relation to *Rêves et hallucinations* – where the photographic reproduction of a famous painting is juxtaposed with military photographs and media advertisements – was already at work within French society in the general circulation of images drawn from both high and low culture. Ernst's collages of neo-classical statues in *La Femme 100 têtes* were drawn from popular nineteenth-century publications which had made art-works available to the general public in wood-engraving reproductions. The surrealists' appropriation involves the cutting and pasting of wellknown icons, such as the Statue of Liberty (Styrsky, Ernst, Duchamp) or the Venus de Milo (Ernst), discussed in chapter 7. For his collage-novels Max Ernst used engravings by illustrators such as Thiriat, Flaxman and Tilly for *La Femme 100 têtes*, combining them with illustrations from *La Nature*. In *Une semaine de bonté*, William Blake and Gustave Doré were the source of collage elements, which were combined with illustrations from popular melodramatic novels. The selection of texts for verbal collage underwent a similar levelling process: texts belonging to the literary canon were cut up and recycled, with Rimbaud's 'un salon au fond d'un lac' resurfacing – with or without its quotation marks – as the paradigm of collage citational strategies. Aragon rewrites Fénelon filtered through Lautréamont in *Les Aventures de Télémaque* (1921), Eluard and Breton parody the *Kama Sutra* in *L'Immaculée Conception* (1930), while Dali's 'Les pantoufles de Picasso' (1935) appropriates Sacher-Masoch's 'La pantoufle de Sapho' (1859).

In conclusion, the surrealists' encounter with collage material can be seen to be informed by desire, whether in spatially isolated or temporally defunct fragments, the latent erotic text of advertising language or the fetishistic appeal of part-bodies, the desire to 'bouleverser le réel' in the recycling and re-energizing of banal postcards and clichés, or the iconoclastic manipulation of consecrated aesthetic forms. All signs, aesthetic or non-aesthetic, especially fragmented or isolated, whose meanings are eroded with age, fixed within fossilized social codes, or rendered enigmatic through estrangement from their original context, become potentially reproducible commodities, to be cut out and reassembled, either used as ready-made elements or transformed and perverted. The central issue in this section is not, however, the simple labelling of collage elements. This has been clear in the *dérive* in my own text from enumerating sources to discussing their relations and transformations, which will be developed more fully in the following chapters.

Pasting

Agitez doucement Tristan Tzara[1]

A British Columbian mask alongside a painting by Douanier Rousseau, a case of tropical butterflies next to an Ormec statuette, a schizophrenic drawing by Wölfli, an *inua* mask from Alaska: the surrealists were alert to the hallucinatory, auratic, fetishistic or disorientating character of certain elective objects, images or textual fragments, 'ces objets *à halo* qui nous subjuguent'.[2] More essentially, perhaps, they were interested in the potential of such objects to create new encounters. Breton's studio, where primitive masks were placed next to surrealist paintings, found objects and personal mementoes, was less a depository of fixed images than an active collage space, evoking the Renaissance *Wunderkammer*, with its bric-à-brac of curios displayed in a seemingly haphazard fashion, rather than the museum's systematic organization of data.[3] Breton constantly moved the objects of his collection around the walls of his studio, appropriating Ernst's collage game of patience, provoking new associations. In a letter to Robert Amadou (1953), Breton refers to this combinatory game in relation to de Chirico's painting *Le Cerveau de l'enfant*:

> Le tableau chez moi ayant pris place entre deux masques 'à transformation' de Colombie Britannique, un dispositif de ficelles permet à volonté d'ouvrir ou fermer les yeux . . . il m'est difficile de savoir si le besoin de prêter un regard à ce visage (exsangue sans âme?) a été surdéterminé par le voisinage des masques ou si, au contraire c'est ce besoin, encore subconscient, qui m'a incité à les suspendre de part et d'autre de lui.[4]

In encounters like this, objects, liberated from fixed meanings and liberating new energies, contaminate and transform each other. The male figure in de Chirico's painting with its closed eyes interacts with the opening and closing

43

eyes of the British Columbian transformation mask. This particular dynamic exchange was in fact followed up when Breton produced a collage, *Réveil du 'Cerveau de l'enfant'* (1950), where he pasted open eyes onto a cheap print of de Chirico's painting.[5]

A similar combinatory activity is found in exhibitions, where surrealist objects and paintings are juxtaposed with ethnographic and other objects. In *Tableaux de Man Ray et objets des îles* (galerie Surréaliste 1926), Man Ray's paintings were displayed alongside Oceanic objects, including New Guinea and New Ireland masks lent by Breton; the exhibition *Yves Tanguy et objets d'Amérique* (galerie Surréaliste 1927) displayed Tanguy's paintings with ethnographic objects from Eluard and Breton's collections; at the *Exposition surréaliste d'objets* (galerie Ratton, 1936), surrealist objects, found objects, mathematical, ready-made and natural objects were displayed alongside American and Oceanic masks from Charles Ratton's personal collection; and the 1960 exhibition *Le Masque* (musée Guimet) included ethnographic masks from various parts of the world set alongside masks made by Jean-Claude Silbermann and Mimi Parent among other surrealists. The pages of reviews present similar combinations. For example *Documents* (1929–30), whose subtitle 'Doctrines, Archéologie, Beaux-arts. Ethnographie' sets out its programmatic aim to bring together heterogeneous fields, combines a still from an American film *Broadway Melody* with a line of African schoolboys, the cover of a popular detective story *L'Œil de la police* with a reproduction of Dali's painting *Le Sang est plus doux que le miel*, a drawing by Grandville and a photograph of the actress Janet Flynn.[6] According to James Clifford, such combinations constitute a 'playful museum that simultaneously collects and reclassifies its specimens'.[7]

Whether in personal collections, exhibitions or journals, the juxtaposition of ethnographic, cultural or anatomical fragments on the surrealist dissecting table – 'la rencontre fortuite sur un plan non-convenant' (E, 253) – is a bricolage activity whose aim, as will be shown, is less to trace analogies between disparate objects, than to produce a spark lit by their very contrasts and contradictions, and thereby provoke the disorientation of the viewer. Through the deliberate staging of incongruous encounters the surrealists create a vast *cadavre exquis* of cultural artefacts, in a levelling process which constitutes a radical re-evaluation of orthodox values and hierarchies.

While mimetic compositions mask their status as an assemblage of parts by pictorial strategies based on compositional devices inherited from the Renaissance, which present a homogeneous pictorial and representational space, surrealist collage disrupts representational coherence by displaying its combinatory processes. The analysis of *Rêves et hallucinations* explored the various ways in which the pasting process is made visible in the work. Firstly, on the material level, there are strong contrasts in colour and surface textures

between the gloss finish of the black and white photographs, the grainy printed paper of the advertisements (now much yellowed with age), the engravings, and the ground formed by the title-page of the book, or between the bold black pen-and-ink additions by Ernst and the lighter blue of Aragon's handwriting. The glueing stage is inscribed as the trace of a physical action in the irrregularly cut edges of overlapping collage fragments pasted at various angles. In addition, different types of media have been collated in a single space: photographs and engravings, printed texts, handwritten messages and graffiti. Written language is combined with icons (photographs and engravings) and indexes (the arrow and the pointing hands). Elements from various discursive and iconographic registers have been combined – a poetic text with an advertising slogan, a news photograph with an art-historical reproduction. On the iconic plane, collage construction is visible in the disparate scales of the various collage elements, so that the female figure appears much larger than the figure of the cardinal placed in front of it, while the cardinal seems to tower over and partly crush the military scene at his feet. Doubling devices – evident in the two parallel hands, in the double profile in the upper part of the work, and in the double image created by the shape in the upper right, both female head and scene of a ruined city – also signal collage-space as a construct. Pictorial depth is denied in favour of a side-by-side or overlapping arrangement of autonomous elements, drawing attention to the process of production. Finally, on the representational level, distinct historical moments are combined, a seventeenth-century statesman with a First-World-War military scene, a female figure in early nineteenth-century dress with gentlemen from turn-of-the-century advertisements. Through these various strategies, which disrupt coherent representational space to foreground a heterogeneous pictorial space, collage overtly points to its status as a combinatory process.

'L'effort humain, qui tend à varier sans cesse la disposition d'éléments existants, ne peut être appliqué à produire un seul élément nouveau' (*OCI*, 245), writes Breton in his preface to Ernst's Paris exhibition in 1921. He suggests in this text that the innovatory character of Max Ernst's collages lies not so much in the materials selected as in their combination. The rhetorical mode of *inventio*, which will be discussed in chapter 4, is largely dependent on *dispositio* or the mode of assemblage, which characterizes the second stage of collage-making, analysed here. The importance of the combinatory process – 'la verve de combinaison' (*OCII*, 486) – is emphasized throughout Breton's writings on literature and art. He traces the use of radical syntagmatic combinations to the poetry of Lautréamont and Rimbaud: 'L'interdépendance des parties du discours n'a pas cessé . . . d'être attaquée et minée de toutes manières' (*OCII*, 481). Among the surrealists, Picabia, according to Breton, 'a été le premier à comprendre que tous les rapprochements de mots sans exception étaient

licites' (*OCII*, 1077–8). Breton characterizes the surrealist verbal image as a novel mode of montage, the 'rapprochement en quelque sorte fortuit [de] deux termes' (*OCI*, 337). The poet acts on the combination between words in such a way that Rimbaud's 'alchimie du verbe' is considered by Breton as 'une véritable chimie', presented in a formula: 'Il s'agissait: 1° de considérer le mot en soi; 2° d'étudier aussi près que possible les réactions des mots les uns sur les autres' (*OCI*, 284). The combinatory activity is also privileged in the pictorial field. Breton remarks on Ernst's collages: 'Il ne s'agissait de rien moins que de rassembler ces objets disparates selon un ordre qui fût différent du leur', adding that the process is similar to that used in poetry, 'de la même façon qu'en poésie on peut rapprocher les lèvres du corail' (*SP*, 26). Thanks to the spontaneous or concerted assemblage of verbal or pictorial components, collage offers the poet and artist new combinatory possibilities liberated from the constraints of mimesis or discursive logic, so that the sewing machine and the umbrella can share a space on the table top, replacing the quotidian conjunctions of apples and pears in a fruit-dish, such combinations liberating energies which charge the banal images with new meanings. 'Le syntagme,' writes Groupe MU, 'domaine de la combinaison, devient alors celui de la liberté, d'un certain chaos, ou mieux, d'une connaissance encore future.'[8]

The combinatory process can be more or less overtly signalled. The collage process is visibly inscribed when the material heterogeneity of its elements is foregrounded in the contrasts of media and surface textures used. Such collages openly display their status as *papiers collés*. 'Instead of leading the spectator's eye on towards an unattainable distance', writes Rodari, 'the pasted paper traps it in concreteness. It celebrates materials, substances, textures. It brings the artist's actions and the interaction of forms into visibility.'[9] For example, Magritte's collages, such as *L'Esprit et la forme* (figure 4), discussed later in this chapter, combine watercolour or gouache with shapes cut out from sheet music; Miró pastes onto a canvas postcards, transfers or advertising images, then adds line drawings around them, as in *Collage (Prats is quality)* (figure 9); Breton and Hugnet combine decalcomania and collage, as in the latter's *Les Charmes des saisons* (1936). When material traces of the collage process have been carefully masked so that collage presents a homogeneous appearance, the collage process is often visible in the syntactic structure of the works. Collage can be recognized for example by representational incoherence, such as shifts in scale, as in Conroy Maddox's *Uncertainty of the day* (1940), where a baby's legs and diapers hover large and cloudlike above three tiny figures in an empty landscape; or in Breton's *Charles VI jouant aux cartes pendant sa folie* (1929), in which a giant coffee-pot with the distorted reflection of a figure, taken from *La Nature*, has been overlaid on the print of two figures playing cards, material disjunctions carefully erased, creating an

hallucinatory Alice-in-Wonderland image. These examples also present semantic anomalies in the enigmatic juxtapositions of images. In others, such as Ernst's engravings for *Une semaine de bonté*, where dragon-wings are convincingly attached to a lady's bodice (figure 14), syntactic cohesion contrasts with the representational incongruity of the graft.

The visible breaks which characterize collage, whether material, syntactic or iconographic, are sometimes parodied or mimicked. For example, Dali plays on the heterogeneity of materials and illusory pictorial coherence in several of his paintings of 1929 which integrate collage elements: in *Le Jeu lugubre*, for example, painted fragments give the illusion of collage, while real collage elements – the chromolithograph of a girl's head, a hand holding a cigarette, men's hats, fragments of microscopic photography – appear to be painted in a *trompe-l'œil* style. Similarly, in *Les Accommodations du désir*, the apparently seamless representational surface of the oil-painting is belied on closer inspection, which reveals that the lions' heads are in fact made up of both collaged and painted images.[10] 'Partly as a mirror to measure his extreme realism', writes William Rubin of Dali's method, 'the photographic realism is perfectly matched by the painted realism. These "invisible" materials constitute a kind of "anti-collage", a complete reversal of the role and meaning of the original Cubist invention.'[11] The collage process is also mimicked in many of Magritte's oil-paintings, where hard-edged pictorial objects are represented in disparate scales and modelling, as in *L'Annonciation* (1929). The pictorial elements are articulated in conflicting spaces, meeting on the planar surface of the canvas rather than in the illusory depth of representational space, signalling their origin in collage construction.

It was suggested in chapter 1 that verbal collage is often difficult to recognize, and that sometimes only the original manuscript can show material evidence of the collage process. Such material traces are available in a number of surrealist texts. For example, Breton's notebooks for *Poisson soluble* contain several collage-poems which were published for the first time in 1988; the documents pasted in the manuscript of Breton and Aragon's *Le Trésor des Jésuites* (1928) include a newspaper cutting from the weekly *Détective* which was collaged into the text with only slight modifications. In the absence of the evidence of manuscripts, collage elements are materially invisible in the printed text, unless its typographical layout signals the heterogeneity of the collage elements, as in Aragon's *Le Paysan de Paris*. It would appear that verbal collage is usually more obliquely encoded than pictorial collage. Sometimes, an extratextual feature signals the presence of collage, such as the testimony of the collagist, or a cultural or literary reference, as in Breton's 'Nœud des miroirs' (*OCII*, 88) where a pharmaceutical formula for the cure of angina interrupts and deviates the lyrical development. Collage is more usually recognized intratextually, by a break in the discursive register or in the diegetic

logic of a text, or more generally by various forms of 'agrammaticality', to use Riffaterre's term, which signal an imported element.[12] Identification of collage depends in this case on the reader's competence. Aragon writes of Lautréamont's *Poésies*: 'La lecture des *Poésies* ne ressemble aucunement à la lecture d'un autre livre. Elle suppose connu le monde de l'auteur.'[13] Recognition of the citational process is dependent on a shared culture, the 'lieux communs' of iconographic or verbal clichés or those of the literary doxa.

'Quel pivot, j'entends, dans ces contrastes, à l'intelligibilité?', writes Mallarmé; 'il faut une garantie – La Syntaxe'.[14] Traditionally, syntax, and its pictorial equivalent, compositional devices, are structuring mechanisms which ensure the seamlessness of the text or image, thanks to verbal or representational coherence. Verbal syntax, establishing logical or sequential relations between discursive units through devices of coordination – juxtaposition, subordination, entailment or implication – ensures the clear articulation between parts. In visual art, various compositional devices, such as linear perspective, function as modes of pictorial syntax. One of the essential characteristics of modernist aesthetics is the minimization or – in certain extreme cases – the suppression of the structuring devices of verbal or pictorial syntax, in a shift from traditional modes of conjunction, based on (chrono)logical coordination and subordination, which fix relations between elements, to the mode of juxtaposition, 'the setting of one element beside another without supplying the connective'.[15] Cubist pictorial collage, denying illusory depth, and stressing, on the contrary, the pictorial surface and formal qualities of the composition, called into question traditional compositional codes of perspective, based on a single viewpoint and a homogeneous representational space. In poetry the combinatory mode was radicalized in the futurist practice of *parole in libertà*. In his manifesto *Destruction of syntax – Imagination without strings – Words in Freedom* (1913), Marinetti advocates the abolition of such grammatical connectives as articles, adjectives and conjunctions, liberating words from the 'connecting wires of syntax', and allowing them to collide like bombs or torpedoes.[16] The dadaists also favour juxtaposition over sequential development, as evidenced in Tzara's 'Pour faire un poème dadaïste':

> Prenez un journal.
> Prenez des ciseaux.
> Choisissez dans ce journal un article ayant la longueur que vous compter donner à votre poème.
> Découpez l'article.
> Découpez ensuite avec soin chacun des mots qui forment cet article et mettez-les dans un sac.

Agitez doucement.
Sortez ensuite chaque coupure l'une après l'autre.
Copiez consciencieusement dans l'ordre où elles ont quitté le sac . . .[17]

The cutting and pasting process clearly constitutes a critical and playful appropriation and disarticulation of already constituted texts and images – and the resulting debunking of literary, artistic and moral values. The role of chance in the aleatory concatenation of fragments marks it as a limit-form of dada textual experimentation. In fact, Aragon reduces this recipe to a strategy of provocation, and claims that Tzara's poems were never composed using this method (*C*, 124). It can be distinguished from the surrealist mode, where chance, informed by desire (in the form of objective chance), dictates the selection of collage material, which makes the surrealist collage technique less an aleatory instrument of production, as in dada, than a means of subjective expression, as was shown in the last chapter. Thus Breton, adapting Tzara's model – albeit on a less radical note – presents in his 1924 *Manifeste* his own formula for writing a surrealist poem:

Les moyens surréalistes demanderaient . . . à être étendus. Tout est bon pour obtenir de certaines associations la soudaineté désirable . . . Il est même permis d'intituler POEME ce qu'on obtient par l'assemblage aussi gratuit que possible (observons, si vous voulez, la syntaxe) de titres et de fragments de titres découpés dans les journaux. (*OCI*, 341)

Although the emphasis in both texts is on the apparently arbitrary juxtaposition of elements, there is an essential difference between the two poets. While the question of syntax does not figure in Tzara's instructions, Breton's bracketed injunction states the need to preserve a formal structure.[18] Breton is keen that syntax should be maintained even in the most experimental surrealist productions, and it is significant that for the first edition of *Poisson soluble*, he excluded texts where syntax had been eroded. Syntax, far from being a constraint, is readily used as a formal frame within which the poet can explore new poetic combinations: 'j'observe *naturellement* la syntaxe (la syntaxe qui n'est pas, comme le croient certains sots, une discipline)' (*OCII*, 276).[19] Aragon also underscores the importance of syntax when he refers to images as 'formes d'appréhension de l'idée purement syntaxiques, à inventer, chaque fois'.[20]

The surrealists' use of syntax, far from being as negativist as that of the futurists or the dadaists, is perhaps more perverse, for they seek to erode syntax from within by stretching its structures to the limit, rather than abolishing syntax altogether. Their practice might therefore be considered to be closer to that of Mallarmé than to the futurists or dadaists. Surrealist syntax

minimizes or perverts normative connections between constituent discursive units, and it does this in two opposing ways, by adopting paratactic or hypotactic strategies. On the one hand, the use of mimimal syntactic links and of different typefaces, or the combination of iconographic and verbal elements, allows discursive or figurative units to clash more forcefully, conferring on the text a spatiality which disrupts the temporality of syntax, while still ensuring its readability. On the other hand, the use of fixed syntactical frames, as in surrealist games (where syntax is aggressively foregrounded), presents an overt frame lending an apparent formal cohesion which contradicts the semantic anomalies of the collage elements. Let us look at these syntactic devices more closely.

'Nous avons alors rêvé de ce que nous appelions le poème-affiche' (C, 99), observes Aragon, recalling the early experiments in verbal collage undertaken with Soupault and Breton. The analysis of Ernst's *Rêves et hallucinations* in the last chapter showed how the passage from traditional literary language to the new lyricism of advertising language was made explicit in a graphic form, in the crossed-out epigraph by Shakespeare and the arrow pointing to the advertisement pasted beneath it. Breton's text 'Poeme' is made up solely of pasted newspaper headlines and fragments of articles. The manuscript of *Poisson soluble* (1924) includes eleven texts produced in a similar way which were not published in the original edition.[21] The text 'Poeme' (*OCI*, 341–3) was included in the *Manifeste* to illustrate Breton's second formula for writing a poem (quoted above), and it was republished under the title 'Angle de mire' in *Le Revolver à cheveux blancs* (1932), which included two other collage-texts based on a similar principle of fabrication, 'Poses fatales' (*OCII*, 56–7) and 'Confort moderne' (*OCII*, 59–62).[22]

'Poeme' is an example of a language-game played by the surrealists in the early 1920s at Breton's studio in the rue Fontaine, consisting of poems made up of words and phrases cut out of newspapers. Breton's archives contain several school exercise books, belonging to Jacques Baron, Max Morise and Simone Kahn, which include similar collage-poems. The texts are composed of ready-made phrases rather than the individual words favoured by the futurists and dadaists. The surrealists' interest in pre-formed groups of words is linked to Jean Paulhan's work on proverbs and clichés. 'Je commence à connaître Jean Paulhan', writes Breton in a letter to Aragon. 'La grande question qui l'occupe est de savoir s'il ne faut pas plutôt croire au "sens" des ensembles, des phrases, qu'à celui des mots.'[23] Paulhan was interested in proverbs as fixed linguistic units, and in the possibility of remotivating the signifier hence revitalizing meanings through strategies of defamiliarization.

The page from 'Poeme' (figure 3) displays the literal cutting and pasting process which determined its composition: fragments made up of phrases or words in different typefaces are pasted onto the page of the exercise book.

L'Amour, d'abord

Tout pourrait s'arranger si bien

PARIS EST UN GRAND VILLAGE

Surveillez

Le feu qui couve

LA PPIÈRE

Du beau temps

Sachez que

Les rayons ultra-violets
ont terminé leur tâche
Courte et bonne

LE PREMIER JOURNAL BLANC
DU HASARD

Le rouge sera

Le chanteur errant

OÙ EST-IL ?

dans la mémoire
dans sa maison
au bal des Ardents

Je fais
en dansant
Ce qu'on a fait, ce qu'on va faire

Figure 3 André Breton, 'POEME' (*c.* 1924)

The layout of 'POEME' is informed by techniques characteristic of newspaper headlines and advertisements, such as different typefaces, a centred text and isolated phrases. The typographical strategies of 'POEME', much more rudimentary than futurist or dada formal experiments, are limited to the use of roman and italic types, bold face and capitalization. The text displays its mode of fabrication as collage through the appearance of each fragment presented primarily as a visual sign. The diverse typefaces and the isolation of each phrase – underscoring the discrete quality of each fragment and spatializing the text – make the reader apprehend the work firstly as a material reality, a spatial, rather than a linguistic, unit.

Several fragments are pasted in groups in syntactically coherent, yet semantically incoherent, sentences:

<div align="center">

Sachez que

Les rayons ultra-violets

ont terminé leur tâche

Courte et bonne.

</div>

Elsewhere syntactical structures are minimized in favour of paratactical constructions, where fragments are simply juxtaposed:

<div align="center">

Le chanteur errant

OU EST-IL?

dans la mémoire

dans sa maison

AU BAL DES ARDENTS,

</div>

or combined by minimal grammatical links, as in the opening lines of the poem:

<div align="center">

Un éclat de rire

de saphir dans l'île de Ceylan.

</div>

Recourse to *de* as a linking device functions as a grammatical connective with minimal semantic value, a process, writes J. H. Matthews, 'like that of glue in surrealist pictorial collage'.[24] The sequential or consequential links of standard syntax, which determine spatio-temporal relations, are replaced here by juxtaposition as the dominant structuring mode, which articulates, both on an intra- and inter-sentence level, appositional relations of equivalence, identity or simple succession. The more discreet the syntax, the greater the polyvalence of the parts assembled, since (con)sequential links, which seal the constituent parts of the discourse univocally, are replaced by the more ellip-

tical mode of juxtaposition, often overdetermined by typographical blanks. For example, the lines in apposition:

Un saut dans le vide
UN CERF

can be read as two discrete statements, or bridged as a metaphor. Similarly the lines:

Surveillez
Le feu qui couve
LA PRIERE
Du beau temps

can be read as successive ('Le feu qui couve *et* la prière du beau temps') or as equivalent phrases ('Le feu qui couve *est* la prière du beau temps'). Appositional structures, heightening ambiguity, increase polyvalence.

In the first two lines of the poem, the literal meaning of the cliché 'un éclat de rire' is reanimated through its proximity with 'un éclat . . . de saphir'. The collage text thus invites the reader to actively construct meanings, by juggling with the parts of incomplete statements or isolated phrases, creating associations and filling in the spaces between the collage elements. Incomplete syntactic structures also function as a trigger to the imagination, suggesting the possibility of dramatic developments, as in the fragmentary narrative sequence:

MADAME,
une paire
de bas de soie
n'est pas

which evokes the arrested movement of unveiling the female body in an incomplete narrative, creating suspense and suspending desire, in an example of *beauté convulsive* where movement is both suggested and arrested. Such partial narratives will be discussed in chapter 5. Similarly, the lines:

Une voie carrossable
vous conduit au bord de l'inconnu,

can be read as an allegory of the very process with which the surrealists are engaged: the known path ('la voie carrossable') of familiar expressions and ready-made language is the vehicle which will lead to the edge of the

unknown ('au bord de l'inconnu') in a defamiliarizing process where the poetic is awakened through the transformation of the hackneyed and the banal.

Anticipating the discussion in the next chapter, it is clear that the cutting and pasting process of collage, far from being a simple formula for disruption, is a mode of production of meaning. The reader attempts to fill in the gaps which the absence of syntactical links has left. Breton effectively modifies advertising language by exploiting its lyrical potential in the metaphorical and metonymical links outlined above. Yet such cohering links are local, and the search for (ana)logical links is constantly resisted by syntactic fragmentation and irreducible semantic anomalies. In addition, the desire for coherence, pushing towards the effacement of typographical differences, is constantly resisted by the visual pull of the text as a spatial entity, in a literal sense, as formulated by David Scott: '"spatial" implies the apprehension of space, that is, the perception of the page itself as a site on which textual elements are arranged or juxtaposed'.[25] The spatial structure, privileging the phrase over the sentence as the basic unit, through typographical differentiation and graphic spatialization, as well as the page as a spatial unit, is an active (counter)force in the elaboration of meaning. Linear reading as determined by syntax is thus constantly held in tension with the visual scanning of the text, where signs dialogue across the page rather than in their sequential order. In the final analysis, syntax is doubly subverted in this text: from within, since the sentence is held in tension with the phrase as the basic structuring unit; and from without, since the spatial frame of the page vies with the temporality of syntax. The reader is actively engaged in the reading process as an attempt to create links, yet the visual layout of the text, foregrounding the cutting and pasting operation through its typographical and spatial features, exerts a pull which works against the text as a semantic space where signs interact. The tension in the reading process, between verbal linear decipherment and visual scanning, far from being resolved, is constantly reactivated.

The analysis of 'POEME' has suggested that other counterforces are also operative in reading the collage-poem, namely the rhetorical and narrative links deciphered in an incipient state in this text. These will be developed further in the following chapters: rhetorical structures will be analysed in chapter 4, while narratives will engage our attention in chapter 5. In general, syntagmatic structures greater than the sentence, whether rhetorical, narrative or intertextual, identified in the next three chapters, show a similar perversion of codes: rhetorical and narrative structures are eroded from within. Breton has pushed to their limits strategies of perversion of the linear structuring of the text.

'POEME' illustrates an extreme mode of poetic construction inherited

from the dadaists. Breton largely lost interest in typographical experiments after 1924, and it was only revived in the early 1930s in his collages which combine pictorial and verbal elements, and notably in his object-poems. In the mid-twenties the surrealists turn to collaborative collage experiments in the form of surrealist games. 'Le temps était au plaisir et rien autre' (*SP*, 288), recalls Breton referring to surrealist gatherings in the mid-twenties when, after an evening discussing the day's events, the surrealists would play collective games. For Breton such games constitute 'un des *lieux de rencontres* les plus extraordinaires' (*OCI*, 822). Based on the pooling of mental resources and the chance associations of words or images, games deliberately break with the normal flow of discourse which threatens to release clichés and automatisms of speech, by producing singular analogies and unprecedented associations.

The key game played by the surrealist group was the *cadavre exquis*. The *Dictionnaire abrégé du surréalisme* (1938) gives the following definition:

> Jeu de papier plié qui consiste à faire composer une phrase ou un dessin par plusieurs personnes, sans qu'aucune d'elles puisse tenir compte de la collaboration ou des collaborations précédentes. L'exemple, devenu classique, qui a donné son nom au jeu tient dans la première phrase obtenue de cette manière: *Le cadavre – exquis – boira – le vin – nouveau.* (*OCII*, 796)

The formula produced sentences such as:

> La vapeur ailée déduit l'oiseau fermé à clé;
> La grève des étoiles corrige la maison sans sucre;
> Les femmes blessées faussent la guillotine aux cheveux blonds.[26]

In the verbal version of this game, the rules of syntax were strictly adhered to. In its visual form, the *cadavre exquis* is based on the 'volonté préexistante de *composition en personnage*' (*SP*, 290), that is a compositional rule, analogous to the syntactic construction of the sentence, based on the anatomical structure of the body: the first participant drew the equivalent of a head, the second shoulders and arms, and so on. This produced hybrid forms such as an umbrella-head, a trunk-body and saucepan-legs, reproduced in the *Dictionnaire*, recalling the monstrous creatures of Max Ernst's collage-novels.

A variant of the *cadavre exquis* is the dialogue or definitions game. Based on the question-and-answer principle, one participant formulates a question: 'Qu'est-ce que . . .?', asking for the definition of a word. The second participant, without knowing the question asked, gives an answer. This gave results such as the following 'dialogues' between Simone Kahn [S] and André Breton [B]:

> S. – Qu'est-ce que le jour?
> B. – Une femme qui se baigne nue à la tombée de la nuit.
> S. – Qu'est-ce que la lune?
> B. – C'est un vitrier merveilleux. (*OCI*, 946)

A third variant of the surrealist game was the hypothesis game, whose rules were defined as follows:

> Vous vous asseyez autour d'une table. Chacun de vous écrit, sans regarder sur son voisin, une phrase hypothétique commençant par SI ou par QUAND d'une part, d'autre part une proposition au conditionnel ou au futur sans lien avec la phrase précédente. Puis les joueurs, sans choisir, ajustent deux à deux les résultats obtenus. (*OCI*, 991)

This gave rise to micro-narratives such as:

> A.B. – Si la Révolution éclatait demain
> L.A. – Etre récidiviste serait un honneur pour tous.
>
> A.B. – Si tout s'envolait un jour de grand vent
> S.M. – Les somnambules se promèneraient plus que jamais sur le bord des toits.
>
> B.P. – Quand les racines ne sauront plus où donner de la tête
> A.B. – Les cloches à melon se mettront à sonner.
>
> E.P. – Quand les couleurs n'auront plus aucun éclat
> A.B. – L'oeil ira voir l'oreille. (*OCI*, 992)

The common denominator to all surrealist games is that they articulate a syntactic or compositional rule, and a semantic or iconic transgression. A rigidly mechanical rule is combined with the workings of chance encounters in a paradoxical structure where incongruous statements and images clash within a fixed framework. For the reader, the recognition of a familiar formal frame, which defines the space within it as a coherent autonomous reality promising logical cohesion or representational coherence, appears to lend credibility to the statement. Basic syntactical or iconographic rules are followed, ensuring a limit-form of communication, as in the pictorial *cadavre exquis*, where often only residual anatomical categories can be recognized, or in the hypothesis game which presents the formal framework of a micro-narrative statement. Conditional or logical relations are posited by the syntactic frame, but are not substantiated by the semantic content. The disorientating effect on the addressee derives from a tension between the euphoric recognition of the formal structure and the disphoric departure

from the familiar in the random semantic filling of syntactic frames. Surrealist games are both polemical weapons which defy rational and stereotypical discourse, and mechanical devices set up to produce metaphors and narratives whose overarching principle is the chance encounter. For Breton, analogical thought is liberated in the *cadavre exquis* which becomes 'un moyen infaillible de mettre l'esprit critique en vacance et de pleinement libérer l'activité métaphorique de l'esprit' (*SP*, 290). New metaphorical and narrative associations are created by pushing to their limits the principles of analogy, causality and consequence, as articulated by syntax. Furthermore, they often reveal a community of discourse which Breton attributes to a form of tacit communication between the players, and which Eluard sees as a form of secular communion: 'Les préoccupations se révélaient semblables, toutes nocturnes, ce jour-là, à onze heures du matin, par grand soleil, en Provence. Et nous ne faisions qu'un.'[27]

The pleasure of transgression is associated with the social function of games, the pleasure of adhering to rules (grammatical and syntactical) while breaking the laws (of association and logic). Games are a concretization of freedom from social constraints, liberating the pleasure principle, analogous to carnival, a time of celebration and renewal in societies, when social taboos are relaxed and primal chaos is re-enacted by a return to origins – strictly controlled however by the social laws which allow this momentary release, whence the liberating effect of challenging social codes by subverting them from within. External causality is displaced by an internal transgressive causality linked to desire. By promoting the *trouvaille* and the unexpected encounter, a new mode of poetic association is activated, a liberating form of logic akin to the logic of dream-work.[28]

Surrealist language games are inscribed in the space between a normative syntax and a semantic *dérive*, between rule and transgression. Julien Gracq comments on the contradiction in Breton's poetry between a coherent syntax and the sudden explosion of the image, and his observations could be applied to the products of surrealist games: 'ce jaillissement de l'image, cette révolte anarchique, cet éclat insoutenable du mot soudain *dégaîné* . . . intégrés à la trame intelligible, à la fois souple et serrée'.[29] While Gracq concludes that the disparate semantic elements are integrated into a coherent syntactic frame, the evidence of such texts seems to show that there is often an unresolved tension between a cohesive syntax and disparate semantics, the simple collation of disparate elements and the push towards novel configurations. The tension, only partly reduced through metaphorical or narrative codes, is constantly reactivated. It is this tension which will be discussed further in chapter 5.

The syntactic frame can manifest itself on a transphrastic or discursive level, as in the litanic structure of Breton's poem 'L'union libre', based on the

repetition of 'Ma femme'. Elsewhere, highly coded frames are used, as in the melodramatic frame present in *Une semaine de bonté*, discussed in chapter 5. *Comme il fait beau!* (1923), a collective play by Breton, Desnos and Péret, includes (transformed) quotations from Quintilian, Camoëns and Musset, and utterances by Desnos and Péret while in hypnotic sleep and recorded by Breton.[30] It also displays a familiar narrative frame in the form of the biblical creation story:

> L'escargot: I. Au commencement la gourmette créa le tabac et l'anthracite.
> II. Le tabac était informe et glabre. Les fumées couvraient la face des promeneurs et l'esprit de la gourmette flottait sur l'alcool.
> III. Or la gourmette dit: 'Que les plombs sautent!' et les plombs sautèrent.
>
> (*OCI*, 443)

As in surrealist games, this formal structuring device coexists with and contradicts a series of incongruous actions. This scene is in turn inscribed within an (arbitrary) dramatic mould, which provides a semantically void structural frame which only gives an illusory cohesion to a text made up essentially of borrowed elements. Marguerite Bonnet draws an analogy between the paper or canvas ground of pictorial collage, which allows the assemblage of distant elements, and the theatre stage in *Comme il fait beau!*, which is a site for the encounter of disparate scenes and characters (*OCI*, 1418).

Theatre-space is the paradigm of post-Renaissance painting, which suggests three-dimensionality, analogous to the Albertian view through a window. Perspective is a compositional or ordering device which unifies diverse elements into homogeneous spatial and coherent iconographic relations. The coherence of Renaissance perspective is determined by geometrical projections whereby all orthogonals converge in a single vanishing point. The surrealists' use of space corresponds neither to the perspectival space of post-Renaissance painting, nor to the flat surface of modernism, but constitutes a combination and perversion of both. On the one hand, the use of framing devices in pictorial collage both simulates and parodies the unified space of traditional visual compositions by bringing together divergent images, as in the hypotactic syntactic frames of surrealist games; while on the other hand, the principle of concatenation, analogous to the techniques of minimal verbal syntax explored earlier, replaces the hierarchical compositional devices of classical art.

Framing devices, characteristic of surrealist collage, present partial, and often parodic, compositional strategies. The anatomical structure of the *cadavre exquis* was discussed earlier, and a vestigial *cadavre exquis* was delineated in the juxtaposition of images on the left of Ernst's collage *Rêves et*

hallucinations. Such framing devices are frequent in surrealist painting, and include de Chirico's city squares, Delvaux's fairbooths, Dali's boxes and Magritte's circles and frames. In collage it is seen in the closed room, in Ernst's *The Master's Bedroom*, for instance, or in the pedestals, picture-frames, and the many screens, curtains, paintings, mirrors and salons which appear in *Une semaine de bonté*. Self-conscious display devices are also present in Ernst's *Loplop présente* collages of 1930–1, where an anthropomorphic figure, usually represented in a line drawing, presents, within the frame of an easel, which figures his body, a set of images in various media: drawn, watercolour or frottage elements, cut-out engravings or photographs. The multiple borders and frames signal an ostentatious parading of images, rendering visible the mechanism of image-making, where the body is the site for the inscription of images.

The iconic motif of the theatre perhaps best exemplifies the subversion of pictorial compositional devices in surrealist collage. In many of his works, and notably in the collages produced in the 1920s, Magritte uses the theatre stage as an ambiguous space to frame enigmatic encounters between disparate elements. In the 1920s Magritte worked as a commercial artist: he designed sets for the Théâtre du Groupe Libre, an experimental theatre group in Brussels, while his designs for a furrier's catalogue, *Le Catalogue Samuel* (1927), incorporated pasted elements. His first surrealist paintings were produced towards the end of 1925, coinciding with a series of collages. Magritte often made a collage and an oil version of the same image, as in *Le Goût de l'invisible* and *Le Ciel meurtrier*, dating from 1927, although it is not known whether the collages were preparatory works for the oil canvases or whether they were produced after the paintings. Between 1925 and 1928 he was to produce about thirty works in gouache, watercolour or crayon on paper, incorporating pasted elements. Almost all use shapes cut out of sheet-music, taken from the piano score of a popular musical comedy, *The Girls of Gottenburg*. Several of these collages suggest a theatre locale, either implicitly or explicitly. In three collages, on a ground made of *faux bois* pasted paper suggesting a tilted plane, and recalling the exaggerated perspectives of de Chirico's stage-like squares, female figures drawn from fashion magazines are placed in dramatic poses, and shapes cut out from the sheet-music evoke different images according to their placement, such as a reclining female figure, or a tree set vertically on a tilted horizon.[31] In at least three collages, *Nocturne* (1925), *Le Jockey perdu* (1926) and *L'Esprit et la forme* (c.1928) the theatre motif is explicit: in *L'Esprit et la forme* (figure 4), for instance, a painted proscenium curtain frames an open space where a wine glass and a bilboquet cut out from sheet-music are set side by side, while a drawn fish is placed above the pasted elements and in front of the proscenium curtains. Theatrical space as a coherent representational space is destabilized not only by the mix of

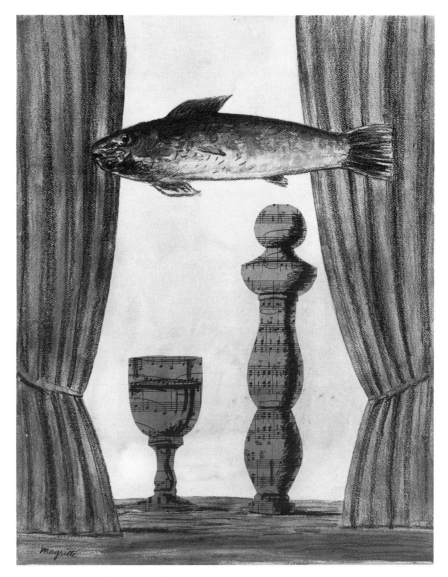

Figure 4 René Magritte, *L'Esprit et la forme* (c. 1928)

surface textures – watercolour combined with pasted paper – emphasizing the materiality of the image, but also by the spatial ambiguities in the work. The bilboquet articulates both the two-dimensional surface of sheet-music and the illusion of a solid object through shading, presenting contradictory planes. Spatial relationships between the objects are also ambiguous. While proscenium curtains, a variant of the window frame as the paradigm of Renaissance perspectival space, would normally frame the deep space of the

theatrical stage, coherent illusionistic depth is denied in this collage in several ways. Firstly, the curtains are slightly out of line, presenting a skewed theatre space. The fish is represented in front of the curtains, while appearing to be on the same plane as the glass and bilboquet which are situated within the space of the stage. Contradictory shading further heightens the incoherent spatial relationships: the fish appears to be lit up from below right, while the bilboquet is lit from the left, yet the glass, which seems to be on the same plane as the bilboquet, does not bear modelling marks and thus appears to be in the shade. The objects are of disparate scales and are aligned in a lateral, planar continuity rather than in depth. Pictorial space is neither the three-dimensional space of traditional western painting nor the modernist flat surface, but an ambiguous space combining the optical qualities of a purely pictorial space and the tactility of illusionistic depth, while destabilizing both. The objects appear more suitable for a still-life composition than a dramatic event, so that the public space of the theatre seems to merge with the private space of the table. Such framing devices, like that of the dissecting table in the Ducassian simile, create a separate space for the staging of enigmatic encounters. Yet the frontal mode of depiction of the objects and their lateral arrangement situate them in an optical space rather than the tactile space of still-life objects. These are less the objects of a composition than the inventory of objects from a child's primer. And the representational space of the vertical tabletop is conflated with pictorial space.

This theatrical space thus presents an ambivalent ontological reality, renouncing mimesis; constructed as a simulacrum, it is a space of presentation rather than re-presentation. Magritte often introduced objects into his paintings in such a way that they appear to have no apparent connection; he considered this operation as an exploration of the unknown. The objects are estranged, freed from fixed spatial relationships because of the absence of a coherent pictorial syntax, and appear to float in space and to be suspended in a moment of time. A single enclosed space – the frame or the stage – combines incongruous objects. The indexical function of the curtains, like that of the frame discussed above, signals the fictionality of the elements assembled. Presented as pure artifice, collage space stages incongruous and enigmatic actions, suggesting, without explicitly articulating, a narrative, and inviting the viewer's suspension of disbelief. Paradoxes are accepted, such as the fish suspended in mid-air, which suggests a bird while stubbornly remaining a fish. Magritte distrusted attempts at interpreting his works, claiming that the pictorial objects in his paintings were not symbols: 'In my painting a bird is a bird. And a bottle is a bottle, not a symbol of a womb.'[32] Yet the totemic appearance of the objects appears to invite a symbolic interpretation; in this case the fish and chalice could be read as vestigial christian symbols. Finally, *L'Esprit et la forme* seems to provide a formal underpinning for that *other* space,

the space of dreams, in its contradictory modelling, in the absence of an explicit pictorial syntax, which would establish fixed relations between objects, and the consequent literal suspension of objects in an indeterminate space, in the space around the objects which provides a screen for the projection of the viewer's fantasies, and in the enigmatic symbols which tease the imagination.

While Magritte's theatre-spaces, assertively two-dimensional, keep the viewer out,[33] the perspectival spaces of Ernst's collage-novels invite the viewer to step into them. In works such as *Une semaine de bonté*, which will be discussed in chapter 5, Ernst deliberately chose wood-engravings with a homogeneous material appearance which he assembled in such a way as to eliminate all marks of the glueing process by disguising the breaks, often working on the engraver's plate to hide the seams in order to produce a formally homogeneous image. The seamlessness of the collage surface helps to underscore illusionism and hence fictionality at the expense of materiality. The formal masking brings out by contrast the iconographic incongruities, the enigmatic yet credible *rapprochement* of incongruous elements contrasting with the syntagmatically homogeneous image. The *dépaysement* is all the more disturbing in that the material appearance of the image is homogeneous and the space (almost) familiar. The disquieting quality of such collations derives from their uncanny nature, the disruption of a familiar space, in the sudden emergence of the other, of libidinal forces usually kept suppressed.

The analysis above has tried to show that in surrealist collage a tension is created between the cohering and disjunctive operations of the pasting process, which both brings together elements and keeps them separate. The more discreet or arbitrarily fixed the syntax, the greater the polysemic relations of the parts assembled. Elliptical forms of juxtaposition, often over-determined by typographical blanks, replace consequential forms which fill the gaps between the constituent parts of the collage. Syntax is threatened at one extreme by parataxis, or the absence of explicit logical or sequential links, and at the other by hypotaxis, the formal marks of a framing structure which function as limit-means of cohesion. Collage as collation rather than configuration invites the viewer/reader to project links onto an incomplete image, onto the gaps which act as a screen for her own fantasies. The reader or viewer inhabits the space between the fragments collated, striving to reduce the incongruity of constructs by appealing to rhetorical or narrative models in order to decode the text or image. The collations generate chains of metaphorical and narrative associations, which will be analysed in the following chapters. In rhetorical terms, the frames could be read as the – highly artificial and quite arbitrary – englobing terms in radical metonymies. There is a jostling within the same text or image of traditionally poetic and

imported ready-made expressions, of three-dimensional fragments and deliberately flat elements, creating new associations, by perverting, revitalizing or simply destabilizing former meanings, in a mobile carnivalesque space.

It is difficult to separate the formal structures of the pasting process from the pragmatic strategies of the viewer engaged in decoding or inhabiting the spaces of collage. The analysis undertaken in this chapter of the perversion of pictorial or linguistic codes as an essentially parodic process of laying bare the devices which underpin effects of pictorial illusionism or verbal coherence, does not claim to fully explain the surrealists' use of these devices. In the last analysis, it is the transcendence of these processes which is important. For Renaissance artists, transcendence consisted in the naturalization of pictorial codes to create mimetic illusionism or narrative coherence. Is there a similar transcendence in surrealist collage? If the surrealists' juggling with pre-formed messages is to go beyond the playful manipulation of signs or the desultory perversion of images, the ludic and iconoclastic should be transcended by the poetic. François Rigolot distinguishes between ludic and poetic language when he writes: 'il semble possible de différencier le langage poétique du pur ludique en disant que le premier postule non seulement une cohérence interne du message mais l'aveu d'un *projet transcendantal* qui dépasse la matérialité des moyens qu'il met en œuvre'.[34] It is this principle of transcendence which will be explored further in the next two chapters in the discussion of metaphoric and narrative codes.

Cocking a snook

Si l'on découvrait sur un mur de cathédrale les empreintes de pas d'un rhinocéros laineux, nul doute qu'avant peu on en proposerait une explication. Plus elle est impossible, plus le besoin est fort . . . ils faisaient du tissu avec la lune et le soleil qui autrement eussent été inaccessibles et leur eussent causé de l'angoisse . . . Bon ou mauvais, il fallait qu'il y eût tissu. Il faut toujours qu'il y ait tissage. Mais fallait-il vraiment ainsi toujours tant d'indécente assurance?

Henri Michaux[1]

'Ce n'est pas la colle qui fait le collage' (*E*, 256)

In his discussion of Braque's paintings in 'Le surréalisme et la peinture', Breton admits to experiencing ambivalent feelings towards the cubist artist. On the one hand he is critical of Braque's concern for realism, quoting the famous anecdote in which Braque matches up his paintings against reality: 'Braque eut naguère l'idée de transporter deux ou trois de ses tableaux au sein d'un champ de blé, pour voir s'ils "tenaient"' (*SP*, 11). On the other hand Breton's continuing fascination with Braque's paintings is linked to the poetical associations which they evoke in the poet. Braque's *papiers collés*, which integrate banal wallpaper fragments, appear to pierce the closed pictorial space of his compositions and open onto the realm of the imaginary: 'ce papier qui tapisse les murs de notre chambre est maintenant pour nous une touffe d'herbe au flanc d'un précipice' (*SP*, 10). The relations established between familiar objects by Braque, 'le maître des *rapports concrets*', are evoked by Breton in metaphorical terms: 'A quelle plus belle étoile, sous quelle plus lumineuse rosée pourra jamais se tisser la toile tendue de ce paquet de tabac bleu à ce verre vide?' (*SP*, 12). Breton is referring to a *Nature morte* (1921) by Braque, which illustrates his text, creating an imaginary space in the

gaps between the objects on the canvas, the tobacco packet and the empty glass, in a metaphor which plays on the double meaning of 'toile', as 'canvas' and 'cobweb'. The space between the pictorial objects, which nothing seems to inhabit because of the tense or stretched canvas ('tendue') which covers it, is transformed into an imaginary space subject to flux and metamorphosis, where the 'toile' generates, through sound association, 'étoile', which in turn becomes 'lumineuse rosée'. Breton creates this space through metaphor, even if only tentatively in the interrogative mode, imaginatively 'weaving' new associations between (and thereby transforming) domestic still-life objects, in a process similar to that of Ernst creating new links between the banal objects lined up on the pages of a commercial catalogue.[2] Such everyday objects have the power to fascinate insofar as they appear to move in an open space, and the artist or poet inhabits, through his imagination, the interstitial space between pictorial objects on a catalogue page or the canvas. From the simple juxtaposition of pictorial objects, Breton establishes links through free association, instigating a metaphorical or narrative mode of perception, spinning a fantastic yarn between the still-life objects and thereby awakening their secret life. He thus rejects Braque's so-called realism in favour of a surrealist perception of his paintings, and transcends both the pictorial and the representational space of the cubist painting: to the surface values of *papiers collés* he prefers the depth of metaphoric processes; to fixed spatial relations he prefers the temporality of potential narratives.

In a similar fashion, in a survey published in *Le Surréalisme au service de la révolution*, 'Sur les possibilités irrationnelles de pénétration et d'orientation dans un tableau', Eluard refers to the surrealists' desire to bring to life, through the poetic imagination, the apparently inert objects in de Chirico's painting *L'Enigme d'une journée*:

> [O]n a voulu faire revivre, en s'introduisant dans ce tableau, tout ce qui semblait s'être définitivement figé à un moment particulièrement vide de la vie . . . l'espace, le ciel, la lumière, des murs, des cheminées, une statue, une voiture de déménagement, un caillou, un train, tous les vieux éléments des décors auxquels l'homme est accoutumé de ne pas se heurter.[3]

The surrealists were asked a number of questions about de Chirico's painting. Whom does the statue represent? How do you imagine the statue of the wife of the figure represented on the square? Where would an elephant appear? Where would one make love? etc. With its absence of perspectival depth and the consequent hovering of pictorial objects in an indeterminate space with no fixed relations, similar to the objects in Magritte's collage *L'Esprit et la forme* discussed in chapter 3, de Chirico's painting appears to approximate a moment in a dream where disparate signifiers float,

enigmatically, like the fragments of a hidden narrative, inviting the viewer to inhabit the spaces between and behind the isolated pictorial elements and, through her imaginary engagement, to continue or complete the painting by filling in the spaces. The viewer thereby reactivates the painting – Eluard refers to the need to 'réanimer ce rêve endormi' – by investing it with the temporality of fiction. Eluard, like Breton or Ernst, is imaginatively inhabiting the spaces opened up by banal juxtapositions, and he concludes: 'Il est possible qu'un jour nous soyons tentés par exemple de nous laisser vivre dans une nature morte.'

Yet, in his repeated attacks on Cézanne, 'cet esprit de fruitier', Breton excoriates the inertia of traditional still-life's familiar objects. Breton, who could not digest the recurrent motif of apples and pears in fruit-dishes in Cézanne's paintings, and who was intent on putting an end to 'un mysticisme-escroquerie à la nature morte' (OCI, 246), misunderstood the latter's radical innovations in art, although a passing observation, in which he refers to '[l]a volonté de Cézanne de laisser la pomme non fermée' (SP, 52), seems to suggest the poetic *faille* which he explores in Braque's painting. In traditional still-life, the links between objects are already exhaustively coded, and the viewer moves in a familiar space, where he can immediately decipher the relations between fruit-dish and plate, tankard and crystal glass, lobster and silverware, because these objects tell a familiar story from a cultural milieu which makes the links explicit, by relating them to a domestic space and its specific codes of bourgeois economic wealth or the interrelation between nature and culture, or to a wider social space where objects are related to the ideology of colonial or bourgeois expansion.[4] The image is saturated by the codes of a specific culture, and their immediate recognition immobilizes the composition within a familiar, already classified narrative. Dutch still-life, for instance, pervaded with the traces of familiar gestures and memories, is a domestic tactile space, analysed by Barthes as a space of *luisance*: 'lubrifier le regard de l'homme au milieu de son domaine, et . . . faire glisser sa course quotidienne le long d'objets dont l'énigme est dissoute et qui ne sont plus rien que des surfaces *faciles*'.[5] The enigma of juxtaposition is immediately dissolved in the gaze which glides over a familiar space in instant recognition, confirming well-established codes. The objects are composed into a seamless construct, leaving between them no imaginary gap.

In contrast to traditional still-life compositions, surrealist collage juxtaposes incongruous images and words, creating ruptures in the traditionally seamless surface of representation, and subverting the very mechanisms of selecting and collating: the traditional metonymical associations of table-top arrangements give way to a more radical form of metonymy, characterized by Lautréamont's 'rencontre fortuite, sur une table de dissection, d'un parapluie et d'une machine à coudre'. In surrealist works, the table – or its vari-

ants the dissecting table (in a parodic reference to the still-life genre), the theatre stage, room, box, frame or easel discussed in the last chapter – is often still present as ground, as are the banal objects selected, whether umbrella and sewing machine, bilboquet, fish and glass, or commode and cake (Humphrey Jennings, *Commode and Gâteau de Style*, 1936). It is their assemblage which jars, and the viewer's gaze, far from gliding smoothly over the represented space, is jolted into defamiliarization. In *Le Paysan de Paris*, Aragon refers ironically to God's imagination which promotes 'l'absurde, le bazar, le banal', through incongruous juxtapositions: 'l'imagination de Dieu: imagination attachée à des variations infimes et discordantes, comme si la grande affaire était de rapprocher un jour une orange et une ficelle, un mur et un regard. On dirait que pour Dieu le monde n'est que l'occasion de quelques essais de nature morte.'[6] Objects, cut off from their original functions, appear to be staged in awkward *mises-en-scène*, as if poised for a future dramatic action which might provide an explanation for their strange encounters.

Norman Bryson distinguishes between history or anecdotal painting based on narrative, and traditional still-life, 'the world minus its narrative or, better, the world minus its capacity for generating narrative interest'; while the structures of narrative engage processes of change and discontinuity, 'still-life pitches itself at a level of material existence where nothing exceptional occurs: there is wholesale eviction of the Event'.[7] Surrealism subverts this distinction between still-life and narrative genres.[8] In place of the reassuringly familiar assemblage of objects found in traditional still-lifes, the incongruous placement presents itself as enigmatic, a rebus to be solved by the viewer. Why the encounter between a sewing machine and an umbrella? What is the link between a fish, a glass and a bilboquet, or between a commode and a cake? Such enigmatic arrangements invite an explanation for their conjunction. Instead of the familiar historical narratives or collective symbolic codes which underpin traditional still-lifes, the narratives suggested by surrealist collage are suspended in an enigmatic code, hidden in a rebus, eroded through repression, not yet recounted or, simply, unrecountable. Traditional still-life objects look back to a specific social and ideological context; surrealist collage objects look both back, carrying the traces of eroded social codes, and forward, to future metaphorical and narrative configurations. Unfinished, suspended between almost erased and not yet articulated narratives, these objects invite the artist and viewer to complete them. The artist's encounter with the image or group of words provokes associations, transforming the raw material 'en drames révélant [ses] plus secrets *désirs*' (E, 259); while the viewer/reader also participates in the creative process 'afin de donner une vie métaphorique à ces demi-fabriqués que sont les collages'.[9]

'Inventez ce qui déjà a été inventé'[10]

'Si ce sont les plumes qui font le plumage,' asserts Ernst, 'ce n'est pas la colle qui fait le collage' (*E*, 256). Surrealist collage can clearly not be defined solely in terms of a 'scissors and paste' technique: 'En dehors des ciseaux et de la colle . . . l'authenticité réside ici dans le phénomène de détournement, c'est-à-dire dans une utilisation abusive, à l'intérieur d'un "discours" original, d'éléments empruntés à d'autres discours.'[11] The third stage of the collage process is characterized by the semantic transformations effected as a result of the assembling operations outlined in chapter 3. Images and words, isolated from their original meanings, once placed in new contexts, acquire new meanings. 'Toute apparence,' writes Aragon of Ernst's collages, 'notre magicien la recrée. Il détourne chaque objet de son sens pour l'éveiller à une réalité nouvelle' (*C*, 26).

This essential characteristic of surrealist collage distinguishes it, for the surrealists at least, from cubist collage.[12] In 'Comment on force l'inspiration' (1933), Ernst writes that

> le surréalisme a permis à la peinture de s'éloigner à pas de bottes de sept lieues, des trois pommes de Renoir, des quatre asperges de Manet, des petites femmes au chocolat de Derain et du paquet de tabac des cubistes, pour voir s'ouvrir devant elle un champ de *vision* limité seulement par la *capacité d'irritabilité des facultés de l'esprit*.[13]

In contrast to the contingency of objects in a painting by Derain or Braque, the shapes and textures in *grattage* or the unexpected encounter of objects in a sales catalogue trigger Ernst's hallucinatory faculties and lead to the transformation of the original material and the creation of new images. Similarly, Aragon contrasts the semantic transformations effected in surrealist collage with the realistic function of collage elements in cubist painting. Picasso takes an everyday object, for instance a shirt or postage stamp, and incorporates it into his composition as a quotation from reality: 'Picasso *cite* cette chemise, comme il *citerait* un timbre-poste' (*C*, 109). The imaginary quotation signals the pasted element as borrowed from reality; it remains a shirt, uncontaminated by the objects around it. In his texts on collage, Aragon is intent on interpreting cubist collage as an essentially realistic practice: when he refers to the cubists 'collant un journal ou une boîte d'allumettes au cœur du tableau, histoire de reprendre pied dans la réalité' (*C*, 66), the shirt, stamp or matchbox are less important for their status as signs than for their function as actual objects.

William Camfield has suggested that Ernst's collages from the 1921 exhibition are largely proto-surrealist, and hence quite distinct from the work

of Picabia, Ribemont-Dessaignes, Duchamp and others among the Paris dadaists. 'With a few arguable exceptions in the work of Duchamp', writes Camfield of the Paris dadaists, 'their mechanical and mecanomorphic constructions remain constructions; they are not transformed into beings, and they neither have nor seek that "marvelous faculty" of striking a spark with the rapprochement of two distant realities.'[14] Camfield claims that Ernst's works are already surrealist in the suggestion of organic life and meta-morphosis, or the evocation of dreamlike imagery. Dada mecanomorphic objects – and one could add the ready-made object – often resist, or indeed are indifferent to, semantic transformation: in Duchamp's *Fontaine*, the urinal stubbornly remains a urinal in spite of the evidence of its title. While dada collage is essentially a radical statement about discursive practices, surrealist collage is characterized by transgressive signifying practices. The spark in Ernst's collages operates within the works themselves, as a semiotic process, altering the functions and meanings of the original photographed or engraved images.

'Toute découverte changeant la nature, la destination d'un objet ou d'un phénomène, constitue un fait surréaliste', declares the surrealist group in an early programmatic text.[15] Through processes of systematic appropriation, surrealist collage transforms words and images, disrupting the established order and creating new meanings. As both iconoclasts rebelling against tradi-tional social and artistic codes, and visionaries exploring new aesthetic forms and ideological practices, the surrealists use collage as a privileged mode of production of new meanings through the perversion of the discourse of the doxa. Advertising images and slogans, objects from sales catalogues, proverbs and established icons, where the element of desire is often eroded through repetition and distance, are deviated from their original functions and revital-ized in new configurations which reveal their parodic, satirical, playful or poetic charge. The subversive manipulation of the sign unsettles established codes by revealing their subtext and thus questioning their certainties, or by unveiling normally repressed desires. The semantic disruption and icono-graphic incongruities destabilize the reader or viewer by promoting the irra-tional and the non-mimetic, and thereby liberate the imagination from demands for logical coherence or mimesis.

The analysis of *Rêves et hallucinations* in chapter 2 showed how the constituent parts of the collage are freed from their original meanings and generate new meanings as a function of their new contexts, meanings both satirical in the parodic use of images of the establishment, and poetic in the *cadavre exquis* suggested in the arrangement of the collage signifiers. This essential characteristic of surrealist collage as a semiotic reality can be con-sidered as both a critical operation with a parodic or satirical charge, and a poetic activity where metaphorical and metonymical transformations are

effected. My intention, however, is not to offer a totalizing reading which tames the monster collage by reducing its signifiers to a parodic or poetic rebus; the last part of the chapter will explore the ways in which surrealist collage resists such netting strategies.

'Il faut battre son père quand il est chauve'

In the analysis of *Rêves et hallucinations* in chapter 2, the satirical function was shown to be the direct result of deviating already constituted signs, laying bare the mechanisms of the balance of power through overt syntactic links. The new combinations serve to destabilize the values of the institution, whether social, religious, artistic or moral, helping to 'précipiter la crise de conscience générale qui doit avoir lieu de nos jours'.[16] This critical function of collage is to be read in the context of the surrealist political agenda: material produced by and for a bourgeois society is appropriated, cut up and pasted in new combinations. In these acts of subversion the surrealists favour the use of clichés, a major discursive strategy of the dominant discourse, offering a secure identification with the doxa in arrested modes of representation. By recycling such clichés, both verbal and pictorial, the surrealists question and distort their fixed meanings, and destabilize the ideological principles on which they are grounded.

Péret's photocollage *Collage (untitled)* (1929) (figure 5) is clearly a rewriting of the stereotypical discourse of colonialism. Péret uses the familiar topoi of the colonial narrative – white master and black slave, army, slaveship, 'civilization'. The white athletic male figure occupying the left foreground, much larger than the other figures, is the modern equivalent of the ancient Greek hero, as suggested in his pose and sandals. In the right foreground a naked African female figure, portrayed in profile, is standing subserviently before the towering male figure. Between and set back from the two main figures, two smaller figures, American Civil War soldiers, are standing beside disproportionately large shells. The framed painting of a ship at sea appears to be suspended between the male and female figures. The athletic male is wielding a whip which is wrapped around the neck of the female figure. The ground is the deep perspective of a long corridor of highly ornate classical architecture; the end of the corridor opens onto a romantic landscape composed of a mountainscape and the sun or moon. Péret has deliberately dismantled and reassembled the syntagms of the colonial narrative, reshuffling them to construct another story. The combination of the syntagms white male-ship-arms-black female, linked by the whip, is an ironic reworking of the narrative of the colonial enterprise. Its power is dependent on the technological hardware of military weapons, and on the slaveships of the

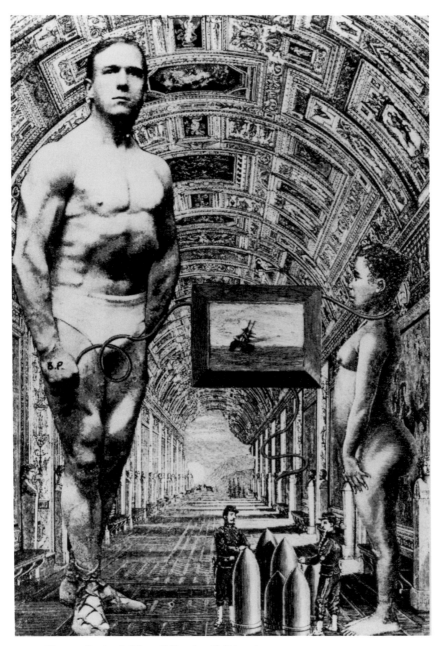

Figure 5 Benjamin Péret, *Collage (untitled)* (1929)

middle passage transporting slaves from Africa to America under the whip. The larger male figure and the smaller female figure, representing the master-slave relationship of colonial society, also suggest the Adam and Eve narrative as it is rewritten through colonialism. The temptress has been collared and immobilized by male power, represented by the serpentine line of the two-pronged whip as a modern reworking of the serpent. Péret's collage also reveals the extent to which the colonialist narrative usually masks sadism and justifies political and sexual oppression in the name of cultural values, symbolized by the backdrop of classical architecture as the apogee of western civilisation. Péret thus exposes the ideological subtext, by staging the collusion between oppressive sexual attitudes and military power in a *mise-en-scène* where the forces engaged are foregrounded, thereby laying bare the violence and collusions of the colonial enterprise. Péret is here using parody as a vehicle of satire to expose western ideology, whose civilization is exposed as predicated on mercantilism and violence. By deconstructing social and artistic codes, the artist disrupts the stability of orthodox perceptions, shaking the viewer into a critical engagement with the historical narrative.

In Péret's collage, as in Ernst's *Rêves et hallucinations*, the habitually seamless representations of the doxa are rent apart by the cutting and pasting process which reassembles its elements to foreground its codes. The collage machinery lays bare the discourse of the doxa, by exposing the usually implicit, and often repressed, links between the actors of the social or colonial drama. The parodic charge of such collages is the result of the perverse and often crudely articulated syntactic links which have been established between these signifiers. Many surrealist works exemplify a similar design, using parodic strategies to satirize the values of the ecclesiastical, military and political establishments. For example Breton's *L'Œuf de l'église (le serpent)* (1932) is composed of a page taken from a catalogue of clerical vestments – a mitre, a cardinal's hat, a bishop's staff and a stole; a woman's face has been pasted below the mitre, while a reclining female figure holding the staff seems to be lying on the lap of the clerical figure. A similar combination of female figure and clerical objects is exploited in Styrsky's collage *L'Annonciation* (1941) which also combines isolated religious images – a monstrance, a ciborium, a popular print of a cherub – arranged around a semi-naked female figure sprawled over a dish of food.[17] By isolating and perversely combining the props of the ecclesiastical establishment in order to stage a taboo, Breton and Styrsky are satirizing its rituals; and by juxtaposing female figures with these estranged elements the work is alluding to the sexually repressive codes of the church.

Parody thus fires the spirit of revolt by laying bare the mechanisms of the old order. The clichéd image as a frozen mode of representation, recognized yet not seen, eroded through repetition, is recycled and revitalized by

the surrealists who not only expose the subtext of the coercive structures of the establishment, but also reanimate the familiar by infiltrating it with the discourse of desire, as I shall show in the analysis of Styrsky's *La Baignade* later in this chapter.

A similar parodic destabilization of the doxa is operative in verbal collage. 'Il faut battre son père quand il est chauve', writes Victor Hugo in *Les Misérables*. As a parodic statement, this utterance transforms the proverb: 'Il faut battre le fer quand il est chaud', by the modification and addition of two consonants (*fer* → *père*, *chaud* → *chauve*), thereby foregrounding the arbitrariness of its presuppositions. As a micro-narrative, it constitutes a playful reenactment of the oedipal scenario, and as a self-reflexive statement, it comments on the need to do violence to the old and *dépassé*, to the proverb as a peremptory statement, the language of the father. Little wonder then that when Desnos and Man Ray rewrote the proverb in a caption for *L'Etoile de mer*: 'Il faut battre les morts quand ils sont froids', the censors objected and demanded it should be removed.[18] When the surrealists transform once more the same proverb into: 'Battre sa mère quand elle est jeune', they also doubly disrupt the doxa, by dismantling the discourse of conventional wisdom, and by articulating a perverse desire. This last variant of the proverb is an entry in Eluard and Péret's collaborative work *152 proverbes mis au goût du jour* (1925), which consists of appropriated and reworked proverbs, presented as partial collages in that they transform already constituted utterances.[19] A range of techniques is exploited: the familiar syntactic framework of the maxim or aphorism ('Il n'y a pas de désir sans reine' (49), 'Il n'y a pas de cheveux sans rides' (109), 'Il n'y a pas de bijoux sans ivresse'(131)); the substitution of words ('Un trombone dans un verre d'eau' (128) for 'une tempête dans un verre d'eau', 'A quelque rose chasseur est bon' (86) for 'à quelque chose malheur est bon'); or the montage of two proverbs ('Faire son petit sou neuf' (87) as an amalgam of 'faire son petit malin' and 'propre comme un sou neuf'). Marie-Paule Berranger compares this strategy of appropriation-reworking to the 'ready-made aidé', 'en ce que Eluard et Péret collent des moustaches au vieux portrait de la Sagesse des Nations comme Duchamp à la Joconde'.[20] The disruption of fossilized utterances, in the form of fixed linguistic forms, and by extension of dogmatic thought, serves both to question intellectual certainties, and to suggest the possibility of new linguistic and intellectual formulations.

'Proverbe ressemble aux piliers d'un pont détruit': the image of the demolished bridge underscores dada and surrealist strategies of perverting fixed expressions through parody.[21] The transformation of aphorisms is commonly used as a polemical weapon in both dada and surrealist reviews. For the dadaists, they were used essentially as an insult or an anarchistic dismantling of familiar forms through the play on the signifier. As Tzara writes:

'Le motif du proverbe populaire est l'observation, l'expérience; celui du proverbe dadaïste une concentration spontanée qui s'introduit sous les formes du premier et peut arriver au même degré et résultat: petite folie collective d'un plaisir sonore'.[22] The surrealists' transformation of aphorisms can be parodic or didactic, poetic or simply playful. Firstly, by perverting fixed forms of discourse, the surrealists subvert the order of reality and challenge socially accepted models based on conventional values and so-called common sense, those automatic forms of discourse which convey popular wisdom and belief. The surrealists thus deride the doxa, essentially pre-reflexive and unquestioned, by a process of defamiliarization which exposes and destabilizes the certainties on which they are based. The parodic reworking of proverbs is a tool used to satirize institutional values and beliefs: the church ('Qui couche avec le pape doit avoir de longs pieds' (8), 'Les curés ont toujours peur' (24)), the family ('A bonne mère suie chaude' (150)), folk wisdom ('Les éléphants sont contagieux' (4), 'Trop de mortier nuit au blé' (51)) or logic ('Trois font une truie' (59)). The effect of surrealist proverbs derives from their status as the 'double-voiced' text characteristic of parody, defined by Linda Hutcheon as 'repetition with critical distance which marks difference rather than similarity'.[23] Surrealist proverbs read as a trajectory from an expected statement, situated within automated forms of language, to new formulations which undermine the beliefs ensconced in the ready-made. While the recognition of familiar formal structures lends credibility to an injunction, its semantic incongruities undo its formal mechanisms and disorient the reader.

It can be seen from the above that the appropriation and perversion of clichés, like the parodic use of iconographic fragments studied earlier in this chapter, both disrupt the language of the institution and suggest the possibilities of a parodic or poetic discourse generated by the perversion of known forms. This dual function of the surrealist appropriation of proverbs is underlined by Marguerite Bonnet: 'La maxime retournée n'est pas nécessairement plus *vraie* que la maxime initiale, mais le renversement, l'écart, creusent un vide; attentant à l'ordre des mots, ils attentent à l'ordre des choses; ils ébranlent les certitudes et, dessinant l'espace possible d'un *autre* ordre, ils promettent une aube nouvelle, une création recommencée, l'avènement de l'inaccompli'.[24] While traditional maxims are closed self-contained structures, linked by synecdoche to a fixed totalizing system, the surrealists' reworking breaks up the system into fragments. They dismantle an assertive statement by transforming it into a playful or poetic one, exposing the fluidity of meanings beneath the fixity of the stereotype: 'Sommeil qui chante fait trembler les ombres' (11). Clichés hide a creative potential which is activated by their isolation, their transformation or their accumulation; by disturbing these reified forms, and rupturing their seamlessness

through the introduction of incongruous signifiers, the poet unleashes their poetic charge.

The surrealists often favour ready-made phrases as titles: *Feu de joie, Une vague de rêves* (Aragon), *Mont-de-piété, Les Pas perdus* (Breton), *Les Pieds dans le plat* (Crevel), *Je ne mange pas de ce pain-là* (Péret). Their very indeterminacy – isolated from their habitual linguistic functions and suspended in a conductive space – invites the reader to engage imaginatively with the fragment. Like surrealist proverbs, ready-made titles are deceptive, playing on the reader's expectations. They point to a familiar language grounded in quotidian reality; at the same time, projected onto a blank space which lacks the reassuring parameters of their original function, their meanings are destabilized, and they become the site of multiple potential meanings. In a perceptive analysis of surrealist cliché-titles, Ruth Amossy and Elisheva Rosen write of this semantic drift of the fixed expression: 'Sa plénitude de figure lexicalisée se dessine ici en creux: métaphore ressassée qui, dans le vide qui l'entoure, laisse aller son sens à la dérive et s'ouvre à tous les possibles.'[25] Literal meanings are reanimated in dead metaphors. In Aragon's title *Une vague de rêves*, for example, the absence of an immediate context allows the literal wave to be released from the clichéd expression in which it had been freeze-framed and delexicalized: set in motion, it metamorphoses dream into an aquatic space. Often the title itself is a transformed cliché, a kind of 'rectified ready-made', as in Breton's *Clair de terre* (← *clair de lune*), Desnos' *Deuil pour deuil* (← *œil pour œil*) or Tzara's *Indicateur des chemins de cœur* (← *indicateur des chemins de fer*). These phrases hover semantically, pointing both back to the fixed delexicalized phrase, and forward to fluid semantic transformations, in a space which invites maximum polyvalence because of the absence of semantic limits imposed by a specific context.

The surrealists' appropriation of clichés is linked not only to social critique, nor simply to an incipient poetic language, but more essentially perhaps to the surrealist politics of liberation. Breton argues that the group's desire was to subvert the reality principle by privileging the pleasure principle, thus contradicting Freud who purported to bring the pleasure principle under the control of reality. In so doing, proverbs and clichés, like the defunct fleamarket objects discussed in chapter 2, taken from their original context, are perverted and hence revitalized. The humour of parody marks a release and is therefore an important rhetorical strategy used to undermine the belief in the permanence of social values. There is in short a move from the language of authority, a vehicle for the reality principle, to a new creative language associated with desire. Hence the importance of the aphoristic structure in programmatic texts, as in the *incipit* to Breton's 1924 *Manifeste du surréalisme*: 'Tant va la croyance à la vie, à ce que la vie a de plus précaire, la vie *réelle* s'entend, qu'à la fin cette croyance se perd' (*OCI*, 311), which is a

transformation of the proverb: 'Tant va la cruche à l'eau qu'à la fin elle se casse.' The proverb is the expression of the most fossilized social values and intellectual presuppositions; rewritten, it dismantles and innovates.[26] Similarly, the aphorisms which make up the section of *L'Immaculée Conception* titled 'Jugement originel', are a call for spontaneity and revolt:

> Mets l'ordre à sa place, dérange les pierres de la route.
>
> . . .
>
> Forme tes yeux en les fermant.
>
> Comme la lettre *l* et la lettre *m*, vers le milieu tu trouveras l'aile et le serpent.
>
> (*OCI*, 880, 1)

The peremptory character of these aphorisms is expressed in the use of the second person singular, the imperative mode and the future tense. Such prescriptions are an apology for a libertarian ethics to replace the voice of common sense. Yet, from constituting a rebus, these aphorisms resist re-cuperation, since we are dealing with poetic statements rather than familiar proverbs.

Dissecting the exquisite corpse

'C'est ainsi que naissaient ces étranges fleurs formées de rouages, ces échafaudages anatomiques complexes. C'est ainsi qu'un patron de broderie représentait ici avantageusement le turf d'un champ de course, que des cha-peaux, ailleurs, se constituaient en caravane' (*C*, 53–4). Aragon is referring here to Ernst's early collages, alluding to works such as *La Grande Roue orthochromatique* (c.1919), *C'est le chapeau qui fait l'homme* (the hat makes the man) (1920), *L'Ascaride de sable* (1920) and *Dada-Degas* (c.1920). He is focusing on the double images produced in such collages, both literal and figurative. Conflating pictorial and verbal modes of expression, Aragon considers this double vision as a poetic practice, and uses the discourse of rhetoric – and more specifically of the metaphor – to identify the process of transformation of the collage signifiers. Indeed, it was pointed out in chapter 1 that the few critics favourable to Ernst's 1921 Paris exhibition, critics such as Jacques-Emile Blanche and Pierre Deval, responded above all to the poetic quality of the artist's works, unlike the *Daily Mail* journalist, who found this 'lobster salad nightmare' totally indigestible, since he saw only the raw materials – 'faces, and fishes, and animals, and scientific figures, and hats all jumbled up together' – and not their transformation. Yet such a transformation is mani-fest in Ernst's *fatagaga* photocollage, *Hier ist noch alles in der Schwebe (le vapeur*

et le poisson) (1920) – the title-inscription is by Arp – in which the inverted image of an X-ray photograph of a beetle evokes a boat, and the skeleton of a fish appears to float dreamlike in the sky. Similarly, in *C'est le chapeau qui fait l'homme* (1920), the pasted hats have been arranged to suggest schematic anthropomorphic figures, while remaining hats, in a visual pun on the cliché 'the hat makes the man' – which is also an allusion to the collage process. A more subtle transformation is effected in Ernst's *L'Ascaride de sable* (1920), an overpainting, produced while Ernst was working in his father-in-law's hat-blocking business. Taking a page from a manufacturers' catalogue (such as *Le Magasin pittoresque*), representing two rows of ladies' hats, Ernst inverted and overpainted it with a ground of yellow and blue gouache and watercolour to suggest a desert landscape. The hats, set at an angle, are not immediately recognizable; arranged in a line they evoke a procession of shellfish or ostriches. Aragon writes of this double image: 'illusion cette caravane d'oiseaux extraordinaires traversant un désert, de près ce sont des chapeaux de femmes découpés dans un catalogue de grand magasin' (*C*, 26). The lateral arrangement is echoed in the handwritten text below the rows of hats, which forms an integral part of the pictorial space, and which is less a title than a poem:

> l'ascaride de sable qui rattache sa sandale / la mouche torpille qui forme un aparté / les terribles lèvres solaires qui s'enroulent autour de l'horizon / Max Ernst.

Rather than commenting on the pictorial collage, the text continues it: like the hats-animals, the text is segmented into distinct syntagms, each of which articulates a double image, bringing together disparate realities (animal/human, animate/inanimate), and each component echoes the others structurally and thematically.

A similar transformation of hats drawn from a milliners' catalogue can be seen in Breton's collage *Chapeaux de gaze garnis de blonde* (1934) (figure 6), where elaborate ladies' hats are juxtaposed onto the engraving of a dramatic landscape. The hats are held in suspension in a contradictory pictorial plane: the pasted elements are arranged frontally across the pictorial field, underscoring its flatness, while perspectival depth is exaggerated in the stepped waterfall of the landscape. The hats, momentarily caught in the net of a landscape, fleetingly transformed into a jellyfish, a butterfly or an exotic plant, remain autonomous and mobile, as if arranged in ephemeral and arbitrary combinations, open to further jugglings. They both retain their original identity and are transformed by their new context, hovering between hats and animals or plants, the literal and the figurative, reality and illusion. This process of *détournement* of hats as seen in both Breton's and Ernst's collages,

Figure 6 André Breton, *Chapeaux de gaze garnis de blonde* (1938)

focusing beyond or beside a simple object, is the concretization of a double vision which Ernst links to Dali's paranoiac image: 'une image double, c'est-à-dire la représentation d'un objet qui, sans la moindre modification figurative ou anatomique, soit en même temps la représentation d'un autre objet absolument différent'.[27] Characterized formally by superimposed or juxtaposed elements, and semantically by identity or contiguity, these double images invite a rhetorical reading.

The pictorial *cadavre exquis* can be considered as the model of the rhetorical process, since it overtly displays the paradigmatic and syntagmatic mechanisms on which metaphorical and metonymical operations are based (figure 7). The aim of the game was to construct a body collaboratively, each participant substituting for a body-part another image, without seeing the contribution of the other participants. The example under discussion is one of a series of *cadavres exquis* made in February 1938 by Breton, Jacqueline Lamba, Yves and Jeannette Tanguy, composed of cut-out images pasted onto squared paper. Breton wrote the names of the participants on the back of the sheets.[28] In this collage, the head has been replaced by the image of an inverted balloon, the ears by a cup-and-saucer and two birds, the neck by an inverted turnip, the shoulders by a table-top and shoe, the torso by a piece of

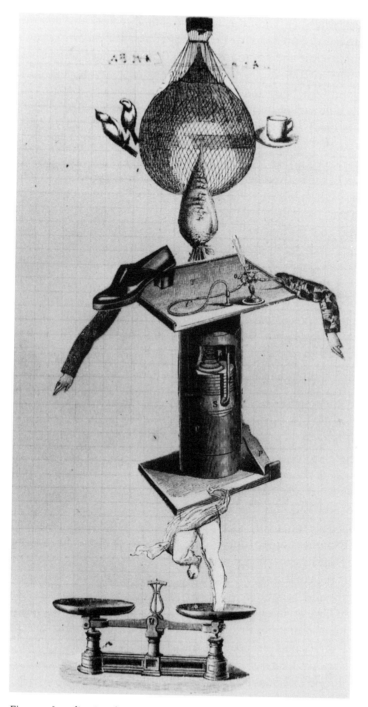

Figure 7 Jacqeline Lamba, André Breton, Yves Tanguy, *Cadavre exquis* (1938)

machinery, while arms and legs are represented realistically, and the figure
appears to balance precariously on a set of scales. The *cadavre exquis* is struc-
tured as both a rule and a transgression, the essential characteristic of surreal-
ist games, as was shown in the last chapter: the basic rules governing the
articulation of the body are followed (head + shoulders + arms . . .), while
the standard lexicon of the body is partly replaced by random elements which
flout the rules of anatomical coherence. This figure combines quite realisti-
cally portrayed limbs (arms, legs), albeit out of proportion with the rest of
the body; objects which have been displaced, such as the shoe moved to the
upper part of the body which seems to stand in for a monstrous shoulderpad;
elements that have a form resembling the original limbs, such as the balloon-
head and the turnip-neck; and totally incongruous elements, such as the cup-
and-saucer and bird ears. By this subversion of established modes of
representation of the body, the surrealists replace the mimetic model by a
semiotic model, to produce a hybrid body, or the other of the body. 'Dans leur
volonté préexistante de *composition en personnage*', observes Breton, 'les
dessins obéissant à la technique du *Cadavre exquis* ont, par définition, pour
effet de porter l'anthropomorphisme à son comble et d'accentuer pro-
digieusement la vie de relation qui unit le monde extérieur et le monde
intérieur' (*SP*, 290). Breton is underscoring the analogical principle which
informs the structure of the *cadavre exquis*; in the same article he refers to the
fact that the surrealists thereby hold 'un moyen infaillible . . . de pleinement
libérer l'activité métaphorique de l'esprit' (*SP*, 290). Such paradigmatic sub-
stitutions and syntagmatic combinations effectively present the formal struc-
tures not only of metaphor but also of metonymy. Let us consider more
closely these rhetorical operations.

'Seul le déclic analogique nous passionne', declares Breton.[29] In opposi-
tion to the word *donc*, 'le mot le plus haïssable', because it is linked to deduc-
tive logic, Breton favours the word *comme*: 'le mot le plus exaltant dont nous
disposions est le mot COMME, que ce mot soit prononcé ou *tu*. C'est à travers
lui que l'imagination humaine donne sa mesure et que se joue le plus haut
destin de l'esprit humain' (*SA*, 7). Analogy is a liberating force which frees the
mind from the constraints of rationality: 'La clé de la prison mentale ne peut
être trouvée qu'en rupture avec ces façons dérisoires de connaître: elle réside
dans le jeu libre et illimité des *analogies*' (*SP*, 200). The emphasis on analog-
ical structures in Breton's theoretical texts has prompted critics to assert that
metaphor, predicated in analogy, is the dominant trope in surrealism.[30]

Metaphorical figures are constituted by the presence of two isotopes
and the process of semantic intersection or *mediation*, which creates coher-
ence and neutralizes dichotomies: 'Mettant en relation deux ensembles
sémiques distincts par certains éléments et analogues par d'autres, la
métaphore réalise une structure lisible sur deux isotopies et qui conjoint

celles-ci en assurant le passage de l'une à l'autre.'[31] Hence, in the *cadavre exquis* described above, the substitution of a balloon for a head can be read in metaphorical terms, where the common element, a spherical shape, ensures the analogical passage from one isotope to the other. In a letter to the Tate Gallery, on the occasion of the acquisition of his collage *The Strange Country* (1940), which integrates a similar balloon-headed figure, Conroy Maddox refers to the 'double-focus image', echoing Aragon and Dali:

> It does illustrate the beginning of one aspect of collage that interested me as a Surrealist. And which I continued to develop. The use of the double-focus image. The figure with folded arms has a balloon for his head. Although we recognise its function as a head at the same time one does not lose sight of the fact that it is also a balloon.[32]

While the substitution of a balloon for a head can be rationalized, what of the cup-and-saucer or bird ears, or the machine-torso? Such substitutions seem irreducible to the analogical process. This limit-form of representation is based on the use of the formal mechanisms of the analogical principle, pushing metaphorical operations to their limits. Whereas in traditional metaphors the two semes brought together can be reduced to a single isotope by the presence of common semantic markers, in the surrealist metaphor the intersection is often minimal or apparently absent. 'La métaphore surréaliste, déjà,' writes the Groupe MU, 'en réduisant au minimum l'intersection des deux sémèmes qu'elle mettait en rapport, entendait disqualifier en le poussant à sa limite le bon fonctionnement rhétorique et rendre, pour la lecture, la médiation incertaine.'[33] This limit-figure, where arbitrary substitutions appear to replace analogical links, corresponds to poetic analogy as defined by Breton: '[L'analogie poétique] transgresse les lois de la déduction pour faire appréhender à l'esprit l'interdépendance de deux objets de pensée situés sur des plans différents, entre lesquels le fonctionnement de l'esprit n'est apte à jeter aucun pont et s'oppose à priori à ce que toute espèce de pont soit jeté' (*SA*, 9). Breton's definition of the surrealist image in his *Manifeste du surréalisme* as a limit-form of analogy constitutes a radical reworking of Reverdy's definition set out in the text 'L'image', published in *Nord-Sud* in 1918. Breton quotes the first part of Reverdy's article:

> L'image est une création pure de l'esprit.
> Elle ne peut naître d'une comparaison mais du rapprochement de deux réalités plus ou moins éloignées.
>
> Plus les rapports des deux réalités rapprochées seront lointains et justes, plus l'image sera forte – plus elle aura de puissance émotive et de réalité poétique . . . etc.
>
> (*OCI*, 324)[34]

While Reverdy emphasizes the notion of appropriateness ('justes'), positing a common ground which counterbalances the semantic distance ('lointains') between the realities brought together, Breton's notion of arbitrariness assumes little or no such common ground, as is made manifest in his rather haphazard catalogue of surrealist imagery (*OCI*, 338–9). In addition, Breton rejects Reverdy's emphasis on the concerted nature of image-production ('une création pure de l'esprit') when he postulates the spontaneous bringing together of disparate signifiers, '[le] rapprochement en quelque sorte fortuit des deux termes' (*OCI*, 338). Whereas Reverdy posits a limit to the analogical principle, which rests on a prior rational connection, Breton rejects any such restriction by pushing analogy to its limits. It is significant that Breton, by resorting to the use of 'etc.' to close the quotation, glosses over the sentences which follow in Reverdy's text: 'Deux réalités qui n'ont aucun rapport ne peuvent se rapprocher utilement. Il n'y a pas de création d'image.' In contrast, surrealist analogy is not grounded in prior links, to be deciphered upstream of the image; analogical links on the contrary are projective, forging new semantic realities. As Aragon writes in *Traité de style*: 'L'homme qui tient la plume ignore ce qu'il va écrire, ce qu'il écrit . . . le sens se forme en dehors de lui. Les mots groupés finissent par signifier quelque chose.'[35] For Breton the surrealist image resists all but partial processes of mediation. Such openended analogies are a breach onto the arbitrary; indeed, Breton defines the surrealist image *par excellence* as 'celle qui présente le degré d'arbitraire le plus élevé' (*OCI*, 338). Conflating the analogical with the arbitrary, collage is situated at the outer edges of metaphorical practice.

The second rule of the *cadavre exquis* technique is the compositional principle of the articulation of a body. The segments of the body are in a relationship of contiguity with the other parts of the body, balloon-head on turnip-neck, machine-torse below table-shoulders, etc., establishing metonymical relations, characterized by the copresence of elements within an englobing whole.[36] However, as we saw in the case of metaphorical procedures in surrealism, metonymical mechanisms are also pushed to their limits. Where traditional metonymy draws its signifiers from the same semantic field – manifest in Arcimboldesque assemblages where each part is the synecdoche of an englobing whole – the lexicon of the surrealist body flouts the rules of anatomical coherence, producing a hybrid body. The limbs of the exquisite corpse remain spare parts, scarcely interlocking; their disparate character is irreducible and they remain ultimately allotopic. Where the englobing term is present, it can actually add a further disjunctive element: 'La relation de contiguïté et donc l'exclusion mutuelle des deux termes demeurent à l'avant-plan. Deux isotopies peuvent alors s'instaurer entre lesquelles la métonymie noue un lien artificiel mais certain.'[37] While de Chirico englobes an artichoke or a bunch of bananas within an urban space,

Magritte places a bilboquet, a fish and a glass in a theatrical décor. Similarly, in the case of the *cadavre exquis*, the anatomical frame provides an artificial englobing space, like the stage space discussed in the last chapter, an open anatomy filled by random limbs: 'Tout comme la métaphore peut tendre à la limite vers une intersection nulle, la métonymie peut recourir à un ensemble englobant infini. Les deux figures ainsi se rejoignent sans justification intrinsèque ni extrinsèque.'[38] Hence each disjunctive element is ultimately part of an englobing whole, characterized as the surreal or the *merveilleux*. Rather than reducing the disjunction of the parts, the englobing term as stage, frame, box or anatomy simply displays the *merveilleux* as a space of paradox. Such dissociative metonymies tease the imagination without ultimately yielding to the cognitive processes of decoding. In conclusion, a rhetorical reading of such works is invited by the formal staging of metaphoric and metonymical operations (or more precisely, syntagmatic and paradigmatic operations), yet frustrated by the irreducible character of the signifiers brought together. A further example will bring out the ambivalence of this process.

The Czech artist Jindrich Styrsky was a member of the Devetsil group in Prague, which collaborated with the Paris surrealists in the 1930s.[39] In 1934 Styrsky produced a series of sixty collages titled *Stekovaci Kabinet (Removals' Agency)*, a humorous reference to the collage process. The surreal borders on the grotesque in Styrsky's strange juxtapositions, such as a mummified child fired by a cannon, a gigantic sewing machine towering over a battlefield, or two large shoes hovering above a bathtub. Many of his collages are made from separate pasted elements on a white paper ground, while others consist of cheap prints modified by the addition of pasted elements. In one of his collages, also dated 1934, *La Baignade* (figure 8), Styrsky has used a popular colour print of two young women bathing in a lake or river, and onto this bucolic scene he has pasted fragments of anatomical plates: the head and shoulders of the young woman in the water have been replaced by the engraving of an inverted heart with a vertical slit, while the face of the figure at the water's edge has been covered with a masklike bladder to which are attached a rectum and a long bowel hovering above the slit in the heart. By substituting anatomical parts for human heads, Styrsky uses a method similar to the *cadavre exquis*, making manifest the double articulation of collage analysed in chapter 2, as a paradigmatic process of selection (where the head is replaced by an incongruous image), and a syntagmatic process of combination (where a heart-head or a bladder-head is combined with a human torso), producing a hybrid body. These incongruous encounters, like those of the *cadavre exquis* discussed above, seem to stage the mechanisms of metaphor and metonymy, but are they rhetorical figures? Does the substitution of heart or bladder-bowel for head constitute a metaphorical operation? And in the copresence

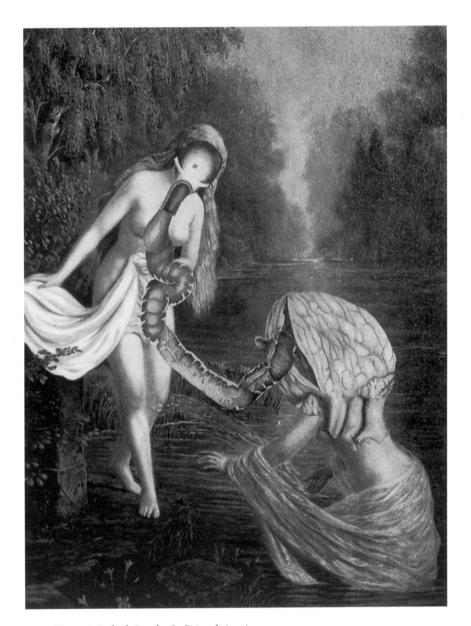

Figure 8 Jindrich Styrsky, *La Baignade* (1934)

of disparate elements, does Styrsky's collage articulate a metonymical struc-
ture? Is there a process of mediation operative here which would justify the
substitution or juxtaposition of these elements, transforming them into a
configuration?

Analogical links can be established between head and anatomical frag-

ments in the common seme of roundness, and the bladder-head and heart-head share the isotope of anatomy. However, the images both invite and elude analogical reduction, and such links do not fully reduce the incongruity of the work. Explicitly stated, yet largely unmotivated, the substitutions resist rhetorical transformation, and the hybrid creatures ultimately remain disjunctive. Materially, the bright colours of the anatomical fragments contrast with the more muted pastel colours of the chromo-lithograph. Iconographically, there is a confusion between inner and outer anatomical parts, since the inner anatomy is displaced/displayed on the surface, as in the flayed body present in many surrealist collages. In addition, disparities of scale are manifest between female body and anatomical head in the disproportionately large head formed by the heart, while the second head is extended in the long bowel attached to the rectum, suggesting the proboscis of an insect. As a result, the centripetal function of the anatomical frame, within which each limb, as a synecdoche, would normally be subordinated to the whole, is countered by the centrifugal force of the substitute hypertrophied heads, transforming the limbs of these hybrid creatures into decentring synecdoches, separate and dislocated. Situated at the limits of figurative coherence, they reject the classical aesthetic of the whole body by constructing a hybrid body, so that the anatomical frame, lacking any real power of coordination, functions only nominally as a global unity. The individual parts are marked by a strong countermovement, departing from their formal functions. The phallic shape suggested by the bladder combines in a bestial mating with the slit in the heart which evokes female genitals. The work thereby aggressively stages a multiple displacement, from the lower to the upper anatomy, genitals to head, the female body to the male organ, the veiled to the unveiled. These hybrid creatures can be read as the bestial other of the subject, as in Max Ernst's alter ego the bird-headed Loplop, or in the many animal-headed figures which proliferate in surrealism. This explains the sense of unease the viewer experiences when looking at this plate, since what is expressed indirectly in the partly veiled bodies in the bucolic scene of the original print, is loudly and grossly displayed in a scene of bestial coupling.[40]

Far from being situated outside rhetorical structures, collage operates on the contrary at the frontiers of rhetoric, characterized by a disfigured rhetoric rather than terrorism. Traditional rhetorical figures map a boundary-line: by placing the compared term on the side of the 'unreal', they preserve clearly demarcated frontiers. In surrealist images in general, the hierarchy of traditional rhetoric is replaced by a process of levelling, 'une figuration du propre ou une littéralisation du figuré'.[41] The compared term, no longer the sign of an *ailleurs*, is read on the same plane as the comparing term, or substituted for it, hence dismantling the traditional hierarchy of diegesis over figure, so that the comforting distinction between figurative and literal

levels is no longer operative. 'Il n'y a plus d'écart de langage', writes the Belgian surrealist Paul Nougé, referring to the shift from the figurative to the literal:

> La métaphore ne relèverait pas d'une difficulté à nommer l'objet, comme le pensent certains, ni d'un glissement analogique de la pensée. C'est au pied de la lettre qu'il conviendrait de la saisir, comme un souhait de l'esprit que ce qu'il exprime existe en toute réalité . . . Ainsi des mains d'ivoire, des yeux de jais, des lèvres de corail, un ciel de feu.[42]

While traditional rhetorical space is structured in depth, the hybrid creatures in Styrsky's collage are reversible figures evolving in a continuous space: the insect-headed woman is also an insect with a female human body, the figure on the left is both male and female. The formal mechanisms of analogy (in the substitution of heart for head) and contiguity (in the juxtaposition of heart-head with female torso) are preserved but as purely spatial realities. As in collage texts (for example Breton's 'POEME' analysed in chapter 3), the pull of spatialization works against the hierarchy of rhetorical operations, in a material process without any justification other than spatial concatenation, thus cocking a snook at traditional rhetoric by pushing its mechanisms to the limit. The juxtaposed parts do adhere, but on a single plane rather than in depth; the framework survives, enclosing a space of inventory where limbs are displayed in a side-by-side arrangement, rather than a semantic space where body-parts are resolved in a totality. A verbal equivalent of this levelling process is evident in a text by Maurice Béchet:

> Crane-oursin, sexe-gastéropode, diaphragme et foie-carapace tortue, lèvres-limaces, coeur-méduse prisonnière;
>
> toujours la chère et fraternelle identité terrestre.[43]

The appositional structure, whether visual or verbal, suggests an analogy – in a tenuous fashion, it is true, since syntactic links are minimal – yet semantic associations are insubstantial. There is an incomplete interweaving of parts, which are held in suspension because of their existence within an ambivalent space: formally, they depart from the familiar body, semantically they approach the *other* body. The oscillation between the known and the unknown in this ambivalent space triggers in the reader/viewer the poetic emotion of *dépaysement* when confronted with a mode of production where the completely other resides so close to the known, in the disruptive insertion of monstrous creatures in the clichéd bucolic setting of a bathing scene. The viewer moves between the hybrid

as a collation or a substitution of parts, occupying a literal space, and a configuration, occupying a figurative space, precisely because associations do function, since the mind will always cross the gap between two discrete elements in order to bring them together. As Eluard writes: 'Pas un jeu de mots. Tout est comparable à tout, tout trouve son écho, sa raison, sa ressemblance, son opposition, son devenir partout. Et ce devenir est infini.'[44] The wider the gap, the more active the participation of the addressee, who produces a fantastic narrative triggered by the very gap between the disparate signifiers, in an interstitial space colonized by the imagination, which creates links between signifiers in a 'delirium of interpretation'.[45] Such tenuous mediations, characteristic of surrealist collage, are underlined by Breton in the recurrent metaphor of the bridge: 'sur un air de pont démoli où s'engage le tramway du rêve' (*OCI*, 519). The parts of collage, like dream imagery, are indeed rationally unbridgeable, and the metaphor of the bridge is frequently relayed by that of the spark, the leap replacing the passage in this impossible articulation between parts of the collage: 'je vais avec le sentiment m'engager sur une longue, longue étincelle violette qui est une passerelle peu sûre' (*OCI*, 534). Breton is more interested in recognizing the immediacy of an encounter than in elaborating interpretations, whence the metaphors of electricity and light which evoke the presence of assemblages before they are cristallized into configurations of meaning. Consequently, he privileges emotional affect over semantic decipherment, an affect grounded in the break with discursive thought and the sudden emergence of the impossible analogy: 'j'aime éperdument tout ce qui, rompant d'aventure le fil de la pensée discursive, part soudain en fusée illuminant une vie de relations autrement féconde' (*SA*, 7). The workings of *dépaysement* have been identified more dispassionately in these pages in semiotic terms, situating collage at the allotopic pole of discourse, but Breton also alludes to a semiotic dimension when he links this affect of *dépaysement* to the hidden key or 'contacts primordiaux' which are fleetingly re-awakened in the shards of the image, 'ces brefs éclats du miroir perdu' (*SA*, 8), or to a future revelation when he observes of surrealist writing: 'L'"illumination" vient *ensuite*' (*OCII*, 389). The poet wishes to prolong the effect of the image, less as a symptom to be interpreted, than for its capacity for illumination of the viewer/reader, who is dislodged from her jaded vision of the world.

Finally, collage parts hover between contingent matter and significant fragments, between a literal collation and figurative configurations, a spatial and a semantic reality. Surrealist collage both rejects and posits difference. In his desire to unveil the magician's stratagem, Aragon emphasizes the optical illusion involved in the metaphoric process. Thus, in the case of Ernst's *Dada-Degas*, he writes: 'Voici une haie que sautent des chevaux. C'est

une illusion: approchez-vous, ce que vous preniez pour une haie, c'était un modèle photographique de dentelle au crochet' (*C*, 26). Here Aragon is underscoring the transformation as a process, where the objects are *both* hedge and lace, or, as was seen in *L'Ascaride de sable*, a caravan of birds and a row of hats, in a signifying process which oscillates between the original meaning of the pasted element and new meanings determined by the context.[46]

It sometimes happens however that hats appear to resist metaphorical transcendence and obstinately remain hats. Whilst Ernst transforms hats into anthropomorphic figures (*C'est le chapeau qui fait l'homme*) or a procession of birds or shellfish (*L'Ascaride de sable*), while Breton's hats become butterflies or plants, Miró's pasted hats remain literal hats in *Collage (Prats is quality)* (1934) (figure 9). This work belongs to a series of drawing-collages executed by Miró in 1933–4, which combine pasted elements with automatic drawing. Christian Zervos describes Miro's technique of fabrication: 'Il commence par coller, dans un endroit quelconque de la toile, une image détachée d'un catalogue ou d'un journal, quelquefois une carte postale. Celle-ci l'amène à dessiner une forme, laquelle à son tour l'oblige à coller une autre image jusqu'au moment où le tableau atteint à l'expression poétique la plus intense.'[47] The pasted images include turn-of-the-century postcards, children's transfers, or photographic images from commercial catalogues. Miró pasted hats at various angles, a leaf, a postage-stamp and a label, *Prats is quality*,[48] and the line drawings he added evoke human figures with schematic heads and limbs, breasts and penises. Unlike the paintings made after collages discussed in chapter 2 (where the pasted images are transformed into biomorphic shapes), in this work the cut-out images are left unchanged, and the material heterogeneity of the assemblage is foregrounded, creating a palimpsestic effect: the hats and postage-stamp appear to be suspended at the end of or in front of phallic shapes, while others seem to float in space on an ambivalent pictorial plane. Other collages from the same series present similar incongruous juxtapositions, such as the postcard of a landscape pasted in the space between two figures, the photograph of a young woman suspended at the end of a phallic shape, or a transfer butterfly hovering below the large nose of a figure drawn in silhouette. The pasted fragments are quite unintegrated into the drawings, in an unresolved confrontation between the ready-made and the fantastic shapes of the line-drawings. As Zervos suggests: 'Miró fait confronter la réalité la plus ordinaire et les hallucinations auxquelles l'excitation a donné naissance.' Whereas Ernst, using a similar technique of drawing lines between the collage fragments, transforms the pasted images, Miró's collage elements occupy a distinct semantic space, and in this they are closer to dada works where objects are often aggressively and humorously literal.

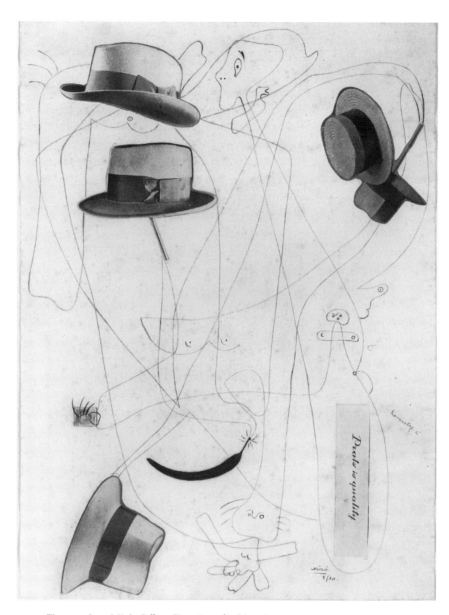

Figure 9 Joan Miró, *Collage (Prats is quality)* (1934)

'Jeux poétiques, etc . . .'

The analysis of Ernst's collage *Rêves et hallucinations* in chapter 2 showed that verbal collage is made up of ready-made discursive units (in this case, a quotation, a title, advertising slogans and texts, graffiti and a dedication), with no

obvious semantic coherence. As a programmatic model, it presents graphically the shift from traditional poetic language (the crossed-out epigraph) to a new lyrical mode to be explored in the language of advertising. We saw such a poetic transformation brought about tentatively in Breton's 'POEME', analysed in chapter 3. A similar partial poetic transcendence is manifest in an early collage-poem by Breton, 'Le Corset Mystère' (1919), where semantic incongruities are partly reduced through metaphorical interpretation. Aragon refers to this text, made up of fragments of advertisements, as 'probablement le premier collage poétique: au moins, le premier systématiquement fait' (C, 99):

Le Corset Mystère

Mes belles lectrices,

à force d'en voir de **toutes les couleurs**
Cartes splendides, *à effets de lumière*, Venise

Autrefois les meubles de ma chambre étaient
fixés solidement aux murs et je me faisais attacher pour écrire:

J'ai le pied marin

nous adhérons à une sorte de **Touring Club**
sentimental

UN CHATEAU A LA PLACE DE LA TETE

c'est aussi le **Bazar de la Charité**
Jeux très amusants pour tous âges;

Jeux poétiques, etc.

Je tiens Paris comme – pour vous dévoiler
l'avenir – votre main ouverte

la taille bien prise. (*OCI*, 16)

The material used for this poem is described by Breton himself: 'Un collage des plus authentiques. (Bouts d'annonces alternant avec des expressions toutes faites et de menues inventions). "Le Corset Mystère", très belle enseigne qu'on peut encore voir au balcon d'un premier étage rue de la Paix.'[49] In addition, in a letter to Tzara, who wished to publish 'Le Corset Mystère' in *Dada*, Breton set out precise instructions on the desired layout of

the text which was to have the visual appearance of an advertisement, presented 'sur la largeur d'une colonne de journal, entre deux traits verticaux et deux filets horizontaux'.[50] (It was actually first published in the fourth number of *Littérature* in June 1919.)

Marguerite Bonnet sees 'Le Corset Mystère' as the positive pole of a poetics of which the negative pole is 'Une maison peu solide', a collage made up of a *fait-divers* with minimal transformations. In a conversation with her, Breton evoked the lyrical potential of the title: 'Une métaphore vit dans l'enseigne, comme dans les autres matériaux offerts par le hasard, sans que le poète y soit pour rien, mais en les réunissant, il libère leurs virtualités et leur donne une existence plus profonde et plus mystérieuse.'[51] This may well constitute on Breton's part a subsequent re-appropriation of an early text for the essentially analogical surrealist enterprise, yet the associations triggered by this banal advertising sign, like the street signs recorded in *Nadja* (1928), point to the hidden topography of the city as the site of desire. 'Le Corset Mystère', an embryonic model for the *cadavre exquis*, can be read as both metonymy and metaphor. As a figure of contiguity, in which clothing displaces the body, it hides and displays the female form; as a fetish object signalling the absent body, it is a metaphorical substitute for the desired woman, or for desire itself, articulating both desirability and interdiction. The isolation of the words, both from their original urban and commercial context and on the page, serves to heighten their evocative potential.

The reader's attention is drawn firstly to the visual appearance of the text: apprehended as a montage of fragments, it displays its structure as collage. The eye at first wanders freely across the text, picking out the groups of words in bold or capitalized typeface. After the title, the eye is drawn to the bold-face capitals ('**UN CHATEAU A LA PLACE DE LA TETE**'), the centred and isolated phrases ('**Mes belles lectrices**', '**J'ai le pied marin**', '**la taille bien prise**'). The various typefaces, foregrounding the discrete quality of each component, work initially against a linear reading of the text. There is a parodic reference to the sonnet form in the symmetricality of the text, which can be read as a visual metaphor of the title, which seems to find an echo, if not a *dénouement*, in the last line ('**la taille bien prise**'), thus promising a unified significance. Syntactical links between the pasted fragments are minimized in favour of juxtaposition, in appositional structures which ensure maximum free association between the pasted groups of words. Thus in the lines:

> à force d'en voir de **toutes les couleurs**
> **Cartes splendides**, *à effets de lumière*, Venise,

the appositions invite a polysemic reading. The precise link between the syntagms is not made explicit: the literal meaning of the clichéd phrase: 'en voir

de toutes les couleurs', is reactivated when placed in apposition to 'Cartes splendides'; the grammatical construction ('à force d'en voir') is incomplete and functions as a dramatic device, creating suspense. The reader picks out semantic links across the text such as the isotope of femininity present in the addressee ('Mes belles lectrices'), as well as metonymically in the title, and in the synecdoches 'votre main ouverte' and '**la taille bien prise**'; light ('**de toutes les couleurs**, *à effets de lumière*'); and travel ('Cartes splendides . . . Venise', '**J'ai le pied marin**', 'une sorte de **Touring Club** sentimental'[52]).

The text can also be read as thematizing a new poetic practice in which Breton was engaged at the time. Whereas in the past, everyday objects ('les meubles de ma chambre') were fixed in their position and the poet felt constrained or corsetted ('je me faisais attacher pour écrire'), he has now acquired his sealegs ('**J'ai le pied marin**') and is embarked with others on a voyage ('nous adhérons à une sorte de **Touring Club** sentimental'), where objects, freed from their fixed positions, can be combined in new and arbitrary ways ('**UN CHATEAU A LA PLACE DE LA TETE**'). The 'Bazar de la Charité' can thus be read as an allusion to collage activity as the recycling of objects, while 'Jeux très amusants pour tous âges' might well evoke the essentially playful practice of collage.

Yet such linkages as adumbrated here generate a local, if not tenuous coherence, and the search for a global sequential logic or analogical associations is met by constant resistance, both in the pull of the visual layout of the text and in the presence of irreducible semantic anomalies. The analysis of rhetorical codes shows that they are initiated then frustrated in the reading process. The text is characterized by fragmented metaphorical and metonymical links, oscillations between figurative and literal readings, and a pervasive dehierarchizing process undoing the very possibility of a rhetorical interpretation. Breton effectively modifies advertising language by exploiting its poetic potential in a text where rhetorical links can be established, yet the essential heterogeneity has not been reduced. The recognition of partial rhetorical structures appears to promise a systematic reading, while the presence of incongruities makes the reading playful and desultory, mere '**Jeux poétiques**, etc.'

In spite of Breton's later contention that any disparate sequences in surrealist texts could be read as hidden hieroglyphs, they contribute textually to the effect of the poem as a collage of fragmentary units. The reading of this poem thus involves a conflict between literal acceptance, semantic reduction and symbolic interpretation. Indeed, the resistance of verbal material to fulfilling the simple role of presence and paradox – more acceptable in pictorial collage – accounts for much of the apparent obscurity of Breton's poems. The written text invites a decipherment: an apparently arbitrary juxtaposition of words or sequences undergoes the process of rationalization by the

reader, who searches for analogies, metaphoric relations, and an ultimate coherence. Yet a poem such as 'Le Corset Mystère', in which juxtaposition as a structuring principle heightens ellipsis and discontinuity, lacks sustained semantic interaction. When anything can be juxtaposed to anything, arbitrary concatenations proliferate and meaning flounders. The *merveilleux*, which emerges at the point of the impossible analogy, borders on the arbitrary and the absurd.

In the final analysis, it is impossible to establish a globally coherent rhetorical reading, since collage elements seem to function 'littéralement et dans tous les sens'. These limit-forms of poetic language can be linked to Rimbaud's language which often hovers at the edge of rhetorical functioning, resisting the reductive process of mediation. Rimbaud's poetics of fragmentation and discontinuity is appropriated by the surrealists as an essential model for their collage practice, and Aragon, Breton and Ernst all quote Rimbaud's image 'un salon au fond d'un lac' as the paradigm of incongruous juxtapositions, a poetic seal of approval for the combinations of disparate elements in pictorial collage:

> [Aragon on the German dadaist John Heartfield]
> L'artiste jouait avec le feu de la réalité (. . .) Le vertige dont parle Rimbaud s'emparait de lui, *le salon au fond d'un lac* de la *Saison en enfer* devenait le climat habituel du tableau (*C*, 67);

> [Breton on Ernst's collage-novel] *La Femme 100 têtes* sera, par excellence, le livre d'images de ce temps où il va de plus en plus apparaître que chaque salon est descendu 'au fond d'un lac' et cela, il convient d'y insister, avec ses lustres de poissons, ses dorures d'astres, ses danses d'herbes, son fond de boue et ses toilettes de reflets (*OCII*, 306);

> [Ernst in reply to the question 'QU'EST-CE QUE LE COLLAGE?']
> *L'hallucination simple*, d'après Rimbaud, *la mise sous whisky marin*, d'après Max Ernst. Il est quelque chose comme l'alchimie de l'image visuelle . . .
> 'La vieillerie poétique avait une bonne part dans mon alchimie du verbe.
> Je m'habituai à l'hallucination simple: je voyais très franchement une mosquée à la place d'une usine, une école de tambours faite par des anges, des calèches sur les routes du ciel, un salon au fond d'un lac; les monstres, les mystères, un titre de vaudeville dressait des épouvantes devant moi.
> Puis j'expliquai mes sophismes magiques avec l'hallucination des mots!'
> (Arthur Rimbaud, *Une Saison en enfer*) (*E*, 253)

Aragon, insisting on the reality of the elements juxtaposed, appropriates Rimbaud's image for his argument on the so-called realism of Heartfield's collages. Breton tames the incongruity of the image by continuing the

analogical process in an extended metaphor. Finally Ernst, in a statement which is itself a collage of quotations from Rimbaud and Ernst himself, models his discourse on that of Rimbaud, without resorting to the appropriative strategy of Aragon or Breton. Rimbaud's images or 'hallucinations simples' can be read as a transposition of visual impressions, and as such they are to be read literally rather than figuratively. As Tzvetan Todorov writes: 'Je dirais . . . que le langage des *Illuminations* est essentiellement littéral et qu'il n'exige pas, ou même n'admet pas, la transposition par tropes.'[53] Semantic incoherence is elided in favour of literal meaning, and, as Todorov stresses, there are few metaphors in Rimbaud's text, but a significant number of metonymies and synecdoches. The *Illuminations* triggers revelations rather than interpretations, creating a space where disparate elements cohabit and clash, exploiting the levelling process already observed in pictorial collage. The literalness of the viewing process is often emphasized by the surrealists, by Desnos for example who refers to the surrealist way of looking at a painting:

> et de même qu'il y a une manière surréaliste de concevoir et de réaliser un tableau, il y a une manière surréaliste de le regarder. Laquelle? La plus simple: le regarder comme un spectacle réel, dont l'existence tombe sous le sens et, par conséquent, est absolue, indéniable et qu'il convient de subir comme la pluie et le beau temps, la neige et l'orage, le cyclone et le tremblement de terre.[54]

Finally, the analyses above have tried to show that metaphoric processes, although present, are tenuous and do not ultimately reduce the allotopic discourse of collage to a single isotope. Rather than metaphoric processes, we are in the presence of radical metonymy where the englobing term is either absent, or so wide – identified with dream space or the surreal – that it frames any arbitrary juxtaposition. This leads to the conclusion that radical metonymy, or the syntagmatic figure, is the dominant trope in collage. Todorov sees metonymy as the least motivated, and most arbitrary, of the three principle tropes where a transient contiguity (characteristic also of collage) is the basis of a metonymic operation: 'l'arbitraire peut devenir presque total avec la métonymie, puisqu'il n'est même plus exigé qu'il y ait des traits communs entre les deux objets: il suffit d'une co-occurrence, d'une contiguïté spatiale ou temporelle, fût-elle d'un seul instant'.[55] Perceived as a spatial collation as well as a semantic configuration, surrealist collage is the site of a tension between literal and figurative interpretations, where semantic analogy is on the point of collapsing into spatial contiguity. In this limit-form of metonymy, signs are copresent in the same phenomenological, but not necessarily semantic, space, hence the transcendence of rhetorical operations is constantly undermined by the literal presence of textual or pictorial

fragments irreducible to figurative transformation. This underscores the importance of collage as a *process* of meaning-making rather than a finished product, a process in which radical metonymy might be read as the provisional stage for a future metaphor.

Beyond rhetoric – monsters

> Je vous annonce qu'une terrible époque s'approche, une époque des visionnaires, semblable à celle qui avait précédé la Création . . . Les divers types d'animaux vont se croiser librement entre eux et ce sera sans la surveillance des biologues que naîtront de nouveaux monocères, des coléoptères-mammifères, des moutons magiques et des êtres faits de sabres, d'aiguilles et de poignards.[56]

Surrealist collage is an experimentation in limit-forms of analogy which englobes anomalies in monstrous matings, as evoked in this text by Styrsky. Anomalies are the result of syntactic operations of pasting or juxtaposing disparate signifiers, 'thus producing monsters that analogy will then attempt to reduce'.[57] The process of mediation analysed in this chapter is clearly a means of taming the otherness of the intrusive signifier, yet it has been shown that the analogical principle is often pushed to excess so that it appears no longer operative, and the anomalies persist.

As a figure articulated on several isotopes, the monster, by rejecting the depth of metaphorical discourse and parading its being as a literal agglomeration of heterogeneous limbs, seems to defy analysis – can it not be netted? While admitting to the *inadmissibility* of surrealist monsters, Breton does actually try to tame the beast:

> Je suscite sur mes pas des monstres qui guettent; ils ne sont pas encore trop malintentionnés à mon égard et je ne suis pas perdu, puisque je les crains. Voici 'les éléphants à tête de femme et les lions volants' que Soupault et moi, nous tremblâmes naguère de rencontrer, voici le 'poisson soluble' qui m'effraye bien encore un peu. POISSON SOLUBLE, n'est-ce pas moi le poisson soluble, je suis né sous le signe des Poissons et l'homme est soluble dans sa pensée! La faune et la flore du surréalisme sont inavouables. (*OCI*, 340)

By deciphering the parts of the 'soluble fish', Breton traps it in a rebus, rendering it harmless, exploiting a method which reduces the monster to an extra-linguistic reality, draining it of its alterity. Similarly, Ernst dissects the constituent parts of the porte-manteau word or verbal collage *phallustrade*: 'C'est un procédé alchimique, composé des éléments suivants: l'autostrade, la balustrade et une certaine quantité de phallus' (*E*, 262). However, such

dissecting strategies, labelling the spare parts of the monster, do not account for its global meaning; it remains an agglomeration of parts, a linguistic monster and not a new synthesis.

Most verbal monsters emerge abruptly, unable to merge with their environment, trapped in titles such as Breton's *Poisson soluble*, *Le Revolver à cheveux blancs*, 'Les reptiles cambrioleurs' or 'Epervier incassable', or Ernst's collage titles: *Ascenseur somnambule*, *La Semence des pyramides*. Such verbal monsters are rarely gregarious, as if stressing through the empty space around them their unassimilable otherness. In pictorial collage, on the contrary, the monster often contaminates and subverts the space it occupies. In Styrsky's collage discussed earlier in this chapter, the monster surfaces to contradict and rupture a clichéd pastoral scene; while in the chapter 'La cour du dragon' from *Une semaine de bonté*, discussed in the next chapter, the monster springs up uninvited in the salons and streets of Paris: chair legs become claws, baroque ornaments turn into jaws, the voluminous folds of ladies' dresses sprout webbed feet, dragon tails or bats' wings, in the contamination of the everyday by the bestial (figure 14).

Monsters as limit-forms of rhetorical operations can also be identified in the verbal *cadavre exquis*, where the rule of syntactic coherence is much less restrictive than that of anatomical coherence in visual collage, and hybrid forms are present in even the smallest linguistic juxtapositions, in the random coupling of a subject and verb, the fleeting soliciting of a noun and adjective, producing monstrous matings:

> L'hippogriffe frisé poursuit la biche noire;

> Le douzième siècle, joli comme un coeur, mène chez un charbonnier le colimaçon du cerveau qui ôte respectueusement son chapeau;

> L'écrevisse fardée éclaire à peine différents baisers doubles.[58]

We are in the domain of the *merveilleux* which emerges when analogy and the arbitrary coincide in the anomalous figure. Such monsters tend to lurk in domains which are generally considered peripheral. As linguistic beings they operate at the frontiers of *langue*: 'they are both within and without *langue*, on the uncertain frontier between *langue*, and the other side of language'.[59] Surrealist teratology is concerned with excentricity, working at the frontiers of linguistic, pictorial and rhetorical spaces, at the limits of mental space, rather than in the oppositional space traditionally occupied by the monster. No longer a symbol of evil, a sign of the deformed or a symptom of the dysphoric, the surrealist monster suspends and neutralizes oppositions rather than resolving them. It occupies territories in surrealist experimentation where rational activity is flouted, analogical operations are stretched to their

limits, the figurative bridge between the two terms becomes a tenuous tight-rope, and a material practice predicated on random concatenations and free associations is openly promoted. Etymologically, the monster is associated with the marvellous and the enigmatic, traditionally considered as a creature beyond the pale, to be paraded at fairgrounds – *monstrum* suggests the idea of spectacle – provoking laughter and horror, fear and fascination. Yet paradox-ically, what is normally deemed peripheral – fleamarket objects, old-fash-ioned engravings, yellowed advertisements, or the marginal zones of the mind, that dusky space between the sleep of reason and the waking of the imaginary – occupies a central position in surrealism. The hybrid unsettles reality by eroding the limits of the possible: as a metaphor of undecidability, it is both a rhetorical and a literal beast moving in a mobile space, on the borders between literal presence and figurative meaning, a heterogeneous beast, whose otherness is loudly proclaimed in the bold capitalized '**UN CHATEAU A LA PLACE DE LA TETE**'.

Finally, the monster cannot be frozen as a rebus or an allegory or trapped within the pre-existing categories of traditional teratology, in reduc-tive processes which would obscure the radical otherness of the beast, on the one hand as a multiple signifying process, and on the other hand as a literal monster. The disparate parts of the hybrid creature, while overlapping, retain their autonomy; it is their monstrous interlocking which generates meaning, not their common denominator. The reader is constantly returning to the material existence of collage, to the paradoxical presence of the collage parts, in other words to the collage-monster as a literal agglomeration of parts, in the process of becoming configured, an embryonic monster at the gestation stage, a figurative being (since we can outline meanings) but, above all, as a verbal or pictorial presence. In the final analysis, collage elements partly resist transcendence through metaphorical transformations, more often they func-tion as the locus of a tension, in a dynamic oscillation between the monster as a figurative process and the monster as matter.

Surrealist collages are liberated forms, masks in a perpetual carnival, the irruption of the other in the midst of outmoded images or hackneyed phrases. In these limbs, whether pasted (Ernst) or displaced (Bellmer), dispro-portionate (Dali) or fragmented (Hugnet), aggressivity and eroticism are unleashed, along with the licence of the fantastic and the vitality of the mar-vellous. With the emergence of the monster hierarchies are overturned, taboos are transgressed in the joyous collision of limbs: collage-monsters are a manifestation of *jouissance*.

Between Fantômas and Freud

C'est seulement alors qu'en signes fulgurants se précisera pour tous le sens, je crois
extrêmement particulier, de notre intervention.
André Breton[1]

Zapping

'Il y a des contes à écrire pour les grandes personnes, des contes encore
presque bleus' (OCI, 321), writes Breton in his first Manifeste. Coming after his
attack on Dostoevsky's so-called realistic narrative, this statement points to
Breton's interest in an alternative narrative discourse, an interest also mani-
fested in his predilection for the gothic novel or roman noir.[2] The surrealists
explore new forms of narrative – partial, elliptical or arrested – which privi-
lege suspense and undecidability, approximating dream narratives and creat-
ing the merveilleux. 'Dans le domaine littéraire', writes Breton in the same
text, 'le merveilleux seul est capable de féconder des oeuvres ressortissant à
un genre inférieur tel que le roman et d'une façon générale tout ce qui par-
ticipe de l'anecdote' (OCI, 320). 'Blue' or 'black', surrealist narrative modes
parody familiar fictional mechanisms, juggle with stereotypical topoi, favour-
ing the casual over the causal, local epiphanies over sustained diegetic
development. This chapter presents an overview of narrative strategies in
collage, at both its encoding and its decoding stages, followed by an analysis
of melodramatic structures in Ernst's collage-novel Une semaine de bonté. The
parodic treatment of melodramatic and dream fragments raises the question
of reading strategies: how does the reader / viewer read such narratives – as
detective or criminal? psychoanalyst or dreamer? These questions are
explored in the final section of this chapter.

Isolated sequences are favoured over extended narratives in the zapping

practices of Breton and Vaché. They would enter a cinema at random, view a short sequence of the film, then leave and repeat the process at another cinema, thereby assembling their own films from the sequences they had seen, creating an incongruous montage which *charged* them for several days. 'Je n'ai rien connu de plus *magnétisant*', remarks Breton in 'Comme dans un bois'.[3] The film medium was important in liberating the surrealists from the constraints of traditional narrative structures since, thanks to its montage techniques, film, perhaps more freely than any other form of aesthetic production, allows images to be juxtaposed in an order different from that of conventional spatial and temporal reality, and without the overt syntactic links of verbal narrative. 'Et par le fait qu'il joue avec la matière elle-même', writes Artaud about his film *La Coquille et le clergyman*, 'le cinéma crée des situations qui proviennent d'un heurt simple d'objets, de formes, de répulsions, d'attractions. Il ne se sépare pas de la vie mais il retrouve comme la disposition primitive des choses.'[4] Similarly, collage creates new narrative forms from the (re-)editing of ready-made sequences, or the simple 'bumping together' of incongruous pictorial or poetic elements.

Radical editing as a means of subverting established narratives is used in visual collage, as was argued in the last chapter in the analysis of Péret's *Collage*, where the elements of the orthodox colonial narrative are redistributed in order to unveil and hence satirize its ideological presupppositions. Similarly, Ernst plays with historical chronology when he places Fantômas, Dante and Jules Verne together in a hot-air balloon in *La Femme 100 têtes* (plate 126), a collage based on a German engraving of the 1804 ascent by balloon of Gay-Lussac and Biot, to which the figure of Dante has been added, and the names of Fantômas and Verne substituted for those of the scientists. At the time he was composing *La Femme 100 têtes*, Ernst was also working on a project for an illustrated book, *Morceaux choisis de l'histoire de France*, a satirical rewriting of French history, which was never completed. Four of these collages were published in 1929 in the last issue of *La Révolution surréaliste* – *L'Autel de la patrie*, *Jeanne de Hachette et Charles le Téméraire*, *L'Esprit de Locarno* and *Nostradamus, Blanche de Castille et le petit Saint-Louis*. In this last collage, for instance, Ernst places the famous astrologer (1503–66) alongside Blanche de Castille and her son, the future Louis XI (1423–83), in a playful disregard for chronology. The surrealists also juggled with familiar narrative schemas, as one sees in *Le Double Meurtre* (1932), where Max Bucaille pastes together within a single frame separate sequences from a melodramatic story, whose *topoi* and props are manifest in the appearance of the ghost, the murder, the bound corpse or the horrorstruck figure. These immediately legible signs, conjoined with the absence of connecting links between the sequences, create a spatio-temporal disjunction. Each fragment is presented as a theatrical décor, on a stage or against a backdrop which displays the proliferating

hysterical ornamentation characteristic of melodramatic and dream spaces. Like the jumbled fragments of a dream, each scene is familiar, yet their combination is disorientating.

Similar strategies are operative in verbal modes of montage. Reference was made in chapter 3 to the use by Bryen and Breton of *fait-divers* headlines or fragments of advertisements in their collage-poems. Similarly Péret's text, 'Hier en découvrant l'Amérique' (figure 10), is composed of newspaper clippings of fragments of *faits-divers* and advertisements in various typefaces, assembled on the page at various angles.[5] Several of these are grouped together as micro-narratives:

> LE «*COUP DU FRIGORIFIQUE*»
> **Une porte s'ouvre**
> deux coups de revolver;
>
> La coupe brisée **INGENUMENT**
> bien chinoise
> **qui disparaît**
> conduit au bagne.

Each sequence is enigmatic, as if the reader were only given fragments of a story in a telegraphic style, which she tries to complete. In addition, there are no evident links between the micro-narratives placed in contiguity; each sequence remains in suspension, displaced by the next segment, as in a series of film sequences. Temporal indications are contradictory – 'hier', 'demain', 'mille et une nuits' – mixing quotidian time with the time of fictional fantasy. Péret is both a criminal leaving multiple clues from his savage chopping, and a wayward detective piecing together the evidence of crimes in erratic combinations. The language of sensational journalism and advertising is perverted; fragmentary, suspended and incomplete, it becomes a discourse of fantasy. A similar practice of collating part-narratives is used by the English surrealist Roger Roughton in his text 'Final Night of the Bath', composed of newspaper clippings drawn from the *Evening Standard* dated 6 June 1936.[6] Fragments of articles have been cut out and glued together:

> A little later, according to reports from Batavia, she was dead. The body was left lying on the pavement of Downing Street and was damaging to Mr Baldwin's reputation. When they saw it Sir Samuel's friends said that the assassination was a dastardly deed.

Fragments of sensational news and political reports have been pasted together in a coherent narrative, and the elements of the familiar have been reshuffled to create an alternative reading of daily news.

Figure 10 Benjamin Péret, *Hier en découvrant l'Amérique* (1926)

When the marks of (chrono)logical development are maintained, it is often in the form of hypotaxis, which carries the overt signs of the cause-and-effect sequence of the narrative mode. In the surrealist hypothesis game, discussed in chapter 3, *si* and *quand* connect two unrelated statements in a (con)sequential order to form an embryonic narrative:

> A.B. – Si tout s'envolait un jour de grand vent
> S.M. – Les somnambules se promèneraient plus que jamais sur le bord des toits

> P.U. – Si on dormait sans arrêt
> B.P. – Le rêve serait de se laisser glisser (*OCI*, 992–4);

> Quand on verra des âmes et des singes parodier la messe le sang bouillonnera dans les bouteilles

> Quand l'amour ne se fera plus qu'en rêve on chantera et les oiseaux mourront

> Quand surgiront du feu des vierges par milliers les poissons tordront les barreaux des cages.[7]

The conditional and future tenses in these sentences express desire through suspense or delay, heightening the visionary: they suggest anticipation in the use of the future tense, or hypothetical actions in the use of the conditional – 'Mais *Si* qui ressemble au désir', writes Aragon.[8] Similar syntactic structures, often incomplete, can be found in the poems of Breton or Péret. For example, Breton's 'L'aigrette' is constructed on a series of conditional clauses:

> Si seulement il faisait du soleil cette nuit
> Si dans le fond de l'Opéra deux seins miroitants et clairs
> Composaient pour le mot amour la plus merveilleuse lettrine vivante
> Si le pavé de bois s'entrouvrait sur la cime des montagnes (*OCI*, 183)

'Unfulfilled as they are', comments Richard Stamelmann about such virtual conditions, 'they maintain an infinite potentiality; they are desires that remain desires.'[9] Elsewhere, logical relations are posited then suspended, as in Hugnet's *poèmes-découpages*, *La Septième Face du dé*, where the reader is disorientated because of the absence of the safeguard normally provided by syntax:

<div align="center">

1°

Parce que
C'est le soleil
qui a tort

</div>

2°

Parce que
UN TALON
peut être comparé à
LA JEUNE FILLE QUI REVE A L'AMOUR.[10]

In other instances, the discursive signs of a diegetic development are displayed but jumbled up, as in the intertitles of *Un chien andalou*, where the spectator is deprived of a coherent narrative development despite the presence of overt markers of causality.[11] The first title ('Il était une fois') situates the narrative in the suspended time of fairy-tale narratives, yet it is followed by a precise – and totally arbitrary – temporal indication ('Huit ans après'), which is contradicted by the action: the young woman whose eye is slit in the first sequence reappears in the following sequence, perfectly whole. The hyperprecision of 'Vers trois heures du matin' appears totally non-motivated, serving to undo even further any temporal coherence, while the flashback suggested by 'Seize ans auparavant' is contradicted by the fact that the characters in fact continue the action from the previous sequence. As for the last temporal indication, 'Au printemps', it is followed by images of disintegration and death, rather than the renewal promised by the title. Hence, by misusing the markers of conventional narrative, Buñuel and Dali destabilize the spectator's expectations and suggest a temporality analogous to dream narratives.

In visual collage, temporal links are usually implicit, as in the collage series, or the many stages, frames and other modes of figuration of a theatrical space discussed in chapter 3. The copresence of objects or figures within a single frame often suggests an elliptical narrative, as in the staged encounters of disparate objects in Magritte's collages, such as *L'Esprit et la forme*, discussed in chapter 3; or in Ernst's 1922 collages, where he sets the stage – adding a horizon line, a podium, a landscape – for potential dramatic developments, but neglects to explicit the links between each object. Faced with an apparently unmotivated alignment of images or objects, the viewer/reader is projected into a defamiliarized space, where the elliptical character of the narrative signs disrupts the symbolic order. She is invited to participate in the construction of a narrative through the projection of her fantasies, creating connections between disparate elements and turning them into a causal configuration. The many glosses on Lautréamont's famous meeting on a dissecting table, interpreted as a sexual encounter, testify to the mind's capacity to forge narrative links, often erotic, where none are explicit. Similarly, in one of Breton's collage-poems, the opening words seem to present a rebus:

LA FLORE DE
LA FEMME
Est-ce un enlèvement? (*OCI*, 575)

The question 'Est-ce un enlèvement?' appears to solicit a narrative. The suppressed connective is the word *défloration*, implicit in the metaphor 'LA FLORE DE *LA FEMME*' and overdetermined by the double meaning of *enlèvement* as 'abduction' and 'removal'. The reader rationalizes the concatenation of apparently incongruous elements by finding their point of intersection, thus retrieving a hidden, or articulating a possible, narrative. More often, however, collage resists such decoding processes; the key is diffuse or discarded and the text is left in suspense.

Surrealist works, and notably collage, favour local clashes and sometimes appear to be deliberately a-narrative. Indeed, Breton's early comments on surrealist language in his first *Manifeste du surréalisme*, laying stress on the image as a 'spark' in the instant of revelation, has promoted a widely accepted view of surrealist works essentially as a bombardment of individual images, an accumulation of discontinuous flashes indefinitely repeated. In this perspective the intensity of the poetic effect of *dépaysement*, as outlined by Breton, is the result of the shock of the single image rather than the consequence of cumulative or developmental processes. This form of short-circuited imagery, favouring local shock encounters, feeds a surrealist aesthetic which values lexical concatenations over diegetic elaboration as the site of the surreal, appearing to grant the surrealist image a solely spatial reality and hence deny it any temporal dimension. Yet the collages already discussed above are evidence that the spatial contiguity of elements often conceals or invites potential narratives. This is exemplified in the recurrent surrealist motif of the locomotive in the forest, as in the following examples from Breton's own poetry:

> Ce qui reste du moteur sanglant est envahi par l'aubépine: à cette heure les
> premiers scaphandriers tombent du ciel. (*OCI*, 162)

> Sans un regard pour la locomotive en proie aux immenses racines
> barométriques
> Qui se plaint dans la forêt vierge de toutes ses chaudières meurtries
> Ses cheminées fumant de jacinthes et mues par des serpents bleus.

(*OCII*, 90)

In such micro-narrative sequences, or more precisely, stasis statements which infer a prior or future event, spatial juxtapositions displace temporal causality, and fictional time is at once implied and silenced. The conjunction of becoming and being, of movement and stasis in the tension of an arrested

narrative, is characteristic of the collage principle. This tension is at the heart of the surrealist aesthetic defined in *L'Amour fou* as *beauté convulsive*, where Breton refers once again to the image of the locomotive:

> Il ne peut, selon moi, y avoir beauté – beauté convulsive – qu'au prix de l'affirmation du rapport réciproque qui lie l'objet considéré dans son mouve-ment et dans son repos. Je regrette de n'avoir pu fournir comme complément à l'illustration de ce texte la photographie d'une locomotive de grande allure qui eût été abandonnée durant des années au délire de la forêt vierge.
>
> (*OCII*, 680)

Such a photograph – which approximates the collage mode in its juxtaposi-tion of incongruous elements – was reproduced in 1937 in *Minotaure* to illus-trate an article by Péret, 'La nature dévore le progrès et le dépasse.'[12] The photographic still negates, while alluding to, cinematographic movement, fixing a moment of an unknown drama. Similarly, the recurrent juxtaposition in surrealist iconography of the clock and the train thematizes time arrested and narrative suspended, as in Magritte's painting *La Durée poignardée* (1938), which portrays an empty room with a train coming out of a fireplace and a clock on the mantelpiece. Such a conjunction of iconic motifs, present also in de Chirico's painting *La Conquête du philosophe* (1914), provokes Breton's imagination which conjures up a future action:

> C'est là même ... à l'heure prévue pour l'arrivée de ce train, à cette heure qui ne peut tarder, c'est parmi ces arcades et quand se sera calmé le vent qui monte abominable de la terre à lancer verticalement le rouge des oriflammes, que le livre dont nous avons si longtemps contemplé la reliure muette s'ouvrira au feuillet marqué. C'est seulement alors qu'en signes fulgurants se précisera pour tous le sens ... de notre intervention. (*SP*, 19)

These 'signes fulgurants', pointing to a possible narrative, invite the inter-pretive *intervention* of the viewer/poet. Breton selects iconic motifs from more than one painting by de Chirico – the allusion to the closed book for example is clearly a reference to *Le Cerveau de l'enfant* (1914), a painting in his own collection – and projects a fantastic narrative. Like the isolated moments of a dream whose narrative is to be reconstituted on awakening, the enig-matic conjunctions in de Chirico's paintings are read as fragments of a tem-poral reality which overspill the frame, and which Breton imagines in the dramatic mode.[13]

In the mid-1930s Eluard produced several collages based on turn-of-the-century postcards or engravings. Some include a single pasted element which disrupts the seamless surface of reality, such as an incongruous action in a

familiar urban setting: in *Le Bon bourgeois* (c.1935), for example, a banal sub-urban garden where builders are working and the husband sits calmly at a table is disrupted by the figure of a hysterical woman; *Zone interdite* (1935) depicts two figures suspended in mid-air on washing-lines thrown across a busy working-class street.[14] In such collages familiar social spaces are frac-tured by the return of the repressed in the sudden emergence of bestiality, sexuality or madness. In such frozen moments of narrative intensity, the simple spatial contiguity of elements and the absence of explicit syntagmatic links underscore the incongruity of the events. Jean-Charles Gateau links Eluard's images of the irruption of violence in a quotidian setting to encroaching fascism on the social level, and on a personal level to the rage and frustration experienced by Eluard at the constraints of a comfortable bourgeois life.[15] In a similar vein, the collage *A chacun sa colère* (c.1935) (figure 11) presents a banal café scene disrupted by the intrusion of an elephant on the rampage. Yet the potentially disturbing invasion of the familiar space of the café by an alien element is defused by the humour of the image which is based on the visualized transposition of the expression: *un éléphant dans un magasin de porcelaine* (a bull in a china shop). A link can be made with the humorous postcard illustrations in Eluard's collection, where clichés (such as *sobre comme un chameau*) are represented visually. This image is also similar to the illustrations of popular novels, and it is significant that the surrealists' fascination with illustrated novels, ranging from *Nick Carter* to *Fantômas*, often focuses on the single image, as in the advertisements on Paris walls on the publication of new serialized novels in *Le Matin* or *Le Petit Parisien*, or the covers of popular novels. 'Je voudrais marquer du poinçon poétique certaines couvertures de romans populaires', writes Desnos about such images which depict not necessarily the most climactic, but certainly the most curious scene:

> Et chaque mois paraissait un nouveau volume: un monde de religieuses s'affrontant revolver au poing, dans un entrepont de bateau, en présence d'un cerceuil vide . . . de mains coupées sur le tapis de la roulette de Monte-Carlo . . . de fiacre conduit par un cocher mort, d'assassin vidant dans la Seine le contenu macabre d'un carton à chapeau.[16]

Several of Eluard's collages present similar images of violent melodramatic actions: in *Jardin public*, nuns are being tortured against the background of a rocky garden and fireworks; while *L'Intruse* presents a man, a naked woman in his arms, walking towards steps where a group of people striking dramatic poses are assembled.

Freeze-frame images or stills are sometimes placed in sequence, as in Ernst's collage-novels discussed later in this chapter, or in Jacques Brunius'

Figure 11 Paul Eluard, *A chacun sa colère* (c. 1935)

photomontage, *Collage en neuf episodes* (1942) (figure 12). Brunius, an actor and filmmaker, compared the montage technique of the filmmaker with surrealist collage practice, considering both of them as the equivalent of poetic metaphor: '[a]u cinéma, une simple collure peut remplacer le mot *comme*'. He imagined a montage film made with ready-made elements, such as footage from newsreels and sound from film archives, which would give concrete expression to Reverdy's notion of *rapprochement* of distant realities.[17] This work, composed of nine photocollages grouped as in a series of filmic stills, could be considered an example of such a montage. In this work, poised between still-life and narrative, there is a contrast between the implicit narrative suggested by the layout and title, and the explicit descriptive format of still-

Figure 12 Jacques Brunius, *Collage en neuf épisodes* (1942)

life. The arrangement in nine 'episodes' invites the viewer to read the work sequentially as a narrative. The stills appear to constitute a part-sequence: a continuous diegetic space seems at first to be represented, a car interior, with a shift from back seat to front seat in still 8, a closed space characteristic of surrealist collages, with the exception of the central still, where the ground is undefined. However, a closer look reveals that the car interiors are shot from slightly different angles from one still to the other; and the material of the car-seat presents varying patterns – striped, checked, two-tone, one-tone. Onto each of these car spaces is superimposed an incongruous object: a rhinoceros, a glass of water, a shrimp, the trunk of a tree, a white cross, a pair of lips and a pair of eyes, a butterfly and a siphon bottle. The central collage represents the heads of a man and woman holding up a gigantic leaf inscribed with painted lips. These juxtapositions can be partly rationalized through metaphorical and metonymical links: for example, the rhinoceros hide can be associated metonymically with the car-seat leather; the shape of the lips in the central collage echoes the outline of the leaf; the windows of the car in still 7, evoking the shape of glasses, have been used to frame a pair of eyes, in a pun on the word *lunette*, meaning 'rear window' and 'glasses'. Another pun links the butterfly in still 8 to the steering-wheel in the same collage through the double meaning of *volant*, as 'steering-wheel' and 'flying'. If we scan the image in a paradigmatic reading, other semantic links can be forged: the tree in still 4 is echoed through synecdoche in the leaf in still 5, the glass in still 2 can be linked metonymically to the siphon bottle in the last still, while the lips in still 5 are echoed, if somewhat more discreetly, in still 7. But such partial metonymical or metaphorical links between different stills do not fully neutralize the dichotomies. On the contrary, such analogies underscore the spatial structure of this collage and disrupt any potential syntagmatic or temporal sequence which might sustain a narrative reading. In spite of partial associations, the lateral succession of images remains stubbornly irreducible.

Spatialization is compounded on the formal level, where repetition and variation invite the perception of this work in terms of simultaneity rather than in terms of temporal development. Formally, each still presents contra-dictory planes: the images of the car interior are presented in perspectival depth, whereas the objects juxtaposed on these grounds are presented frontally in a two-dimensional mode, in disparate scales. The objects overlay the perspectival depth of the car interior, on a plane coextensive with the pic-torial surface rather than with representational space. Their lateral posi-tioning links them formally from one still to the next rather than integrating them in their local space. They appear thus both divorced from their former functions and yet not engaged in new configurations. Their vertical arrange-ment confers on them a totemic character, and their collateral arrangement suggests a rebus as in Magritte's *L'Esprit et la forme* or his painting *La Clé des*

rêves which presents a similar arrangement of framed objects. The cross in still 6, whose function is essentially indexical, marking the location of an (absent) body or object, points to the position of a corpse and suggests the possibility of a crime. The human agent is present only as part-body, as in the lips already mentioned, the heads and hands in still 5, and the eyes framed by the windows of the car in still 7. Any attempt to totalize those fragments and create the whole body from the parts scattered across the different stills, is frustrated. The body parts are thus placed on the same ontological level as the inanimate objects. These objects and part-bodies do not quite succeed in becoming significant indices: they have the status of things rather than signs, or rather seem to hover between the two. It is this non-fixity which leads Roger Cardinal to refer to surrealist experiments in 'pure Enigma' as developing techniques which present 'neither static, autonomous *things*, nor yet dynamic, polyvalent *signs*, but indefinable conjunctions of the two'.[18] Although each object is instantly recognizable and as clearly legible as in a school primer, the collation of objects hints at the uncanny, as if these objects occupied an alien space just outside the coded symbolic space which would help us read them as signs.[19] They inhabit a space somewhere between the table and the stage, between the proximity and legibility of the domestic interior with its recognizable objects – glass, bottle, seafood – and the distance and visuality of a frozen *tableau* suggesting a dramatic event. The quasi-repetition of structure, motifs and context introduces a circularity within the sequence which arrests diagetic development. It is clear that partial rhetorical or narrative links can be woven between the discrete fragments, but these processes of mediation do not completely neutralize dichotomies, and the work ultimately resists a totalizing reading. The collage is perceived sequentially in parts and *as* parts, and the objects remain material, 'simply bumping together', stubbornly refusing any transcendence.

The analysis above is designed to show that narrative is not only encoded by the artist at the production stage of collage, but that narrativization is also a reading strategy which seeks to tame the otherness of the incongruous and the incoherent. Narrative, by mediating between discrete elements, is the essential mode of ordering data. Several of the surrealists' texts on visual art involve a narrative discourse, particularly when the works evoked are fragmented as in collage. The narrative impulse, which is pointed to rather than fully realized in Breton's text on Braque's *Nature morte*, discussed at the beginning of chapter 4, is developed more fully in one of Breton's texts on Ernst, 'La vie légendaire de Max Ernst' (1942), where he deliberately eschews formal or iconic disruptions, by transposing the iconic motifs from various collages and paintings into the syntagms of an extended narrative. Aragon himself had already referred to the theatrical quality of Ernst's collages, which constitute mysterious *mises-en-scène* suggesting potential dramatic developments: 'Les

acteurs jouent un rôle sur une scène, où sont plantés les portants de plusieurs possibilités. J'ai souvent pensé qu'il y avait un drame immense et merveilleux qui résultait de la succession arbitraire de tous ces tableaux' (*C*, 54). Breton effectively creates a *drame* of this type in a stylized narrative where the recurrent iconic motifs in Ernst's work are woven into the episodes of an imaginary biography, in the form of an itinerary which is at once biographical and geographical, a journey in time and space in the life of the artist. Starting in Cologne, and passing through the Tyrol, the journey is continued in Paris, in a trajectory where urban landmarks and iconic motifs are conflated. We move from the Châtelet, 'où nous font la haie les appareils orthopédiques', in a reference to the mechanomorphic works of 1919–20 (*La Grande Roue orthochromatique qui fait l'amour sur mesure*), to the 'réservoir désaffecté' near the Saint-Martin canal, alluding to the painting *Acquis submersus* (1919). There follows a more sinister episode: 'Mais quelque événement grave est survenu: on emporte des blessés, des rapts se commettent en plein jour, la femme elle-même est murée, le bélier du printemps penche la tête, il n'est pas jusqu'au rossignol qui pour la première fois n'apparaisse maléfique' (*SP*, 162). The syntagms of this micro-narrative are triggered off by the motifs of Ernst's 1922–4 collages and collage-paintings, such as *Sainte-Cécile* (1923) or *Deux Enfants sont menacés par un rossignol* (1924). Then comes the episode of 'la grande retraite dans la forêt', which alludes to the first *Forêts* series (1927–8). The artist is described as 'pris avec la femme dans un seul écrin de chair', as in the painting *Pays charmant* (1923). After returning to Paris and a meeting with Loplop and Perturbation, characters drawn from *La Femme 100 têtes* (1929), Ernst travels to an imaginary country where 'des jardins suspendus ont été plantés de néphentès géants et invisibles', as in the *Jardins gobe-avions* (1935) series. He then returns to the forest, 'la jungle tout court, non plus la jungle humaine', such as we find in the Rousseauistic *La Joie de vivre* (1936). Finally, in a closing episode, 'le poteau totémique [qui] continue à regarder la mer' refers to the recurrent motif of paintings from Ernst's American period, such as *Day and Night* (1941–2).

A narrative-intertextual reading thus allows the iconographic fragments to be bound together in a familiar narrative in a reworking of the topos of the journey through life. Breton, fascinated by the book of images constituted by Ernst's paintings and collages, '*saute les pages*' (*OCII*, 304), in an imaginary zapping from one painting to another, simulating the artist's collage strategy of juggling with images. Narrative appears to conjure away the otherness of the works, by reducing their elements to a series of syntagms in a development whose stages are clearly articulated syntactically ('Peu après . . . Mais quelque événement . . . La scène a tourné . . .'), giving the text a temporal framework and, thus, the illusion of coherence. However, although the narrative framework is fixed, the elements gain little cohesion within this new structure; indeed, within the flow of a continuous narrative, the reader

comes up against the disparity of irreconcilable fragments, and although she might recognize their original context, labelling them in an intertextual reading, their displacement remains a source of disorientation.[20]

'Une semaine de bonté': juggling with melodrama

In a stranded railway carriage sits a bowler-hatted passenger with a bestial head; on the floor of the carriage, half out of the plate, lies a second passenger or truncated corpse; the Sphinx is visible through the open door and window of the carriage, infested with a plague of bizarre animals, half-rats, half-dogs. The scene, frozen like a still from a silent film, stages the encounter between Oedipus – presumed name of the animal-headed protagonist – and the Sphinx (figure 13). This is a plate from Ernst's third collage-novel, *Une semaine de bonté ou les sept éléments capitaux* (1934).[21] It has been chosen for close analysis because it deliberately manipulates narrative codes, suggesting then frustrating various interpretive strategies. The discussion which follows will focus on Ernst's use of the codes of melodrama – present in this plate in villain and corpse – and on his appropriation of dream mechanisms, suggested in the hybrid nightmare figure and in the incongruity of the image as a rebus to be decoded.

Une semaine de bonté was produced in the summer of 1933 while Ernst was visiting friends in Italy, where he had taken a suitcase filled with the raw materials for his collage-novel, wood-engravings from illustrated novels and scientific and natural history journals, as well as a volume of *Paradise Lost* illustrated by Gustave Doré which he had acquired in Milan.[22] The collages were reproduced photographically and printed as *clichés-traits*, an etching process similar to the technique of wood-engraving. Composed of 182 plates, the novel was initially published in five separate paperbound booklets with different colour covers, in the mode of a serial novel or popular adventure story.[23] It is divided into seven *chapters* corresponding to the days of the week, and each chapter is linked to an *element* and an *example*:

[colour]	day	element	example
[purple]	dimanche	la terre	Le lion de Belfort
[green]	lundi	l'eau	L'eau
[red]	mardi	le feu	La cour du dragon
[blue]	mercredi	le sang	Oedipe
[yellow]	jeudi	le noir	Le rire du coq
			L'île de Pâques
	vendredi	la vue	L'intérieur de la vue
	samedi	inconnu	La clé des chants

Figure 13 Max Ernst, 'Oedipe', *Une semaine de bonté* (1934)

This framing device appears to give the work a certain coherence which, however, turns out to be deceptive. While the days of the week provide a chronological framework, and the elements associated with the first three chapters, 'la terre', 'l'eau' and 'le feu', clearly belong to the category of elements, 'le sang' and 'le noir' are not strictly speaking elements – although

blood could be retrieved as a subcategory of water, and blackness as a metonym of air; but with 'la vue' the category wavers, then totally collapses with 'inconnu'. As for the 'exemples', which make up the chapter headings proper, some refer to the main protagonist as *persona* or mask: the uniformed lion-headed protagonist in 'Le lion de Belfort', the cock or rooster in 'Le rire du coq', Oedipus in the chapter of that name, a villainous creature with an Easter Island statue head in *L'île de Pâques*. But in 'La cour du dragon', the attributes of the dragon, as lizard, serpent, salamander or other monstrous beast, contaminate various characters: bat-wings and dragon-tails sprouting from the backs of characters, dragon-combs as head-dresses, dragonlike domestic animals – the dragon motif infests even the architecture and furniture. In the chapter representing Monday both element and example are 'l'eau', and the protagonists are voluptuous women confronted with floods, tidal waves and voyeuristic gazes. Among the quotations which follow the chapter headings, some are authentic, others apocryphal, the majority enigmatic. The viewer's search for coherence, instigated by the partial frames provided by Ernst, is constantly frustrated, and the reading experience becomes a tension between the recognition of familiar patterns and the defamiliarization of disruptive fragments.

Alongside these fragmented narrative signs, Ernst appropriates several narrative codes in the various chapters of his novel. For example, historical narrative is parodied in the chapter entitled 'Le lion de Belfort', which refers to the French defenders of Belfort in the Franco-Prussian war. In a satire of militarism, Ernst's main protagonist, a lion-headed officer sporting various non-military medals, struts about pompously, and commits a series of violent and apparently unmotivated crimes. The Oedipus story is evoked, not only in the chapter of that name, but disseminated throughout the novel. Ernst also exploits the narrative formulae of popular genres, the gothic novel in 'Le cri du coq', and above all nineteenth-century melodrama, especially in 'La cour du dragon' and 'L'île de Pâques'.

Many collage elements are drawn from late nineteenth-century popular illustrated novels or 'drames de passion', such as Jules Mary's *Les Damnées de Paris* or *Mémoires de M. Claude*, which were serialized in publications such as *Le Journal du dimanche*. Most of the collages are composed either of an existing complete image from the nineteenth-century source, establishing a coherent and recognizable frame, with a few elements added or altered; or of the combination of two images from separate sources, as for example the collage on page 44, which combines a dramatic landscape of the Tigris by Doré and a female figure from *Mémoires de M. Claude*.[24]

The topoi characteristic of the melodramatic genre proliferate in *Une semaine de bonté*, in the characters (sinister villain, masked criminal, women as victims, vamps or vampires, elderly gentlemen and prostitutes), the actions

(the chase, imprisonment and murder), and the emotions (the sentimental and the lustful, the bestial and the romantic), in a series of crises and crimes, ranging from robbery, bondage, abduction and seduction, to torture, shooting, and skewering, hanging, burying alive and guillotining. For John Cawelti, the success of the melodramatic genre, playing on the reader's desire for order and anxiety, rests on a simple recipe: take a stereotypical narrative structure, and add an element of uncertainty, which heightens our expectations without disrupting them fundamentally.[25] Popular literary forms are often slightly subversive, operating at the outer limits of social codes, voicing the pre-conscious or the unconscious rather than sustaining the social order. For Cawelti, '[f]ormulas enable the audience to explore in fantasy the boundary between the permitted and the forbidden and to experience in a carefully controlled way the possibility of stepping across this boundary'.[26] This explains the presence in melodrama of archetypes of horror, such as the villain as half-man half-beast, or the rupture of quotidian space by the bestial or the organic. The choice of melodrama thus allows Ernst to explore the limit-forms of a literary code which is already based on a rhetoric of excess. Let us look then at how Ernst exploits the rhetoric of melodrama and parodies its codes.[27]

Firstly, on the level of the plot, *Une semaine de bonté* contains micro-narrative sequences familiar to the consumers of melodramatic novels. For example, in the chapter 'L'île de Pâques', seduction scenes are followed by violent assaults and finally death. But the elements of the melodramatic plot are usually present in a more dispersed form, appearing as single stereotypical actions such as the chase, the abduction, the duel or the robbery, rather than integrated into a diegetic development. In addition, they are frequently presented as fragmentary, incomplete and unexplained actions. By isolating the engravings from their original narrative context and modifying them, Ernst underscores their power of suspension; and by collating them in a series of nonsequiturs, he further disorientates the viewer. The traditional melodramatic plot is built on a series of episodes full of suspense: the author instils in the reader a temporary sense of anxiety, sustaining tension until the final resolution. The simplest model of suspense is of course the 'cliff-hanger scene', where 'the protagonist's life is immediately threatened, while the machinery of salvation is temporarily withheld from us'.[28] Ernst's cliff-hanger – a young woman bound with a rope is being lowered over the edge of a steep bank by two men, and hangs suspended above a huge wave (p. 46) – is literally left hanging. The following plate does take up similar motifs – female anatomy, waves, two men – but these are jumbled, forming a variant to a dramatic event rather than a continuation of the events of the previous plate, teasingly suspending the narrative rather than resolving it.

In another collage (p. 124), a winged bird-headed man stands on the

shoulders of another man to talk to a woman behind a window with bars; in the background, the moon and a corpse (or a person lying asleep?) – truncated again – are instantly recognizable as the familiar props of melodrama. The body, whose presence is ignored by the two men, remains a mystery. Although the following two plates do once again present a certain repetition on the level of iconic motifs – the bird-heads, a cage, nighttime – the action is not related to the previous plate. Far from resolving the mystery, these plates serve to defuse or diffuse it by suspending and displacing the previous episode. In this case the scene of the crime is superseded by a circus scene – suggested by the cages on wheels, the animal heads, the circus performers and whip – like a whimsical diversion to the previous scene. The plot thus proceeds through a series of suspended events, where each incomplete sequence is arrested and superseded by the next. In these plates of arrested actions, the lexical elements of melodrama are presented without the habitual connecting links or syntax. A certain number of signs are repeated, creating echoes and seeming to suggest meanings. Werner Spies considers repetition and serialization in Ernst's collage-novels as structuring devices, constituting paratactic modules which induce intelligibility.[29] Ernst himself seems to have partly encouraged such a reading by using formal rhyming strategies. Whereas his first two collage-novels, *La Femme 100 têtes* and *Rêve d'une petite fille qui voulut entrer au Carmel*, are made up of single plates on a right-hand page facing a blank page, *Une semaine de bonté* presents plates on facing pages. By pairing images through visual rhyming, Ernst gives an illusion of continuity, rearranging elements to form configurations which are both familiar and enigmatic. However, the individual collage plates are assembled in a series rather than a sequence, where images echo, cite or parody one another, yet are not resolved in a coherent diegetic development. Repetition as a structuring device is thus used here as another red herring. The effect is similar to that of the *unheimlich* experienced in a recurrent dream, where the familiar and the unknown cohabit uneasily.

The plot structure in traditional melodrama is often based on polarized forces, enacting the manichean struggle between good and evil. This is exploited in *Une semaine de bonté* in dramatic scenes based for example on oppositions between culture and nature: human beings are victims of fires, avalanches or floods; buildings, bridges and ships are swept away by tidal waves. The struggle between bestial torturer and female victim is also a recurrent motif located within the manichean paradigm: an eagle-headed man carries off a woman wrapped up in a sheet (p. 139), drags a woman by her hair (p. 140) or plunges a dagger through the body of his female victim (p. 141). In traditional melodrama, these sharply polarized forces, designed to evoke strong primary emotions of pity or fear, are usually resolved in the *dénouement* which marks the triumph of good over evil. No such resolution exists,

however, in *Une semaine de bonté*. The subtitle *Les sept éléments capitaux* indicates that we are dealing with a parody of the seven deadly sins, where antitheses such as good and evil forces are constantly blurred, whence the ambivalence of these plates. Are we for instance dealing with a torturer and his victim or an accomplice (p. 30–1)? The traditional opposition between culture and nature, far from being resolved in Ernst's novel, gives way to a displacement of nature by cultural iconic motifs. Referring to this intermingling of culture and nature in *Une semaine de bonté*, Margot Norris observes: 'Each of the books depicts through a series of private fantasies sordid adventures of the bestial impulse filtered through culture.'[30] Moreover, the dragons and salamanders proliferating in the claustrophobic spaces of 'La cour du dragon' mark the infiltration of familiar space by bestiality, as in Lewis Carroll's *Alice through the Looking Glass*, where drawing-rooms, tea-parties and croquet games are permeated with the Other.

Melodrama as a representation of intensified emotions concentrates on highly charged individual incidents. Ernst's plot similarly involves incidents of violence and sexual possession, danger, horror and death, where buxom females submit willingly or reluctantly to the violent and sadistic actions of tyrannical males. Ernst's parodic reworking of melodramatic images foregrounds the sexuality and violence inscribed in the original scenes. His hybrid creatures wear the mask of bestiality, like the figures in Styrsky's *La Baignade* analysed in chapter 4, while the convoluted forms of his stylized interiors signal the hysterical mode. The excitement is often defused through a decentring process. There is no single enigma to be solved, no single crime to be detected, but traces of crimes disseminated throughout the novel in a proliferation of corpses or tortured victims. Corpses in particular abound, often displaced to the periphery of the plate, off-centre or truncated, as if unseen by the protagonists. The linear development of traditional narrative is halted by a focus on the proliferation of detail which highlights the foreground, the periphery, the accessory, the supplement. The central fissure which signals enigma in conventional narrative, generating the development of the plot and provoking the reader's desire to solve the mystery, is multiplied in a series of fissures, both within a single plate and between plates. In addition, the poses and props of classical melodrama – eavesdropping, duelling, swooning, pleading, tears, letters, daggers and corpses – are traditionally transparent signs offering immediate legibility.[31] Melodrama often has recourse to stylized *tableaux*, often at the end of a chapter, where the protagonists are portrayed striking exaggerated poses, in a momentarily frozen scene designed to give a clear visual summary of the narrative and emotional situation. In *Une semaine de bonté*, however, far from summarizing what preceded, such tableaux (pp. 25, 109) can remain quite hermetic.

The codes of excess which have been outlined in *Une semaine de bonté* as

examples of Ernst's reworking of stereotypical melodramatic structures – narrative fragmentation, the absence of polarizations, rhetorical excess, and enigmatic or recurrent signs – these codes are characteristic of a child's fantasies or an adult's dreams. 'It is as children and dreamers', argues Eric Bentley, '– one might melodramatically add: as neurotics and savages too – that we enjoy melodrama.'[32] The narrative structures of *Une semaine de bonté* outlined above in the context of melodrama, reproducing the formal mechanisms of Freudian dream-work, appear to simulate dream processes. For example, the visible suspension of causal relations can be read as resulting from the editing process of prior narratives, or the interference of elements alien to the diegesis, which characterize dreams. The obsessional is marked by the compulsive repetition of signs and scenarios and the codes of hysteria and hyperbole. Strategies of displacement are displayed in the proliferation of cropped corpses and elaborate frames, and condensation is inscribed in the ambivalent meanings of recycled signs. The experience of the dream, like that of melodrama, is both familiar and disturbing, provoking the *dépaysement* which surrealism deliberately cultivates in the juxtaposition of the known and the totally other. Just as formulaic genres in general, and melodrama in particular, explore the boundary between the permitted and the forbidden, similarly dream inhabits the space between the conscious and the unconscious. As Richard Brooks argues, the rhetoric of melodrama with its codes of excess allows desire to triumph over repression.[33] The melodramatic stage is thus analogous to a dream-space where fantasies and anxieties are enacted.

Max Ernst's second collage-novel, *Rêve d'une petite fille qui voulut entrer au Carmel* (1930), is explicitly presented as a dream. In *Une semaine de bonté*, on the contrary, the dream space is implicit, in both the formal and iconic codes used. The closed spaces of *Une semaine de bonté* can be read as analogues of the unconscious: in 'La cour du dragon', for example, the claustral compressed spaces of the bourgeois interiors, with their clutter of furniture, their many doors and screens, heavy drapes and curtains, stiff collars and wide skirts; or, in 'Le rire du coq', the crypt of the gothic novel, with its open tombs and criminal activities: these closed spaces evoke a dream space, whose folds, draperies and furniture are inhabited by hybrids, giant insects and bestial heads (figure 14). The mistress of the house sprouts bat-wings, while the ribbons and frills of her voluminous skirts become a bestial adjunct. The repressive limits of a bourgeois household thus dissolve in the space of the unconscious.

Elsewhere, Ernst uses framing devices to highlight the objects or actions contained, as on a stage or in a nightmare scene. In 'La cour du dragon', for example, the bourgeois salon functions as a freeze-frame, but this frame in turn is framed by a curtain or door, by a mirror or painting. Such a process often serves to destabilize the ontological reality of the scene depicted, result-

ing in a confusion between the naturalistic space of the bourgeois salon, the fictional space represented by the excessive codes and gestures of melodrama, and the fiction within a fiction of the pictures and mirrors, which isolate elements of reality or fantasy, investing the space of the room with the sense of impending drama or exacerbated desire. Ernst thus creates the transitional space of the dream, where the real and the fantastic intermingle. The frames often contain partial objects or fragments: a hand firing a revolver, horses' feet galloping, an enlarged treestump or leaf, objects life size or larger than life, grotesque details framing the repressed. These pictures within a picture have been read as an example of wish-fulfilment, as in the oriental servant kissing his mistress's hand (figure 14) or the entwined organic forms on a screen alluding to the lustful fulfilment of the couple's embrace (p. 102). Mary Ann Caws has suggested that the framing of the fetishistic detail can imply a violent action which is repressed in the main image: she interprets the animal skin flattened against the wall (p. 127) as a violent *mise en abyme*, pointing to the flattening or violence done to the corpse or body of a young woman.[34] These many partial images disorientate the viewer: everything is excentric, framed or frozen, denied movement or life. Each frame, as in a filmic still, constitutes an instant cliché pointing to a moment in a drama or dream, perhaps not exactly the '180 climactic moments' which Renée Riese Hubert claims to distinguish in this novel,[35] but rather pre- or post-climactic moments, as on the covers of serialized novels discussed earlier, scenes sustaining or confounding desire. Such collages materialize images which are both familiar and enigmatic, and where the conjunction of nonsequiturs is instrumental in triggering the imaginative engagement of the reader.

Ernst not only mimes the various operations of dreams, however, he uses psychoanalytical texts as ready-made material in his collages, often in a parodic mode. Evan Maurer has argued that Freud's *Dora, an Analysis of a Case of Hysteria* is a source for chapter 2, 'L'eau'.[36] Freud underlines the importance of water as a symbol of sexuality in his analysis of the dreams and neuroses of Dora, a young female patient, associating aquatic images with Dora's infantile memories of bedwetting, interpreted as a displaced expression of her sexual fears and desires. This association appears to be dramatized by Ernst in a series of collages featuring young women lying on beds surrounded by floods or cascades of water, watched by male characters, as in figure 15 (p. 49), where a bearded man stands with folded arms behind the bars of a cage observing a sleeping woman, in an image drawn from Mary's *Les Damnées de Paris* (p. 329). In Dora's dreams, the male figure represented either her father, the symbol of unfulfilled love, or Herr K, the object of her sexual anxieties.[37] However, contrary to Maurer, who reads this image as a direct *calque* of the Freudian scenario, I would contend that Ernst parodies the Freudian scenario, by elaborating the manifest elements of Dora's original memory and

Figure 14 Max Ernst, 'La cour du dragon', *Une semaine de bonté* (1934)

redistributing them. The collage thus represents a scene of erotic fulfilment: the woman lies in a self-engrossed euphoria, and the bedwetting memory is clearly parodied, magnified and transformed, staged as a visual hyperbole in the cascade of water and breaking waves, in an image suggesting desire fulfilled rather than repressed. This was already explicit in the preceding plate, where a woman lies floating ecstatically on the waves which cover her bed. There is no stern father or feared suitor here.

Figure 15 Max Ernst, 'L'eau', *Une semaine de bonté* (1934)

Not only are dream narratives parodied, but so are symbolic processes themselves, particularly in the juxtaposition and proliferation of common sexual symbols: a serpent (p. 17) or a severed hand (p. 29) symbolize male organs, while floating birds' nests (pp. 29, 141) or scallop shells sported as head-dresses by large-breasted women (pp. 28, 29, 44) are recurrent symbols of female genitalia, but scattered throughout the novel like the odd pieces of a jigsaw puzzle, in a playful rewriting of a psychoanalytical 'key of symbols'. Ernst also juggles with familiar myths. In the chapter 'Oedipe', several collages refer to isolated or displaced topoi of the Greek story: a bird-headed male pierces the foot of his female victim (p. 141), echoing the incident in which Laius pierced the feet of the infant Oedipus with a spike before abandoning him. This provided the basis for Albert Cook's analysis of *Une semaine de bonté*, in which he plots a 'completely skewed' Oedipus story in the dissemination of its topoi: in the first collage of the chapter (p. 117), for example, the hybrid traits of the sphinx are displaced on to the male protagonist who wears a cape resembling wings and a bird-head, while a Jocasta-like figure points Oedipus in the direction of the darkness beyond the door, instead of Oedipus sending the Sphinx to the abyss.[38]

In juggling with psychoanalytical images or mythical motifs, Ernst cuts them out of their original contexts and meanings, and inserts them within a new context. Do these fragmented and suspended references then constitute the elements of a story already narrated, cut up and redistributed, or the raw material for a future narrative?

Reading strategies: detective or dreamer?

'Il restait à interroger ces pages, ornées comme des grilles, se détachant de mille livres anciens qui ne se défendent plus', writes Breton about Ernst's first collage-novel *La Femme 100 têtes* (*OCII*, 303). If Ernst explores and explodes the codes of melodrama on the one hand, the mechanisms of dream and familiar myths on the other, what strategy does the viewer adopt when confronted with the fragments of narrative and suspended signs of the collage-novel? Breton suggests that the viewer's position is fundamentally paradoxical:

> ces pages dessinées . . . représentent pour nous une somme de conjectures tellement déroutantes qu'elles en sont précieuses, comme la reconstitution incroyablement minutieuse d'une scène de crime à laquelle nous assisterions en rêve, sans nous intéresser le moins du monde au nom et aux mobiles de l'assassin.
>
> (*OCII*, 303–4)

The viewer-reader's position corresponds both to the work of the detective – as an analogue of the role of the critic as interpreter – reconstituting the scene

of the crime, and to the experience of the dreamer as a voyeur of criminal activities. The role of the viewer is indeed ambivalent, both detective, yet unable, or indeed unwilling, to solve the crime, and dreamer-voyeur finding pleasure in the fragment as such in scenes of apocalyptic disorder, violence, torture, seduction and murder. Ernst's collage-novel, and by extension collage in general, thus appears to elicit two alternative modes of reading: as enigma and as dream.

Firstly, in her role as detective – or its variants, the critic or the psychoanalyst – the viewer sets out to decipher the enigma or solve the crime. Brooks claims, rather dogmatically perhaps, that melodrama and psychoanalysis 'represent the ambitious, Promethean sense-making systems which man has elaborated to recuperate meanings in the world'.[39] These two hermeneutic activities are based on a similar pattern: restoring rational order to a society or psyche threatened with disruption. While melodrama offers the promise of a legible world in which a set of actions, words and gestures yield an ultimate coherence, psychoanalysis interprets its material as signs of an inner reality. In these two explanatory modes, the collage fragment, interpreted as clue or symptom, is subsumed within a coherent significant whole which, by retrieving a lost narrative, overcomes confusion and restores order.

This so-called Promethean task was undertaken by Breton in his search for the surrealist 'point suprême' to resolve all contradictions, which he identified for a time with the explanatory model offered by psychoanalysis. However, he failed to propose anything more than a mechanistic decoding of dream images, in an amateur diagnosis closer to the fixed symbolization of the 'key of dreams' than to a veritable psychoanalysis. Such a procedure is parodied by Ernst in *Une semaine de bonté* in the title of his last chapter, 'La clé des chants'. The relevance of the sexual paradigm as a mode of interpretation had already been parodied by the dadaists in a tract or *papillon*: 'Pour comprendre Freud, chaussez des testicules en guise de lunettes.'[40] It is precisely this kind of detective method, 'la méthode nic-cartérienne' of early applications of Freudian analysis, which had been criticized in 1922 by Jean Epstein, and which Ernst seems to be exploiting ironically in his use of isolated sexual symbols.[41]

A number of critics have applied more sophisticated psychoanalytical tools to interpret individual sections or aspects of the novel. Maurer's interpretation of chapter 2, 'L'eau', as a reworking of a Freudian scenario, has already been mentioned. Foster analyses 'La cour du dragon' as 'an implicit mise en scène of the unconscious', where Ernst relates the historically outmoded spaces of claustrophobic nineteenth-century interiors to the psychically repressed, in images of proliferating ornament, the monstrous figures of the unconscious, and the traumatic tableaux of primal scenes and fantasies.[42]

However, rather than functioning as a dramatization of the return of the repressed, the many frames, pedestals and other (im)pediments seem to suggest that these scenes stage *mises-en-scène* of sexuality not as a liberating force, breaking through the constricted moral world of the nineteenth century, but of sexuality repressed or displaced, in visual hyperboles which signal the parodic reworking of Freudian material. This can be seen for example in the second collage of the first chapter.[43] The Lion de Belfort, accompanied by a young woman, visits an art gallery, where the picture of a large female breast in an oval frame, and the statue of a female figure sporting a chastity belt suggest the oppressed body, sexuality repressed or displaced as fetishism or voyeurism. The bestial, as the return of the repressed, is annexed by culture in ornamental symbols such as the stone lion-head – echoing the plaster figure above this head. Elsewhere this villain sports a head recycled from a doorknocker (p. 5). His many medals include the *Mérite agricole* (p. 24) and *L'Ecole française de coiffure* (p. 29) – nature tamed and appropriated! And in the drawing-rooms of 'La cour du dragon' several of the hybrid beasts are drawn from engravings of heraldic signs, while the stylized interiors are decorated with plant or animal motifs as nature reified into decorative elements carved in stone or wood, and the associations between the female and the bestial are portrayed in highly stylized frozen tableaux (p. 25–7). All these devices present nature, not as a primitive force resurfacing and rupturing the social, but constrained and reified as culture.

Alchemical interpretation provides another totalizing account which englobes all signs within a coherent narrative. For M. E. Warlick, alchemical imagery provides *the* interpretive code for *Une semaine de bonté*; the critic contends that the characters, motifs and narrative structure of Ernst's collage-novel derive from alchemical symbolism, and analyses the first three chapters as the main stages of the alchemical process: the first stage of putrefaction is conveyed in the images of violence and destruction of 'Le lion de Belfort', the stage of ablution is portrayed in the water imagery of 'L'eau'; and the couples in the claustral salons of 'La cour du dragon' evoke the conjunction or union between male and female principles in the alchemical vessel, as the final stage of the alchemical process.[44] Warlick associates the lion, bird and dragon to alchemical symbols, and the actions of violence, decay, death and sexual union to the stages in the alchemical transmutation of base matter.

Such totalizing readings, predicated on psychoanalysis or alchemy, claim to tease out the meanings already secretly encoded in the juxtaposed images. Yet, however attractive they may appear, they do not take into account Ernst's deliberately manipulative practice of fragmentation and *détournement* operative, as we saw, in the narrative strategies of *Une semaine de bonté*. Ernst instigates, then deflates interpretation. By exploring the codes of melodrama, the mechanisms of dreams or alchemical motifs, he seems to be providing point-

ers for the reader in their role as detective or psychoanalyst; yet these codes are exploited as partial codes only, designed to dis/orientate the viewer. In playing with recognizable codes, consciously undoing familiar mechanisms and playfully recombining them, Ernst defuses their drama in a playful gesture, a play on the constant deferral of meaning.[45] There is no final explanation of the enigma, no single 'cure'. Indeed, the dissemination of the elements of the Oedipus myth, in the chapter of that name, can be read as a *mise en abyme* of the task of Oedipus as detective: any attempt to interpret the signs as clues or symptoms is ultimately frustrated. In the last part of *La Femme 100 têtes*, the caption: 'La Femme 100 têtes garde son secret', is repeated six times, and the caption to the last plate: 'Fin et suite', is a reversal of the heading 'Suite et fin' found in novels serialized in magazines and newspapers, while the last image echoes the first. The text invites yet resists a totalizing interpretation, it finally turns in on itself, guarding its (supposed) secret, presenting itself as a palimpsest of interconnected motifs rather than a clearly defined pattern of meaning.

The large number of reified signs – isolated sexual symbols, alchemical motifs, the reified griffons and dragons of Second Empire decorative motifs, the postures and gestures of the hysterical figures of the last plates, drawn from the engravings of Charcot's *Iconographie* – suggests that Ernst is playing with signifying processes. Enigmatic signs proliferate, especially codified signs or symbols: the Sphinx or Oedipus, statues and dummies, masks and medals, shells, birds' nests and heraldic beasts. In Ernst's collages they become itinerant and polyvalent signs: for example the Sacred Heart is devalued from religious to sexual fetish, recycled as a *cache-sexe* (p. 14) or perched on the end of a cigarette-holder (p. 28), depriving it of any stable meaning through the dispersal of its symbolic identity. Many of the signs recycled are already fossilized symbols, for Ernst drew many of his materials from nineteenth-century interior design and particularly the Empire style, which is characterized by a proliferation of arabesques and wreathes, lions' heads, griffons and sphinxes. Siegfried Giedion has analysed these as devalued classical images, Roman symbols recycled as simulacra, reduced to decorative elements in bourgeois interiors, where sphinx heads support flower baskets, and vases balance on sphinx tails.[46] Recycled once again in Ernst's collages, they constitute enigmatic figures which tease the imagination, pointing like hieroglyphs to a possible decipherment, yet proposing none. Yet other examples of these enigmatic signs are the primitive masks appropriated by Ernst, images from alien cultures, such as the giant Easter Island sculpted heads (pp. 168–71), Aztec heads (p. 174) or African masks (p. 176) (figure 16), drawn from engravings in the journal *La Nature*, as cultural artefacts cut off from a coded system whose key has been lost through ethnographic distance and artistic manipulation. In *Une semaine de bonté* these masks are reified signs among

Figure 16 Max Ernst, 'L'île de Pâques', *Une semaine de bonté* (1934)

many others; their original significance is present only *en creux* as enigmatic, yet in these short-circuited fictions, the masks remain invested with an expressive charge which links them to an unknown, and disturbing, dramatic event. These are less the elements of a story already narrated than the raw material for potential dramas.

 This analysis of narrative codes has suggested that undecidability and suspension are discursive strategies, constructed syntagmatically in the per-

verse or absent links between images, and paradigmatically in the superposition of fragments. The reassuring euphoria experienced by the reader when presented with familiar narrative structures gives way to *dépaysement* when confronted with iconographic incongruities which do violence to the reader's expectations and hold her in suspense. In their very inconclusiveness surrealist narratives, fragmentary and incomplete, stage the theme of expectation and desire, where the enigmatic structures constitute a strategy which stimulates desire, and the constantly reactivated suspense intensifies the pleasure in narrative, or, in Breton's words, 'le désir resté désir'. Desire appears in collage as the signal less of an absence than of a future fulfilment. Breton himself, in spite of his Promethean project, is less interested in decoding and interpreting than in combining incongruous images and disorientating the reader, who engages with the surrealist collage-text on the level of the imagination as a vicarious experience. Causal links, suspended in the narrative, are introduced by the viewer, in the construction of narratives which are a projection of her own fantasy rather than the retrieval of an *a priori* narrative in the text. As Rosalind Krauss suggests, the simple assemblage of incongruous elements in surrealist objects, such as Man Ray's *Cadeau*, where a row of nails is glued on to a flat-iron, provokes narrative associations: 'The object is shrouded in the temporality of fantasy. It can be the recipient of the extended experience of the viewer who projects his own associations onto its surface. The metaphoric connections supported by the object solicit the viewer's unconscious projections – invite him to call to consciousness an internal fantastic narrative he has not previously known.'[47]

Instead of eliciting a single reductive reading, these collages activate a plural reading; the signs proffered are less clues or symptoms than signals pointing to potential meanings, or more precisely to meaning as a potentiality. Such visual conundrums are perhaps less to be analysed and deciphered than to be enjoyed as affects. The sign is thus experienced as a mystery to inhabit rather than an enigma to be deciphered. As Borges writes in *El Aleph*: 'The solution to the mystery is always inferior to the mystery itself. The mystery can be linked to the divine, the solution to a conjurer's trick.' Pleasure derives less from the solution to a mystery than from the disorientation founded in desire, in the enigma as enigma. In the final analysis, the motiveless crime, the fragmentary and the incongruous are subsumed into the category of the *merveilleux*, which involves a suspension of disbelief, sanctioning irrational juxtapositions and presenting the fragment as fragment, the mystery as mystery. The encounter with the collage text, whether on the part of the collagist or the reader, can be seen as an instance of objective chance, the meeting between desire and an external reality, in a configuration which reassembles the familiar elements of the real into a composition shot through with the contradictory and the ambivalent.

The Sphinx is the traditional symbol of symbolization, and the necessity of interpretation has been considered the imperative associated with the Oedipus myth. In a text on Chirico, Breton refers to the Sphinx as representing the old order of the imagination, and he invokes the need for a new mythology originating in the modern unconscious (*OCI*, 251). In *Le Paysan de Paris*, Aragon evokes the 'sphinxes méconnus' which people the modern city; when the new Oedipus questions them he is faced with 'ses propres abîmes que grâce à ces monstres sans figure il va de nouveau sonder. La lumière moderne de l'insolite, voilà désormais ce qui va le retenir' (*PP*, 18). In the collage-plate which opened this discussion (figure 13), Oedipus turns his back on the archaic symbol of the Sphinx, decomposing and swarming with rats, relegated to the background, outside the (modern) mental space represented by the carriage. The Sphinx remains visible but is about to disappear, having lost its significance, its attributes disseminated throughout the novel, while a new hybrid being takes its place in the foreground. The new Oedipus, rather than overcoming the monster, has assimilated its features. The visual rhyming within the plate, between animal-headed human and human-headed beast, between atrophied corpse and hypertrophied head, far from opening onto a single clarified meaning, establishes links in a self-reflexive movement, blocking the unfolding of a linear narrative. The image does not yield any unified meaning: Oedipus – criminal and/or detective? – returns our gaze, fascinating and deeply disturbing.

CHAPTER SIX

Masking

Qui sait si, de la sorte, nous ne nous préparons pas quelque jour à échapper au principe d'identité?

André Breton (1921)[1]

Qui sait si, de la sorte, nous n'avons pas déjà échappé au principe d'identité?

Max Ernst (1935)[2]

'Qui suis-je?' asks Breton in the opening lines of *Nadja*. 'Si par exception je m'en rapportais à un adage: en effet pourquoi tout ne reviendrait-il pas à savoir qui je "hante"?' (*OCI*, 646) In a play on the proverb, 'Dis-moi qui tu hantes et je te dirai qui tu es', Breton suggests that the self as a stable and coherent unity is replaced by the notion of a fluctuating identity, where the personal ('qui suis-je?') is traversed and constructed by transpersonal factors ('qui je "hante"'). Recording the signs that make up his identity, Breton presents the 'haunting' self as a nomadic individual constantly displaced and dissolved by the palimpsest of the city, its libidinal forces and enigmas. Identity is thus expressed, not as an essentialist concept or an ontological given, but as a mobile construct constantly remodelled by objective chance. As the appropriation of ready-made elements, collage might at first appear to present the most recalcitrant material for the formulations of subjectivity. And yet, we have seen how collage as a medium allows the artist or poet to express his desires and fantasies. As Ernst states in 'Comment on force l'inspiration', surrealist techniques, and in particular collage, 'ont permis à certains de fixer sur papier ou sur toile la photographie stupéfiante de leur pensée et de leurs désirs'.[3] More recently, José Pierre has firmly stated that 'le procédé du collage permet de coller la subjectivité de celui qui le pratique'.[4] In its appropriation of external reality through the action of desire – as in Ernst's transformation of banal images taken from commercial catalogues into a stage for the enactment of a subjective drama – collage is a

privileged site for the encounter between an inner compulsion and an exter-
nal reality, (dis)locating the self in the boundaries where these two spaces
overlap.

This chapter explores the overlapping spaces of surrealist identity, focus-
ing on the ways in which the search for the self – who am I? – is constantly
displaced by the search for the other – whom do I haunt? The process is
perhaps best exemplified by the image of the *pagure* or hermit-crab. 'Le
pagure dit' is the title of a group of automatic texts from *Les Champs magné-
tiques*, written very rapidly by Soupault and Breton, and inducing in its
authors a disturbing experience of depersonalization. In his notes to *Les
Champs magnétiques*, written in 1930, Breton comments on the experiment:
'Peut-être ne fera-t-on jamais plus concrètement, plus dramatiquement saisir
le passage du *sujet* à *l'objet*, qui est à l'origine de toute la préoccupation artis-
tique moderne'.[5] The hermit-crab colonizes empty shells, often after having
devoured the mollusc inside, hosting in its turn other marine creatures.
Similarly, in the surrealists' intertextual strategies, the self appropriates the
texts of others, constructing an identity through the process of cannibaliza-
tion. 'Dans cet hybride simulé', asks Philippe Audoin, 'lequel est *je*, lequel est
l'autre?'[6] While Audoin sees the hermit-crab as the symbol of automatic
writing, Béhar elects it as the emblem of collage: 'Comme le pagure, le
collage accapare une forme et une substance, s'en nourrit et se crée un objet
nouveau dont il est le vecteur et, à son tour, l'élément nourricier.'[7] My aim,
therefore, is to investigate the identity of the surrealist subject: formed by the
converging or conflicting voices which haunt or inhabit it, it is located in the
interplay of various discourses or images. 'La recherche de l'autre', declares
Gérard Durozoi, 'est toujours recherche de soi. A travers l'autre qui me hante
se révélera à moi qui je suis.'[8] In the following pages the *haunting* self is traced
in the hybrid identities assumed by surrealist writers and artists, firstly in their
intertextual strategies, secondly in their portraits and self-portraits, and
finally in their appropriation of masks. Identity is explored as essentially a
semiotic strategy where the self is both displayed and displaced in figures
which articulate ambivalent spaces of identity.

Dialogues of self and other: intertextuality

The quasi-obsessive repetition of the name Breton in an early collage text
'PSTT' (1920) (OCI, 156), consisting of an extract from a telephone directory,
follows the familiar path of the family romance, from identification with (*nom
du père*) to rejection of (*non du père*) the father, charted by Lacan in his study
of the child's maturing process, in a strategy of perversion (*père-version*) of
already constituted texts. The surrealists' appropriation of literary and non-

literary texts and of art-historical or mass-media fragments is both a destructive act abolishing the father and a creative statement affirming an autonomous voice: 'Si les lois esthétiques existantes peuvent se rattacher à la toute-puissante autorité d'un Père idéalisé, la destitution de ce dernier reproduit . . . sa mort, cette fois-ci impliquée par l'acte de création.'[9] By placing the effigy of Anatole France, father-figure of the orthodox literary generation, in a wooden bouquiniste box and throwing it into the Seine, the dadaists performed a ritual killing of the Father. The practice was continued by the surrealists who carried out further ritual murders in a plethora of inquisitorial *cadavres* in the course of the 1920s. Yet the relation to the voice of the father is essentially ambivalent: the surrealists both identified with literary ancestors and contested the other in their oedipal need to assert their own origins. Thus Breton, who remains silent about his own father, establishes throughout his writings a chain of substitute fathers, literary and political figures alive or dead, from Rabelais to Rimbaud, Valéry to Trotsky. The rapport was always fluid, however, and these relations were to evolve with time: Breton's rejection of Valéry, his literary mentor, was followed later by that of Lautréamont and even Rimbaud – although the latter were to be reinstated later as fellow poets rather than poetic precursors, brothers instead of fathers. Breton's writings thus fluctuate between the ponderous listing of literary precursors, legitimizing the surrealist enterprise, and the rejection of all predecessors, liberating it.

The erasure of the name of the genitor is accompanied by the dismantling of the rules of filiation, and the rejection of the notion of the paternity of the text is an essential manifestation of this stance, as manifested notably in collage, where the notion of the author as originator of text is overtly challenged. Thus Oedipus joins anti-Narcissus: the rejection of the notion of begetting the text is coupled with the idea of the poet, speaking in the name not of an individual subjectivity but through the intersubjectivity of language – *parole* and not *langue*. In such an optic, the emphasis on the literary chain established by proto-surrealists and pre-surrealists is considered not in a hierarchical, vertical space, but on a horizontal plane. The poet, no longer anxiously engaged in the oedipal struggle, locates himself in an intersubjective discursive space, within a network of texts. As a result of these experiments in a collective and non-hierarchical mode of textual production, the *I* is effectively displaced by the *other*. In the pages of his *Entretiens* dealing with the early days of surrealism, Breton stresses the importance of the collective activities of the group, which he compares to a *Bund* or fraternity: 'Je crois pouvoir dire qu'est mise en pratique entre nous, sans aucune espèce de réserve individuelle, la collectivisation des idées' (*En*, 77). In a similar spirit, Antoine Compagnon, fired by Borges' character César Paladian who publishes under his own name canonical literary texts, imagines a literary

revolution which would put an end to authors' rights as private property, and where each individual would be free to appropriate the discourse of the other. 'A l'appropriation privative du texte', imagines Compagnon, 'se substituerait une actualisation anonyme et indivise, le communisme intellectuel dont Freud invoquait l'avènement.'[10] It is this collective enterprise which is manifest (albeit on a less ambitious scale) in the recycling of textual fragments among the surrealists: for example, the title of Breton's poem 'Le volubilis et je sais l'hypoténuse' (*OCI*, 164) is taken from a phrase uttered by Desnos while in a hypnotic sleep, while Soupault's poetic invocation of Eluard as 'nourrice des étoiles' is recycled by Breton in 1938 as the title of a photocollage portrait of Eluard.

Such strategies challenge traditional concepts of artistic or literary subjectivity. Before the surrealists, Lautréamont had already heralded a new poetic mode in *Poésies*: 'La poésie personnelle a fait son temps de jongleries relatives et de contorsions contingentes. Reprenons le fil indestructible de la poésie impersonnelle.'[11] The surrealists also sought to deflate the dominant ideology of literature as the expression of an individual ego, denigrating such products as 'explosions de petits "moi" ridicules' (*En*, 263). They overturned the Romantic myth, which privileges genius and individuality, and replaced it with an aesthetic of textual and iconic appropriation. 'Le collage', declares Aragon, 'met en question la personnalité, le talent, la propriété artistique, et toutes sortes d'idées qui chauffaient sans méfiance leurs pieds tranquilles dans les cervelles crétinisées' (*C*, 37–8). Such an aggressively radical shift opens onto new formulations of identity as a nomadic and fluid identity constructed through relational practices beyond the bounds of individual subjectivity, in a mobile space where voices intermingle.

Such a paradoxical space can be found in Breton's text 'PSTT', first published in *Cannibale*, 2 (25 May 1920):

Neuilly 1–18 . . .	Breton, vacherie modèle, r. de l'Ouest, 12, Neuilly.
Nord 13–14 . . .	Breton (E.), mon. funèbr., av. Cimetière Parisien, 23, Pantin.
Passy 44–15 . . .	Breton (Eug.), vins, restaur., tabacs, r. de la Pompe, 176.
[. . .]	
Roquette 09–76..	Breton et Cie (Soc. an.), charbons gros, q. La Rapée, 60 (12e).

<div align="right">

Breton (André)

(*OC*, 156–7)

</div>

As a page from a telephone directory, flagged when the 'S' is deleted in the title – P[S]TT – it does not seem to qualify as a poem at all. Its disruptive quality arises not so much from semantic incompatibilities within the text as from its context; it is situated as a disruptive space, a page of both literature and telephone directory, both poem and non-poem. Yet the very act of selec-

tion of such mundane reified material, seemingly impervious to poetic transformation, presupposes an authorial voice, 'la personnalité du choix' (*C*, 43), and a signifying intention. Indeed, one critic has gone so far as to label it as 'one of the most egocentric texts imaginable without once using the personal pronoun'.[12] And yet the text seems to display a pointed absence of significance. The title, read as the onomatopoeic 'pst!', draws attention as if inviting communication, but it is not followed by any message. As a 'non-poem', it functions as a pointer to the renouncement of poetry as a signifying subjective activity. As a poem, it presents the effacement of the subject: firstly through the proliferation of Bretons, where the unique individual self is replaced by multiple others identified by the much despised 'réussite dans l'épicerie'; and secondly, through the signature, 'Breton (André)', which reduces the subject to the anonymity of official language, not even distinguished from other Bretons by a profession or an address. Breton refers to this process in a letter to Picabia: 'Je suis à la recherche d'un incognito et pour cela je serais prêt à me composer un semblant d'existence avec n'importe quoi.'[13] Aragon, on the contrary, interprets the poem as subject-centred, linking it to Breton's anxieties about depersonalization when writing *Les Champs magnétiques*.[14] The very repetition of the name Breton, which for each individual indicates a unique, socially recognized, personal identity, but appears here as a series of possible interlocutors codified in the text, narrativizes the passage into anonymity. Thus the poem, with its overtly conflictual status as a hyper-narcissistic exercise and as an experiment in anti-narcissism, functions on a dual level: it is both an anonymous discourse and a discourse about anonymity, dramatizing the process of self-effacement.

While 'PSTT' stages the disappearance of the subject – and of the poetic voice – and can be deemed to belong to an essentially dada aesthetic, Aragon's *Aventures de Télémaque* (written in 1919–20) can be read as a work which charts the emergence of the individual voice of the poet.[15] 'Ma vie est dans le sillage de quelqu'un', writes Aragon in *Télémaque*, and his text enacts various forms of intertextual dialogue in the agonistic narrative of the young writer in search of a voice. The first part of *Télémaque*, combining parody and pastiche, is a rewriting of Fénelon through Lautréamont.[16] Aragon appropriates Fénelon's classic text *Les Aventures de Télémaque* (1699), which was itself a rewriting of Homer.[17] Aragon comments on his own literary experiment as follows:

> Quand j'avais ainsi entrepris de réécrire Fénelon, de le corriger (plus précisément), il y avait de ma part un retour à mes commencements, et l'effet de l'influence dominante que je subissais en ce temps-là, celle d'Isidore Ducasse, comte de Lautréamont, dont je venais de découvrir que les *Poésies* étaient dans leur ensemble une *correction* de plusieurs auteurs.[18]

Aragon condenses Fénelon's detailed account of Télémaque's early adventures to four pages, focusing on the narrative sequence which takes place on Calypso's island. The *incipits* read:

[Fénelon]
Calypso ne pouvoit se consoler du départ d'Ulysse. Dans sa douleur, elle se trouvoit malheureuse d'être immortelle. Sa grotte ne résonnoit plus de son chant; les nymphes qui la servoient n'osoient lui parler. (p. 119)

[Aragon]
Calypso comme un coquillage au bord de la mer répétait inconsolablement le nom d'Ulysse à l'écume qui emporte les navires. Dans sa douleur, elle s'oubliait immortelle. Les mouettes qui la servaient s'envolaient à son approche de peur d'être consommées par le feu de ses lamentations. (p. 9)

In Aragon's text the description of Calypso is followed by the arrival of the shipwrecked boat and the encounter between Télémaque and Calypso. But Aragon's rewriting is in the burlesque tradition, where the noble tone of the seventeenth-century text is degraded – Genette refers to a process of *dévalorisation*[19] – in the use of caricature and anachronisms. Whereas the classical Télémaque acquires wisdom through his travels, Aragon's Télémaque commits suicide: during a philosophical debate on freedom Télémaque jumps off a cliff to prove his free will (p. 100). His companion Mentor philosophizes on the absurdity of this death, but his speech is definitively interrupted when he is crushed by a rock. This dialogue with the hypotext is marked by perversion and parody: 'C'est en lisant de près la prose d'Aragon qu'on comprend comment il apprit à écrire dans Fénelon par un dialogue pervers avec le texte autre.'[20] The use of parody marks an ambivalent attitude towards Fénelon, since it is both an act of complicity with the classical author who provides the point of departure for Aragon's text, and an act of distancing by the parodic reworking of the hypotext. The literary model provided by Lautréamont is paramount in this strategy, for Aragon's technique is similar to that of Lautréamont who, in *Poésies*, parodies or 'corrects' French classical authors, and in particular Vauvenargues. But not only does Aragon imitate Lautréamont's technique of appropriation of earlier texts, he also rewrites Fénelon through the nineteenth-century author. Fénelon's classically structured text undergoes a Ducassian *dérive*:

[Fénelon]
La grotte de la déesse étoit sur le penchant d'une colline. De là on découvroit la mer, quelquefois claire et unie comme une glace, quelquefois follement irritée contre les rochers, où elle se brisoit en gémissant, et élevant ses vagues

contre des montagnes. D'un autre côté, on voyait une rivière où se formoient des îles bordées de tilleuls fleuris et de hauts peupliers qui portoient leurs têtes superbes jusque dans les nues. (p. 122)

[Aragon]
La grotte de la déesse s'ouvrait au penchant d'un coteau. Du seuil, on dominait la mer, plus déconcertante que les sautes du temps multicolore entre les rochers taillés à pic, ruisselants d'écume, sonores comme des tôles et, sur le dos des vagues, les grandes claques de l'aile des engoulevents. Du côté de l'île s'étendaient des régions surprenantes: une rivière descendait du ciel et s'accrochait en passant à des arbres fleuris d'oiseaux; des chalets et des temples, des constructions inconnues, échafaudages de métal, tours de briques, palais de carton . . . (p. 15)

The classical text is thus a point of departure for a poetic reworking, based on the principle of elaboration. Aragon's text abandons narrative logic, deviated by pastiches of Ducassian rhetorical devices: simile ('plus déconcertante que les sautes du temps multicolore . . .'), hyperbole ('une rivière descendait du ciel'), the metonymic series ('chalets . . . temples . . . constructions . . . échafaudages . . .'), and metaphorical inventions ('les lampes-pigeons') which recall Lautréamont's bestiary in Book VI of *Les Chants de Maldoror*. The lateral elaboration of the text, infiltrated and perverted by baroque amplification, destroys any narrative coherence and descriptive verisimilitude, as in Lautréamont's texts where lyrical developments constantly deflect the text from its narrative trajectory, with the result that it develops its own momentum, challenging narrative coherence and elaborating a discourse of fantasy. As Jacqueline Chénieux suggests: 'il s'agit . . . de nier un contenu de sens par glissement dans le champ du fantasme . . . l'œuvre de Fénelon est récrite afin de laisser les rêves envahir le texte'.[21] The momentum of the text thus produced through parody and pastiche, suggests Aragon, is brought out in the interval between the original text and the 'corrected' text, and Aragon's voice is heard in the movement of 'correction', in the interplay between the voices of Fénelon and Lautréamont. Other intertexts are present as pastiche or collage, according to Aragon, who does not reveal to the reader all his secrets, 'afin de lui ménager le plaisir de les découvrir soi-même, de s'en indigner, et de se réjouir de sa propre érudition'.[22] For example, Aragon integrates – as a text in a bottle – an article on Mars (pp. 64–5) taken from a scientific journal and the entry for the word *memory* from the Littré dictionary (p. 85).

Fénelon's text is displaced not only by the pastiches of Lautréamont or the collage of various other texts, but also by self-collage. In the second part of Aragon's text, '[s]a propre vie, [s]es préoccupations *modernes*, viennent bouleverser le développement' of the homeric narrative.[23] He incorporates

into Book II (pp. 32–8) the text of a dada manifesto, 'Système d'introduction à une morale momentanée' (first published in *Littérature* 15, July–August 1920), and into Book III another dada text, 'Révélations sensationnelles' (pp. 51–3) (*Littérature* 13, May 1920). He also incorporates an unpublished text dating from 1920, titled 'Ailleurs, un jour ou l'autre' (pp. 59–63). These self-collages are inserted in the text with no transitions or reworking, yet appear clearly distinct from the rest of the text – the first two texts, in italics, are presented as speeches, while the third is presented as a text found in a bottle. This contrasts with the first part of Aragon's text where the pastiche of Lautréamont both continues and undermines the parody of Fénelon, underscoring the heterogeneity of the text as the locus of multiple voices. As Piégay writes: 'Pastiche, parodie et citations s'inscrivent dans le cadre de cette dialectique entre identité et altérité propre à l'archéologie de l'écriture aragonnienne.'[24]

There is yet another displacement of voices in the passage which closes the text:

> Le firmament se constella du sexe des lumières. La voûte des jours et des nuits devint une chair et ceux d'entre les hommes qui avaient survécu aux bouleversements moururent de désir devant la croupe impudique au-dessus de leurs têtes. Le sable des déserts devint serpent, ouvrit les yeux, soubresaut d'éclair, au frisson des pollutions nocturnes. Les nébuleuses rôdèrent dans les paysages riants. Les quenouilles dansèrent en perdant leurs cheveux argentés. (p. 101)

In this erotically and poetically charged text can be heard the hallucinatory tone of the incipient surrealist voice, 'ce lyrisme de l'incontrôlable, qui n'avait pas encore de nom, et devait de notre consentement en 1923 prendre le nom de surréalisme'.[25]

Aragon, far from being a mere compiler of texts, assumes an active role of *metteur en scène*, staging divergent discourses, orchestrating their various dialogues, amplifying Lautréamont, silencing Fénelon, creating a space for his own multiple voices, both the dada voices of the past, framed and distanced through the italicized discourse, and the emergent surrealist voice which supersedes the earlier voices in the last pages of the book. In conclusion, Aragon's identity can be traced in the dialogic principle of the interaction of texts, a fluid identity generated by a constantly renewed alterity, which marks the importance of this text firstly as a turning-point between the negativist tactics of dada and the surrealist search for an authorial voice, and secondly between the parodic rewriting of the text of authority, the fraternal pastiche, and the voice of the individual subject. The play, within the same text, of multiple voices, undermines the concept of an authorial presence, hence a unifying subject of enunciation, and the combined voices produce a

mobile space in which they echo, interweave or simply collide with each other.

On occasion, the hypotext is cannibalized and so totally assimilated by the speaking or writing subject that it is scarcely recognizable as a distinct voice. This is the case in Dali's text 'Les pantoufles de Picasso', published in 1935 in *Les Cahiers d'art*, and – at least according to Dali – considered by the editor of the review, Christian Zervos, as one of the most pertinent studies of Picasso's work.[26] It is in fact a rewriting of Sacher-Masoch's text 'La pantoufle de Sapho' (1859), which has been totally absorbed through Dali's paranoiac-critical discourse. A comparison of the two texts will bring out the work of rewriting:

> [Sacher-Masoch]
> . . . Mais, quand elle paraissait drapée à la grecque, sur les planches, quand sa superbe voix laissait tomber les ondes mélodiques de la langue rythmée, quand son génie invoquait des figures d'une vérité saisissante et d'une dignité surhumaine, elle entraînait les coeurs, comme jamais aucun artiste ne l'avait fait. A ces moments, elle devenait belle, d'une beauté antique et qu'on eût crue sortie d'un sarcophage ancien . . .

> [Dali]
> . . . Mais quand Picasso, par hasard et très tard dans la nuit, apparaîtra un instant à son balcon, drapé à la grecque, quand son superbe casque de travail laissera tomber sur la rue La Boétie les ondes lumineuses annonçant aux passantes que son génie vient d'invoquer des figures d'une laideur accablante et d'une indignité surhumaine, Picasso entraînera à cet instant les coeurs et les reins flottants des noctambules comme aucun artiste ne l'a encore jamais fait. A ce moment Picasso deviendra d'une beauté ignomineuse et on le croira sorti d'un lointain relief aztèque représentant un sacrificateur ensanglanté, terriblement civilisé, dégénéré et apothéosiquement gâteux . . .

The reworking process is characterized by substitution, elaboration and degradation, as in Aragon's parody of Fénelon's text. Dali has preserved the narrative framework while modifying the characters and setting: Sacher-Masoch's heroine, the singer Sophie, is replaced by Picasso, and the setting of nineteenth-century Vienna is replaced by France in the 1930s. Past tenses are replaced by future tenses, which lends an apocalyptic or visionary tone to Dali's text. The classical references in the hypotext, identified by the sublimation of the human form – 'des figures d'une vérité saisissante et d'une dignité surhumaine' – are replaced by a new aesthetic evoking Bataille's *bassesse* – 'des figures d'une laideur accablante et d'une indignité surhumaine'. The aesthetic paradigm of ancient Greece ('un sarcophage ancien') is inverted in the reference to the bloody sacrificial rites of ancient Mexico ('un lointain relief

aztèque représentant un sacrificateur ensanglanté'). The hyperbolic para-
noiac-critical discourse serves to obscure the hypotext which has been
effectively cannibalized by Dali, in contrast to Aragon's text discussed above
which undermines Fénelon's text through its lateral elaborations, while the
armature remains visible.

Dialogue also structures 'L'enfant planète' (1926), a collaborative text
written by Desnos and Péret, which combines automatism and collage. It was
composed by taking two automatic texts, written by Desnos (in italics below),
the other by Péret, and putting them together in alternating blocks, as in par-
allel editing in film. The title was obtained from the first word of the Péret
text and the last word of that of Desnos:

> L'enfant posa sa langue sur l'œuf si doucement que l'oiseau ne songea pas à
> s'envoler. *Le cloître au fond de la brume ouvrait à tout venant le guichet des express.*
> *Un merveilleux lutteur s'engagea à détruire les colonnes torses qui supportaient les*
> *murailles.* L'enfant était blond, avait la langue épaisse comme une table . . .
> L'enfant regarda les lunettes à travers le monde et sourit à la jeune femme nue
> qui touchait son petit doigt rose. *Quant au cheval favori des héros de la grande*
> *guerre il vomit son jockey aux pieds de la femme inconnue.* Elle était russe et aimait
> la neige comme le faux-col aime le cou. *Elle n'ôta son masque qu'à la minute qui*
> *précéda l'explosion.* Elle ouvrit son corsage et prit un de ses seins qui était creux
> et contenait un minuscule nécessaire de toilette. *Ses yeux, deux volcans, sup-*
> *primèrent la transition des astres. L'empreinte de ses pieds resta dans la muraille à*
> *hauteur d'épaule.* Après la toilette des vents, elle découvrit sa hanche blanche sur
> laquelle était tatouée une tête de nègre dont l'œil gauche manquait. *Le ridicule*
> *peut bien vous tuer, vous autres, pourvu que le joli railway qui ceinture mon espoir ne*
> *croule pas dans l'effroi des paysans ensanglantés.* Le tout était entouré de cette
> inscription: Dieu et le Roi. *La T.S.F. est susceptible de tentatives modestes mais dan-*
> *gereuses pour la collectivité.* Elle coupe la main d'un singe aux fesses bleues qui
> lui rit au nez en découpant un manche de balai en fines rondelles qu'il destinait
> à un mystérieux usage: éteindre les cierges de l'église voisine. *Ne vous fiez pas*
> *au miracle du buffet et de la sainte richesse des fleuves, enfoncez vos talons dans les*
> *marées des soirs au chloroforme de planète . . .* [27]

Péret's text (10 sentences) is a fabulous tale based on the familiar surrealist
topos of encounter, seduction and violence. The child places his tongue on
an egg and smiles at a naked woman who touches him ('son petit doigt rose'),
unbuttons her blouse and uncovers her thigh. The woman then cuts off the
hand of a monkey, who in turn cuts up a broom-handle into rings. Desnos'
text (17 sentences) relates a series of unconnected events, involving a marvel-
lous wrestler, monks with magnetized looks, and un unknown woman with
eyes like volcanoes. The montage gives rise to chance encounters and partial
semantic links between the two texts. The female protagonists lend a certain

coherence to the montage: 'la jeune femme nue' (Péret) is echoed in the next sentence in 'la femme inconnue' (Desnos); 'des crânes de singe' (Desnos) resurfaces later in 'le singe aux fesses bleues' (Péret). Violence and mutilation are recurrent themes, in 'une tête de nègre dont l'œil gauche manquait', '[e]lle coupa la main d'un singe' who in turn 'découpe un manche de balai en fines rondelles', 'paysans ensanglantés'. The recurrence of body-parts – the child's tongue and finger, the severed hand, the hollow breast, a tattooed thigh and a missing eye – might suggest a tale of castration. These topoi – seduction and violence, sexuality and mutilation – are characteristic of automatic writing, which justifies Marie-Claire Dumas' observation: 'on est bien plus frappé par les accords entre les deux textes que par leurs dissonances: ces écritures automatiques sont faites pour s'entendre'.[28]

However, such points of convergence between the two texts do not silence the specificity of each of the two voices heard. The narrative thread of Péret's fairytale world is continuously broken by semantic anomalies within his own text, as well as by the more apocalyptic tones of Desnos' lines. The 'two-headed monster' to which Dumas refers gives only an illusion of unity, for the two voices remain in opposition, like the 'bribes de plusieurs discours' which Breton refers to as the discourse of the unconscious. The two poets have simulated through collage the production of the unconscious as the site of several voices, which sometimes echo and mingle with each other, but more often remain in opposition: 'peut-être toutes les convergences des textes, toutes les intertextualités sont-elles des manifestations de l'univers en nous', writes Robert Sctrick.[29]

A counter-example to the dialogic voices of collage – whether conflictual or integrative – is visible in Breton's text *Nadja*, where the voice of the other, far from being absorbed by the narrator's voice, is kept at a distance and carefully framed by the authorial voice. *Nadja* constitutes a montage of disparate discourses – diary, dream account, polemic, photographs, Nadja's statements and illustrations of her drawings. Breton explicitly states his intention from the outset: 'Je n'ai dessein de relater, en marge du récit que je vais entreprendre, que les épisodes les plus marquants de ma vie *telle que je peux la concevoir en dehors de son plan organique*' (*OCI*, 651). The alleged immediacy of the facts and events explains the montage effect in the first part of *Nadja*, where he records random events, strange coincidences, chance encounters and sudden illuminations, in a series of incomplete diary-like entries which signal the open-ended character of his experiences. Yet, when Nadja appears in his life (*OCI*, 683), the diary entries present a continuous narrative with few breaks in the text, a narrative in which the narrator adopts a pseudo-scientific discourse. In the 1963 preface Breton writes: 'le ton adopté pour le récit se calque sur celui de l'observation médicale, entre toutes neuropsychiatrique, qui tend à garder trace de tout ce qu'examen et interrogatoire peuvent livrer'

(*OCI*, 645). Nadja's words and actions are pasted into this highly structured narrative, carefully framed and contained by the authorial voice. While collage is characterized by a levelling process, where voices intermingle or simply collide on a horizontal plane, the inverted commas of quotation frame the words as a discrete statement, placing them in relief in a hierarchized discourse where authorial responsibility is retained.[30] In fact, quotation may be seen as a form of anti-collage, as Béhar has recognized: 'la citation fonctionne à l'inverse du collage. Elle se signale par des marques graphiques (ou verbales), elle est prise à témoin, appel à la barre; dès lors, elle ne s'intègre pas au contexte. Par la citation, l'auteur se démarque d'une manière ou d'une autre, tandis que le collage est confusion.'[31] The inverted commas insulate the quotations from the host text, which does not absorb and transform them, so that the authority of the narrator is not threatened by the free play of the voice of the other as it is in collage. Hence the deliberately documentary tone exploited, which registers Nadja's utterances, drawings and extracts from her letters, listing them as if they were a simple anthology of surrealist images:

> Je ne veux plus me souvenir . . . que de quelques phrases . . . phrases qui sont celles où je retrouve le mieux le ton de sa voix et dont la résonance en moi demeure si grande:
> 'Avec la fin de mon souffle, qui est le commencement du vôtre.'
> 'Si vous vouliez, pour vous je ne serais rien, ou qu'une trace.'
> 'La griffe du lion étreint le sein de la vigne.'
> 'Le rose est mieux que le noir, mais les deux s'accordent.' (*OCI*, 719)[32]

While Breton is fascinated by her words as poetic utterances, he keeps the voice of subjectivity at arm's length. In the words of Susan Rubin Suleiman: 'the usually fragmented text does not allow itself, here, to be "contaminated" by the madness it reports; it is fascinated but keeps its distance'.[33] In addition, the movements accompanying Nadja's words are recorded in brackets, as if the narrator were observing them from a distance, or on a stage: 'Un point, c'est tout. J'ai senti tout à coup que j'allais te faire de la peine. (Se retournant vers moi:) C'est fini' (*OCI*, 698). Nadja's behaviour holds the same attraction for Breton as Solange in the play *Les Détraquées*, which Breton relates in detail in the first part of *Nadja*. The polemical outburst against psychiatrists and psychiatric institutions towards the end of his text effectively silences Nadja. Indeed, her words have always been in-significant for the narrator, who has heard them as signals of poetry rather than the discourse of a subject expressing her alienation. The allegedly objective stand of the narrating 'I' allows him to control, contain and objectify the statements of the Other, thereby dis-

tancing himself from their otherness. Indeed, the use of quotations in Breton's *Nadja* can thus be considered as a form of anti-collage, a counter-example to the appropriation of texts analysed above.

Convulsive identities: surrealist (self-)portraits

'A en croire la description de sa personne contenue dans sa carte d'identité, Max Ernst n'aurait que quarante-cinq ans au moment où il écrit ces lignes. Il aurait le visage oval, les yeux bleus et des cheveux grisonnants' (*E*, 267). In this description of his physical appearance, which opens the text 'Identité instan-tanée', Max Ernst refers to himself in the third person. The self is presented as double, not only in an implicit reference to the mirror-image reflecting the subject as both observer and observed, but also, as the text proceeds to explain, in the apparently contradictory traits of Ernst's character. Ladies find Ernst's pleasant manners and gentle expression ('du charme, beaucoup de "réalité" et de séduction, un physique parfait et des manières agréables') difficult to reconcile with violent thoughts and a stubborn character ('un car-actère difficile, inextricable, indéfrisable'). They conclude:

> ('[I]l est un nid de contradictions, disent-elles), *transparent à la fois et plein d'énigmes*, comme les pampas à peu près . . . Ce qui leur est particulièrement désagréable, insupportable, c'est qu'elles ne réussissent que mal à retrouver son IDENTITE dans les contradictions flagrantes (apparentes), qui existent entre son comportement spontané et celui qui est dicté par la pensée con-sciente.

An example of this apparent contradiction is to be found in Ernst's attitude to 'nature'. 'Il est à la fois un cérébral et un végétal', identifying, on the one hand, with 'le dieu Pan et l'homme Papou' in a fusion with nature, and, on the other hand, with Prometheus, 'voleur de feu' and sworn enemy of nature. Ernst thus constructs his identity as the site of an unresolved tension, which he compares explicitly to the collage principle: 'à la manière de ce qui se passe quand on met en présence l'une de l'autre deux réalités très distantes sur un plan qui ne leur convient pas'. And he ends his text with the programmatic: 'Je conclus, en transposant la pensée d'André Breton, que L'IDENTITE SERA CONVULSIVE OU NE SERA PAS'. Not only is Ernst openly transposing Breton's closing words in *Nadja*: 'La beauté sera CON-VULSIVE ou ne sera pas' (*OCI*, 753); there is also a second, unacknowledged appropriation of Breton, who had ended his article on Max Ernst's first Paris exhibition written in 1921 with the words: 'Qui sait si, de la sorte, nous ne

nous préparons pas quelque jour à échapper au principe d'identité?' (*OCI*, 246).

Max Ernst's invitation to his 1935 Paris exhibition, *Exposition Max Ernst*, is a montage based on a formal photograph of the artist taken by Man Ray (figure 17). The glass-plate negative of Man Ray's photograph has been smashed and the glass splinters stuck together with tape, which has been written on with india ink and the result exposed, so that the light-coloured tape has come out black and the writing white.[34] As a result, the face of the artist appears as if in a broken mirror, and a text, giving the details of the exhibition and titles of some of the works exhibited, fills the cracks. Like the verbal self-portrait presented in 'Identité instantanée', this portrait presents a parodic allusion to the mirror stage when the child preceives him- or herself as a unified whole. The adhesive simulates cohesive unity. Ernst is visibly parodying the traditional function of photography as a mimetic recording of reality, by shattering representation and forming a new reality with its splintered pieces; and by focusing on the medium itself, he is challenging the claim that photography is an *instantané* or index of presence. In short, by exploding the claim of photographic mimeticism, fragmenting the face and displacing the visual by the verbal, Ernst foregrounds the (self-)portrait as an artefact, presenting identity as a construct – split, fragmented, held together by writing – bringing together irreconcilable fragments in the manner of collage.

Other surrealists also explore, through their texts and pictorial works, the destabilization and splitting of identity, portrayed as a site of contradiction, fragmentation and decentring. Although the discussion in the following pages focuses essentially on surrealist photomontage portraits and self-portraits, with special reference to Ernst and Breton, other visual and verbal modes of production – where the principle of deliberate assemblage is visibly inscribed – are discussed.

The dadaists had already parodied the genre of the portrait. Picabia stuck a toy monkey onto cardboard, and inscribed around it *Portrait de Cézanne, Portrait de Rembrandt, Portrait de Renoir, natures mortes* (1920); Soupault's *Portrait d'un imbécile*, exhibited at the Salon Dada in 1921, is an eighteenth-century mirror, while Aragon's contribution to the same Salon was a *Portrait de Jacques Vaché*, made up of cut-out papers and dried leaves. In *Bloomfield-Dada-Chaplinist* (1921), Blumfield pastes a photograph of his head onto the postcard of a naked female body, in a parodic use of the popular fairground photograph. The term *photomontage* itself was allegedly invented by the Berlin dadaists, several of whom claimed paternity for the term. For Raoul Hausmann: 'This term translated our aversion at playing the artist, and, thinking of ourselves as engineers . . . we meant to construct, to assemble [*montieren*] our works.'[35] Many of these works are, in fact, photocollages,

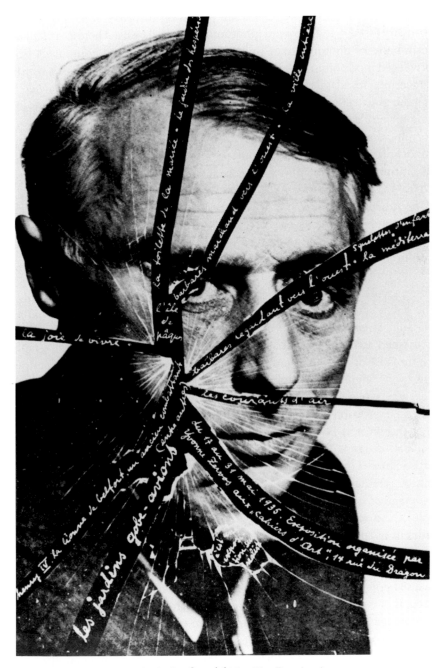

Figure 17 Max Ernst, invitation for exhibition *Max Ernst* (1935)

since the photographic fragments are pasted on the page or canvas rather than processed,[36] and the word 'photomontage' will be used here as a blanket term both for photomontage proper and photocollage. Photomontage is a privileged mode of portrayal of surrealist identity, since, to use Ernst's words concerning his identity, the medium is *'transparent à la fois et plein d'énigmes'*. It is a *transparent* medium, because of the apparent immediacy of the photographic mode; but it is also an *enigmatic* medium, since montage, by transforming reality, appears as a visibly coded discourse. The surrealists use the model of the formal studio or identity photograph in order to undo its role as a means of fixing identitites by reproducing an external likeness. 'The principle of montage', writes Adorno, 'was supposed to shock people into realizing just how dubious any organic unity was.'[37] Hence, by manipulating photographic fragments, the surrealists question the principle of the unitary self – *instantaneous identity* – and expose identity as a construct, staging conflicts, displacements and decentring.

Identity staged as a dramatic conflict is present in a large number of Max Ernst's works, notably as the reworking – or rather the conscious replay – of the œdipal situation. In an early self-portrait, titled *The Punching Ball ou l'immortalité de buonarotti* (1920), for example, a formal photograph of Ernst is combined with a second, smaller figure composed of the cut-out photograph of the bust of a woman onto which is pasted a head from an anatomical engraving (figure 18). The photograph is inscribed with Ernst's dadaist name *dadamax*, while the *écorché* of the engraving is identified as *caesar buonarotti*. The title, probably a *fatagaga* title or inscription given to it by Arp, indicates that this work is both a political parody and a re-enactment of the classic œdipal scenario. The reduced father-figure is both law-giver (Caesar) and artistic model (Michelangelo). The figure has been flayed (disfigured), feminized (given a female bust), cut up (castrated), ridiculed (in the grotesque montage of anatomical head and female bust), reduced to the subordinate role of the donor in a parody of early religious paintings, and objectified as an item of sports equipment. A political reading foregrounds the caricature of Kaiser Wilhelm, whose discredited rule was the object of many parodies in postwar Germany. (In 1920 John Heartfield enacted a similar dramatization in a self-portrait in which he represents himself with a pair of scissors, in the process of cutting up the effigy of the Berlin Chief of Police.) In Ernst's photomontage, in opposition to the photographic mimeticism, and hence enhanced ontological reality of the son, who occupies the focal point of the composition, the father is displayed on the periphery, as an ungainly artefact, a two-dimensional puppet similar to a fairground effigy – its lower edge overlaps the bottom of the frame – propped up and prevented from toppling over the edge by the son. It is less a human figure than an object, a *cadavre* rather than a *cadavre exquis*. In a parody of the academic self-portrait, the palette and

Figure 18 Max Ernst, *The Punching Ball or l'immortalité be buonarotti* (1920)

brush of the ideal or real father (Ernst's own father was an amateur painter) are replaced by the collage materials of the son's artistic activity. Ironically, these were learned from Ernst père himself, for Max's first lesson in collage is said to have been watching his father paste the head of family members and friends on bodies of saints and angels in copies of old masters – or heads of Nietzsche, Calvin and Luther on the shoulders of the damned![38]

The visibility of the collage process in *The Punching Ball* is further under-scored by the use of various media: photograph, engraving and text. We have already seen that the figures are identified by fictitious names. In addition, to the right of the two figures a measuring line has been drawn, regularly notched and inscribed with the number 5000, held by a disembodied hand. These inscriptions break the mimetic continuum of the photograph by point-ing to the image as an artefact, thus further destabilizing the role of the photograph as an index of reality. The immediacy of standard photography, based on its seamlessness (the photograph of Ernst), is coupled with the mediated discourse of photomontage, predicated on the overt juxtaposition of parts, involving fragmentation, hence the presence of seams or *spacing*, which articulate the sign.[39] 'Pour qu'il y ait signe', writes Barthes in *La Chambre claire*, 'il faut qu'il y ait marque; privées d'un principe de marquage, les photos sont des signes qui ne prennent pas bien.'[40] In photomontage the mark is foregrounded, thus articulating a double system of representation, where the immediacy of the photographic element is coupled with the mediacy of the sign – 'transparent à la fois et plein d'énigmes'.

The ambivalence of surrealist portraits, as both presence and sign, can be seen in Max Ernst's first collective portrait of the Paris group in 1922, *Au rendez-vous des amis*. Although an oil-painting, it is based on the collage prin-ciple, visibly assembled from separate fragments which are not perfectly adjusted: there are discrepancies in scale and lighting, and the stiffness of the poses reminds us of the many fairground photographs of the surrealist group taken around that time. Ernst used individual photographs as a model for each of these portraits; for example the portrait of Desnos is based on a fair-booth photograph of the early surrealist group, posing self-consciously in a cut-out car at a fairground in Montmartre. As in *The Punching Ball*, the viewer is made aware that she is looking at an artefact: numbers identify the members of the group as in scientific diagrams. Into this painting, Ernst inte-grated images based on engravings from the popular science journal *La Nature*: the circular forms in the background above the figures, for example, are derived from an engraving of the haloes observed around the sun, turned on its side; the still-life arrangement in the lower left is based on another engraving from *La Nature*, a 'Bird's eye view of an underground fortress', and the knife and apple are taken from an illustration of a trick cutting of an apple, itself an allusion to the collage process.[41] Although each of the

members is realistically depicted and immediately recognizable, their gestures – modelled on the gestures of sign language (Ernst's father was a teacher of deaf-mutes), but also on the jerky movements and stiff poses of the insane (the visual model here being Kraepelin's group photographs of catatonic patients[42]) – defy interpretation. Thus, by processes of reification – language reified as gestures emptied of their significance in this painting, or the figure of the father fossilized as a fairground dummy in *The Punching Ball* – the work challenges the doxa, the authority of the father or of coded language. At the same time it points to a new language in the enigmatic gestures and still uncoded signs of the future surrealist group.

The dual status of the portrait as presence and sign is also explicitly staged in Max Ernst's second portrait of the surrealist group, *Au rendez-vous des amis or Loplop introduces Members of the Surrealist Group* (figure 19). It forms part of a series of some 70 collages produced in 1931–2 where the composite figure Loplop, as Max Ernst's *alter ego*, displays images on an easel or canvas. Loplop had made its first appearance in *La Femme 100 têtes* (1929), and Ernst identifies him as a 'fantôme particulier d'une fidélité modèle, attaché à ma personne' (*E*, 247). Ernst refers to the series as *papiers collés* rather than collages: the pasting process is visible and the components are made up of different media, in contrast with the collages produced at the end of the 1920s – notably *La Femme 100 têtes* – designed for reproduction, which were based on wood-engravings and where Ernst carefully masked the seams. In *Au rendez-vous des amis 1931*, Loplop appears as a variant of the *cadavre exquis*: the collaged head of Loplop is visible in profile above the frame, while the photographic and engraved elements constituting the 'body' are made up of the portraits of the surrealist group, and two schematic 'feet' appear below the frame. Ernst added a caption to the work identifying the individuals portrayed:

DESCRIPTION DE L'IMAGE CI-CONTRE

De haut en bas, en suivant le serpent des têtes: sifflant dans ses doigts, Yves Tanguy – sur la main, en casquette, Aragon – au pli du coude, Giacometti – devant un portrait de femme, Max Ernst – debout devant lui, Dali – à sa droite, Tzara et Péret – devant l'homme enchaîné et les mains dans les poches, Buñuel – allumant sa cigarette, Eluard – au-dessus de lui, Thirion et à sa gauche, la main levée, Char – derrière la main qui se ferme sur Unik, Alexandre – plus bas, Man Ray – puis, immergé jusqu'aux épaules, Breton. On remarque au mur le portrait de Crevel et tout en haut à droite, tournant le dos, Georges Sadoul.

In his 'Description' Max Ernst directs the viewer's gaze in a serpentine line from top to bottom, a visual structuring device repeated as a *mise en abyme* in

Figure 19 Max Ernst, *Au rendez-vous des amis or Loplop introduces Members of the Surrealist Group* (1931)

the cut-out image of the snake to the left of Eluard. Herta Wescher interprets this work as an apocalyptic scene: 'Tanguy, Aragon and Alberto Giacometti are being carried down from heaven by bodiless hands and arms, while the heads of Breton and Man Ray slither up amidst worms and serpents out of the water of a gloomy cave.'[43] For Werner Spies, the snake is both a structuring device and the totemic figure of the surrealist group; he associates this work with the motif of the Last Judgement, identifying the surrealists with fallen angels.[44] Such readings indicate that this work is not only a historical record of the contributors to the fourth issue of *Le Surréalisme au service de la révolution*, but, more importantly, a dramatic *tableau*. The artefactual character of the work is underscored in the *ostensio* motif: the hand which points and demonstrates (as in the illustrations in *La Nature*) is also the hand which cuts and pastes. Loplop the artist is visibly displaying, and his easel or frame functions as a performative, a sign addressed directly to the viewer. The play on different media – photographic print, contact print, negative, engraving – serves to undermine the role of the image as simply representational, and the simple, indeed simplistic, labelling offered by Ernst clearly does not adequately account for the various components of the montage. We recognize Gala behind Ernst – is it significant that none of the female figures are identified by Ernst in his description? – but who is the female figure behind Breton, or the woman behind Char who is reproduced in a negative print? Who is the tall man in chains and a helmet towering over Buñuel? Ernst is also silent about the other photographed or engraved scenes and objects juxtaposed with the portraits – reptiles, knives, an eyeball, a crowd scene, several hands, entomological plates. Several of these signs can be deciphered by reference to the surrealist context. For example, the figure of Buñuel is pasted over a display of knives, while a gigantic eye appears on the same level on the right of the photomontage, in a reference to the opening sequence of Dali and Buñuel's *Un chien andalou*. Georges Sadoul, an active communist like Aragon, is standing on the photograph of a crowd of workers, whose heads are echoed in the engraving to the left where rows of dolls' heads are lined up, taken from the illustration of a dolls' factory in *La Nature*.[45] The analogy between disembodied heads in the image of the massed workers and the image of mass-production techniques can be read as a satirical comment on workers' alienation. Yet many of the signs appear to invite a decoding while resisting interpretation: why the entomological plates, the schematic engravings of reptiles? Why all these hands, clenched, open or holding objects or heads? The hands in the upper left do direct our gaze towards the main part of the photomontage, but the hand above Tzara's head holding an insect-like form is enigmatic, as is the hand at the end of a reptile body holding a long stick-like object, and the hand hovering over the crowd of workers.[46] Severed from the body, they hover between the status of object and sign, indeed they

appear to function as signals rather than signs, both promising yet with-holding meaning.[47] And this very resistance to meaning serves to emphasize their strong presence as objects, a quality which Breton discusses in his intro-duction to Ernst's *La Femme 100 têtes*: 'il est bien entendu qu'on peut aller jusqu'à dépayser une main en l'isolant d'un bras, que cette main y gagne en tant que main' (*OCII*, 305).[48] The viewer is faced with the existence of photo-graphs as an index of reality, a reading suggested by Max Ernst's caption iden-tifying the various members of the surrealist group, and as potential signs, which function as destabilizing factors, not only by challenging the mimetic function of photography, but also by drawing the viewer's attention to details in a decentring process. Identity is not a simple labelling, it is a questioning, a riddle or rebus, where subject becomes object, and the photographic por-trait, using photomontage techniques, framed by the easel, and fore-grounded by the 'Loplop présente' motif, hovers between presence and sign.

The role of the photographic portrait as a nomadic sign, whose mean-ings are determined by its various contexts, can be seen in the recycling, and often satirical *détournement*, of such images. For example, the photograph of Breton in the photomontage of the surrealist group assembled around Magritte's painting of a naked female figure, inscribed with the words *Je ne vois pas la [femme] cachée dans la forêt* (published in 1929 in the last number of *La Révolution surréaliste*), was used in the 1930 pamphlet *Un cadavre* (itself an appropriation of the surrealists' 1924 *cadavre* on Anatole France) signed by Georges Ribemont-Dessaignes and Georges Bataille among others. A crown of thorns and drops of blood have been added to the original photograph, producing a satirical comment targetting the leader of surrealism. In Valentine Hugo's group portrait of the surrealists, *Surréalisme* (1934), the head of Breton – the same head that seems to emerge from the waters of the unconscious in Ernst's *Au rendez-vous des amis* (1931) – is repeated three times, once enlarged in the centre, surrounded by the portraits of the surrealists, with two smaller versions, floating on cut-out paper shapes on a dark ground. Hugo appears to elevate Breton's image among the saints, surrounding it with halo-like paper cut-outs as in popular iconography, indicating here a laudatory intention, in contrast to the 1930 *cadavre*.

This photograph of Breton had first appeared in *Nadja*, which as was suggested at the outset of this chapter, charts the exploration of a nomadic identity. A few pages before the end of *Nadja*, Breton includes a studio por-trait of himself (*OCI*, 745). Yet, far from fulfilling the traditional function of the photographic portrait as an index of reality and a key to identity, and thus providing an answer to the opening question 'qui suis-je?', this photograph is as enigmatic as the earlier shots of empty Paris streets and squares, or Nadja's drawings. Just as the photographs of Paris do not uncover the hidden topog-raphy of the city, so the formal photograph of Breton, masklike, appears to

deny access to his identity. Subjectivity is encoded in the signs of the city, whether in shop signs such as *Bois et charbons* or the pointing hand, constantly displacing and destabilizing the writer's identity, reformulating it through encounters between subjectivity and external events. The photographic portrait, read in the context of *Nadja* as a montage text, hovers in an indeterminate space, between iconic likeness and enigmatic sign, recalling an early self-portrait by Chirico (1911) painted in the traditional style of the Renaissance nobleman portrayed in profile, and inscribed on the frame with the words (in latin): 'What shall I love if not the enigma?'

The opening question, reformulated as 'qui je "hante"', displaces the focus from a fixed identity to fluctuating signs, from metaphorical identification to metonymical displacement. This kind of decentring of identity is sometimes evoked through the metonymical series or list, such as that presented by the Loplop collages. In his *Design for an Exhibition Poster* (1921), which can be considered formally as a proto-Loplop montage, Ernst has combined a photograph of himself with 'samples' of some of his works, to create a masklike shape. He includes a text (in German) which reads: 'Exhibition of Painting. Drawing. Fatagaga. Plastoplastik. Watercolour. Max Ernst is a liar, legacy-hunter, scandalmonger, horsedealer, slanderer, and boxer.' An equally arbitrary listing of attributes is included in Marcel Mariën's 'Autoportrait', where a photograph of Mariën is combined with the photograph of a parrot and a *curriculum vitae* consisting of a long list of attributes:

> Distingué – pouilleux – jeune – sinistre – habillé – estropié – prolétaire – gai – débraillé – solitaire – moustachu – brutal – heureux – sale – lent – paresseux – conférencier – stupide – photographe – fanatique – fœtus . . . asthmatique – 'Jules' – impie – terne – paroissien – cinéaste – libidineux – pubère – infidèle – cadavre – préoccupé – oisif – vandale – sceptique – pantouflard – fumeur – croyant – marxiste – ovule fécondé.[49]

This is clearly a parody of a police identikit portrait, evoking identity through an open-ended inventory which articulates contradictory qualities, arbitrary fragments listed in a constantly decentring process. Another playful example of the portrait as an open-ended amalgamation of features is seen in the portrait game played by the Birmingham surrealist group – Conroy Maddox, John and Robert Melville. The following 'portrait' of Maddox is an example of this collective text:

> I hope Conroy goes home too
> They say he's made of ectoplasm
> He's nice really
> He's a surrealist incarnate

Surrealist, my arse!
That's why he has a moustache
But it's all mixed
With his cardboard wrist
His whimsical smile.[50]

These catalogues of autonomous details are similar to an ever-proliferating *cadavre exquis*, or to the part-bodies which people surrealism. Far from forming a unitary identity or a complete portrait, they are autonomous fragments, a collation of units rather than a finished configuration.

Breton's photomontage *L'Ecriture automatique* (*c.* 1938) also incorporates a list (figure 20). Below the image Breton has added a handwritten text where he enumerates his imaginary ancestors and imagined alter egos:

Jugement de l'auteur par lui-même. Héraclite mourant, Pierre de lune, Sade, le cyclone à tête de grain de millet, le tamanoir; son plus grand désir eût été d'appartenir à la grande famille des indésirables.

This photomontage can also be read as a cross between portrait and theatrical tableau. Similar in construction to the stylized tableaux of nineteenth-century melodrama, where the protagonists are portrayed striking exaggerated poses, theatricality is encoded in the highly artificial poses (Breton in the guise of a scientist alongside his microscope) and expressions (the fixed smile of the woman). In melodrama, these momentarily frozen scenes are intended to give a clear visual summary of the narrative situation, the objective being to make signs transparent and hence immediately legible.[51] In this photomontage however, there are no obvious links between the figure of Breton, the female figure behind bars and the microscope on the table. Krauss reads this work in the manner of a rebus, both as a *mise-en-scène* of the automatic process where the microscope as a lensed instrument is used as a metaphor for automatic writing, characterized by Breton as 'la photographie de l'esprit' (*OCI*, 245), and as a *mise en abyme* of writing, where photographic fragments become signs, transforming reality into representation.[52] Yet I would contend that we are also dealing with objects which resist this reading: Breton's head, disproportionately large in relation to his body, is the head of the scientist-poet actor of a dramatic tableau; but it is also a 'dumb' index of reality, both presence and sign. Like John Berger, I would argue that 'the peculiar advantage of photomontage lies in the fact that everything which has been cut out keeps its familiar photographic appearance. We are still looking first at *things* and only afterwards at symbols.'[53]

A related staging of the self is explored in Man Ray's *Self-portrait*, which is reproduced as the frontispiece to *Minotaure*, 3–4 (1933), a rare example of the

Figure 20 André Breton, *L'Ecriture automatique* (c. 1938)

use of photomontage by Man Ray. It consists of a plaster bust, surrounded by several of the artist's works: a hand holding a lightbulb, a round prismatic form from which a hand emerges, the photograph of a woman's eyes with artificial tears, entitled *Tears*, and a child's bilboquet. The self, displayed/ displaced as a plaster bust, is presented on a plinth among other objects,

arranged like stage props. The formal echoes – the round head repeated in the ball, lightbulb, tears, bilboquet and eyes – detract from the role of the head as a posing subject and underscore it as an object among others. The eye of the viewer is distracted from the bust, although it is placed at the centre of the composition, onto the objects arranged around it. The bust as self-portrait appears displaced in these objects or in the artist's works, as in the Loplop series. And whereas *L'Ecriture automatique* enacts the passage from portrait to theatrical tableau, Man Ray's *Self-portrait* is situated between portrait and still-life: the portrait becomes a table or stage, where the head, objectified or petrified as a plaster bust, merges with the objects, and, through this levelling process, relinquishes its status as the compositional focus.

Enter the self as other, located between the stage and the table-top, mediated through the enigmatic objects of a still-life. In de Chirico's *Self-portrait* (1913) – allegedly the first portrait in western art not to be a representation of the sitter – disparate elements are arranged on a stage-like construction suspended in space: two plaster feet, an egg, a roll of paper, a proscenium wall on which the sign X is inscribed, signalling the absent body, the invisible corpse. Similarly, Ernst's collage with watercolour *Portrait de Paul Eluard* (1922), reproduced as the frontispiece to *Les Malheurs des immortels*, a collaborative work by Ernst and Eluard, is made up of the engraving of a barrel and insulators, cut out of a nineteenth-century scientific journal. The so-called portrait is pure artifice, exploiting the Arcimboldo principle to excess in a totally arbitrary construct. In the surrealist quest for a multiple identity or the 'moi soluble', the individual often merges with the anonymous, where the self as the site of a distinct identity is displaced or dissolved in the totally other.

In their exploration of identity, the surrealists experience the double limits of the self, as the multiple other dissolved in anonymity and as the reified self in the mask. Such an anonymity is enacted in the ambiguities of Max Ernst's *Loplop présente le Facteur Cheval*. An anthropomorphic shape is suggested in the head, the bow-tie, the blue rectangular torso, and the feet. The schematic form is both a figure and an amalgam of diverse media and objects – grattage, cut-out engraving (the coral shape), line-drawing, photograph, postcards – while the postman Cheval is present only by metonymy in the envelope held by the Loplop figure. The peep-show motif is humorously encoded in the postcard of semi-naked women partly visible through the torn see-through envelope, and in the young girl looking through the peephole of the torso, none of which appears to refer to the postman Cheval at all.

By foregrounding the manipulation of images, such photomontage portraits overtly acknowledge and exploit the portrait genre as a fictional construct. Far from being the central posing subject, the self is constantly displaced in strategies of decentring, doubling or erasing. The surrealist por-

trait thus often becomes the site of an uncanny identification of the self with the other. In such deliberately artificial *mises-en-scène*, the photographed face itself becomes a mask, as in the photograph of Breton in *Nadja*, or in Duchamp's transvestite pose as *Rrose Selavy*. In Man Ray's *Portrait of André Breton* (1930), Breton poses in aviator's goggles, his face framed by a white paper rectangle, which gives it a masklike quality – as does a later photomontage of Breton by Duchamp, where the face is pasted onto the Statue of Liberty, in yet another parodic use of the popular fairground photograph.[54] In 'Le masque', Bataille discusses the harmony of 'the open face': 'Ce qui est communiqué dans l'accord des visages *ouverts* est la stabilité rassurante de l'ordre instauré à la surface claire du sol des hommes.' The open face contrasts with the mask, which conveys the absence of certainty and the threat of sudden changes.[55] In these photomontages the familiar face, projected into an alien context, is destabilized as a recognizable entity, thus endangering the order of a stable identity. Consequently, from the haunting self seeking a point of convergence, that of objective chance, between the signs of the city and personal desire, the focus is displaced in the constant decentring or mediation of identity, via the shattered surfaces of photomontage, the shifting representations of Loplop, the synecdoches of the identikit portrait, the mythical identification with Pan, Papuan man or Prometheus, or via the arbitrary combinations of the mask.

'Un masque peut en masquer (ou démasquer) un autre'

'Le peintre vous permet d'ignorer ce que c'est qu'un visage', writes Max Ernst (*E*, 367). Any representation of the face is an emergent sign, the emergence of another face, of the face as other or as mask. Indeed, the face cannot be named except by something other than itself, just as identity can only be articulated through processes of displacement. Hence, as we have seen throughout this chapter, the search for 'qui je suis' is constantly reformulated as 'qui je "hante"'.

Breton's well-known fascination with Oceanic masks is related to the transcendence of the individual face: 'Nous pouvons . . . mesurer l'étendue des prestiges qui s'attachent à la transfiguration, aussi bien qu'à l'éclipse, de ce que représente d'individuel l'aspect du visage humain'.[56] The mask in surrealism is essentially an ambivalent object: as the other face which supplements the absent face, it is located between a fixed and a mobile form, a substitute for the head and an acephalic monster, between veiling and unveiling, a simulacrum revealing a profound identity. The distinctive features of the individual – which characterize traditional portraiture – are replaced by the arbitrary features of the surrealist portrait, like the 'portraits' of Magritte,

where an apple, orange or dove replaces the human head or face. The mask is often an exploded space whose centrifugal movement threatens the centripetal structure of the head, as in the *cadavre exquis*, which is only residually structured by anatomy. Hence in Miro's *Carnaval des harlequins* (1924), the signs for the head are centrifugal, participating in the carnivalesque space around them, as in Eskimo masks. Alterity is often suggested in the disappearance of boundaries between heads and the space around them, for example in the architectural structure of Matta's great cage-heads and scaffolding-bodies, crossed by space, as in Malangan masks.

The surrealists often juggle with heads, by processes of substitution or adjunction, either by obliterating them or replacing them by heterogeneous objects or the radically other. Hence Breton's 'un château à la place de la tête' (*OCI*, 16) is echoed later in Péret's text on Hopi dolls where the head is surmounted by a castle-like construction, imagined by Péret as a cosmic space to be explored:

> Je pense aux poupées des Indiens Hopi du Nouveau-Mexique, dont la tête parfois figure schématiquement un château médiéval. C'est dans ce château que je vais essayer de pénétrer. Il n'a pas de porte et ses murailles ont l'épaisseur de mille siècles . . . voici que par un phénomène d'osmose, je suis à l'intérieur, dégageant des lueurs d'aurore boréale.[57]

The surrealist head becomes an autonomous figure, liberated from the body: this explosion of the boundaries of the head articulates a desire among the surrealists to transcend the self towards a state of depersonalization, in a space where the frontiers between body and world would be abolished, a metamorphic space where the mask is the figure of alterity, exploding the limits of the body. Hence Breton comments on Ernst's collages: 'la tête humaine qui s'ouvre, vole et se ferme sur ses pensées comme un éventail . . . la tête fragile et sans poids . . . crénelée de bleu comme dans les poupées du Nouveau-Mexique' (*SP*, 27). The physical space of the head is transcended in a dynamic space of fantasy. The surrealists have made of the head less the space structured in depth, as described by Freud, than an exploded space, where randomness of entry is matched by freedom of egress. 'Nous sommes les vaporisateurs de la pensée', writes Aragon. 'Nos jolies têtes de caoutchouc serties de petits filets rouges s'aplatissent et se gonflent suivant les alternances des marées d'idées.'[58] They thus dislodge the seat of reason, transforming rational space into a space of instincts which surface on the face of the mask. This, no doubt, explains why surrealist writers and artists often elect hybrid creatures as their *alter ego*: if Loplop Bird Superior has been seen by some critics as the artist's miniature superego,[59] cataloguing and framing his samples, some bestial others mark the surfacing of the id – Breton's soluble

fish or Dali's soft grasshopper, Picasso's minotaur – as the outer limits of an *informe* identity. Through this staged hybridity, the self is displayed as a convulsive being. The mask expresses the search among the surrealists for the dispossession and dissolving of the self in a space where the limits of self and other are abolished, creating a form of *convulsive* identity. However, whereas the traditional mask is a structure for managing anguish, hence a means of mediation which allows the wearer or viewer to relive primal fears in order to overcome them, for the surrealists, on the contrary, the unconscious surfaces directly on the face of the mask. The absence of the face as a system of recognizable features, replaced by the mask as a *dérive* of free associations, testifies to the often violent irruption of the other within the framework of a familiar space, as was seen for example in Styrsky's collage *La Baignade* (discussed in chapter 4).

The ambivalence between (dis)simulation and exposure is staged in the subversion of the iconographic codes of the portrait, as in Magritte's painting *Le Viol*, where the features of the face are replaced by the features of the body of a woman, and where the controlled social appearance typifying the portrait is replaced by the exhibitionism of fantasy. A similar surfacing is at work in Max Ernst's collage *Rencontre de deux sourires*, from *Les Malheurs des immortels*, which exploits the iconographic code of the formal (wedding-)portrait or masked ball.[60] An eagle-headed man in formal dress stands behind a woman whose face has been replaced by a death's head moth, on a carpet made from the *Figaro* newspaper, in a humorous allusion to the *Marriage of Figaro*. The woman holds a duckfoot-fan, while a serpent-like form on the floor between the two figures parodies the iconographic motif of Adam and Eve. The ambivalence is based on the copresence of the strongly coded iconographic framework of the social portrait of the married couple and the masks of bestiality revealing the libidinal, producing a displacement of the primal scene through the iconographic codes of social ceremonies. In this disturbing, ambivalent space between the veiled and the unveiled, the bestial mask unmasks what is normally masked, and points to what is present but unsaid in a social ceremony which veils its libidinal intentions. Similarly, in *Une semaine de bonté*, masks are torn from their original contexts and placed at the heart of a bourgeois melodrama, as testified for example by the recurrent image of an Easter Island head in the chapter titled 'L'île de Pâques', worn by the male protagonist as a carnival mask (p. 170). It is an object of fascination for the man's voluptuous female companion, as is the phallic-serpent wrapped around his waist, which she has seized. The mask functions as an element of rupture of the order of social appearance, allowing libertinage and the doubling of the protagonist. In the last image of 'L'île de Pâques', the protagonist, crouched in a space of chaos, is wearing an African mask (figure 16). In this collage the mask, isolated from its original context, is an

aleatory substitution, a reified object among other fragments, a figure of death. 'Le masque est le chaos devenu chair', writes Bataille. 'Il est présent devant moi comme un semblable et ce semblable, qui me dévisage, a pris en lui la figure de ma propre mort.'[61] In the work of Max Ernst, these masks problematize the concept of the other, which suddenly emerges within a familiar context, whether the exogenous other in the mask of ethnological cultures, or the endogenous other in the mask as the expression of personal fantasms.

In conclusion, surrealist (self-)portraits are equivocal spaces, situated between the melodramatic stage where oedipal conflicts are selfconsciously enacted, the still-life table where the face becomes an object among others, and the mask where instincts surface and the ego is displaced by the id. In their portraits the surrealists often prefer to manipulate the socially coded face by strategies of disjunction and displacement, rather than create the irretrievably other. Max Ernst may well have identified with Pan and Papuan in a Dionysian participation with the other; yet it is significant that he also identifies with Prometheus who, through conscious strategies, appropriates the fire of the gods, in an act of defiance of the other. The convulsive identity that he constructs from these conflictual selves does not transcend the cracks in the mirror; oppositions are not resolved in the dialectical flourish favoured by Breton. Surrealist identity is apprehended and articulated *as conflict*. It remains both contingent *and* opaque, *'transparent à la fois et plein d'énigmes'*. Finally, the mask explodes the limits of the body and explores the frontiers of identity. Staging the ambivalent movement of surrealism, of integration and disintegration, totalization and fragmentation, the mask, as the space of the equivocal and the figure of alterity, is the site of the emergence of the other within the same, of the surreal in the heart of the real. Identity is the stranger within, undoing the fairbooth photograph or the social face, like the hermit-crab discussed at the outset of this chapter. The latin word *persona* – both person and mask – is linked to the verb *personare*: *'Là est* persona *où Ça sonne à travers; et devient ainsi Moi'*, writes Jacques Bril.[62] Hence, no doubt, the question that Breton asks at the end of the second part of *Nadja*, in an obsessive reformulation of his opening question: 'Qui vive? Je ne vous entends pas. Qui vive? Est-ce moi seul? Est-ce moi-même?' (*OCI*, 743).

The future of statues?

Le devoir des yeux est de voir, des oreilles d'ouïr . . . qui voudra se servir de ses membres à tout autre usage qu'ils ne sont destinés, celui-là pervertira l'ordre et l'ordonnance de la nature et enfreindra les lois.

Jean Polman[1]

Statues in ditches

'*Mon corps je t'appelle du nom que les bouches ont perdu depuis la création du monde / Mon corps mon corps c'est une danse rouge c'est un mausolée un tir aux pigeons un geyser*', writes Aragon in *Le Mouvement perpétuel*.[2] Windmill thighs and algae sex; porcupine quill ankles next to matchstick feet; heads replaced by a castle or a butterfly, a fan or a dove; stoat-breasts, eye-breasts, waterfall-breasts: surrealist representations of the body, whether male, female or androgynous, are overtly displayed as constructs. As a verbal or pictorial configuration, the image of the body is the result of processes of substitution and displacement and, as an assemblage of parts arbitrarily stuck together, of fragments proliferating freely, it constitutes an impossible totality. In this chapter the disparate limbs of the surrealist body are dissected in three stages: the first section, focusing on the surrealists' appropriation of classical statues, explores the disfiguring and dismemberment of canonical forms and the creation of a new body from the fragments; secondly, an erotics of the surrealist body is outlined, premised on the structure of the *cadavre exquis* and the principles of substitution, fragmentation and hyperbole, elaborating on the rhetorical analysis undertaken in chapter 4; this is followed by a discussion of body-parts and whole bodies.

'A son image Dieu a fait l'homme, l'homme a fait la statue et le mannequin', writes Breton in an early article on de Chirico (*OCI*, 251). Surrealism

is peopled not only by statues and mannequins, but by disarticulated dolls and automata, shadows, silhouettes, coffins or bilboquets. Among these displaced persons, artefacts or ready-mades, the recycling of art-historical icons is widespread. In *Le Bouquet tout fait* (1956), Magritte overlays the image of a bowler-hatted man viewed from the back with the figure of Flora from Botticelli's *Primavera*; the same figure is used in Robert Benayoun's collage *Le Printemps sous la cendre* (1977), where the head is replaced by a ship. Such art-historical citations include a large number of statues, in the guise of institutional bodies such as Bertoldi's Statue of Liberty, or (neo-)classical statues, such as the recurrent motif of the Venus de Milo as the paradigm of the ideal human form. Indeed, the surrealists' citational strategy anticipates the appropriation of familiar art images performed by postmodernist artists, as testifies for example the further recycling of the Venus de Milo by artists such as Mario Merz, Andy Warhol or Jim Dine.

The surrealists' use of statues in collage and related modes of production can be considered as both an iconoclastic and a creative activity. The practice derives from dadaist gestures of taking established icons – the *Mona Lisa*, a Rembrandt painting, the Venus de Milo – and cannibalizing, disfiguring or defacing them, in order to defy dominant aesthetic and social codes, such as the untouchability of the work of art, the originality of the artist, or more specifically the containment and closure of the classical body. In their appropriation of art-historical images, the surrealists cut figures out of their frames and wrench statues from their pedestals; they flatten, distort, crumple and dismember them, dispersing the fragments or juxtaposing them with disparate objects in incongruous situations. Yet the surrealists' treatment of statues cannot be reduced to a mere iconoclastic strategy: they dynamite statues in order to dynamize them. The clichéd icons of a moribund culture are recycled in the elaboration of a radically new vision, a mode of creating the surreal by transgressing the limits of existing codes of representation. Statues become the site of transformations or displacements, refashioned as fantasized bodies in the light of desire.

The static, contained aesthetic of classicism appears to be opposed to the modernity of the *cadavre exquis*, generally considered to be the paradigm of surrealist representations of the human body, and belonging to an aesthetic of fragmentation and dynamic interplay. While the classical body is naturalized as an organic whole, the modern body visibly displays its status as a construct, as was argued in an earlier chapter. A collage by Ernst, designed as an invitation-poster for the 1935 Paris exhibition *Man Ray, Peintures & objets*, stages the encounter between the classical and the modern body in a humorous confrontation between two anthropomorphic figures (figure 21). The larger figure in the left foreground, structured on the principle of the *cadavre exquis*, is composed of an assemblage of various items of

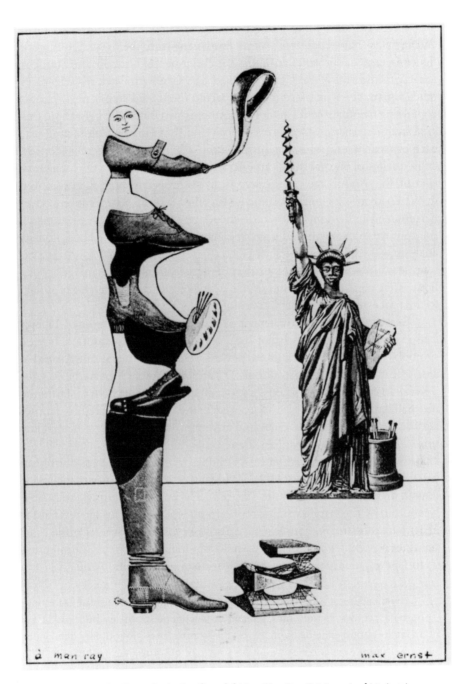

Figure 21 Max Ernst, invitation for exhibition *Man Ray, Peintures & objets* (1935)

footwear, a tiny moon-head, an inverted ladle suggesting a proboscis form, and a phallic-shaped painter's palette protruding from the figure. This hybrid figure faces a second smaller figure, set closer to the horizon, the Statue of Liberty transformed: the figure, overlaid by a face with black male features, holds a giant screw in place of the expected torch, and stands next to a pot containing paintbrushes. This collage presents two modes of figuration, classical and modern, not so much as oppositional, but rather as interacting with each other. The unified image of the Statue of Liberty has been eroded as a consequence of the substitutions effected in the image, while the interpretation of the assemblage on the left as an anthropomorphic figure is over-determined by its juxtaposition with the statue. The interaction is narrativized in the humorous erotic encounter suggested by the proximity of the concave shape of the ladle and the giant screw held erect. The following analysis will explore the surrealists' strategy of deconstruction of classical representations in their manipulation of statues, those reified images of the body. They construct from the rubble new icons of the human body similar to the processes of the *cadavre exquis*.

Ernst's transgressive treatment of statues such as the Statue of Liberty can be explained by the fact that statues are essentially institutional bodies, symbols of state, church or cultural powers, vehicles for the rigidified social or aesthetic myths of these institutions. Traditional reverence for statues is satirized in *Le Paysan de Paris*, where Aragon anticipates the day when 'statuomania' will have become so pervasive, 'qu'à peine l'on pourra circuler dans les rues de socles, à travers des champs d'attitudes . . . ce cimetière de l'imagination' (*PP*, 186). He then imagines these statues as the idols of a new religion, and envisions the transformation of public monuments across European cities, such as 'les phallophories de Trafalgar square où Nelson le manchot est témoin de l'hystérie d'un peuple' (*PP*, 188). The empty posturing and hollow symbolism of the familiar statues of Paris streets are also an incitement for imaginative transformations in a surrealist survey carried out in 1933, titled 'Sur certaines possibilités d'embellissement irrationnel d'une ville'.[3] Commenting on the survey, Eluard describes the reification of urban monuments:

> Leurs habitants, pour combattre l'agoraphobie, ont élevé partout des monuments et des statues sans se soucier aucunement de les mêler à la vie réelle, quotidienne de l'homme . . . Les statues, presque toujours d'individus dérisoires ou néfastes, sont sur des socles, ce qui leur enlève toute possibilité d'intervention dans les affaires humaines et réciproquement. Elles pourrissent sur pied.[4]

Participants of the survey are asked whether specific monuments or statues in Paris should be kept, moved, modified, transformed or eliminated. In their

replies the surrealists subject statues to the most imaginative of manipulations: the statue of the Lion of Belfort is skewered and roasted on bronze flames; Gambetta, painted in a realistic style, is turned into a winter alpine landscape at dusk; Camille Desmoulins, transported into the Métro, is fitted out with a ticket-punching device; and Joan of Arc is auctioned. In the survey the surrealists, asked to 'intervene' on the petrified urban stage, subvert the traditional functions of the statues and, by their action, counteract the 'pourriture' of statues as objects of vanished cults. The symbolic enactment of the destruction of a repressive tradition recalls the iconoclastic actions of the French Revolution; for example, in Jean-Louis David's Festival of Unity and Indivisibility, the statue of Louis XV was destroyed, to be replaced by a statue of Liberty placed on a pedestal and decorated with fragments – sceptres, orbs and crowns – the defunct symbols of monarchy.[5] In surrealist practice, statues are not only dislodged as models of the institutional body, losing thereby their social intelligibility. The survey reveals that the role of the statue as a fantasized body complements the iconoclastic gestures aimed at the statue as a social body. Hence the statue of Alfred de Musset and his muse is reimagined as a sexual encounter or placed opposite 'un exhibitionniste vigoureux', while the Chevalier de la Barre is placed in the middle of a priests' cemetery where beautiful naked women play an endless game of hoops. Like the transformation of clichés and proverbs analysed in chapter 3, such transgressions go beyond dada antics to put into practice an ethics of liberation where social taboos are broken in the playful or erotic manipulation of the eroded symbols of the establishment. Dali's celebration of Modern Style architecture is seen as such an intervention of desire which destabilizes the urban scene, as René Crevel underlines: 'Et que ces *réalisations des désirs solidifiés*, de leurs ombres abolissent les statues des héros nationaux et celles aussi des entités maîtresses en fait ou en parole, et des brimborions poreux et peureux qui s'accrochaient toujours à tes jupes, tu t'en souviens, grande pétrifiée, Raison d'Etat.'[6] Crevel is evoking the power of desire to abolish the institutional body, characterized as 'grande pétrifiée, Raison d'Etat', and create new forms through the projection or 'solidification' of desires.

In their collages, the surrealists' appropriation of classical statues is carried out in two essential ways, through strategies of displacement and transformation. This dual activity can be seen in a collage from *La Femme 100 têtes* (plate 19) portraying three young men playing leapfrog over a giant soap-bubble which reflects the Venus de Milo as in a deforming mirror. The statue has been displaced both spatially, from its consecrated place in the museum to the street, and functionally, from a work of art to a toy. In addition, refracted and distorted through the soapbubble, the statue has undergone a change of substance, turned from solid marble to elongated fluid form and *trompe-l'œil* appearance. The caption reads: 'On augmentera par des lessives

bouillantes le charme des transports et blessures en silence.' In a playful refer-
ence to alchemical processes ('par des lessives bouillantes'), these words can
be read as an allusion to the strategies of displacement ('le charme des trans-
ports') and transformation ('blessures'), carried out on the statue. These two
processes will now be analysed in detail.

In the first mode of appropriation, that of displacement, the statue is
removed from its pedestal, hence isolated from its habitual context, both
topographical (a square, the museum) and semantic (the meanings and
values associated with it), and placed in an alien context. Eluard for instance
juxtaposes statues and ploughed fields in his own imaginary 'embellish-
ment' of Paris referred to above: 'Les plus conventionnelles des statues
embelliraient merveilleusement les campagnes. Quelques femmes nues en
marbre seraient du meilleur effet sur une grande plaine labourée.' Such dis-
placements follow the principle formulated by Breton in relation to Ernst's
collages according to which 'une statue est moins intéressante à considérer
sur une place que dans un fossé' (*OCII*, 305). Spatial shifts are accompanied
by a shift in the statue's function or meaning: 'Toutes choses sont appelées
à d'autres utilités que celles qu'on leur attribue généralement', writes
Breton (*ibid.*). Yet it must be stressed that statues are not totally defunct but
retain traces of their original meanings. This explains why the surrealists'
repertory is deliberately restricted to familiar statuary, thus ensuring
recognition of their citational strategies, hence of the gesture of displace-
ment. These well-known icons circulate among the surrealists and are sub-
jected to various (re-)appropriations, as can be seen for example in the many
transformations of the Statue of Liberty. Such a reworking has already been
encountered in Ernst's exhibition poster; it also appears in a collage by
Styrsky, *The Statue of Liberty* (1939), where the head has been replaced by
scaffolding, and an enormous breast has been added which appears to burst
out of the torso, transforming the figure into a grotesque goddess of fecun-
dity. Duchamp appropriated the same icon in a photomontage designed for
the cover of Breton's *Young Cherry Trees Secured against Hares* (1942), where
the face of the statue has been overlaid with the photographic portrait of
Breton.

In his preface to Magritte's first one-man exhibition in Brussels held in
1933 at the Palais des Beaux-Arts, significantly titled '. . . Et l'avenir des statues',
Paul Nougé refers on a humorous note to familiar cultural icons being sub-
jected to a radical questioning, while recognizing their original significance:

> L'esthète, le Dada, l'épicier se confondent devant tel Léonard. L'un se pâme,
> l'autre lui met des moustaches, le troisième regarde ailleurs; et la Joconde de
> sourire à son image privilégiée. Chef-d'œuvre elle reste, dans nos têtes comme
> au Louvre.

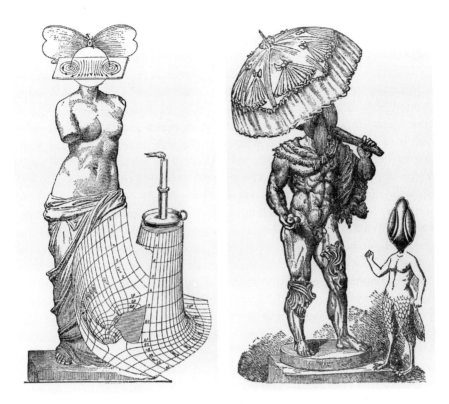

Figure 22 Max Ernst, Venus, from *Paramyths* (1949)
Figure 23 Max Ernst, Hercules, from *Paramyths* (1949)

Ernst unmasks in a deliberately anti-naturalistic gesture, by laying bare the geometrical underpinnnings of illusionistic representations.[14] The use of geometrical figures and a topographical chart traps the figure of Venus as iconic form, and the contrast between the naturalistic representation of the torso and the limit-metaphor of the head is not resolved in a unified representation. As in his *écorché* motif, or his use of masks, skeletons or anatomical charts, where volume and depth are translated into a planar field, Ernst is pushing to their limits codes of representation, and unmasking them as processes of construction.

The parodic unveiling of pictorial codes is accompanied by a semantic transformation. The geometrical construction suggests the head of an insect, while the chart evokes the fluidity of water. Part woman, part insect, both flesh and water, this is a parody of the birth of Venus. In addition, she is clearly presented as a phallic goddess – Ernst refers in the English version of the first text of *Paramyths* to 'phallas athene' – as is suggested by the curious prolongation of the chart which supports a candle, as the debased substitute for the goddess's traditional emblem, the sun. Ernst's 'intervention' on the

engraving of the classical figure thus liberates it from its fixed links to ancient mythology to create a hybrid, polyvalent body. In his preface to Magritte's 1933 exhibition, referred to earlier, Nougé writes of a similar transformation by Magritte of the Venus de Milo, *Les Menottes de cuivre* – originally called *L'Avenir des statues* – a miniature plaster cast reproduction of the statue painted flesh-coloured and blue: 'Mais ce torse de chair joignant une tête de craie à des jambes drapées de bleu pur, et les bras tranchés s'ouvrant sur la nuit la plus noire, – voici une statue dont la seule vertu de présence nous délivre de l'authentique marbre de Milo'.[15] The 'presence' of Magritte's statue displaces the authentic Venus de Milo, freeing the artist and viewer from the reified weight of the original work.

The disorientation created in the viewer by the transformation of the figure of Venus in Ernst's collage is therefore not simply the result of formal games played with codes of representation, but also the effect of semiotic hybridity. This is also the case with Ernst's collage of Hercules, the sixth collage in *Paramyths*, also based on one of Bullfinch's engravings (figure 23). In classical mythology Hercules was condemned by Queen Omphale to be her slave: he was dressed as a woman – hence the shawl he wears in the original engraving – and, according to Bullfinch, 'lived effeminately'. Ernst has reworked the misogynistic cross-dressing of the original Greek legend, which was a means of humiliating the male, by parodying it through hyperbole. In Ernst's collage Hercules is gendered female by the further addition of feminine attributes – an ornate parasol and an intricate hairpiece which covers his face like a mask. In its grotesque forms the image parodies Winckelmann's hermaphroditic ideal of late classical sculpture. The duality of sexual difference is renounced, through the perversion of monolithic norms of sexual identity in favour of a blurring of gender distinction. Ernst's figure suggests androgyny without accomplishing it, achieving less the proposed resolution of opposites than an oscillation between male and female attributes in the juxtaposition of a heavily muscular body and the excessive ornateness of the added elements. The text which accompanies the collage is titled *Le Protège-mythe*:

> oh hercule herr kule et madamekule
> oh madamekule oh madame
> oh frèrekul oh makule
> oh herkule et madame

Ernst's title evokes in a parodic tone the playful appropriation of classical myths evident in this series of collages. In addition, echoing *le protège-sexe*, it confirms Charlotte Stokes' contention that the 'fig-leaf is the heart of his subject'.[16] The text is based on a bilingual pun, where the word 'hercule' is

humorously cut up into 'herr' + 'cul', and developed through wordplay in 'madamekule', 'frèrekul' and 'makule'. The scrambling of gender codes in the pictorial collage is thus echoed in the scatalogical wordplay of the accompanying poem.

In addition to the conflating of gender codes, the figure presents a blurring of distinctions between the body and the non-body, the human and the organic, the architectural and the anatomical, the essential and the ornamental. The statue's solidity is threatened by the fluidity and formlessness of organic matter. This is evident not only in the highly ornate hairpiece and parasol, but also in the Second Empire kneeguards which Ernst has added to the original engraving – a humorous echo and gross amplification of the stylized genitals in the original engravings. In fact, Hercules' kneeguards can be considered as a parodic displacement of the nineteenth-century *cache-sexe*, favoured in puritanical Second Empire France which masked the nakedness of its public statues. These ornamental forms are instances of the double or paranoiac image, which Ernst, following Dali, analyses in his article 'Comment on force l'inspiration', where he discusses his use of architectural motifs: 'un ornement "second empire" trouvé dans un livre pour l'enseignement du dessin montra une forte propension à se transformer en une chimère, tenant à la fois d'un oiseau, d'une pieuvre, d'un homme et d'une femme'.[17] The collage elements chosen throughout *Paramyths* are highly intricate ornamental or organic forms with contrasting textures – ribbons, ruffles and drapes, shells or architectural motifs. Such details, recalling the collage materials used in Ernst's Loplop series in the early 1930s, create grotesque forms midway between the animal, vegetable and architectural domains, monstrous proliferating shapes both material and metaphoric, never achieving closure. The organic unity of classical statuary is replaced in these works by an aesthetics of the hypertrophic detail, its euphoric complete forms giving way to the disturbing hybridity of the *informe*. It designates a transgressive space in its excentric style, working at the edges of the system, stretching its limits without destroying it, an act of transgression of normative forms rather than the creation of the totally other.

Through processes of erosion of the homogeneous and foregrounding of the fragmented, the body itself becomes decentred. The proliferating details juxtaposed on Ernst's classical figures – the butterfly head in *La Santé par le sport* or on his Venus figure, the lady's fussy parasol, the intricate hairpiece-mask, or the stylized kneeguards adorning Hercules – these challenge the hierarchical structure of the classical work, diverting the viewer's attention from the body as an entity to focus on the detail or accessory. The hysterical excess of these details exercises a centrifugal pull on the body. A similar decomposition of the body is evident in other collages from *Paramyths*: in the figure of Hymen, a huge fanlike shape appears to emerge

from the genitals, spreading out as an autonomous hypertrophied limb, decentring the body; while Helios the sungod, scarcely identifiable by his attributes, the whip and the sunwheel, is dwarfed by an assemblage (smothering a second figure) made up of collars, ruffles and other lace motifs, suggesting both an architectural construction and the anthropomorphic forms of the exquisite corpse. The promotion of such hypertrophic details to a central position destabilizes the gaze of the viewer, who finds it difficult to distinguish between the ornamental and the anatomical, the central and the peripheral. In contrast to coherently modelled classical representations of the body premised on a homogeneous monolithic and hence centripetal system, the surrealist body is essentially centrifugal, the proliferation of parts threatening the closed unity of the whole body. While Hubert suggests that 'Ernst, in his liberal borrowing, appears to tinker rather than invent',[18] I would contend that it is the very act of 'tinkering' with already constituted images that is the source of invention in collage. The surrealists' appropriation of statues, which I have stressed as a trajectory, points to the possibility, rather than full realisation, of new figurations of the human body as effectively other. These statues are situated in the interstitial space between the memory of the city square and the museum on the one hand, and on the other hand the sphere of subjective obsessions, the threat of the *informe* and alteration.

Finally, surrealist statues as instances of montage subvert classicism. The two kinds of *intervention* effected on statues by the surrealists – the removal from their pedestals and the transformation and fragmentation of their cohesive unity – both articulate and deconstruct a certain number of oppositions: iconoclasm and creation, classicism and modernism, representation and construction. Firstly, as we saw, the iconoclastic gesture is never completely transcended in the creative gesture, the production of the other body. Iconoclasm and creation, far from being in opposition, are mutually dependent, for the production of new figurations is based on a trajectory between past and future meanings of the collage elements. On the one hand statues have an *aura*, an historical or mythological dimension, carrying the traces of their former meanings and values. In this respect, surrealism contrasts with postmodernist practices of recycling images which are essentially amnesiac, cut off from their historical roots and meanings, belonging to a vast emporium to be appropriated without concern for the narratives or values they once promoted. On the other hand, it has been suggested that statues have a utopic dimension, pointing forward to – rather than fully realizing – the resolution of opposites in the scrambling of codes such as masculine-feminine, architectural-anatomical, animate-inanimate. The second opposition which is both declared and deconstructed is between the (neo-)classical and the modern, as suggested earlier in this chapter in the confrontation between

Ernst's (modified) Statue of Liberty and the anthropomorphic assemblage of shoes. Classical categories of judgement are based on stable ordered structures; for Joshua Reynolds, neo-classical aesthetics opposes (male) form to (female) matter, the latter characterized by the ornamental, the decorative, the detail, monstrous proliferating forms.[19] The surrealists challenge the unity of classical disciplined figuration by exaggerating the ornamental, the tangential, the arbitrary, the feminine. Such a predilection for the proliferating decorative forms of the Empire style is significant in this case, since the Empire style, which marked the beginning of spatial disintegration, challenged and eventually replaced classical unity.[20] Finally, classical representations are challenged and destabilized by montage techniques. Modernist sculpture, commencing with Rodin, is preoccupied with constructing the human figure as an articulation of parts rather than representing it naturalistically. Similarly, the structuring of the human figure based on anatomical principles, that is predicated on the concept of the figure as an entity, is replaced in surrealist collage by the human figure overtly constructed as a montage of parts. 'Le geste du colleur dévoile ainsi tout l'arbitraire de la figuration classique.'[21] And, like the exquisite corpse, human figuration based on the statue is doubly displaced: as a human analogue it is less representation than sign, as a ready-made it is less naturalistic than artefact. The image-making process is thus foregrounded, underscoring the artefactual structure of all representation, and it is precisely the additive character of representation which the *cadavre exquis* exploits.

The collage process lends itself to this dual activity of subversion and production. By cutting up classical figures the surrealists challenge norms from within the system by pushing forms to their limit and displaying assemblage techniques. By pasting together disparate elements they produce the hybrid, monstrous or fantasized body. Traditional statues are not quite corpses. They are rotting on their pedestals, nearly defunct, almost desemanticized. But far from simply burying these moribund beings in a ditch, the surrealists exploit and revitalize them, transforming them into exquisite corpses.

Part-bodies: crime or miracle?

Femmes qu'on ne voit pas, attention!

POETE CHERCHE modèle pour poèmes. Séances de pose exclusiv. pendant sommeil récipr. René Char, 8 ter, rue des Saules, Paris (Inut. ven. avant nuit compl. La lumière m'est fatale.) (*OCI*, 1028)

Who are these elusive women evoked by Breton and Eluard, pursued in the wanted columns of an imaginary newspaper? Invisible by day, they emerge in total darkness during the poet's sleep. Is this the woman represented in Magritte's photomontage, published in the last issue of *La Révolution surréaliste* (15 December 1929), which is composed of photobooth portraits of the surrealist group framing a painting by Magritte of a nude female figure in a demure pose, inscribed with the words: 'Je ne vois pas la [. . .] cachée dans la forêt'? The male surrealists, their eyes closed, appear to be dreaming, perhaps creating fantasized images of the desired woman.[22] For David Sylvester, 'Magritte's elusive, self-absorbed, mysterious, mythic woman – Diana, Venus, Eve – could be said to have become the great iconic image of Surrealism.'[23] Instead of simply accepting that the rather scrawny *Venus pudica* represented here could be an appropriate projection of the male surrealists' desires, it could be argued that this image can be read parodically as a counter-example to the paradigm of the surrealist woman. The surrealists close their eyes to the imaginative void of naturalistic representation of women. The object of desire is not to be found in external models, whether actual persons or representation predicated on conventional aesthetic codes. As Hans Bellmer declares: 'tel détail, telle jambe, n'est perceptible, accessible à la mémoire et disponible, bref, n'est REEL, que si le désir ne le prend pas fatalement pour une jambe . . . L'objet identique à lui-même reste sans réalité'.[24] Desire, focusing on the anatomical detail, transforms and displaces body-parts. The 'REAL' – that is, the surreal – woman is hidden in the forest, she is both invisible and visible, approached indirectly through dreams and fantasy. As Victor Burgin argues in relation to Magritte's photomontage: 'there are other forests to negotiate, not least amongst these the forest of signs which is the unconscious'.[25] The image of woman is fashioned through the dynamics of desire, which transforms the body, constructing the woman as other through fetishistic fragmentation, hallucinatory substitution or the excesses of hyperbole. The female body is made visible obliquely, perceived through the veil of metaphor or in the part-images of metonymy: 'pour *faire voir* un corps,' writes Barthes, 'il faut ou le déplacer, le réfracter dans la métonymie du vêtement, ou le réduire à une de ses parties'.[26] Ironically, the woman in Magritte's photomontage, has become partly veiled over the years: it was acquired by Breton, whose efforts to clean the canvas caused the paint surface to develop a mesh of fine cracks which now cover the figure, blurring its outlines and decomposing the image, thereby – quite accidentally – greatly enhancing its suggestive power.[27]

The opposition between real and 'REAL' woman is also suggested in a collage by Roland Penrose titled *The Real Woman* (1937), which exploits a double image. In the summer of 1937 Penrose developed the technique of using multiple examples of postcards representing views of Paris or the South of France, transforming these clichéd images through techniques of dou-

bling and juxtaposition. On the right is the image of the plaster cast of a female torso made of cut-out frottage paper, a standard studio prop belonging to the same academic tradition as the female nude in Magritte's photomontage. On the left is the collage of a brightly coloured bird: its head is made out of frottage paper similar to the one used for the plaster bust, while its body is composed of a black rectangle with a grey decalcomania shape pasted over it; six postcards, representing a Cannes fountain by night, are arranged in a fan-like shape to suggest the breast of the bird; six other postcards, of the Corniche d'Or on the Mediterranean coast, are arranged in a similar way to represent the bird's tail, while its feet are made up of two postcards of sailing boats at sunset, turned at a 90° angle. The two figures are linked by a long cut-out shape suggesting an umbilical cord. The fabricated bird appears to have lent some of its attributes to the bland studio prop which sports a *cache-sexe* composed of two photographs of an evening sky. As in Max Ernst's invitation-poster for Man Ray's 1935 exhibition discussed earlier in this chapter, this collage juxtaposes two modes of iconographic representations of the body, the classical mode and modern assemblage. The *real* woman is less the reified plaster cast of naturalistic representations than the colourful fantastic bird, an artefact in which reality is modified, displaced – in the visualization of the pun on *bird* as feathered creature and woman, and the recycling of postcards – and thus defamiliarized.

As was suggested in the rhetorical analysis of the *cadavre exquis* in chapter 4, it is through the interplay of metaphorical substitutions and metonymical concatenations that the discourse of desire creates the body as other. A similar process is visible in the literary *blason* which can be read as the verbal equivalent of the *cadavre exquis*. In Renaissance literature the *blason* genre was designed to celebrate – or vituperate – a woman. It is essentially descriptive, both an inventory and an invention, involving the enumeration of body parts and their metaphorization. Yet it is also a narrative, using the topos of the exotic or conquistador's voyage of discovery or uncovering of the body. The surrealists appropriate the literary format of the blason – as they do the ready-made images of classical statues – to parodic and poetic ends, subverting the genre by pushing its mechanisms to their limits.

A number of early surrealist texts parody the blason genre, as in Desnos' poem 'Isabelle et Marie' (1923), which revives the vituperative blason:

> Isabelle rencontra Marie au bas de l'escalier:
> – et toi une main.
> – main toi-même, omoplate!
> – omoplate? c'est trop fort, espèce de sein!
> – langue! dent! pubis
> . . .[28]

The various parts of the body are evoked in a dialogue of insults, which are variants of the paradigmatic term of abuse – *con* – hurled in the last line. Desnos also constructs an entire poem, 'C'était un bon copain' (1923), in the form of a (counter-)blason as a montage of fixed expressions relating to parts of the body:

> Il avait le coeur sur la main
> Et la cervelle dans la lune
> C'était un bon copain
> Il avait l'estomac dans les talons
> Et les yeux dans nos yeux
> C'était un triste copain
> Il avait la tête à l'envers
> Et le feu là où vous pensez
> Mais non quoi il avait le feu au derrière
> . . .[29]

Such a repetition of clichés unhinges the fixed expressions and reactivates the literal meaning of each cliché, in a verbal equivalent of Max Ernst's visual pun in *C'est le chapeau qui fait l'homme* (1920).

In his poem 'L'union libre' (1931), which could be read as an extended *cadavre exquis*, Breton also reworks the blason, to less humorous ends than the examples quoted above. The stereotypical metaphors evoking female beauty, conventionally based on the isotope of nature, are replaced by a succession of images drawn from disparate fields:

> Ma femme aux poignets d'allumettes
> Ma femme aux doigts de hasard et d'as de coeur
> Aux doigts de foin coupé
> Ma femme aux aisselles de marbre et de fênes
> . . . (*OCII*, 86)

The litanic structure of the blason provides a fixed framework for a series of incongruous limit-metaphors. For the reader, the euphoric recognition of a code is disrupted by the *dépaysement* caused by the incongruity of the images. Since the mind finds its bearings in the *déjà-vu* of a recognizable literary genre, the 'grande désorientation'[30] triggered by the *jamais-vu* becomes all the more intense, in the passage through the familiar *pays* of literary tradition whose conventions are both exploited and subverted. Paradoxically, the mind is freed within the fixed parameters of a syntactic form to accept the random fillings and elaborations of body-substitutes. The parts of the body are evoked as irremediably other, presenting a limit-form of description or an impossible fiction, while the residual anatomical func-

tion of the figure vies with the anti-anatomical or centrifugal movement of the parts. In an interview titled 'Les surréalistes ont manqué le corps', Barthes criticizes the surrealists for failing to liberate themselves from a normative concept of the body and sexuality, as evidenced in their supposed failure to deconstruct language. 'Le "corset" imposé à la syntaxe (son drapé énorme, dans le cas de Breton) et la contrainte sexuelle, c'est la même chose.'[31] But Barthes failed to see that the body as constructed by the surrealists, like surrealist language, may well display the 'corset' of familiar anatomical or syntactical frames (as has been constantly underlined in the course of this study), yet it is, after all, a 'corset mystère', and the violation of sexual taboos, like the subversion of discursive norms, is effected through the transgression, inscribed in the space between a rule and its transgression, between normative syntax or naturalistic frames and a free semantic or iconic displacement which transforms external reality, fashions it in the light of inner drives and desires. As it is reworked by Breton, the blason, for instance, like the *cadavre exquis*, simultaneously acknowledges the familiar while pointing to the other body in limit-forms of textual or iconographic constructions. Far from kow-towing to the normative, as Barthes believed, it exploits the paroxystic, daring, as in the *cadavre exquis*, to 'porter l'anthropomorphisme à son comble' (*SP*, 290). The aesthetic pleasure of the reader evolves precisely in the space created by the gap between the recognition of traditional literary forms and the exploration of new combinations. The pleasure of reading is the consequence of the paradoxical structure of the poem, which is both immobile in its repetition of familiar codes and mobile in its departure from such codes. As Barthes himself writes in *Le Plaisir du texte*: 'la culture ni sa destruction ne sont érotiques, c'est la faille de l'une et de l'autre qui le devient',[32] and it is precisely that *faille* which is evident both in the parodic structures of Desnos' poems quoted earlier, and in the poetic structures of Breton's text, since their effect is predicated on the reader's awareness of, and pleasure in, the double voice of the text, as both cultural and subversive.

At times, when the second term of the metaphor in 'L'union libre' is developed in a continuously expanding chain of images, the centripetal isotope of the body is counteracted by a semantic displacement through a series of free associations, creating a destabilizing centrifugal movement:

> Ma femme aux aisselles de marbre et de fênes
> De nuit de la Saint-Jean
> De troène et de nid de scalares
> Aux bras d'écume de mer et d'écluse
> Et de mélange du blé et du moulin.

Such a side-stepping or 'right-branching' syntax leads to 'a kind of fragmentation or confusion and paradox',[33] in a process similar to the one observed earlier in the pictorial *cadavre exquis*, where the coherence of the anatomical structure is countered by the centrifugal movement of the analogical/arbitrary elements substituted for body-parts. Metaphorical elaborations acquire a dynamism of their own, where the point of departure of the image – armpits or arms, later breasts or sex – is elided in favour of their imaginative substitutions, each limb becomes an autonomous part, and the limits of the body contained are transgressed in a process of fragmentation and libidinal decentring which undoes the traditional unity of the body. Breton is thus pushing to its limit the descriptive model of the blason by playing with and displaying the (usually discrete) montage mechanisms of description. As Barthes argued, verbal discourse on the body is necessarily fragmented: the body cannot be described as a totality, it can only be evoked in parts, in a descriptive mode which approximates the montage techniques under discussion. 'Etant analytique, le langage n'a de prise sur le corps que s'il le morcelle; le corps total est hors du langage, seuls arrivent à l'écriture des morceaux de corps.'[34] While Barthes contrasts the fragmented mode of verbal description with the supposedly more unified pictorial figuration of the body, the surrealists have extended the montage techniques characteristic of the verbal medium to pictorial modes of figuration, both in their perversions of the unified classical body, as was shown earlier in this chapter, and more aggressively, in the pictorial images of the *cadavre exquis* and related forms. As a consequence, montage techniques, usually discretely encoded in pictorial representations of the body, are made visible in the overt articulations of limbs.

The narrator of 'L'union libre' projects his own part-images on to the figurations of the woman; the viscera in Styrsky's collage *La Baignade* represent a metonym of male desire; Bellmer isolates dolls' legs, arms, or breasts, fetishizing them as phallic symbols; and Dali indulges in the surgical cannibalism of Gala's body, which he dismantles all the better to possess, metamorphosing it into edible parts to be consumed by the male predator. Such appropriations of the body as phallic symbol or phallocratic fragment raise the issues of the fragment as fetish, synecdoche or metaphor. In the wake of Xavière Gauthier's violent indictment of surrealism as a specifically phallocentric practice, the representation of the body in surrealism has been widely criticized as anti-feminist: the body (usually female) has been reduced to a projection of (usually male) desire, a form of colonization of the other, obliterating alterity and rejecting totality, in male gestures of narcissistic projection and totalitarian dismemberment.[35] However, are all fragmented images of the surrealist body to be interpreted as instances of fetishistic dismemberment?

This may at first appear to be the case when we consider certain photo-collages of the 1930s, by surrealists such as Malet, Styrsky or Hugnet, which recycle mass-media images, and in particular female part-bodies – legs and lips, headless or chained bodies, isolated eyes and breasts. In Styrsky's *Stakovaci Cabinet* (1934), high-heeled stockinged legs are superimposed with a knife, or a leg of ham (*Le Beau Jambon*), or duplicated and assembled in a grotesque figure (*Deux belles Jambes*). In Hugnet's photocollages, and notably in his book *La Septième Face du dé*, composed of twenty *poèmes-découpages*, truncated limbs proliferate – female legs detached, crossed, spread-eagled, legs juxtaposed with large breasts or seashells, or multiple legs forming a rosace shape.[36] The collage *Le Sang en proverbe* (figure 24), also dated 1936 and similar to *La Septième Face du dé* in its structure and the iconic motifs used, is composed of a photocollage and a pasted text. It portrays a female cephalopod: a pair of crossed high-heeled black-stockinged female legs and hips topped by the head of a young lion is duplicated in a second figure, composed of a dotted silhouette which echoes the outline of the legs of the first figure, and a foreshortened torso, whose shape reproduces that of the lion's head, a similarity formally underscored by projection lines drawn between the two figures. The isolation and permutation of limbs in the photocollage exemplify Bellmer's anatomical perversions of the female body: 'il n'y a qu'un pas à faire pour que la jambe, isolément perçue et isolé-ment appropriée à la mémoire, aille vivre triomphalement sa vie propre, libre de se dédoubler . . . libre de se tenir à une tête'.[37] The mechanism of duplication (or multiplication), characteristic of Hugnet's collages, does in fact transform the body into fetishistic fragments, which are explicitly encoded as simulacra in the schematic outline which reduces the body to a flat disembodied sign of femininity. The presence of the 'real' woman is transformed into the sign of the 'REAL' woman, modelled in the light of masculine desire.

The pasted text, arranged around the pictorial elements, reads:

Le sang en proverbe / est écrit sur / les mannequins / EXTREMITES FLEXIBLES / au pied / d'un aquarium mystérieux / RIRE VOLE / d'une main / que raconte / la rose, deux jours et deux nuits / Les demoiselles vivaient au sein / DES REVOLUTIONS / irrésistiblement / voix fluide / des hanches parfaites et blanches.

The text appears to mime the pictorial composition both formally and thematically. It is composed of newspaper clippings of fragments of texts in various typefaces and assembled at different angles in such a way that they appear to frame the two figures. The text suggests a narrative scattered with body-parts, evoked directly ('sang', 'main', 'hanches') and indirectly in the

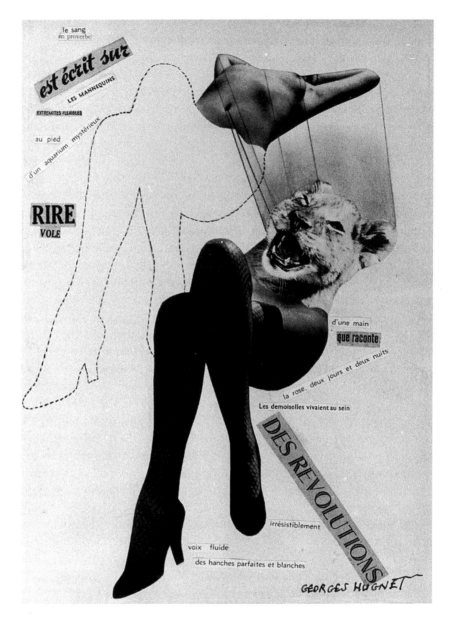

Figure 24 Georges Hugnet, *Le Sang en proverbe* (1936)

literal reading of ready-made expressions ('pied', 'sein') or the metaphorical interpretation of other fragments ('un aquarium mystérieux', 'rose'). Incomplete and suspended, the fragmented syntagms of the narrative articulate the discourse of desire.

For Robert Sobieszek, Hugnet's collages are a major example of surreal-

ist eroticism, made up of cleverly composed literal and narrative images, some 'hermetically pathological' (*sic*), others 'simplistically fetishistic'.[38] Yet the fact that a large number of images are drawn from the standard repertoire of sexual signifiers raises the issue of whether such images transcend the fetishistic exploitation of part-bodies as encountered in mass-media images. Hugnet's collages present a certain ambivalence, which one also encounters in other works which exploit mass-media images, such as Hannah Höch's photomontages. Such works appear to be both complicit with and critical of advertising images. On the one hand, through strategies of fetishistic dismemberment and duplication, Hugnet's photocollage embraces the world of commodity images, where the human figure is reduced to the commodity forms of high-heeled shoes and black stockings. Part-bodies and fragments from advertising slogans articulate the clichés of desire, pre-packaged images which elicit stock responses from the addressee. Sobieszek quotes Hugnet who claims that in his *poèmes-découpages* he is experimenting with the combination of found objects and texts, 'suppressing metaphor for the sole advantage of the image'. The very literalness of Hugnet's pictorial and verbal statements leaves little resonance or interstitial space which would trigger the creative engagement of the viewer/reader. The metaphorical dimension is absent from this collage which seems to be designed for instant gratification rather than the transcendence of its pasted fragments in an erotic reworking of body-parts.

Yet an alternative reading of this collage suggests that it exploits mass-media images critically. Not only is the figure an instance of the fetish, it is also read as a self-reflective comment on the process of fetishization. The female figure on the left is presented as a mere surface or contour, a shadow or simulacrum. Fetishistic dismemberment is implicit in the silhouette which perversely solicits the participation of the viewer who is invited to cut along the dotted lines and reenact the figural operation as the violent and sadistic fragmentation of the female body. In addition, the projection of male desire in the clichéd image of the roaring lion's head – possibly a reference to Dali's multiple pasted lion's heads in *L'Accommodation des désirs* (1929) – is made visible as a process in the addition of the projection lines, which traditionally foreground the formal strategy of iconic projection, and are used here to render visible the mechanisms of the psychological projection of the male self-image on to the female form. Hugnet is deconstructing the mechanisms of displacement, making them a visible part of the fetishistic construction of the female body.

Whether Hugnet's collage stages a 'simplistic' pleasure in fetishism in the phallocentric projection of the male self-image and the ciphers of femininity, or a more complex deconstruction of the mechanisms of fetishization, his manipulations and duplications reduce the image to a closed

Figure 25 Max Ernst, 'La clé des chants', *Une semaine de bonté* (1934)

system of fixed meanings. This contrasts with the exploration of the body, whether male or female, as a limit-form of anthropomorphic representation, which we encountered in the polyvalence of the metaphors in Breton's 'L'union libre' or the suggestivity of Ernst's reworked Venus de Milo or Hercules. This can be shown more clearly if we contrast *Le Sang en proverbe* with a collage by Ernst from *Une semaine de bonté*, also representing a double figure, part human part animal (figure 25). This collage

represents a reworking of the Venus and Cupid iconographic cliché. The ground is provided by an engraving from a nineteenth-century melodramatic source representing a young woman with her hands tied to a bedpost or ballustrade and her body bandaged/bondaged. The head has been overlaid with fragments composed of a squid, a shell and octopus tentacles, while the lower part of the body is obscured by a round shape from an engraving titled 'Harmonie des ondulations' (a diagram recording waves in a dish of mercury) from Camille Flammarion's *Astronomie populaire* (1880).[39] There is a clear contrast between the naturalistic body and the limit-metaphors designating the head and the sex; the concatenation of body fragments creates an oscillatory space between the literal and the figurative, a polyvalent space suggesting multiple associations. The head evokes a monstrous sea-creature, an insect or a bird, while the circular shape suggests a vulva or a mandala, the philosophic egg of the alchemist, erotic rhythms or cosmic movements.[40] This image can be related to Breton's concept of convulsive beauty, discussed in chapter 4. In Man Ray's photograph of the tango dancer, which Breton presents as an example of 'explosante-fixe', the blurred dress designates both movement and its suspension; similarly, in Ernst's collage the circular shape connotes both movement – erotic or cosmic – and arrested movement. The clichéd or reified representation of bondage which underlays Ernst's image has been superseded and dynamized by the addition of the collage fragments and the consequent transformation and freeing of the body. These substitutions of body-parts testify to a generalized eroticism which refutes the overdetermination of phallic substitutions in the representation of the body, in favour of a pleasure in parts. Like Bakhtin's grotesque body, predicated on excess, mutability and the 'violation of natural bodies', these body parts exceed their anatomical limits and become other.[41] Less fetish than metaphor, such body fragments are the site of polysemic processes and differentiation. Where body-parts function as synecdoches they refer to an absent whole, the fetishistic fragments of an almost forgotten entity; while as metaphors they constitute new configurations. Such aesthetic recodings may well be sublimatory tactics on the part of Ernst – and in the present reading! – designed to mask the narrative of loss and anxiety which a critic such as Foster traces beneath the surrealist aestheticization of the body.[42] Yet these images look forward, promising fulfilment of the future body, rather than merely looking back to the arrested narrative of a traumatic past. While the fetish both asserts and disavows lack, metaphor celebrates presence, extending the limits of the body. Finally, the imaginary body, hallucinated by the surrealists behind closed eyes, is irretrievable as a totality. Parts proliferate, acquiring an autonomous existence which has almost lost sight of the anatomical body as a point of departure and does

not constitute a totality. The collage-body is in a constant flux in the multiple analogies, displacements and permutations which constitute it. It is both veiled and unveiled, veiled in order to be unveiled as the dynamic Other of the body, in the material, iconic or semantic dynamism of its parts.

An impossible mosaic

J'ai des morceaux de puzzle, seulement des morceaux: le tableau tout entier, c'est un des aspects du mensonge et de la bêtise contemporaine. J'ai des morceaux de puzzle, une collection.

<div align="right">Jacques Prévert[1]</div>

Throughout this study, surrealist collage has been located in an ambivalent space, both as a literal presence and a semiotic reality, a mythical construct and fictional fragments, an anatomical frame and isolated limbs, the locus of a multiple intertextual voice or of shattered identities, a stage for the contrived seamlessness of mosaic pieces or the cutting edges of irretrievable fragments. It is this dual orientation of the surrealist collage aesthetic which is present within individual works, such as Aragon's *Paysan de Paris*, where the evocation of a 'collage city' of fragments, the realistic or parodic function of collage elements, and the overt display of the assemblage process, are counterbalanced – and contradicted – by the search for 'une mythologie moderne' (PP, 143), a unifying principle identified with the surreal, which purports to resolve the discontinuities of the urban *merveilleux* in a new totality. A similar ambivalence is also present in the surrealists' theoretical and programmatic writings which, at times, profess as the aim of surrealist activities the creation of an ultimate unity, analogous to erotic fusion or the alchemical *coincidentia oppositorum*, while at other times foregrounding strategies of disruption and disorientation.

Such an ambivalence can be seen in the differing treatment of masks by Breton and Ernst, already touched on in chapter 6. For Breton, primal masks occupy a mythical space of unity and transcendence, responding to the need for the primitive other, while also claiming some universal unity. He posits primordial links between different cultures across time as part of universal human experience, denying temporality and distance. The oceanic mask, for instance, allows Breton to participate in so-called 'primitive' mentality, 'cette

brousse de sentiments où l'homme – là comme nulle part ailleurs – en est encore à se chercher dans les entrailles de la nature et se démêle encore incomplètement du serpent et de l'oiseau'.[2] The power of suggestion of ethnographic masks and other objects depends on their detachment from their original contexts. Presumed to be situated outside anthropological discourse, the mask remains mysterious, a sign invested with new meanings, assimilated to an unconscious viewed as universal. Breton's poetic text is in fact characteristic of the anthropological discourse of cultural relativism of the 1920s and 1930s, where the concept of the other is combined with the belief in universal psychic unity: Breton redeems the mask's alterity in a universally valid narrative. By contrast, Max Ernst's masks inhabit a fictional space that is essentially transgressive and disruptive, an ambivalent 'paramythical' space – suggested by the Greek prefix *para* which means both 'against' and 'beside'.[3] Displaced from their original context – as an illustration from an anthropological article, a museum piece or a ritual object – their former significance is both acknowledged and suppressed, and they become a syntagm in a new fictional context characterized by temporal and spatial ruptures, where they tease the memory without yielding any unitary meaning. We have seen how Max Ernst favours such ludic disruptive combinations in *Une semaine de bonté*, where the Easter Island head sported by the main protagonists is replaced in the last plate of the chapters (figure 16) by an African mask, thus privileging lateral syntagmatic elaboration over Breton's paradigmatic integration.

Totalization and fragmentation represent the two poles or 'temptations', to use Jean Ricardou's term, which underpin the modern text. 'S'agissant d'écrire du texte, il y a deux tentations: la fascination de l'homogène, le culte de l'hétérogène. Le systématique, l'épars. Le flux unitaire, la dispersion aphoristique. Bref le refus (en tout cas la minimisation) d'une tension entre deux incompatibles.'[4] Instead of privileging one pole over another, the modern text is located in a tensive space which englobes both a homogeneous discourse, where incongruities are subsumed within a higher unity, and a fragmented discourse whose heterogeneity cannot be fully retrieved. Modern texts are thus to be considered as fundamentally paradoxical structures, writes Ricardou: 'Le texte peut donc se concevoir comme *une mosaïque impossible* qui se place entre le relatif *désordre* d'un épars qui toujours aspire à *l'ordre* d'un assemblage (UNE MOSAIQUE) et une unité toujours astreinte au *contre-ordre* d'un démembrement (IMPOSSIBLE).'[5] The analyses of individual collages in this study have shown that, just as the encoding process of collage oscillates between the search for a totality and the staging of fragmentation, similarly the critic's decoding strategies, accounting both for the configurations of collage fragments and its scattered and irretrievable tessera, engage a dual perspective. Collage, as a paradigm of the modern text,

is located in a space of unresolved tensions, on the one hand tending towards a new perceptual or intellectual unity, and on the other hand foregrounding paradox and undecidability. Collage parts correspond to what Roger Shattuck has termed the 'ambiguous fragment', as in cubist painting where 'scraps of everyday life' – a detached ear, a floating moustache – are fragments set adrift which seem to have lost their bearings, and yet 'at the same time each familiar detail shouts its incipient relation to everything else in the composition and in the world at large'.[6] Let us look more closely at these two poles and their 'impossible' resolution.

'Une mosaïque . . .'

The myth of the totality of the work of art, elaborated by the surrealists, and adopted by many of their critics is an essentially syncretic concept, premised on the notion of the organic unity and functional integration of the work of art, and positing the interdependence of parts within the whole and the transcendence of apparent contradictions or incongruities in the resolution of opposites. It has its roots in Romanticism and Symbolism, and it is fed by the Hegelian dialectic and Freudian psychoanalysis, as well as alchemy and other esoteric philosophies, conceptual models which purport to account for and erase local disruptions in the elaboration of a global continuity.

Hegel is the first to provide an answer to the surrealists' desire to find a unifying principle, since Breton's definition of the surreal in his 1929 *Manifeste* is based on the dialectic:

> Tout porte à croire qu'il existe un certain point de l'esprit d'où la vie et la mort, le réel et l'imaginaire, le passé et le futur, le communicable et l'incommunicable, le haut et le bas cessent d'être perçus contradictoirement. Or, c'est en vain qu'on chercherait à l'activité surréaliste un autre mobile que l'espoir de détermination de ce point. (*OCI*, 781)

The search for the 'point de l'esprit' where contradictions are resolved involves the absorption of difference and the eradication of disjunctions in a totalizing and unifying synthesis. Breton's analyses of apparently disruptive aesthetic practices are often predicated on the dialectical principle. Referring to Victor Brauner's paintings, for example, Breton claims, somewhat vaguely: 'Tout se résout ici dans le sens de la plus haute harmonie' (*SP*, 127). A similar label is attached to collage practices: in his introduction to Ernst's collage-novel *La Femme 100 têtes*, for instance, he refers to 'certaines propriétés transcendantes . . . où les vies antérieures, actuelles, ultérieures, se fondent en une vie qui est *la* vie' (*OCII*, 306).

The surrealist dialectical model has applications in the political, psycho-analytical and aesthetic fields. In the juggling act with Marx and Freud which Breton performed in the early 1930s, and particularly in *Les Vases communicants* (1932), Freudian hermeneutics is filtered through the concept of dialectical materialism.[7] Breton's main objective was to counter criticisms of idealism levelled at the surrealist movement at that time, notably by Georges Bataille. Breton claimed that 'le monde réel et le monde du rêve ne font qu'un', the latter drawing its elements from the '"torrent du donné"' (*OCII*, 142) of material reality (Breton is quoting Lenin here). Later in the same text Breton elaborates the notion of communicating vessels or '*tissu capillaire*' (*OCII*, 202) which ensures the constant exchange between material and oneiric realities. He claims that apparent incoherence covers a latent coherence, and that all texts point to a future (conditional) decipherment, identified here with psychoanalysis as a privileged explanatory model. It was a hope reiterated by Breton in a letter to Rolland de Renéville:

> Le surréalisme . . . passera bientôt, j'espère, à l'interprétation des textes auto-matiques, poèmes ou autres, qu'il couvre de son nom et dont l'apparente bizarrerie ne saura, selon moi résister à cette épreuve. Il est permis de penser que cette entreprise systématique aura pour effet de réduire considérablement le champ des anomalies soi-disant irréductibles de certains langages.
>
> (*OCII*, 328)

If the mind is capable of linking anything to anything else, Breton claims, then any failure to connect can be imputed to the reader or critic. Breton, however, never carried out such a *systematic* reading of surrealist works. When Aragon proposes a psychoanalysis of Max Ernst's early collages – 'Traitez ces dessins comme des rêves et analysez-les à la façon de Freud. Vous leur trouverez un sens phallique très simple. C'est qu'à divers égards, Max Ernst est un primitif' (*C*, 24) – he is, perhaps ironically, alluding to early Freudian applications which involved attaching simplistic meanings to such complex images.

Breton's search for the resolution of opposites was identified not only with psychoanalysis, but also with alchemy, where the Hegelian 'point de l'esprit' is linked to the alchemists' search for the philosophers' stone or 'point suprême'. Alchemical interpretation, proposing 'une clé "hiéroglyphique" du monde' (*En*, 273), provides another totalizing account of natural and spiritual processes, englobing all signs within a grand narrative. Working within the tradition of Hugo, Nerval and Rimbaud, Breton's call for the *occultation* of surrealism in his second *Manifeste*, and his many references to the occult, par-ticularly after 1945, testify to the importance he attached to alchemy as a hermeneutic model.[8] In an interview of 1950, for example, he posits unity

beneath the apparent discontinuity of phenomena – 'Sous ces faits divers de plus ou moins grande échelle court une trame qui est tout ce qui vaudrait la peine d'être démêlé' (*En*, 277) – and he claims that esoteric thought can provide a key to unravelling enigmatic reality. References to alchemy in surrealist writings provide less a hermeneutic key, however, than a poetic analogy between surrealist aesthetic or political activities and the alchemical process of transforming base matter into gold. Central to the collage principle, as was seen in chapter 4, is the transmutation of matter – the 'restes visuels' of waking life resurfacing in dreams, the raw material of commercial catalogues, the clichéd phrase, the oft-repeated quotation – into the surreal; and the surrealists often have recourse to alchemical metaphors to describe these processes. For example Ernst's reply to the question 'Qu'est-ce que le collage?' was to transpose into the pictorial field Rimbaud's 'alchimie du verbe': 'Il est quelque chose comme l'alchimie de l'image visuelle. LE MIRACLE DE LA TRANSFIGURA-TION TOTALE DES ETRES ET OBJETS AVEC OU SANS MODIFICATION DE LEUR ASPECT PHYSIQUE OU ANATOMIQUE' (*E*, 253). A few pages later he gives as an example of verbal collage the porte-manteau word *phallustrade* already mentioned, which he defines as 'un produit alchimique, composé des éléments suivants: l'autostrade, la balustrade et une certaine quantité de phallus. Une phallustrade est un collage verbal. On pourrait définir le collage comme un composé alchimique de deux ou plusieurs éléments hétérogènes, résultant de leur rapprochement inattendu' (*E*, 262).

The erotic metaphor as a paradigmatic narrative of alchemical transmutation is also adopted by the surrealists to account for the collage encounter.[9] In 'L'objet fantôme', for example, Breton decodes Lautréamont's famous simile as an erotic encounter – albeit in rather simplistic equational terms:

> Si l'on songe à l'extraordinaire force que peut prendre dans l'esprit du lecteur la célèbre phrase de Lautréamont: 'Beau comme la rencontre fortuite, sur une table de dissection, d'une machine à coudre et d'un parapluie' et si l'on veut bien se reporter à la clé des symboles sexuels les plus simples, on ne mettra pas longtemps à convenir que cette force tient à ce que le parapluie ne peut représenter que l'homme, la machine à coudre que la femme . . . et la table de dissection que le lit, commune mesure lui-même de la vie et de la mort.[10]

Ernst expatiates on a similar metaphor in an analysis of the collage principle, reworking the androgyne myth which privileges sexuality as a synthetic principle rather than a disruptive force (as in Bataille's writings):

> [P]arapluie et machine à coudre feront l'amour. Le mécanisme du procédé me semble dévoilé par ce très simple exemple. La transmutation complète suivie

d'un acte pur comme celui de l'amour, se produira forcément toutes les fois
que les conditions seront rendues favorables par les faits donnés: *accouplement
de deux réalités en apparence inaccouplables sur un plan qui en apparence ne leur
convient pas.* (E, 256)

In response to Breton's injunction to integrate and unify fragments in a
totalizing reading, critics, in their role as detective or psychoanalyst, have
often assumed the Promethean task of finding unity beneath the apparent
heterogeneity of surrealist production, as was discussed in chapter 5. Anna
Balakian contends that one of the essential characteristics of surrealism 'is
its uncompromising will to find a foolproof unity in the universe'.[11] For José
Pierre, while dadaist collage 'se préoccupe essentiellement d'accentuer les
discordances', surrealist collage is linked to an associative aesthetic: '[le
poète] tentera, de la réunion des éléments discordants, de faire surgir une
unité lyrique inattendue'.[12] Other critics have sought an underlying
harmony, 'une sorte d'esperanto de la vision', a new language or code that
could decipher the enigmatic signs of surrealism.[13] Some have adopted the
discourse of psychoanalysis. Foster, for example, has proposed an analysis of
surrealism in the light of the uncanny which he sees as its overarching prin-
ciple, 'a principle of order that clarifies the disorder of surrealism'.[14] Others
have used the codes of alchemy to explain the apparent incongruities of
collage, as discussed in chapter 5 in the analysis of Ernst's *Une semaine de
bonté*.

However, the deliberate imposition of (ana)logical grids – whether a
Freudian, Hegelian or alchemical model – commits the text to an ultimate
coherence, which purports to transcend, but in fact often eradicates, or
simply bypasses, the incongruous. And despite the recourse to psychoanalyt-
ical and philosophical guarantors by Breton and his critics, the validity of the
associative method as the governing principle in the specific case of collage is
in fact challenged, and indeed contradicted, both in the surrealists' discursive
texts and by the evidence of collage practice itself.

'. . . impossible'

The Romantic myth of totalization is questioned, firstly, in Breton's own
theoretical texts, where totalization is posited as a project rather than fully
realized. His 'point de l'esprit', where the oppositions between life and death,
the real and the imaginary or past and future are to be resolved in a new unity,
is situated not in the present but in the past or future, in a nostalgic regret for
a lost pre-oedipal unity (present in the myth of childhood and the androgyne
myth) or the messianic myth of a future totality,[15] identified for a while with

the marxist myth of reconciliation. The surreal is thus often seen as a hypothesis or a possibility rather than an actual space to inhabit.

The critique of the concept of the dialectic, premised on an idealized notion of (romantic) unity, was launched by Georges Bataille in 'La *vieille taupe* ou le préfixe *sur* dans les mots *surhomme* et *surréaliste*'.[16] For Bataille, Breton's aesthetics valorize homogeneity and elevation in an 'illumination icarienne' which, rather than providing a resolution of the contradiction between 'le haut et le bas', actually constitutes merely an escape from 'la bassesse': 'L'irréalité pratique des éléments hétérogènes qu'elle met en jeu se constitue en une réalité supérieure ayant pour mission d'éliminer (ou de dégrader) la réalité vulgaire.' In contrast to Breton's 'idéalisme absolu', Bataille posits a dynamic dialectical process that maintains the contradictory elements within the synthesis, thus preserving both 'le haut' and 'le bas' in the process. Similarly, in their discussions of collage, some critics have emphasized the continuous dynamic interrelations between parts, rather than their resolution. Donald Kuspit, for instance, writes that the 'incongruous effect of the collage is based directly on its incompleteness, on the sense of perpetual becoming that animates it'.[17]

Bataille's focus on heterogeneity is clearly closer to Aragon's concept of the surreal as contradiction within reality than to Breton's transcendental vision. 'La réalité', writes Aragon, 'est l'absence apparente de contradiction. Le merveilleux, c'est la contradiction dans le réel.'[18] The analysis in chapter I of the texts written by Breton and Aragon on Ernst's early collages confirms this contrast. While Breton considers these collages in dialectical terms, where the contradiction of the realities brought together is transcended – or rather conjured away – in the metaphor of the spark (see *OCI*, 246), Aragon focuses on Ernst's works as contradictory. Revealing the tricks of 'notre magicien', Aragon decomposes the pictorial image into its constituent parts, as a play on illusion and reality: for example, in *L'Ascaride de sable* (1920), the rows of hats are seen simultaneously as literal and figurative, recognized as base matter and transformed into a procession of birds. Aragon, who considers the material presence of the pasted elements as an integral part of the signifying process, appears to have a clearer understanding of the dynamic interaction of collage elements than Breton who, by imposing his dialectical grid on Ernst's collage practice, tends to bypass the material reality of collage and its powers of resistance to transcendence. Collages are antagonistic, rather than accomplished dialectical constructions. Rather than exemplifying the surreal as a dialectical process, as formulated notably in the *Second Manifeste du surréalisme*, they concretize the concept of convulsive beauty elaborated in *L'Amour fou*, a concept of aesthetic paradox rather than dialectical fulfilment, where the co-presence of contradictory elements is foregrounded: 'La beauté convulsive sera

érotique-voilée, explosante-fixe, magique-circonstancielle ou ne sera pas' (*OCII*, 687).

More importantly, Breton's totalizing theory conflicts with the evidence of collage practice itself, since collage enacts process and performance, it dramatizes fragmentation and the arbitrary assemblage of elements, and it suggests the irretrievable presence of otherness, in dynamic tensions rather than oppositions resolved. The structure of collage, whether verbal or pictorial, is predicated on the conjunction of dissimilar elements, and the effect of *dépaysement* is dependent on the constantly reactivated contradiction between the terms of the image, as well as between the fragments and the framing mechanisms. Collage is analogous less to an alchemical product (where base matter has been successfully and fully transformed into gold) than to the gestation stage of the alchemical process, when elements are suspended between base matter and transmutation. Collage, as an experimental mode of production, resists closure, as indeed Breton recognized when he observed about the mobile space created in Ernst's collage universe: 'tout se cherche et est en voie d'articulation nouvelle' (*SP*, 168). Collage, as the site of tensions between material presence and semantic transformation, maintains and celebrates confusion.

Transgressive spaces

The play of contradiction and totality and the search for a resolution, a major feature of Breton's theoretical writings, are replaced in surrealist practice by the exploration of limits – of the frontiers between reality and dream,[19] the body and the non-body, the self and other, the animate and the non-animate, reified discourse and poetic illumination – an exploration which denies, destabilizes or simply displaces contradiction. Indeed, the focus throughout this study has foregrounded collage's exploration of limit-forms. This would suggest that collage occupies a space of transgression rather than a site of transcendence, and it can be viewed in the light of Foucault's remarks on the passage in twentieth-century thought from a focus on the dialectic to the transgressive: 'Peut-être un jour apparaîtra-t-elle aussi décisive pour notre culture, aussi enfouie dans son sol, que l'a été naguère, pour la pensée dialectique, l'expérience de la contradiction. Mais malgré tant de signes épars, le langage est presque entièrement à naître où la transgression trouvera son espace et son être illuminé.'[20] Surrealist practice, and primarily collage, was effectively in advance of surrealist theory, which remained based on essentially anti-rationalist notions, or on the dialectic as an exacerbated form of rationalism. Collage is not the random coupling of arbitrary elements – as postulated for instance in Breton's 'theory' of the image in his first *Manifeste*

– nor does it simply explore the reverse side of social discourses. It undoes them from within, by dismantling oppositions, challenging discursive hierarchies and parodying pictorial conventions. Grounded in excentricity and excess, collage is fundamentally transgressive, exploiting categories that question or collapse boundaries, by working at the edges or margins of linguistic, literary or art-historical codes, thumbing a nose at these codes rather than turning its back on them, and thereby disturbing unified identity, coherent systems or cohesive frames. And it is this provocativeness and ludic excess to which I have tried to respond throughout this study by foregrounding frames, whether the syntactical frames of surrealist games or the codified forms of proverbs, the enclosed spaces of the stage set, the rhetorical constructions of metaphor and metonymy, the literary codes of melodrama or the blason, the socially coded portrait, the perspectival codes of iconography, anatomical structures or art-historical icons. The parodic or poetic strategies of collage unsettle discursive and pictorial entities. Hence, the rhetorical reading of collage in chapter 4 focused on the surrealists' (ab)use of metaphorical frames and the generalized application of the analogical principle; Ernst's collage-novels were seen to push to greater excess the already excessive codes of melodrama; the exploration of identity as multiplicity or alterity charted the threat of dissolution of the self as a unified or 'instantaneous' entity; proliferating organic matter was shown to visibly undo the classical body, while the random couplings of limbs was seen to destabilize the anatomical frame. Collage thus forges a frontier- or 'para-' space, at the very margins of linguistic, rhetorical or pictorial codes, rather than the counter-space of opposition or the unified space of dialectical resolution. It articulates a discourse of excess, destabilizing and extending analogical principles, narrative suspense, anatomical constructs and the principle of identity. Conventions – the familiar *pays* – are exploited and subverted in the *dépaysement* of collage, as was seen for example in the strategies of rhetorical dis-figuring or anatomical dis-memberment analysed in earlier chapters. Recognition of the familiar landmarks (of literary or pictorial conventions) is the necessary prerequisite for dis-orientation.[21]

Collage operates at the periphery of signifying systems, and in this decentring process the fragment becomes an autonomous, essentially centrifugal element. The overt staging of breaks and seams resists retrieval by the application of a 'clé des chants', and it is viewed as fragmentary through a sense of pleasure in parts which replaces a nostalgia for the whole. 'Nous sommes à l'âge des objets partiels, des briques et des restes', writes Gilles Deleuze. 'Nous ne croyons plus à une totalité originelle ni à une totalité de destination.'[22] That privileging of enumeration or simple juxtaposition over fully integrated relations is central to collage in Loplop's side-by-side images, in Breton's listing of 'Bretons' in 'PSTT', in Aragon's unmerged voices in *Les*

Aventures de Télémaque, in the variations of *Une semaine de bonté* or the scattered limbs of the *cadavre exquis*. The 'one plus one plus one' of open-ended enumeration prevails over the closure of the dialectical equation, contiguity or the juxtaposition of discrete units prevails over analogy or a network of relations, metonymy prevails over metaphor.

The encounter of incongruous elements generates partial analogies and multiple meanings. Hence the emphasis should no doubt be laid on the *potential* opening onto meaning, on collage as a sign making signs – whence the importance of the indexical function in collages such as Ernst's *Rêves et hallucinations* – freed from the fixity of a definitive univocal meaning. Collage is an open semiotic space, where meanings are suggested by the cultural codes which cross and permeate it – yet which cannot exhaust collage nor be exhausted – instead of being a closed hieroglyph where the task of the critic is to 'draw out of the work the full complexity of meanings pre-packaged within it'.[23] This feeds not only the conceptual contradictions in surrealist writings but, more importantly, the tensions which animate collage itself, between dissociative metonymy and associative metaphor, between simple material assemblages and complex configurations, between partial fragmentation and an impossible totalization. The hieroglyphic chain of poetic or pictorial imagery is ultimately irreducible: partial chains of associations, links and breaks, can be uncovered, not some ultimate code which would complete that chain. Collage is read as a dynamic signifying process, not an attempt at retrieving the bricks or cementing the fissures.

The howling of monsters

In the final analysis, the reader or viewer encounters collage as a paradoxical reality, both presence and sign, an admixture of the physical and the metaphysical (in the sense given the term by de Chirico), a material entity and a semiotic reality. It is the oscillation between collage as feral matter and as figurative process which engenders – at both the stage of production and reception – a 'singulier pouvoir de frôlement' (*OCII*, 304), the sensual contact with material reality and the intellectual encounter with multiple meanings. It is the shock of the encounter of the irreducible fragments and parts which determines the disorientating effect of collage. Collage preserves on its surface the visible traces of the violence done to former units, like scars left by the grafting of part-bodies, and it is to this that Ernst refers in relation to his early collages: 'Mes œuvres de cette époque n'étaient pas destinées à séduire mais à faire hurler' (*E*, 412). In this he echoes the words of Breton who had observed about the elements brought together in Ernst's collages: 'Ceux d'entre nous qui ont assisté au développement de l'œuvre de Max Ernst leur

ont parfois vu prendre des attitudes hostiles, hurler de se trouver en présence' (*SP*, 26). Sensitive to this tension, R. Bozzetto alludes to the *noise* of the fantastic when referring to incongruous juxtapositions, not in the sense given it in communication theory (since aesthetic discourse is grounded on intentional incongruity), but 'comme simple signe de l'événement brut, du surgissement non localisable'.[24] Thus a reading of Duchamp's and Picabia's transformations of the *Mona Lisa* in their 'rectified ready-made' *LHOOQ* is not a way either of removing the moustache or reducing the figure to a fairground freak. Indeed, the invitation card sent by Duchamp for his 1965 exhibition, representing a playing card with the effigy of the Mona Lisa, and the inscription 'rasé LHOOQ', foregrounds the collage effect by pointing to its presence/absence: the moustache remains, incongruous, shocking, and the dynamic interaction between incongruous elements is indefinitely reactivated.

The reader or viewer encounters collage as a paradoxical presence, a material reality in the incipient stages of configuration, an embryonic monster in the phase of gestation, the body in the process of being reconfigured, the Self deterritorialized. Hence, the aesthetics of the shout – as a continuation of the primal scream enacted in Tzara's *Sept manifestes dada*, where the word 'hurle' is repeated across an entire page[25] – is conjoined with the aesthetics of the dream and its delusory promise of decipherment.[26] The monster is thus the collage figure *par excellence*: premised on transgression and excess, it is the figure of a constantly renewed tension, never fully articulated, composed of analogical mechanisms and anomalous clashes, provocative fragmentation and an always deferred totalization. All the critic can claim to have done is to have proposed a reflection on surrealist collage based on a few collage-monsters stalked at random, knowing that they will always escape the netting strategies of totalization. Collage-monsters – the dragon's tail in the bourgeois salon, the roccoco ornament in the Bauhaus, the white-haired revolver – remain irretrievable objects which will continue to howl long after the critic has fallen silent.

Fin et suite

Notes

1 Beyond painting

1 René Magritte, *Écrits complets*, Paris: Flammarion, 1979, p. 104.

2 André Breton, *Le Surréalisme et la peinture*, Paris: Gallimard, 1965, p. 168 (hereafter cited as *SP*).

3 *Littérature* 19 (May 1921), 17; reprint Jean-Michel Place, 1978. The same issue includes a text by Max Ernst on Hans Arp, and a reproduction of his collage *Relief tricoté*. The title of the exhibition echoes the invitation to Picabia's 1920 exhibition, also held Au Sans Pareil: 'Le mouvement Dada place ses capitaux dans les piqûres de Whisky soda chromatique et InVite . . .'

4 *Paris-Midi* (2 May 1921); Georges Oudard, 'Une soirée chez Dada', *Le Gaulois* (4 May 1921); 'Pauvres fous . . .', *Paris-Danse* (6 May 1921); Asté d'Esparbès, 'Un vernissage mouvementé', *Comoedia* (7 May 1921); 'Réception dadaïste', *Aux Écoutes* (8 May 1921). See the account of the event by Michel Sanouillet, *Dada à Paris* [1965], Paris: Flammarion, 1993, pp. 258–63.

5 This photograph appeared in *Comoedia* (7 May 1921).

6 Max Ernst, *Écritures*, Paris: Gallimard, 1970, p. 257 (hereafter cited as *E*).

7 André Déhal, *L'Ordre naturel* (12 May 1921).

8 H. J. Greenwall, 'Dada-ism let loose in a theatre!', *Daily Mail* (10 May 1921).

9 Jacques-Emile Blanche, 'Préface du professeur André Breton à la *Mise sous whisky marin* du Dr Max Ernst', *Comoedia* (11 May 1921).

10 Pierre Deval, 'Au-delà de la peinture', *Promenoir* 3 (May 21).

11 Eluard, who probably did not visit the exhibition, subsequently acquired several of the works exhibited; the Druot sales catalogue of 3 July 1924 lists the watercolours *Étamines et marseillaise de Arp* (1919) and *La Petite Fistule lacrymale* (1920), as well as the photomontage *Le Rossignol chinois* (1920). Jean-Charles Gateau, *Paul Eluard et la peinture surréaliste (1910–1939)*, Geneva: Droz, 1982, p. 357.

12 Louis Aragon, *La Peinture au défi. Exposition de collages* [Galerie Goemans], Paris: Corti, 1930; in *Les Collages* [1965], Paris: Hermann, 1993, p. 52 (hereafter cited as *C*). There was a controversy about the date of the exhibition. The invitation is dated 1920, but, according to Ernst (*E*, 42), the dadaists deliberately misdated the announcement to create confusion.

13 André Breton, *Entretiens* [1952], Paris: Gallimard (NRF Idées), 1969, p. 74 (hereafter cited as *En*).

14 See André Mercier, 'Aragon et Breton au "Sans Pareil"', in Jean Arrouye (ed.), *Ecrire et voir: Aragon, Elsa Triolet et les arts visuels*, Publications de l'Université de Provence, 1991, pp. 181–90.

15 André Breton, 'Max Ernst', *Les Pas perdus*, in *Œuvres complètes* I, Paris: Gallimard (Pléiade), 1988, pp. 245–6 (hereafter cited as *OCI*).

16 Rosalind Krauss, *The Optical Unconscious*, Cambridge, Mass. and London: MIT Press (October Books), 1993, p. 42.

17 Breton, whose own discourse on art tends to be wordy and hyperbolic, makes a surprising remark on the silence of art initiates: 'Quiconque a vraiment pénétré dans le temple de la peinture sait que les initiés communiquent peu par les mots. Ils se montrent – très mystérieusement pour le profane – tout au plus en le circonscrivant d'un angle de main, tel espace fragmentaire du tableau en échangeant un regard entendu' (*SP*, 171).

18 André Breton and Philippe Soupault, *Les Champs magnétiques*, first published in instalments in *Littérature* 8–10 (Oct.-Dec.1919); Paris: Au Sans Pareil, 1920.

19 Pierre Naville, 'Beaux-arts', *La Révolution surréaliste* 3 (15 April 1925), 27.

20 André Breton, 'Le surréalisme et la peinture', *La Révolution surréaliste* 4 (July 1925), 26–30, 6 (1 March 1926), 30–2 and 7 (15 June 1926); Paris: Gallimard, 1928.

21 J. H. Matthews, *The Imagery of Surrealism*, New York: Syracuse University Press, 1977, p. 101. Laurent Jenny refers to a 'rupture architextuelle' when diegetic or textual (rather than intertextual) breaks are present in the linguistic code rather than the message. Laurent Jenny, 'Sémiotique du collage intertextuel, ou la littérature à coups de ciseaux', in Groupe MU (eds.), *Collages*, *Revue d'esthétique* 3–4 (1978), Paris: Union Générale d'Editions (10/18), 1978, p. 177. Lucienne N'Goué's analysis of collage in Aragon's *Anicet* includes diegetic breaks such as a dream account, a film narrative, interior monologue, or the description of a painting. Lucienne N'Goué, 'Ribemont-Dessaignes, Aragon, Giraudoux: le collage ou le texte en relief', *Ecritures*, *Cahiers de sémiotique textuelle* 1 (1984), 93–105.

22 Michel Murat, 'Jeux de l'automatisme', in Michel Murat and Marie-Pierre Berranger (eds.), *Une pelle au vent dans les sables du rêve. Les écritures automatiques*, Presses Universitaires de Lyon, 1992, pp. 12 and 16.

23 In a letter to the art collector René Gaffé (16 March 1930), Breton states: 'La première partie seule du texte de Valéry a été contredite par nous, selon le procédé utilisé par Isidore Ducasse dans les *Poésies* à l'égard d'un certain nombre de maximes célèbres' (*OCI*, 1756). See Marie-Paule Berranger, 'Paul Valéry corrigé par André Breton et Paul Eluard', *Pleine marge* 1 (May 1985), 103–6.

24 Louis Aragon, *Traité du style*, Paris: Gallimard, 1928, pp. 187–8.

25 Tristan Tzara, 'Le papier collé ou le proverbe en peinture', *Cahiers d'art* 6:2 (1931), 64.

26 Max Ernst, 'Au-delà de la peinture', *Cahiers d'art* 12:6–7 (1937); in *Ecritures*, pp. 235–69.

27 Three of her photocollages are reproduced in Rosalind Krauss and Jane Livingstone (eds.), *Amour fou. Photography and Surrealism*, London: Arts Council, 1986, p. 209.

28 Michel Leiris, *C'est-à-dire*, Paris: Jean-Michel Place, 1992, p. 16.

29 René Magritte, *Ecrits complets*, p. 104.

30 *La Révolution surréaliste* 3 (15 April 1925), 30.

31 André Breton, *Œuvres complètes* II, Paris: Gallimard (Pléiade), 1992, p. 477 (hereafter cited as *OCII*).

32 See, among others, Laurent Jenny, 'La surréalité et ses signes narratifs', *Poétique* 16 (1973), 499–520; Rosalind Krauss, 'The Photographic Conditions of Surrealism', *October* 19 (Winter 1981), 3–34, also in *The Origins of the Avant-Garde and Other Modernist Myths*, Cambridge, Mass. and London: MIT Press, 1986, pp. 87–118.

33 See Béatrice Didier and Jacques Neefs (eds.), *Manuscrits surréalistes*, Paris: Presses Universitaires de Vincennes, 1995.

34 Claude Abastado, 'L'écriture automatique et l'instance du sujet', *Revue des sciences humaines* 184 (1981), 60.

35 '[D]'un coup nous pouvions nous transporter de la façon la moins attendue dans un plan tout autre, et déclencher une machine à bouleverser le monde', writes Aragon about the dadaists' state of mind in 1921. 'La grande saison Dada' [1923], *Opus international* 123–4 (April–May 1991), 109.

36 Herta Wescher, *Collage*, New York: Harry N. Abrams, 1968, p. 163.

37 Groupe MU, 'Douze bribes pour décoller (en 40.000 signes)', in *Collages*, p. 11.

38 Bert M.-P. Leefmans, '*Das Undbild*: A Metaphysics of Collage', *Collage, New York Literary Forum* 10–11 (1983), 186.

39 Florian Rodari, *Collage. Pasted, Cut and Torn Papers*, Geneva: Albert Skira (Editions d'Art), 1988, p. 90.

40 Henri Béhar, *Littéruptures*, Lausanne: L'Age d'homme (Bibliothèque Mélusine), 1988, p. 184.

41 See Gérard Dessons' discussion of collage and the intertextual principle, 'Dérive du collage en théorie de la littérature', in Bertrand Rougé (ed.), *Montages/Collages*, Publications de l'Universite de Pau (Rhétoriques des arts II), 1993, pp. 15–24.

42 Tristan Tzara, 'Pour faire un poème dadaïste', *Œuvres complètes* I, Paris: Flammarion, 1975, p. 382.

43 Denis Bablet, 'Exposé introductif', in Denis Bablet (ed.), *Collage et montage au théâtre et dans les autres arts durant les années vingt*, Lausanne: La Cité-L'Age d'Homme, 1978, p. 13.

44 Béhar, *Littéruptures*, p. 188.

45 Michel Décaudin, 'Collage, montage et citation en poésie', in Denis Bablet (ed.), *Collage et montage au théâtre et dans les autres arts durant les années vingt*, p. 32.

46 Letter to Bosmans (10 July 1963), in *Ecrits complets*, p. 566.

47 Wolfgang Babilas defines collage as 'diverses pratiques sémiotiques auxquelles est commun l'emprunt complet ou partiel d'éléments pré-existants, c'est-à-dire non créés par l'artiste ou l'écrivain lui-même, dans un nouveau contexte'. 'Le collage dans l'œuvre critique et littéraire d'Aragon', *Revue des sciences humaines* 151 (July–Sept.1973), 353.

48 Béhar distinguishes between 'collage pur' and 'collage transformé' (*Littéruptures*, p. 184). Babilas also distinguishes between 'collages purs' and 'réécritures' ('Le collage dans l'œuvre critique et littéraire d'Aragon', p. 353); however, his definition also encompasses 'traductions intersémiotiques', such as the transcription of a painting in verbal terms, which do not fit into the present definition of collage, since the cutting and pasting process is absent. Marie-Paule Berranger restricts her definition to the 'pure' form of collage: 'le collage n'implique aucune réécriture, ni transposition, ni transcription, ni changement de code'. *Dépaysement de l'aphorisme*, Paris: Corti, 1988, p. 123.

49 Murat distinguishes collage as a technique involving the assemblage of pre-existing

statements from 'collage référentiel' characterized as an effect. '*Corps et biens*, ou les beaux effets du surréel', *Information grammaticale* 25 (March 1985), 36.

50 Roman Jakobson, *Essais de linguistique générale*, Paris: Minuit, 1963, p. 210.

51 Groupe MU, 'Douze bribes pour décoller (en 40.000 signes)', *Collages*, p. 14.

52 Philippe Dubois, *Le Collage*, Paris: Centre National de Documentation Pédagogique, 1978, p. 18.

53 See for example: on cubist collage, Christine Poggi, *In Defiance of Painting: Cubism, Futurism, and the Invention of Collage*, New Haven and London: Yale University Press, 1992; on futurist collage, Marjorie Perloff, 'The Invention of Collage', *Collage, New York Literary Forum* 10–11 (1983), 5–47.

54 Jenny, 'Sémiotique du collage intertextuel', pp. 167, 165.

55 Groupe MU, 'Lecture du poème et isotopies multiples', *Le Français moderne* 42 (1974), 223.

56 For Wolfgang Iser the literary work has two poles: an artistic pole, encoded by the author, and an aesthetic pole, decoded or 'realized' by the reader. *The Implied Reader*, Baltimore and London: Johns Hopkins University Press., 1974, p. 274. For Alain-Michel Boyer the specificity of collage comes from its being both 'système de lecture et système d'écriture'. 'Les ciseaux savent lire', *Revue des sciences humaines* 196 (1984), 107.

57 Groupe MU, *Rhétorique générale*, Paris: Larousse, 1970, p. 147.

58 Jacques Bersani, 'Le champ du désespoir. Essai d'analyse de "La glace sans tain"', in Daniel Bougnoux and Jean-Jacques Gateau (eds.), *Le Surréalisme dans le texte*, Publication de l'Université des Langues et Lettres de Grenoble, 1978, p. 21. Bersani is referring to the difficulty of reading automatic texts.

59 Hal Foster, *Compulsive Beauty*, Cambridge, Mass. and London: MIT Press (October Books), 1993.

60 *Ibid.*, p. 81.

61 Jacques Dupin, *Joan Miró, la vie et l'œuvre*, Paris: Flammarion, 1961; trans. *Joan Miró. Life and Work*, New York: Harry H. Abrams, 1962, pp. 199–238; Anne Umland, 'Joan Miró's Collage of Summer 1929: "La peinture au défi"?', in *Essays on Assemblage*, New York: MOMA (Studies in Modern Art 2), 1992, pp. 43–77.

62 Béhar writes: 'L'essentiel du collage n'est pas dans l'énoncé final mais dans l'énonciation, c'est-à-dire dans une pratique gestuelle qui engage tout l'être.' *Littéruptures*, p. 202.

2 Cutting

1 'Le surréalisme et la peinture' (1926) (*SP*, 24–5).

2 See Sylvie Lecoq Ramond, 'Max Ernst (1891–1976), *Rêves et hallucinations*, 1926. Une acquisition du Musée d'Unterlinden à Colmar', *Revue du Louvre et des musées de France* 41: 5–6 (Dec. 1991), 89.

3 Ernst writes about his experience of World War I: 'Enfin, c'est la grande saloperie. Max est mobilisé. Artillerie de campagne. Quatre mois de caserne à Cologne, puis ouste! En plein merdier pendant quatre ans' (*E*, 25).

4 Reproduced in Dawn Ades, *Photomontage*, London: Thames and Hudson, 1986, p. 27.

5 These iconoclastic gestures continue. During the Paris student revolt in May 1968, Philippe de Champaigne's portrait of the Cardinal de Richelieu at the Sorbonne had

the following graffiti scribbled over it: 'Détournons l'art de sa fonction de mortification. L'art est mort vive la révolution. L'humanité ne sera heureuse que quand le dernier cardinal aura été pendu avec les tripes du dernier homme.' Reproduced in *Opus international* 15 (1969), 10.

6 Groupe MU, 'Douze bribes pour décoller (en 40.000 signes)', in *Collages*, p. 13.

7 This idea is reiterated in 'Introduction au discours sur le peu de réalité' (1925): 'Mais, je l'ai déjà dit, les mots, de par la nature que nous leur reconnaissons, méritent de jouer un rôle autrement décisif. Rien ne sert de les modifier puisque, tels qu'ils sont, ils répondent avec cette promptitude à notre appel. Il suffit que notre critique porte sur les lois que président à leur assemblage' (*OCII*, 275–6).

8 Breton had already formulated a similar idea in 'Le surréalisme et la peinture': 'Il ne s'agissait de rien moins que de rassembler ces objets disparates selon un ordre qui fût différent du leur et dont, à tout prendre, ils ne paraissent pas souffrir' (*SP*, 26).

9 Jindrich Styrsky, in a lecture given at Prague University (1938), in *Styrsky Toyen Heisler* [exhibition catalogue], Paris: Centre Georges Pompidou, 1982, p. 83.

10 Roger Cardinal, 'Collecting and Collage-making: The Case of Kurt Schwitters', in John Elsner and Roger Cardinal (eds.), *The Cultures of Collecting*, London: Reaktion Books, 1994, p. 68.

11 *Sitzender Buddha (demandez votre médecin)* (1920) uses a diagram of the brain, with parts painted out and collage elements added, *Jeune Homme chargé d'un fagot fleurissant* (*c*.1920) is based on an anatomical chart, while *Das Schlafzimmer des Meisters (la chambre à coucher de max ernst)* (*c*.1920) transforms an elementary school teaching chart with its rows of everyday objects, animals and plants.

12 'The fetishistic shine of these products has long since dulled', writes Foster of the imaginative charge of such catalogue images; 'what remains are the intentions of wish and anxiety with which they were once invested'. *Compulsive Beauty*, pp. 179, 182.

13 J. J. Sweeney, 'Joan Miró: Comment and Interview', *Partisan Review* 25:2 (Feb. 1948), 210. Christian Zervos writes of Miró's technique of transformation of images: 'En regardant les images qu'il a collées sur les murs de son atelier, Miró pratique des ajustements de formes qui lui font transformer l'objet vu en objet imaginé.' 'Joan Miró', *Cahiers d'art* 9:1–4 (1934), 17.

14 Dupin, *Joan Miró. Life and Work*, p. 253. In the 1989 exhibition *Joan Miró. Paintings and Drawings 1929–41* (Whitechapel Gallery, London), three of these collages were exhibited alongside the 'finished' oil-paintings.

15 André Breton, 'En marge des *Champs magnétiques*', *Change* 7 (1970), 9–29.

16 Pierre Reverdy, a purist in matters of selection of poetic material, criticized Breton for his appropriation of Rimbaud. Reverdy, writes Aragon, 'a fait la belle découverte que (dans *Forêt Noire*), *Que salubre est le vent* est de Rimbaud et accuse AB de prendre ses vers un peu partout'. 'Lautréamont et nous', *Lettres françaises* 1186 (8–14 June 1967), 9. This may have prompted the footnote '*RIMBAUD PARLE*' added by Breton to subsequent publications of the poem.

17 Jean-Jacques Lecercle, analysing Heidegger's view on paratax, argues that far from being the sign of the absence of linguistic sophistication, paratax 'is the language of thought. A paratactic sentence speaks in its interstices'. *Philosophy of Nonsense. The Intuitions of Victorian Nonsense Literature*, London and New York: Routledge, 1994, p. 52.

18 Tzara, 'Le papier collé ou le proverbe en littérature', p. 63.

19 For a documented analysis of surrealism and advertising, see David A. Steel, 'Surrealism, Literature of Advertising and the Advertising of Literature in France 1910–1930', *French Studies* 41:3 (July 1987), 283–97.

20 Louis Chéronnet, 'La publicité moderne: la gloire du panneau', *L'Art vivant* 2 (15 Aug. 1926), 618.

21 'Voyageurs peu clairvoyants, nos contemporains ne sentent pas la beauté des panneaux réclames faisant la haie le long d'une vie ferrée ou miraculeusement disposés au centre d'un glacier. Le mot "Cadum", lumineux attestateur d'éternité mieux que les chênes perclus, la bouteille "Mercier", "Citroën" dans les nuages, mythologie neuve, ont transformé l'horizon.' Robert Desnos, 'Max Ernst ou le nouveau testament' [c.1923], in *Ecrits sur les peintres*, Paris: Flammarion (Textes), 1984, pp. 46–7.

22 André Breton, letter to Aragon (17 April 1919), quoted in Aragon, 'Lautréamont et nous', p. 7.

23 See for example the facsimile reproduction of a collage-letter (13 Jan. 1919) in Georges Sebbag, *L'Imprononçable Jour de sa mort Jacques Vaché janvier 1919*, Paris: Jean-Michel Place, 1989.

24 Georges Hugnet, *La Septième Face du dé*, Paris: Jeanne Bucher, 1936, plate 10.

25 Paul Nougé, *Histoire de ne pas rire*, Lausanne: Age d'Homme (Cistre-Lettres différentes), 1980, p. 240.

26 E. L. T. Mesens, 'Que faut-il pour faire un collage?', *Quadrum* 16 (1964), 115–22.

27 Arthur Rimbaud, *Œuvres*, Paris: Garnier, 1960, p. 228.

28 Walter Benjamin, 'Surrealism. The Last Snapshot of the Bourgeoisie' [1929], in *One Way Street and Other Writings*, London: Verso, 1979, p. 229.

29 Charles Baudelaire, 'Le vin des chiffonniers', in *Œuvres complètes* I, Paris: Gallimard (Pléiade), 1975, p. 381.

30 Tristan Tzara, 'Manifeste dada 1918', *Dada* 3 (Dec. 1918); *Œuvres complètes* I, p. 362.

31 Elizabeth Wright analyses the *unheimlich* in surrealism as an ambivalent state, both a rigidified moment and a moment in flux: 'The uncanny world of the Surrealists catches this moment, sometimes pessimistically, as something gone rigid, sometimes more optimistically, as something in flux, that suggests the possibility of change.' 'The Uncanny and Surrealism', in Peter Collier and Judy Davies (eds.), *Modernism and the European Unconscious*, Cambridge: Polity Press, 1990, p. 265.

32 Reproduced in Gateau, *Paul Eluard et la peinture surréaliste*, p. 221.

33 Anatole Jakowski, 'Joan Miró', *Cahiers d'art* 9:1–4 (1934), 58.

34 'La carte postale a beaucoup utilisé, et le plus souvent de façon très heureuse, le collage, né d'ailleurs bien avant elle. Voir: la famille de centaures, la tête de petite fille dans une boîte à sardines, la Joconde, les fils télégraphiques, le baiser dans un monocle, Napoléon III, la course cycliste avec perspective renversée.' Paul Eluard, 'Les plus belles cartes postales', *Minotaure* 3–4 (Dec. 1934).

35 Montages of familiar city views juxtaposed with incongruous images were popular in turn-of-the-century postcards, as in a view of Picadilly Circus, where the clichéd London landmark is juxtaposed with the canals of Venice. See Ades, *Photomontage*, p. 108.

36 Penrose's postcard-collages include *The Real Woman* (1937), analysed in chapter 7, *Femme-phare* (1937), *Elephant Bird* (1938) and *Magnetic Moths* (1938).

3 Pasting

1 'Pour faire un poème dadaïste' (1918), *Œuvres complètes* I, p. 382.

2 André Breton, *La Clé des champs*, Paris: Livre de poche (Biblio essais), 1991, p. 181.

3 See Isabelle Monod-Fontaine, 'Le tour des objets', in *André Breton. La beauté convulsive*, Paris: Centre Georges Pompidou, 1991, pp. 64–8, and the photographs of Breton's studio, pp. 69–83.

4 André Breton, 'Lettre à Robert Amadou', *Perspective cavalière*, Paris: Gallimard, 1970, p. 42.

5 *Réveil du 'Cerveau de l'enfant'* was reproduced in *L'Almanach surréaliste du demi-siècle* (1950).

6 *Documents* 1:4 (1929).

7 James Clifford, 'On Ethnographic Surrealism', *Comparative Studies in History* 23:4 (1981); in *Predicaments of Culture: Twentieth-Century Ethnography, Literature and Art*, Cambridge, Mass.: Harvard University Press, 1988, p. 132.

8 Groupe MU, *Rhétorique de la poésie. Lecture linéaire lecture tabulaire*, Paris: Éditions Complexe, 1977; Seuil (Points), 1990, p. 138.

9 Rodari, *Collage. Pasted, Cut and Torn Papers*, p. 9.

10 *Les Plaisirs illuminés* presents three boxes aligned across the space of the canvas, enclosing scenes unrelated to the rest of the painting, either pasted (the picture of the church in the left-hand box is a photograph) or painted. A similar combination of boxed shapes with pasted elements is found in *Les Premiers jours du printemps*, where a patterned paper, an advertisement for a shipping line, the photograph of a baby, collaged onto the oil-painting, can only be distinguished at close range from the meticulously painted elements.

11 William Rubin, *Dada and Surrealist Art*, New York: Harry N. Abrams, 1968, p. 218.

12 Michael Riffaterre, 'Semantic Incompatibilities in Automatic Writing', in Mary Ann Caws (ed.), *About French Poetry from Dada to 'Tel Quel'*, Detroit: Wayne State University Press, 1974, pp. 223–41.

13 Louis Aragon, 'Contribution à l'avortement des études maldororiennes', *Le Surréalisme au service de la révolution* 2 (Oct. 1930), 24.

14 Stéphane Mallarmé, 'Le mystère dans les lettres', in *Œuvres complètes*, Paris: Gallimard (Pléiade), 1945, p. 385.

15 Roger Shattuck, in 'The Art of Assemblage' [symposium 1961], in *Essays on Assemblage*, New York: MOMA (Studies in Modern Art 2), 1992, p. 127.

16 Umbro Apollonio (ed.), *Futurist Manifestos*, London: Thames and Hudson, 1973, pp. 95–106.

17 Tristan Tzara, 'Pour faire un poème dadaïste', *Œuvres complètes* I, p. 382.

18 For José Pierre, while Tzara aims at the disintegration of language and the destruction of the poem, Breton 'est à la recherche de la continuité interne du poème, du fil magique de la poésie, de la cohérence souterraine du lyrisme', even in a poem as broken up as 'Forêt Noire'. Here is a clear example of Breton's poetry being read in the light of the (hypothetical) *flow* of automatism, as discussed in chapter 1. 'Le lyrisme exalté ou refusé: Breton et les dadaïstes zurichois', *Champs des activités surréalistes* 16 (June 1982), 43.

19 'La syntaxe est un moyen de création littéraire', Reverdy had written in 1918 as a retort to his critics. 'Syntaxe', *Nord-Sud* 14 (April 1918); reprint Paris: Jean-Michel Place, 1980;

in *Nord-Sud*, *Self-Defence et autres écrits sur l'art et la poésie (1917–1926)*, Paris: Flammarion, 1975, p. 82.

20 Aragon, *Traité du style*, p. 109. A number of critics of surrealism emphasize the importance of syntax: for Henri Meschonnic, for example, '[l]es surréalistes sont des syntaxiers', *Pour la poétique* I, Paris: Gallimard, 1970, p. 102–3. See also André Mercier, 'André Breton et l'ordre figuratif dans les années 20', in *Le Retour à l'ordre dans les arts plastiques et l'architecture, 1919–1925*, St-Etienne: CIEREC (Travaux VIII), 1975, pp. 299–304.

21 Only a third of the texts from the original manuscript of *Poisson soluble* were published by Breton in 1924. The remaining texts, which include eleven collage-poems, were published for the first time in 1988 in the first volume of the Pléiade edition of Breton's works (*OCI*, 514–99). The collage-poems are texts 33, 48–51, 54–8, 61–2.

22 'Poses fatales' was originally published, without a title, in *Proverbe* 2 (1 March 1920). It is made up of nine sentences, laid out in square or rectangular units, with various type-faces. Several sentences had already appeared in *Les Champs magnétiques*.

23 Breton in a letter to Aragon (20 June 1917), quoted in Aragon, 'Lautréamont et nous', *Lettres françaises* 1185 (1–7 June 1967), 8.

24 Matthews, *The Imagery of Surrealism*, p. 71. He gives examples of titles of *recueils*: *Les Paupières de verre* (Maurice Henry), *Un temps de petite fille* (Georges Henein), *La Chaise de sable* (Marcel Mariën). Since Matthews' examples are isolated titles, they provoke maximum polyvalence because of the absence of contextualization.

25 David Scott, *Pictorial Poetics: Poetry and the Visual Arts in Nineteenth-Century France*, Cambridge University Press, 1988, p. 116.

26 *La Révolution surréaliste* 9–10 (1 Oct. 1927), 11 and 24. Several pictorial *cadavres exquis* were also reproduced in this issue. For other examples, see *Le Surréalisme au service de la révolution* 4 (Dec. 1931), 12.

27 Paul Eluard, *Œuvres complètes* I, Paris: Gallimard (Pléiade), 1968, p. 991. Xavière Gauthier refers to such activities in more prosaic terms as 'une sorte de partouze intellectuelle'. *Surréalisme et sexualité*, Paris: Gallimard (Idées), 1971, p. 225.

28 Similar structures, combining syntactic coherence and semantic incoherence, are found in the poetry of Breton and Péret. See Gerald Mead, 'A Syntactic Model in Surrealist Style', *Dada/Surrealism* 2 (1972), 33–7, and Richard Stamelman, 'The Relational Structure of Surrealist Poetry', *Dada/Surrealism* 6 (1976), 59–78.

29 Julien Gracq, *André Breton: quelques aspects de l'écrivain*, Paris: Corti, 1948, p. 195.

30 *Comme il fait beau!*, *Littérature* 9 (1 Feb. 1923), 6–23.

31 Two of these collages, untitled, are reproduced in David Sylvester, *René Magritte*, London: Thames and Hudson, 1992, pp. 87 and 89.

32 Grace Glueck, 'A Bottle is a Bottle', *New York Times* (19 Dec. 1965).

33 'Magritte alienates the onlooker. His inconsistent perspectives and insubstantial objects are irreconcilable with the idea of an "open window" and the viewer is left on the periphery of a world he cannot enter.' Silvano Levy, 'René Magritte and Window Display', *Artscribe* 28 (March 1981), 28.

34 François Rigolot, 'Le poétique et l'analogique', *Poétique* 35 (Sept. 1978), 264.

4 Cocking a snook

1 *La Nuit remue*, Paris: Gallimard, 1967, pp. 97–8.

2 See also Aragon's description of a still-life by Bleu[-Picasso]: 'une nature morte laissa voir au jeune homme dans le jeu ambigu de la guitare et des bouteilles au centre du guéridon les formes jointes d'un couple amoureux'. *Anicet ou le panorama* [1921], Paris: Gallimard, 1951, pp. 136–7.

3 'Recherches expérimentales. C. Sur les possibilités irrationnelles de pénétration et d'orientation dans un tableau', *Le Surréalisme au service de la révolution* 6 (May 1933), 13–16.

4 Norman Bryson, *Looking at the Overlooked. Four Essays on Still-Life Painting*, London: Reaktion Books, 1990, p. 128.

5 Roland Barthes, 'Le monde-objet', in *Essais critiques*, Paris: Seuil (Points), 1964, p. 21.

6 Louis Aragon, *Le Paysan de Paris*, Paris: Gallimard, 1926, p. 60 (hereafter cited as *PP*).

7 Bryson, *Looking at the Overlooked*, pp. 60 and 61.

8 Philip Fisher underlines the importance of still-life as collection or assemblage in modern art, 'a side-by-side set of loosely united matters for attention'. While he claims that the refusal of composition is also a refusal of narrative, I contend that the absence of explicit links between discrete signifiers does not imply the absence of meta-phorical and narrative codes. Philip Fisher, *Making and Effacing Art. Modern American Art in a Culture of Museums*, Oxford University Press., 1991, p. 53.

9 Mihai Nadin and Vicu Bugarin, 'Collage et métaphore', *Revue d'esthétique* 2 (1970), 138.

10 Eluard, preface to *Ralentir travaux* [1930], in *Œuvres complètes* I, p. 270.

11 Peter Kral, 'L'age du collage, suite et fin', *Phases*, 2:5 (1975), 98–117.

12 Rosalind Krauss, among other critics, has convincingly argued that Picasso's early col-lages are also composed of signs in a semantic field. 'In the Name of Picasso', in *The Originality of the Avant-Garde and Other Modernist Myths*, pp. 23–40.

13 Max Ernst, 'Comment on force l'inspiration', *Le Surréalisme au service de la révolution* 6 (15 May 1933), 45. This article was first published in English, under the title 'Inspiration to Order', *This Quarter* 5:1 (Sept. 1932), 79–85.

14 William A. Camfield, *Max Ernst. Dada and the Dawn of Surrealism*, Munich: Prestel, 1993, p. 97.

15 J.-A. Boiffard, P. Eluard, R. Vitrac, 'Préface', *La Révolution surréaliste* 1 (1 Dec. 1924), 2.

16 Ernst, 'Comment on force l'inspiration', p. 45.

17 Styrsky's anti-ecclesiastical collages include *Le Prêtre et l'enfant de choeur*, *Cardinal améri-cain* and *Le Petit Jésus*, all dated 1941. Ernst's *Tambour du corps de garde à pied de l'année céleste en-dimanché représenté de face* (c.1920) is an overpainting of a page from a pedagogical manual (*Bibliotheca Paedagogica* (1914), p. 172) which combines three illustrations: a missionary group, a map of Palestine and clerical instruments. Reproduced in Camfield, *Max Ernst. The Dawn of Surrealism*, fig. 70 and p. 339.

18 Man Ray, *Autoportrait* [1963], Paris: Seghers, 1986, p. 236.

19 Paul Eluard and Benjamin Péret, *152 proverbes mis au goût du jour*, Paris: La Révolution Surréaliste, 1925; in Eluard, *Œuvres complètes* I, pp. 153–61.

20 Berranger, *Dépaysement de l'aphorisme*, p. 124.

21 *Cannibale* (25 April 1920).

22 Tristan Tzara, *L'Invention* 1, *Proverbe* 6 (1 July 1920). See Berranger, *Dépaysement*, p. 125.

23 Linda Hutcheon, *A Theory of Parody. The Teachings of Twentieth-Century Art Forms*, New York and London: Methuen, 1985, p. 6.

24 Marguerite Bonnet, *André Breton. Naissance de l'aventure surréaliste*, Paris: Corti, 1975, p. 146.

25 Ruth Amossy and Elisheva Rosen, *Les Discours du cliché*, Paris: CDU et SEDES, 1982, p. 128.

26 Léon Somville analyses the *incipit* of Breton's *Manifeste du surréalisme* in 'Pour une théorie des débuts. Une analyse de l'incipit de l'œuvre d'André Breton', in Daniel Bougnoux and Jean-Charles Gateau (eds.), *Le Surréalisme dans le texte*, pp. 41–57.

27 Salvador Dali, 'L'ane pourri', *Le Surréalisme au service de la révolution* 1 (July 1930), 10; quoted by Ernst in 'Comment on force l'inspiration', p. 44.

28 A number of these pasted *cadavre exquis* were on show in the 1995 exhibition *Dessins surréalistes. Visions et techniques* (Centre Georges Pompidou, Paris). See exhibition catalogue, pp. 74–9.

29 André Breton, *Signe ascendant* [1947], Paris: Gallimard (NRF Poésie), 1968, p. 10 (hereafter cited as *SA*).

30 See Jean-Michel Adam's critique of the overrating of metaphorical processes among critics of surrealism. 'Relire "Liberté" d'Eluard', *Littérature* 14 (May 1974), 100.

31 Groupe MU, *Rhétorique générale*, p. 118.

32 Conroy Maddox, letter to the Tate Gallery on the purchase of *The Strange Country*, in *Catalogue of Acquisitions, 1970–72*, London: Tate Gallery, 1972, p. 141; in Silvano Levy (ed.), *Conroy Maddox. Surreal Enigmas*, Keele University Press, 1995, p. 46.

33 Groupe MU, *Rhétorique de la poésie*, p. 217.

34 Pierre Reverdy, 'L'image', *Nord-Sud* 13 (March 1918); in *Nord-Sud, Self-Defence*, p. 73.

35 Aragon, *Traité du style*, p. 190.

36 Groupe MU define metonymy as 'contiguïté par inclusion au sein d'un même ensemble'. *Rhétorique de la poésie*, p. 80.

37 *Ibid.*, p. 72.

38 Groupe MU, *Rhétorique générale*, p. 119.

39 The Devetsil group announced their wish to collaborate with the Paris surrealist group in a letter to Breton published in *Le Surréalisme au service de la révolution* 5 (15 May 1933), 31.

40 'The uncomfortable realism of what amounts to an evisceration is amplified by the contrast between the cruelly descriptive treatment of the grafted organs and the mincing banality of the illustration taken from an album of pictures'. Rodari, *Collage. Pasted, Cut and Torn Papers*, pp. 102–3.

41 Philippe Dubois, 'Esthétique du collage: un dispositif de ruse', *Annales d'esthétique* 15–16 (1976–7), 78.

42 Paul Nougé, 'Les images défendues', *Le Surréalisme au service de la révolution* 5 (15 May 1933), 28; in *Histoire de ne pas rire*, p. 253.

43 *La Revolution surréaliste* 3 (15 April 1925), 28.

44 Eluard, *Œuvres complètes* I, p. 971.

45 'Il suffit que le délire d'interprétation soit arrivé à relier le sens des éléments hétérogènes qui couvrent un mur, pour que déjà personne ne puisse nier l'existence d'un tel lien'. Dali, 'L'ane pourri', p. 10.

46 'Central to collage is the refusal to suppress the alterity of elements temporarily united in its structure'. Marjorie Perloff, *The Futurist Movement: Avant-Garde, Avant-*

Guerre, and the Language of Rupture, Chicago and London: University of Chicago Press, 1986, p. xix.

47 Zervos, 'Joan Miró', p. 18.

48 Prats was a Barcelona hatter, a former fellow-student at art school and friend of Miró. He would entertain his artist friends in a room at the back of his boutique, filled with avant-garde journals and books. Miró exchanged works against English-style quality hats which he never wore.

49 Quoted in Bonnet, *André Breton. Naissance de l'aventure surréaliste*, p. 158.

50 Sanouillet, *Dada à Paris*, p. 149.

51 Bonnet, *André Breton. Naissance de l'aventure surréaliste*, pp. 158–9.

52 This sentence was published in *Dada* 6 (Feb. 1920), alongside other 'formules, aphorismes, nouvelles'.

53 Tzvetan Todorov, 'Une complication de texte: les *Illuminations*', *Poétique* 34 (1978), 249.

54 Desnos, 'Peinture surréaliste' [1929], in *Ecrits sur les peintres*, p. 109.

55 Tzvetan Todorov, 'Introduction à la symbolique', *Poetique* 11 (1972), 283.

56 Styrsky, in *Styrsky Toyen Heisler*, p. 83.

57 Jean-Jacques Lecercle, *The Violence of Language*, London and New York: Routledge, 1990, p. 30.

58 *La Révolution surréaliste* 9–10 (1 Oct. 1927), 64.

59 Lecercle, *Philosophy of Nonsense*, p. 48.

5 Between Fantômas and Freud

1 'Le surréalisme et la peinture' (1926) (*SP*, 19).

2 Breton, *La Clé des champs*, pp. 21–6.

3 *Ibid.*, p. 294.

4 Antonin Artaud, '*La coquille et le clergyman*', in *Œuvres complètes* III, Paris: Gallimard, 1978, p. 20.

5 Benjamin Péret, 'Hier en découvrant l'Amérique', first published in . . . *Et les seins mouraient* . . ., Marseille: Cahiers du Sud, 1929, double page between pp. 76 and 77.

6 Roger Roughton, 'Final Night of the Bath', *Contemporary Poetry and Prose* 8 (Dec. 1936), 166.

7 André Breton and Paul Eluard, 'Textes surréalistes. Jeu à Castellane', *Pleine marge* 12 (Dec. 1990), 33.

8 Louis Aragon, *Le Mouvement perpétuel* [1920–4], Paris: Gallimard (NRF Poésie), 1970, p. 94.

9 Stamelman, 'The Relational Structure of Surrealist Poetry', p. 71.

10 Hugnet, *La Septième Face du dé*.

11 Luis Buñuel and Salvador Dali, 'Un chien andalou', *La Révolution surréaliste* 12 (Dec. 1929), 34–6.

12 Benjamin Péret, 'La nature dévore le progrès et le dépasse', *Minotaure* 10 (1937), 20.

13 Arrested narrative is also suggested in the nine photomontages which illustrate Antonin Artaud and Roger Vitrac's brochure 'Le théâtre Alfred Jarry et l'hostilité publique' (1930), representing dramatic and enigmatic *mises-en-scène*.

14 This collage, under the title *Modern Times*, was shown in the exhibition *Unity of Artists for Peace, Democracy and Culture Development* at Grosvenor Square in London in 1937.

15 Gateau, *Paul Eluard et la peinture surréaliste*, p. 226.

16 Robert Desnos, 'Imagerie moderne', *Documents* 1:7 (1929), 377–8.

17 Jacques Brunius, *En marge du cinéma français*, Lausanne: L'Age d'Homme, 1987, pp. 76–7.

18 Roger Cardinal, 'Surrealist Beauty', *Forum for Modern Language Studies* 9:4 (Oct. 1974), 356.

19 Similarly, Elizabeth Legge writes of Ernst's collage-paintings that they are 'situated just outside intelligibility, but still in a suburb of signs'. *Max Ernst. The Psychoanalytical Sources*, Ann Arbor and London: UMI Research Press, 1989, p. 183.

20 Among other collage narratives alluding to paintings are Desnos and Breton's preface to the exhibition 'La peinture surréaliste' (Galerie Pierre, 1925), based on a montage of the titles of paintings displayed (*OCI*, 915), and Ernst's text 'Au-delà de la peinture' (1936), where he lists the titles of his works, creating a fantastic narrative (*E*, 243–8).

21 Max Ernst, *Une semaine de bonté*, Paris: Editions Jeanne Bucher, 1934; reprint New York: Dover Publications, 1976. All references in the text are to the 1976 reprint. Ernst's other collage-novels are *La Femme 100 têtes*, Paris: Carrefour, 1929, and *Rêve d'une petite fille qui voulut entrer au Carmel*, Paris: Carrefour, 1930.

22 John Russell, *Max Ernst. Life and Work*, New York: Harry N. Abrams, 1967, pp. 192 and 200.

23 Solomon Telingater, typographer and constructivist graphic artist, had experimented in a similar kind of 'cinebook', *Komsomolya* (1928), based on a poem by A. Bezymiensky. It was composed of a sequence of pages like moving picture frames, to be read and viewed simultaneously. Telingater also collaborated with Lissitzky in the production of the Polygraphic Exhibition guidebook where different sections were designated by colour codes. Szymon Bojko, *New Graphic Design in Revolutionary Russia*, New York and Washington: Praeger, 1972, pp. 25–7.

24 Reproduced in Werner Spies, *Max Ernst. Collages. The Invention of the Surrealist Universe*, London: Thames and Hudson, 1991, figs. 792 and 793.

25 John G. Cawelti, *Adventure, Mystery, and Romance. Formula Stories as Art and Popular Culture*, Chicago and London: University of Chicago Press, 1976, p. 16.

26 *Ibid.*, p. 35.

27 Mary Ann Caws refers to *Une semaine de bonté* as 'a parody of narrative structures, notably of the codes of melodrama'. *The Art of Interference. Stressed Readings in Verbal and Visual Texts*, Cambridge: Polity Press, 1989, p. 106. Evan M. Maurer, on the contrary, for whom Ernst's collage-novels 'attempt to approximate complex and emotionally charged nineteenth century dramas', does not consider these codes parodic. 'Images of Dream and Desire: the Prints and Collage Novels of Max Ernst', in Robert Rainwater (ed.), *Max Ernst. Beyond Surrealism. A Retrospective of the Artist's Books and Prints*, the New York Library and Oxford University Press, 1986, p. 59.

28 Cawelti, *Adventure, Mystery, and Romance*, p. 17.

29 Spies, *Max Ernst. Collages*, p. 230.

30 Margot Norris, 'Max Ernst: The Rhetorical Beast of the Visual Arts', in *Beasts of the Modern Imagination*, Baltimore and London: Johns Hopkins University Press, 1985, p. 157.

31 Richard Brooks, *The Melodramatic Imagination. Balzac, Henry James, Melodrama, and the Mode of Excess*, New York and London: Yale University Press, 1976, p. 48.

32 Eric Bentley, *The Life of the Drama*, New York: Atheneum, 1975, p. 204.

33 Brooks, *The Melodramatic Imagination*, p. 41.

34 Caws, *The Art of Interference*, pp. 106–7. On framed images as wish fulfilment, see Werner Spies, *Max Ernst Loplop. The Artist's Other Self*, London: Thames and Hudson, 1983, p. 35.

35 'We are apparently viewing a visual transformation of the 180 most poignant sentences cited from an imaginary novel . . . in the absence of words, each collage, as well as the sequence in which it appears, simultaneously produces the impression of shock and hermeticism.' Renée Riese Hubert, 'The Fabulous Fictions of Two Surrealist Artists: Giorgio de Chirico and Max Ernst', *New Literary History* 4:1 (Aut. 1972), 165.

36 Maurer, 'Images of Dream and Desire', p. 83.

37 A similar scenario appears in Ernst's contribution *Desire* to the film *Dreams that money can buy* (1947), in a sequence where the male protagonist manages to tear the bars apart, make his way through an underground passage, and reach the woman on the bed. The film is also parodic: the woman on the bed blows on, then swallows, a small ball like a silent speech bubble! And the man hears, over the phone, and later when he leans over the woman, a medley of female voices – the chatter of the unconscious?

38 Albert Cook, 'Space, Time and the Unconscious in the Collage Novels of Max Ernst', in *Dimensions of the Sign in Art*, Hanover and London: University Press of New England, 1989, p. 127.

39 Brooks, *The Melodramatic Imagination*, p. 202.

40 *Manomètre* 5 (Feb. 1924).

41 Jean Epstein, 'Freud, ou le nic-cartérianisme en psychologie', *L'Esprit nouveau* 16 (1922), 1864.

42 Foster, *Compulsive Beauty*, p. 176.

43 Norris, *Beasts of the Modern Imagination*, p. 159.

44 M. E. Warlick, 'Max Ernst's Alchemical Novel: *Une semaine de bonté*', *Art Journal* 46 (Spring 1987), 61–73.

45 Ernst's conscious elaboration of Freudian imagery recalls the mechanisms of jokes. See Charlotte Stokes, 'Collage as Jokework: Freud's Theories of Wit as Foundation for the Collages of Max Ernst', *Leonardo* 15:3 (1982), 199–204; in Katherine Hoffman (ed.), *Collage: Critical Views*, Ann Arbor and London: UMI Research Press, 1989, pp. 253–69.

46 Siegfried Giedion, *Mechanization Takes Command*, New York: W. W. Norton, 1948, p. 339.

47 Rosalind Krauss, *Passages in Modern Sculpture*, Cambridge, Mass.: MIT Press, 1981, p. 123.

6 Masking

1 'Max Ernst' (1921) (*OC* I, 246).

2 'Comment on force l'inspiration' (1932), *Le Surréalisme au service de la révolution* 6 (15 May 1933), 45.

3 Ernst, 'Comment on force l'inspiration', p. 43.

4 Paris, 9 November 1994.

5 Breton, 'En marge des *Champs magnétiques*'.

6 Philippe Audoin, Preface to André Breton, *Les Champs magnétiques*, Paris: Gallimard (NRF Poésie), 1971, p. 18.

7 Béhar, *Littéruptures*, p. 183.

8 Gérard Durozoi, *André Breton. L'écriture surréaliste*, Paris: Larousse, 1974, p. 189.

9 Guy Rosolato, *Essais sur le symbolique*, Paris: Gallimard (Tel Quel), 1964, p. 177.

10 Antoine Compagnon, *La Seconde Main ou le travail de la citation*, Paris: Seuil, 1979, p. 361.

11 Comte de Lautréamont and Germain Nouveau, *Œuvres complètes*, Paris: Gallimard (Pléiade), 1979, p. 285.

12 Le Roy C. Breunig, 'Kolar/Collage', *Collage, New York Literary Forum* 10–11 (1983), III.

13 Sanouillet, *Dada à Paris*, p. 533.

14 See Louis Aragon, 'L'Homme coupé en deux: un commentaire en marge des *Champs magnétiques*', *Lettres françaises* 1233 (9–15 May 1968), 3–9.

15 Louis Aragon, *Les Aventures de Télémaque* [1921], Paris: Gallimard, 1966.

16 Parody, as the reworking of a text, can be considered as a category of collage, while pastiche, which is the imitation of a style, is not relevant to collage. See Gérard Genette, *Palimpsestes. La littérature au second degré*, Paris: Seuil (Poétique), 1982, p. 32. Quotation is discussed below as a form of anti-collage.

17 François Fénelon, *Les Aventures de Télémaque*, Paris: Classiques Garnier, 1994.

18 Louis Aragon, *Je n'ai jamais appris à écrire ou les incipit*, Geneva: Skira, 1969, p. 20.

19 Genette, *Palimpsestes*, p. 506.

20 Nathalie Piégay, 'Une correction magistrale: *Les Aventures de Télémaque* d'Aragon', *Pleine Marge* 12 (Dec. 1990), 72.

21 Jacqueline Chénieux-Gendron, *Le Surréalisme et le roman 1922–1950*, Lausanne: L'Age d'Homme, 1983, p. 98.

22 Aragon, 'Notes' (1966) added as a postface to the 1966 edition of *Les Aventures de Télémaque*, p. 108.

23 Aragon, *Je n'ai jamais appris à écrire*, p. 20.

24 Piégay, 'Une correction magistrale', p. 75.

25 Aragon, *Je n'ai jamais appris à écrire*, p. 21.

26 Salvador Dali, 'Les pantoufles de Picasso', *Les Cahiers d'art* 10:7–10 (1935), 208–12; in *La Vie publique de Salvador Dali* [exhibition catalogue], Paris: Centre Georges Pompidou, 1979, pp. 52–4, with Sacher-Masoch's text alongside.

27 Robert Desnos, *Nouvelles Hébrides*, Paris: Gallimard, 1978, p. 257; Benjamin Péret, *Œuvres complètes* IV, Paris: Corti, 1987, pp. 277–8.

28 Marie-Claire Dumas and Robert Sctrick, 'Remarques sur "L'enfant planète" de Robert Desnos et Benjamin Péret', in Michel Murat and Marie-Pierre Berranger (eds.), *Une pelle au vent dans les sables du rêve. Les écritures automatiques*, Presses Universitaires de Lyon, 1992, p. 89.

29 *Ibid.*, p. 86.

30 The word 'quotation', characterized by the presence of inverted commas, has a much more restricted meaning here than that used by Compagnon. See *La Seconde Main ou le travail de la citation*.

31 Béhar, *Littéruptures*, p. 186. This view contradicts Aragon, who conflates collage and quotation (*C*, 132).

32 For Gloria Orenstein, Nadja is a visionary whose psychic powers link her to Celtic myths and alchemical symbols. This is perhaps a further appropriation, retrieving Nadja's alterity within the framework of a feminist project. '*Nadja* Revisited: A Feminist Approach', *Dada/Surrealism* 8 (1978), 91–106.

33 Susan Rubin Suleiman, *Subversive Intent. Gender, Politics and the Avant-Garde*, Cambridge, Mass. and London: Harvard University Press., 1990, p. 108.

34 Jürgen Pech, 'Mimesis und Modifikation. Fotografische Portraits und ihre Verwendung im Werk von Max Ernst', in *Max Ernst. Das Rendez-vous der Freunde*, Cologne: Museum Ludwig, 1991, p. 267.

35 Raoul Hausmann quoted in Ades, *Photomontage*, p. 12.

36 'The most significant contribution of the Berlin [dada] group was the elaboration of the so-called photomontage, actually a photo-collage, since the images were not montaged in the darkroom.' William Rubin, *Dada, Surrealism, and Their Heritage*, New York: Museum of Modern Art, 1968, p. 42.

37 Theodor Adorno, *Aesthetic Theory*, New York and London: Routledge & Kegan Paul, 1984, p. 223.

38 Camfield, *Max Ernst and the Dawn of Surrealism*, p. 86.

39 Krauss, *The Originality of the Avant-Garde*, p. 106.

40 Roland Barthes, *La Chambre claire. Note sur la photographie*, Paris: Gallimard (Cahiers du cinéma), 1980, p. 18.

41 See Charlotte Stokes, 'The Scientific Methods of Max Ernst: His Use of Scientific Subjects from *La Nature*', *Art Bulletin* 62:3 (Sept. 1980), 453–65.

42 Legge, *Max Ernst. The Psychoanalytical Sources*, p. 150.

43 Wescher, *Collage*, p. 204.

44 Spies, *Max Ernst. Collages*, p. 242.

45 *La Nature* 771 (10 March 1988), 232.

46 A similar juxtaposition of portraits and apparently unrelated objects, including an entomological plate, is present in Breton's photomontage for the cover of *De l'humour noir*, Paris: GLM, 1937.

47 Pierre Albouy defines signal as 'le signe de la signification'. 'Signe et signal dans *Nadja*', *Europe* 483–4 (July–Aug. 1969), 236; in Marguerite Bonnet (ed.), *Les Critiques de notre temps et Breton*, Paris: Garnier, 1974, p. 127.

48 Breton had also been struck by the presence in Ernst's early collages of photographed images, 'des éléments doués par eux-mêmes d'une existence relativement indépendante et tels par exemple que seule la photographie peut nous livrer une lampe, un oiseau ou un bras' (*SP*, 26).

49 Marcel Mariën, 'Auto-portrait', *Opus international* 123–4 (April–May 1991), 216.

50 Michel Rémy, *Le Mouvement surréaliste en Angleterre. Essai de synthèse en vue d'une définition du geste surréaliste en Angleterre* [Doctorat d'Etat], Université de Paris VIII, 1984, vol. II, p. 1478.

51 Breton's photocollage of Paul Eluard, *La Nourrice des etoiles* (c.1938) is another example of the portrait as a theatrical *mise-en-scène*, based on a rebus. The pun on the milky way ('la voie lactee'), is humorously encoded in the row of milkbottles above Eluard's head and in his jacket, made from a cut-out from an astronomical chart.

52 Krauss, 'Photographic Conditions of Surrealism', p. 102–3.

53 John Berger, quoted in Ades, *Photomontage*, p. 48.

54 Marcel Duchamp, cover design for *Young Cherry Trees Secured Against Hares – Jeunes cerisiers garantis contre les lièvres*, New York: View Edns, 1946.

55 Georges Bataille, 'Le Masque', *Œuvres complètes* II, Paris: Gallimard, 1970, p. 403.

56 André Breton, 'Phénix du masque', in *Perspective cavalière*, p. 185.

57 Benjamin Péret (ed.), *Anthologie des mythes, légendes et contes populaires d'Amérique*, Paris: Albin Michel, 1960, p. 15.

58 Louis Aragon, 'Texte surréaliste', *La Révolution surréaliste* 1 (Dec. 1924), 16.

59 Spies, *Loplop*, p. 80.

60 See Eliane Formentelli's excellent analysis of this collage, 'Max Ernst – Paul Eluard, ou l'impatience du désir', *Revue des sciences humaines* 164 (Oct.-Dec. 1976), 487–504.

61 Bataille, *Œuvres completes* II, p. 403.

62 Jacques Bril, *Le Masque ou le père ambigu*, Paris: Payot, 1983, p. 183.

7 The future of statues?

1 Canon of Cambrai (1635).

2 Aragon, *Le Mouvement perpétuel*, p. 66.

3 'Recherches expérimentales. E. Sur certaines possibilités d'embellissement irrationnel d'une ville', *Le Surréalisme au service de la révolution* 6 (May 1933), 18–20.

4 *Ibid.*, pp. 22–3.

5 Linda Nochlin, *The Body in Pieces. The Fragment as a Metaphor of Modernity*, London: Thames and Hudson, 1995, p. 9.

6 René Crevel, *Dali ou l'antiobscurantisme*, Paris: Editions surréalistes, 1930.

7 Nougé, '. . . Et l'avenir des statues', in *Histoire de ne pas rire*, p. 242.

8 See Charlotte Stokes, 'The Statue's Toe – The 19th Century Academic Nude as Eros in the Work of Max Ernst', *Pantheon* 47 (1989), 166–72.

9 Roger Fry, 'Negro Sculpture' [1920], in *Vision and Design*, New York: Meridian Books, 1957, p. 99.

10 Joel Black, 'The Aesthetics of Gender: Zeuxis' Maidens and the Hermaphroditic Ideal', *Fragments, New York Literary Forum* 8–9 (1981), 180–209.

11 Max Ernst, *Paramyths* [1949], Paris: Le Point Cardinal, 1967.

12 Renée Riese Hubert, *Surrealism and the Book*, Berkeley, Los Angeles and London: University of California Press, 1988, p. 114.

13 Ernst's topographical chart recalls 'cette sorte de demi-cylindre blanc irrégulier' which had fascinated Breton at the fleamarket (*OCI*, 678, illustrated p. 676).

14 See Norris, *Beasts of the Modern Imagination*, pp. 144–5.

15 Nougé, *Histoire de ne pas rire*, p. 242.

16 Stokes, 'The Statue's Toe', p. 453.

17 Ernst, 'Comment on force l'inspiration', p. 45.

18 Hubert, *Surrealism and the Book*, p. 114.

19 Naomi Schor, *Reading in Detail. Aesthetics and the Feminine*, London: Methuen, p. 16.

20 Giedion, *Mechanization Takes Command*, p. 342.

21 Dubois, *Le Collage*, p. 18.

22 This photomontage has been read as 'an emblem of the Surrealist subject, who does not need to see the woman in order to imagine her, placing her at the center but only as an image'. Suleiman, *Subversive Intent*, p. 24.

23 Sylvester, *René Magritte*, p. 166.

24 Hans Bellmer, *Petite Anatomie de l'inconscient physique ou l'anatomie de l'image*, Paris: Eric Losfeld (Le Terrain Vague), 1957, p. 38.

25 Victor Burgin, 'Perverse Space', in Stephen Bann and William Allen (eds.), *Interpreting Contemporary Art*, London: Reaktion Books, 1991, p. 138.

26 Roland Barthes, *Sade Fourier Loyola*, Paris: Seuil, 1971, p. 131. Caws alludes to the 'elliptical effect' of representations of the female body: 'Presented face-on, the body fades;

suppressed or only partly represented, it reappears, in strength. Seen entire, the body seems to say nothing; seen naked, it seems to spark no story. Seen in part, it speaks whole volumes; seen veiled, it leads into its own text'. *The Art of Interference*, p. 48.

27 Sylvester, *René Magritte*, p. 166.
28 Robert Desnos, *Corps et biens* [1930], Paris: Gallimard (NRF Poésie), 1968, p. 84.
29 *Ibid.*, p. 86.
30 Breton, *La Clé des champs*, p. 107.
31 Roland Barthes, 'Les surréalistes ont manqué le corps' [interview], *Le Quotidien de Paris* (May 1975); in *Le Grain de la voix*, Paris: Seuil, 1981, p. 230.
32 Roland Barthes, *Le Plaisir du texte*, Paris: Seuil, 1973, p. 15. The paradoxical structures of 'L'union libre' are explored further in my article 'Narcisse se noie: *L'union libre* d'André Breton', *Romanic Review* 80:4 (1989), 571–81.
33 Gerald Mead, *The Surrealist Image*, Berne: Peter Lang (Utah Studies in Literature and Language 9), 1978, pp. 74 and 84.
34 Barthes, *Sade Fourier Loyola*, p. 131. See also Pascal Durand, 'Le corps rhétorique (absent, revêtu)', in Philippe Dubois and Yves Winkin (eds.), *Rhétoriques du corps*, Brussels: De Boeck, 1988, pp. 153–67.
35 See Whitney Chadwick, *Women Artists and the Surrealist Movement*, London: Thames and Hudson, 1985.
36 Georges Hugnet was a bookbinder, poet and historian of the dada and surrealist movements. *La Septième Face du dé* was published in 1936 by Jeanne Bucher. On the cover of the deluxe edition (20 copies) is an embossed illustration of Duchamp's *Why not sneeze?* The epigraph is from Lautréamont: 'La poésie doit être faite par tous. Non par un.' Each *poème-découpage* is made up of two parts: a text occupies the left hand page composed of different typefaces, incorporating various graphic elements such as vignettes and typographical symbols, such as the pointing hand or the sun and moon; on the facing page are pasted images and fragments of texts drawn from the printed media, advertising slogans and images, and illustrations from scientific and medical journals. Hugnet originally made eighty collages for this publication.
37 Bellmer, *Petite Anatomie de l'inconscient physique*, p. 42.
38 Robert A. Sobieszek, 'Erotic Photomontages: George Hugnet's *La Septième Face du dé*', *Dada/Surrealism* 9 (1979), 66–82.
39 Camille Flammarion, *Astronomie populaire. Description générale du ciel* [1880], Paris: Flammarion, 1975, p. 284.
40 See Warlick, 'Max Ernst's Alchemical Novel: *Une semaine de bonté*', p. 71.
41 Mikhail Bakhtin, *Rabelais and His World*, Cambridge, Mass.: MIT Press, 1968, p. 40.
42 *Compulsive Beauty, passim*.

8 An impossible mosaic

1 *Collages*, Paris: Gallimard, 1981, p. 10.
2 Breton, 'Phénix du masque', in *Perspective cavalière*, p. 183. Breton voices here the commonplace prejudices about the 'savage'. See my article, '"Un masque peut en masquer (ou démasquer) un autre". Le masque et le surréalisme', in C. W. Thompson (ed.), *L'Autre et le sacré. Surréalisme, cinéma, ethnologie*, Paris: Harmattan, 1995, p. 77.
3 'Myths are the agents of stability, fictions the agents of change'. Frank Kermode, *The Sense of an Ending*, Oxford: Oxford University Press, 1970, p. 39.

4 Jean Ricardou, 'Le prisme d'Epsilon', *Degrés* 1:2 (April 1973), d1.

5 Jean Ricardou, 'La révolution textuelle. (Rudiments d'une analyse élaborationnelle)', *Esprit* 12 (Dec. 1974), 944.

6 Roger Shattuck, 'The Alphabet and the Junkyard', *Fragments: Incompletion and Discontinuity, New York Literary Forum* 8–9 (1981), 36.

7 'Il est vrai que dans ce livre [*Les Vases communicants*] je m'entête encore à faire prévaloir les thèses matérialistes jusque dans le domaine du rêve – ce qui est loin d'aller sans arbitraire' (*En*, 171).

8 See Michel Carrouges, *André Breton et les données fondamentales du surréalisme*, Paris: Gallimard, 1950.

9 See Robin Lydenberg, 'Engendering Collage: Collaboration and Desire in Dada and Surrealism', in Katherine Hoffman (ed.), *Collage: Critical Views*, pp. 271–84.

10 Breton, 'L'objet fantôme', *Le Surréalisme au service de la révolution* 3 (1931), 21.

11 Anna Balakian, *Surrealism. The Road to the Absolute*, London: Unwin, 1972, p. 138.

12 José Pierre, 'Le lyrisme exalté ou refusé: Breton et les dadaïstes zurichois', p. 53.

13 Roger Cardinal, 'Les arts marginaux et l'esthétique surréaliste', in C. W. Thompson (ed.), *L'Autre et le sacré*, p. 68.

14 Foster, *Compulsive Beauty*, p. xviii. See also Formentelli, 'Max Ernst – Paul Eluard ou l'impatience du désir'.

15 See Dominique Rabaté, 'Le surréalisme et les mythologies de l'écriture', in Jacqueline Chénieux-Gendron and Yves Vadé (eds.), *Pensée mythique et surréalisme*, Paris: Lachenal & Ritter, 1996, p. 112.

16 Georges Bataille 'La *vieille taupe* et le préfixe *sur* dans les mots *surhomme* et *surréaliste*', *Documents* 1 (1930); in *Œuvres complètes* I, Paris: Gallimard, 1970, pp. 93–109.

17 Donald B. Kuspit, 'Collage: The Organizing Principle of Art', in Hoffman (ed.), *Collage: Critical Views*, p. 43.

18 *La Révolution surréaliste* 3 (15 April 1925), 30.

19 '[Les peintres surréalistes] se meuvent librement, hardiment et tout naturellement dans la région frontière du monde extérieur et du monde intérieur qui, bien qu'elle soit imprécise encore, possède une complète réalité ("surréalité") physique et psychique' (*E*, 232).

20 Michel Foucault 'Préface à la transgression', *Hommage à Georges Bataille, Critique* 195–6 (1963), 754. Foucault distinguishes transgression from subversion, with its negative associations, and dialectics, which implies going beyond limits: '[la transgression] n'est pas violence dans un monde partagé (dans un monde éthique) ni triomphe sur des limites qu'elle efface (dans un monde dialectique ou révolutionnaire)' (p. 756).

21 In his review of the London Tate Gallery exhibition *Rites of Passage*, Patrick Wright historicizes the notion of transgression: 'Meanwhile time seems to be running out on the idea of transgression, which has gone through several generations since the early 20th century gestures of Marcel Duchamp. It was one thing to "challenge perception" and transgress the norms of bourgeois culture, but what becomes of such an endeavour now that history has pulled so many of those "norms" apart? . . . the idea of transgression is acquiring the quaint look of a mannerist gesture preserved from a lost age'. 'Rites and Wrongs', *The Guardian* (10 June 1995), 28.

22 Gilles Deleuze, *L'Anti-Œdipe. Capitalisme et schizophrénie*, Paris: Minuit, 1972, p. 50.

23 Terence Hawkes, *Times Literary Supplement* (15 Oct. 1982).

24 R. Bozzetto, A. Chareyre-Méjan, P. and R. Pujade, 'Penser le fantastique', *Europe* 611 (March 1980), 31.

25 Tristan Tzara, 'Sept manifestes dada', *Œuvres complètes* I, p. 387.

26 José Pierre draws a distinction between dada and surrealist aesthetics where I see their cohabitation: 'L'esthétique du cri et l'esthétique du rêve sont en effet incompatibles: elles appartiennent à deux moments successifs de l'expression humaine.' 'Le Lyrisme exalté ou refusé: Breton et les dadaïstes zurichois', p. 54.

Bibliography

Abastado, Claude, 'Les mots ont fini de jouer', *Les Pharaons* 24 (Aut. 1975), 17–25.

'L'écriture automatique et l'instance du sujet', *Revue des sciences humaines* 184 (1981), 59–75.

Adam, Jean-Michel, 'Relire "Liberté" d'Eluard', *Littérature* 14 (May 1974), 94–113.

Adamowicz, Elza, 'Narcisse se noie: *L'union libre* d'André Breton', *Romanic Review* 80:4 (1989), 571–81.

'Monsters in Surrealism. Hunting the Human-headed Bombyx', in Peter Collier and Judy Davies (eds.), *Modernism and the European Unconscious*, Cambridge: Polity Press, 1990, pp. 283–302.

'André Breton et Max Ernst: entre la mise sous whisky marin et les marchands de Venise', *Lisible visible*, *Mélusine* 12 (1991), 15–30.

'"Un masque peut en masquer (ou démasquer) un autre". Le masque et le sur-réalisme', in C. W. Thompson (ed.), *L'Autre et le sacré. Surréalisme, cinéma, ethnologie*, Paris: Harmattan, 1995, pp. 73–91.

'The Surrealist (Self-)Portrait: Convulsive Identities', in Silvano Levy (ed.), *Surrealism. Surrealist Visuality*, Keele University Press, 1996, pp. 31–44.

Ades, Dawn, *Photomontage*, London: Thames and Hudson, 1986.

Adorno, Theodor, *Aesthetic Theory*, New York and London: Routledge & Kegan Paul, 1984.

Albouy, Pierre, 'Signe et signal dans *Nadja*', *Europe* 483–4 (July–Aug. 1969), 234–9; in Marguerite Bonnet (ed.), *Les Critiques de notre temps et Breton*, Paris: Garnier, 1974, pp. 124–8.

Alexandrian, Sarane, *Le Surréalisme et le rêve*, Paris: Gallimard, 1974.

Amiot, Anne-Marie, 'Le plagiat, soleil noir de l'écriture', *Europe* 717–18 (Jan.–Feb. 1989), 14–26.

Amossy, Ruth and Elisheva Rosen, *Les Discours du cliché*, Paris: CDU et SEDES, 1982.

Antle, Martine, 'Portrait and Anti-Portrait: From the Figural to the Spectral', in Anna Balakian and R. Kuentz (eds.), *André Breton Today*, New York: Locken and Owens, 1989, pp. 46–58.

Apollonio, Umbro (ed.), *Futurist Manifestos*, London: Thames and Hudson, 1973.

Aragon, Louis, *Anicet ou le panorama* [1921], Paris: Gallimard, 1951.

　Les Aventures de Télémaque, Paris: NRF Gallimard, 1922.

　'La grande saison Dada 1921' [1923], *Opus international* 123–4 (April–May 1991), 108–11.

　Le Mouvement perpétuel [1920–4], Paris: Gallimard (NRF Poésie), 1970.

　'Texte surréaliste', *La Révolution surréaliste* 1 (Dec. 1924), 16.

　Le Paysan de Paris, Paris: Gallimard, 1926.

　Traité du style, Paris: Gallimard, 1928.

　La Peinture au défi. Exposition de collages [Galerie Goemans], Paris: Librairie José Corti, 1930.

　'Contribution à l'avortement des études maldororiennes', *Le Surréalisme au service de la révolution* 2 (Oct. 1930), 22–4.

　Les Collages [1965], Paris: Hermann (Savoir: sur l'art), 1980.

　'Lautréamont et nous', *Lettres françaises* 1185 (1–7 June 1967), 5–9 and 1186 (8–14 June 1967), 3–9.

　'L'Homme coupé en deux: un commentaire en marge des *Champs magnétiques*', *Lettres françaises* 1233 (9–15 May 1968), 3–9.

　Je n'ai jamais appris à écrire ou les incipit, Geneva: Skira, 1969.

　'Un art de l'actualité: Jiri Kolár', *Lettres françaises* 1282 (7–13 May 1969), 25–6, 29.

Aragon, Louis and André Breton, *Le Trésor des Jésuites*, *Le Surréalisme en 1929*, *Variétés* (1929); in Breton, *Œuvres complètes* I, Paris: Gallimard (Pléiade), 1988, pp. 994–1014.

Artaud, Antonin, 'La Coquille et le clergyman', in *Œuvres complètes* III, Paris: Gallimard, 1978, pp. 18–25.

Assia, Sonia, 'Hairdressers and Kings: Readymade Revelations in *Le Malheur des immortels*', *French Review* 64:4 (March 1991), 643–58.

Babilas, Wolfgang, 'Le collage dans l'œuvre critique et littéraire d'Aragon', *Revue des sciences humaines* 151 (July–Sept. 1973), 330–54.

Bablet, Denis (ed.), *Collage et montage au théâtre et dans les autres arts durant les années vingt*, Lausanne: La Cité-L'Age d'Homme, 1978.

Bakhtine, Mikhail, *Rabelais and His World*, Cambridge, Mass.: MIT Press, 1968.

Balakian, Anna, *Surrealism. The Road to the Absolute*, London: Unwin, 1972.

Bann, Stephen, and William Allen (eds.), *Interpreting Contemporary Art*, London: Reaktion Books, 1991.

Barthes, Roland, *Essais critiques*, Paris: Seuil, 1964.

　Sade Fourier Loyola, Paris: Seuil, 1971.

　Le Plaisir du texte, Paris: Seuil, 1973.

　'Les Surréalistes ont manqué le corps' [interview], *Le Quotidien de Paris* (May 1975); in *Le Grain de la voix*, Paris: Seuil, 1981, pp. 230–2.

　La Chambre claire. Note sur la photographie, Paris: Gallimard (Cahiers du cinéma), 1980.

Bataille, Georges, 'La *vieille taupe* et le préfixe *sur* dans les mots *surhomme* et *surréaliste*', *Documents* 1 (1930); *Œuvres complètes* I, Paris: Gallimard, 1970, pp. 93–109.

　'Le Masque', *Œuvres complètes* II, Paris: Gallimard, 1970, pp. 403–6.

Baudelaire, Charles, *Œuvres complètes* I, Paris: Gallimard (Pléiade), 1975.

Beaujour, Michel, 'Qu'est-ce que *Nadja*?', *La Nouvelle Revue française* 15:172 (April 1967), 780–99.

Béhar, Henri, 'Dada comme nouvelle combinatoire', *Avantgarde* 0 (1987), 59–68.
 Littéruptures, Lausanne: L'Age d'Homme (Bibliothèque Mélusine), 1988.

Bellmer, Hans, *Petite Anatomie de l'inconscient physique ou l'anatomie de l'image*, Paris: Eric Losfeld (Le Terrain Vague), 1957.

Benjamin, Walter, 'Surrealism. The Last Snapshot of the Bourgeoisie' [1929], in *One Way Street and Other Writings*, London: Verso, 1979, pp. 225–39.

Bentley, Eric, *The Life of the Drama*, New York: Atheneum, 1975.

Berranger, Marie-Paule, 'Paul Valéry corrigé par André Breton et Paul Eluard', *Pleine marge* 1 (May 1985), 103–6.
 Dépaysement de l'aphorisme, Paris: Corti, 1988.

Bersani, Jacques, 'Le champ du désespoir. Essai d'analyse de "La glace sans tain"', in Daniel Bougnoux and Jean-Jacques Gateau (eds.), *Le Surréalisme dans le texte*, Publication de l'Université des Langues et Lettres de Grenoble, 1978, pp. 19–31.

Biro, Adam and René Passeron (eds.), *Dictionnaire général du surréalisme*, Paris: Presses Universitaires de France, 1982.

Black, Joel, 'The Aesthetics of Gender: Zeuxis' Maidens and the Hermaphroditic Ideal', *Fragments*, New York Literary Forum 8–9 (1981), 180–209.

Blanche, Jacques-Emile 'Préface du professeur André Breton à la *Mise sous whisky marin* du Dr Max Ernst', *Comoedia* (11 May 1921).

Blesch, Rudi and Harriet Janis, *Collage: Personalities, Concepts, Techniques*, Philadelphia, New York and London: Chilton Book Co., 1967.

Boiffard, J.–A., Paul Eluard and Roger Vitrac, 'Preface', *La Révolution surréaliste* 1 (1 Dec. 1924).

Bojko, Szymon, *New Graphic Design in Revolutionary Russia*, New York and Washington: Praeger, 1972.

Bonnet, Marguerite (ed.), *Les Critiques de notre temps et Breton*, Paris: Garnier, 1974.
 André Breton. Naissance de l'aventure surréaliste, Paris: Corti, 1975.
 'Le regard et l'écriture', in *André Breton. La beauté convulsive*, Paris: Centre Georges Pompidou, 1991, pp. 32–47.

Bougnoux, Daniel and Jean-Jacques Gateau (eds.), *Le Surréalisme dans le texte*, Publication de l'Université des Langues et Lettres de Grenoble, 1978.

Boyer, Alain-Michel, 'Les ciseaux savent lire', *Revue des sciences humaines* 196 (Oct. 1984), 107–17.

Breton, André, 'En marge des *Champs magnétiques*' [1930], *Change* 7 (1970), 9–29.
 Signe ascendant [1947], Paris: Gallimard (NRF Poésie), 1968.
 Entretiens [1952], Paris: Gallimard (NRF Idées), 1969.
 La Clé des champs [1953], Paris: Livre de poche (Biblio essais), 1991.
 Le Surréalisme et la peinture, Paris: Gallimard, 1965.
 Perspective cavalière, Paris: Gallimard, 1970.
 Œuvres complètes I, Paris: Gallimard (Pléiade), 1988.
 Je vois j'imagine. Poèmes-objets, Paris: Gallimard, 1991.
 Œuvres complètes II, Paris: Gallimard (Pléiade), 1992.

Breton, André and Louis Aragon, *Le Trésor des Jésuites*, *Le Surréalisme en 1929*, *Variétés* (1929); in *Œuvres complètes* I, pp. 994–1014.

Breton, André and Paul Eluard, *L'Immaculée Conception*, Paris, Editions Surréalistes, 1930; in *Œuvres complètes* I, pp. 839–84.

'Textes surréalistes. Jeu à Castellane', *Pleine marge* 12 (Dec. 1990), 33.

Breton, André and Philippe Soupault, *Les Champs magnétiques*, Littérature 8–10 (Oct.–Dec. 1919); Paris: Au Sans Pareil, 1920.

Breton, André, Robert Desnos and Benjamin Péret, *Comme il fait beau*, Littérature, ns, 9 (1 Feb.–1 March 1923), 6–13; in *Œuvres complètes* I, pp. 439–48.

Breunig, Le Roy C., 'Kolar/Collage', *Collage, New York Literary Forum* 10–11 (1983), 105–19.

Bril, Jacques, *Le Masque ou le père ambigu*, Paris: Payot, 1983.

Brooks, Peter, *The Melodramatic Imagination. Balzac, Henry James, Melodrama, and the Mode of Excess*, New York and London: Yale University Press, 1976.

 Reading for the Plot: Design and Intention in Narrative, Oxford: Clarendon Press, 1984.

Brunius, Jacques, *En marge du cinéma français*, Lausanne: L'Age d'Homme, 1987.

Bryen, Camille, *Expériences*, Paris: L'Equerre, 1932.

Bryson, Norman, *Calligram: Essays in New Art History from France*, Cambridge University Press, 1988.

 Looking at the Overlooked. Four Essays on Still Life Painting, London: Reaktion Books, 1990.

Bryson, Norman, Michael Ann Holly and Keith Moxey (eds.), *Visual Theory*, Cambridge: Polity Press, 1991.

Buchloh, Benjamin H. D., 'Allegorical Procedures: Appropriation and Montage in Contemporary Art', *Art Forum* 21:1 (Sept. 1982), 43–56.

Buñuel, Luis and Salvador Dali, 'Un chien andalou', *La Révolution surréaliste* 12 (Dec. 1929), 34–6.

Calabrese, Omar, *Neo-Baroque. A Sign of the Times*, Princeton University Press, 1992.

Camfield, William A., *Max Ernst. Dada and the Dawn of Surrealism*, Munich: Prestel, 1993.

Cardinal, Roger, 'Surrealist Beauty', *Forum for Modern Language Studies* 9:4 (Oct. 1974), 348–56.

 'Collecting and Collage-making: The Case of Kurt Schwitters', in John Elsner and Roger Cardinal (eds.), *The Cultures of Collecting*, London: Reaktion Books, 1994, pp. 68–96.

 'Les arts marginaux et l'esthétique surréaliste', in C. W. Thompson (ed.), *L'Autre et le sacré. Surréalisme, cinéma, ethnologie*, Paris: Harmattan, 1995, pp. 51–71.

Carrouges, Michel, *André Breton et les données fondamentales du surréalisme*, Paris: Gallimard, 1950.

Cawelti, John G., *Adventure, Mystery, and Romance. Formula Stories as Art and Popular Culture*, University of Chicago Press, 1976.

Caws, Mary Ann, *The Art of Interference. Stressed Readings in Verbal and Visual Texts*, Cambridge: Polity Press, 1989.

Chadwick, Whitney, *Women Artists and the Surrealist Movement*, London: Thames and Hudson, 1985.

Chaillard-Chary, Claude, *Le Bestiaire des surréalistes*, Paris: Presses de la Sorbonne Nouvelle (Thèses de l'Université de Paris III), 1994.

Chénieux-Gendron, Jacqueline, *Le Surréalisme et le roman 1922–1950*, Lausanne: L'Age d'Homme, 1983.

'Le Roman de montage dans l'oeuvre de Philippe Soupault des *Champs magnétiques au Grand homme*', in J. Chénieux-Gendron (ed.), *Philippe Soupault, le poète*, Paris: Klincksieck, 1992, pp. 41–54.

'Du bon usage des manuscrits surréalistes. *L'Immaculée Conception*, 1930', in Béatrice Didier and Jacques Neefs (eds.), *Manuscrits surréalistes*, Paris: Presses Universitaires de Vincennes, 1995, pp. 15–40.

Chénieux-Gendron, Jacqueline and Marie-Claire Dumas (eds.), *Jeu surréaliste et humour noir*, Paris: Lachenal et Ritter (Pleine Marge 1), 1993.

Chéronnet, Louis, 'La publicité moderne: la gloire du panneau', *L'Art vivant* 2 (15 Aug. 1926), 618.

Clifford, James, 'On Ethnographic Surrealism', *Comparative Studies in History* 23:4 (1981), 534–64; in *Predicaments of Culture: Twentieth-Century Ethnography, Literature and Art*, Cambridge, Mass.: Harvard University Press, 1988, pp. 117–52.

Cohen, Margaret, *Profane Illumination. Walter Benjamin and the Paris of Surrealist Revolution*, Berkeley, Los Angeles, London: University of California Press, 1993.

Collage, New York Literary Forum 10–11 (1983).

Le Collage surréaliste en 1978 [exhibition catalogue], Paris: Galerie Le Triskèle, 1978.

Collages. Collections des musées de province [exhibition catalogue], Colmar: Musée d'Unterlinden, 1990.

Collages, décollages, images détournées [exhibition catalogue], Montauban: Musée Ingres and Pau: Musée des Beaux-Arts, 1992.

Collages surréalistes [exhibition catalogue], Paris: Galerie Zabriskie, 1990.

Compagnon, Antoine, *La Seconde Main ou le travail de la citation*, Paris: Seuil, 1979.

Cook, Albert, 'Space, Time and the Unconscious in the Collage-novels of Max Ernst', in *Dimensions of the Sign in Art*, Hanover and London: University Press of New England, 1989, pp. 119–29.

Le Corps en morceaux, Paris: Musée d'Orsay (Réunion des musées nationaux), 1990.

Crevel, René, *Dali ou l'antiobscurantisme*, Paris: Editions surréalistes, 1930.

Dada and Surrealism Reviewed [exhibition catalogue], London: Arts Council of Great Britain, 1978.

Dali, Salvador, 'L'ane pourri', *Le Surréalisme au service de la révolution* 1 (July 1930), 9–12.

Les Pantoufles de Picasso, Cahiers d'art, 10:7–10 (1935), 208–12; in *La Vie publique de Salvador Dali*, Paris:Centre Georges Pompidou, 1979, pp. 52–4.

Décaudin, Michel, 'Collage, montage et citation en poésie', in Denis Bablet (ed.), *Collage et montage au théâtre et dans les autres arts durant les années vingt*, Lausanne: La Cité-L'Age d'Homme, 1978.

Deleuze, Gilles, *L'Anti-Œdipe. Capitalisme et schizophrénie*, Paris: Minuit, 1972.

Desnos, Robert, *La Liberté ou l'amour!*, Paris: Kra, 1927.

'Imagerie moderne', *Documents* 1:7 (1929), 377–8.

Corps et biens [1930], Paris: Gallimard (NRF Poésie), 1968.

'La Femme 100 têtes, par Max Ernst', *Documents* 2 (1930), 238.

Nouvelles Hébrides, Paris: Gallimard, 1978.

Ecrits sur les peintres, Paris: Flammarion (Textes), 1984.

Desnos, Robert and Benjamin Péret, *L'Enfant planète* [1926], in Desnos, *Nouvelles*

Hébrides, Paris: Gallimard, 1978, p. 257; Péret, *Œuvres complètes* IV, Paris: Corti, 1987, pp. 277–8.

Desnos, Robert, André Breton and Benjamin Péret, *Comme il fait beau, Littérature*, ns, 9 (1 Feb.–1 March 1923), 6–13; in Breton, *Œuvres complètes* I, pp. 439–48.

Dessins surréalistes. Visions et techniques [exhibition catalogue], Paris: Centre Georges Pompidou, 1995.

Dessons, Gérard, 'Dérive du collage en théorie de la littérature', in Bertrand Rougé (ed.), *Montages/Collages*, Publications de l'Université de Pau (Rhétoriques des arts II), 1993, pp. 15–24.

Deval, Pierre, 'Au-delà de la peinture', *Promenoir* 3 (May 21).

Didier, Béatrice and Jacques Neefs (eds.), *Manuscrits surréalistes*, Paris: Presses Universitaires de Vincennes, 1995.

Dubois, Philippe, 'Esthétique du collage: un dispositif de ruse', *Annales d'esthétique* 15–16 (1976–7), 74–100.

 Le Collage, Paris: Centre National de Documentation Pédagogique, 1978.

Dumas, Marie-Claire and Robert Sctrick, 'Remarques sur "L'enfant planète" de Robert Desnos et Benjamin Péret', in Michel Murat and Marie-Pierre Berranger (eds.), *Une pelle au vent dans les sables du rêve. Les écritures automatiques*, Presses Universitaires de Lyon, 1992, pp. 83–92.

Dupin, Jacques, *Joan Miró, la vie et l'œuvre*, Paris: Flammarion, 1961; trans. *Joan Miró. Life and Work*, New York: Harry H. Abrams, 1962.

Durand, Pascal, 'Le corps rhétorique (absent, revêtu)', in Philippe Dubois and Yves Winkin (eds.), *Rhétoriques du corps*, Brussels: De Boeck, 1988, pp. 153–67.

Durozoi, Gérard, *André Breton. L'écriture surréaliste*, Paris: Larousse, 1974.

Egger, Anne, *L'Œuvre plastique de 3 poètes surréalistes: Louis Aragon, André Breton et Paul Eluard*, Mémoire de Maîtrise, Paris: Université de Paris I, 1990.

Eluard, Paul, 'Les plus belles cartes postales', *Minotaure* 3–4 (Dec. 1934), 85–100.

 Œuvres complètes I, Paris: Gallimard (Pléiade), 1968.

Eluard, Paul and André Breton, *L'Immaculée Conception*, Paris, Editions Surréalistes, 1930; in Breton, *Œuvres complètes* I, pp. 839–84.

Eluard, Paul and Max Ernst, *Les Malheurs des immortels*, Paris: Au Sans Pareil, 1922.

 Répétitions, Paris: Au Sans Pareil, 1922.

Epstein, Jean, 'Freud, ou le nic-cartérianisme en psychologie', *L'Esprit nouveau* 16 (1922), 1864.

Ernst, Max, *La Femme 100 têtes*, Paris: Carrefour, 1929.

 Rêve d'une petite fille qui voulut entrer au Carmel, Paris: Carrefour, 1930.

 'Inspiration to Order', *This Quarter* 5:1 (Sept. 1932), 79–85; trans. 'Comment on force l'inspiration', *Le Surréalisme au service de la révolution* 6 (15 May 1933), 43–5.

 Une semaine de bouté, Paris: Jeanne Bucher, 1934; New York: Dover Publications, 1975.

 'Au-delà de la peinture', *Cahiers d'art* 11:6–7 (1937), 149–83.

 Paramyths, Beverly Hills:Copley Galleries, 1949; trans. as *Paramythes*, Paris: Point Cardinal, 1967.

 Ecritures, Paris: Gallimard, 1970.

Ernst, Max and Paul Eluard, *Les Malheurs des immortels*, Paris: Au Sans Pareil, 1922.

 Répétitions, Paris: Au Sans Pareil, 1922.

Essays on Assemblage, New York: MOMA (Studies in Modern Art 2), 1992.

Fénelon, *Les Aventures de Télémaque* [1699], Paris: Classiques Garnier, 1994.

Fisher, Philip, *Making and Effacing Art. Modern American Art in a Culture of Museums*, Oxford University Press, 1991.

Formentelli, Eliane, 'Max Ernst – Paul Eluard, ou l'impatience du désir', *Revue des sciences humaines* 164 (Oct.–Dec. 1976), 487–504.

Foster, Hal, *Compulsive Beauty*, Cambridge, Mass. and London: MIT Press (October Books), 1993.

Foucault, Michel, 'Préface à la transgression', *Hommage à Georges Bataille, Critique* 195–6 (1963), 751–69.

Fry, Roger, *Vision and Design*, New York: Meridian Books, 1957.

Gateau, Jean-Charles, *Paul Eluard et la peinture surréaliste (1910–1939)*, Geneva: Droz, 1982.

Gauthier, Xavière, *Surréalisme et sexualité*, Paris: Gallimard (Idées), 1971.

Gee, Malcolm, 'Max Ernst, God, and *The Revolution by Night*', *Arts Magazine* 55:7 (March 1981), 85–91.

Genette, Gérard, *Palimpsestes. La littérature au second degré*, Paris: Seuil (Poétique), 1982.

Giedion, Siegfried, *Mechanization Takes Command*, New York: W. W. Norton, 1948.

Gluech, Grace, 'A Bottle is a Bottle', *New York Times* (19 Dec. 1965).

The Golden Age of Collage: Dada and Surrealism Eras 1916–1950 [exhibition catalogue], London: Mayor Gallery, 1987.

Gracq, Julien, *André Breton: quelques aspects de l'écrivain*, Paris: Corti, 1948.

Grossman, Kathryn M., 'Playing Surrealist Games: Parataxis and Creativity', *French Review* 58:5 (April 1979), 700–7.

Groupe MU, *Rhétorique générale*, Paris: Larousse, 1970.

 'Lecture du poème et isotopies multiples', *Le Français moderne* 42 (1974), 217–36.

 Rhétorique de la poésie. Lecture linéaire lecture tabulaire, Paris: Editions Complexe, 1977; Paris: Seuil (Points), 1990.

 Traité du signe visuel. Pour une rhétorique de l'image, Paris: Seuil (La couleur des idées), 1992.

Groupe MU (eds.), *Collages, Revue d'esthétique* 3–4 (1978); Paris: Union Générale d'Editions (10/18), 1978.

Guedj, Colette, 'Rhétorique du collage plastique dans *Les Malheurs des immortels*', *Les Mots la vie* 1 (1980), 51–94.

 'Le collage dans l'écriture de Paul Eluard', *Les Mots la vie* 5 (1987), 171–200.

Haas, Patrick de, 'L'arc électrique et la barre de friction. Les tribulations de l'image chez Reverdy, Breton, Duchamp', in Christian Descamps (ed.), *Surréalisme et philosophie*, Paris: Editions du Centre Pompidou, 1992, pp. 63–71.

Hinton, Geoffrey, 'Max Ernst: *Les Hommes n'en sauront rien*', *Burlington Magazine* 118 (1975), 292–9.

Hoffman, Katherine (ed.), *Collage: Critical Views*, Ann Arbor and London: UMI Research Press, 1989.

Hopkins, David, 'Max Ernst's *La Toilette de la mariée*', *Burlington Magazine* 133:1057 (April 1991), 237–40.

Hubert, Renée Riese, 'The Fabulous Fictions of Two Surrealist Artists: Giorgio de Chirico and Max Ernst', *New Literary History* 4:1 (Aut. 1972), 151–66.

'Une collaboration surréaliste: *Les Malheurs des immortels*', *Quaderni del Novecento Francese* 2 (1972), 203–21.

'Max Ernst: The Displacement of the Visual and the Verbal', *New Literary History* 15, 3 (Spring 1984), 575–606.

'Max Ernst entre la bonté et le plaisir', in Jacqueline Chénieux-Gendron (ed.), *Du surréalisme et du plaisir*, Paris: Corti, 1987, pp. 149–59.

Surrealism and the Book, Berkeley, Los Angeles and London: University of California Press, 1988.

Hugnet, Georges, *La Septième Face du dé*, Paris: Jeanne Bucher, 1936.

Pleins et déliés. Témoignages et souvenirs 1926–1972, Paris: Guy Authier, 1972.

Hutcheon, Linda, *A Theory of Parody. The Teachings of Twentieth-Century Art Forms*, New York and London: Methuen, 1985.

Iser, Wolfgang, *The Implied Reader*, Baltimore and London: Johns Hopkins University Press, 1974.

Jaguer, Edouard, *Les Mystères de la chambre noire. Le surréalisme et la photographie*, Paris: Flammarion, 1982.

Jakobson, Roman, *Essais de linguistique générale*, Paris: Minuit, 1963.

Jakowski, Anatole, 'Joan Miró', *Cahiers d'art* 9:1–4 (1934), 58.

Jenker, Ingrid, 'The Collaboration of Max Ernst and Paul Eluard: A Surrealist Model', *Canadian Art Review* 7:1–2 (1980).

Jenny, Laurent, 'La surréalité et ses signes narratifs', *Poétique* 16 (1973), 499–520.

'Sémiotique du collage intertextuel ou la littérature à coups de ciseaux', in Groupe MU (eds.), *Collages*, *Revue d'esthétique* 3–4 (1978), Paris: Union Générale d'Editions (10/18), pp. 165–82.

Joan Miró. Paintings and Drawings 1929–41 [exhibition catalogue], London: Whitechapel Gallery, 1989.

Jouanny, Alain, 'L'amitié magique de Paul Eluard et Max Ernst', in *Motifs et figures*, Paris: Université de Rouen, Centre d'Art et d'Esthétique, 1974.

Kamber, Gerald, 'Cubism and Surrealism: A Semiotic Approach', *Dada/Surrealism* 9 (1979), 62–5.

Kermode, Frank, *The Sense of an Ending*, Oxford University Press, 1970.

Kochmann, René, '*Une maison peu solide*: lecture d'un texte de Breton', *Australian Journal of French Studies* 21:1 (1984), 85–109.

Kotler, Eliane, 'Sens et sensations. Regards sur les collages et la typographie dans *Le Paysan de Paris*', *Les Mots la vie* 5 (1987), 69–80.

Kral, Peter, 'L'age du collage, suite et fin', *Phases* 2:5 (1975), 98–117.

'Vingt ans après', *Opus international* 123–4 (April–May 1991), 158.

Krauss, Rosalind E., *Passages in Modern Sculpture*, Cambridge, Mass.: MIT Press, 1981.

'The Photographic Conditions of Surrealism', *October* 19 (Winter 1981), 3–34; in *The Originality of the Avant-Garde and Other Modernist Myths*, Cambridge, Mass. and London: MIT Press, 1986, pp. 87–118.

'Corpus Delecti', in Rosalind Krauss and Jane Livingstone (eds.), *Amour fou. Photography and Surrealism*, London: Arts Council, 1986, pp. 56–112.

'Photography in the Service of Surrealism', *ibid.*, pp. 15–54.

'The Impulse to see', in Hal Foster (ed.), *Vision and Visuality*, Seattle: Bay Press, 1988, pp. 51–75.

'The Master's Bedroom', *Representations* 28 (Fall 1989), 55–76.

The Optical Unconscious, Cambridge, Mass. and London: MIT Press (October Books), 1993.

Kuspit, Donald B., 'Collage: The Organizing Principle of Art', in Hoffmann (ed.), *Collage: Critical Views*, Ann Arbor and London: UMI Research Press, 1989, pp. 39–57.

Lascault, Gilbert, *Sur la planète Max Ernst*, Paris: Maeght (Chroniques anachroniques), 1991.

Lautréamont, Comte de and Germain Nouveau, *Œuvres complètes*, Paris: Gallimard (Pléiade), 1979.

Lavin, Maud, *Cut with the Kitchen Knife. The Weimar Photomontages of Hannah Höch*, New Haven, London: Yale University Press, 1993.

Lecercle, Jean-Jacques, *The Violence of Language*, London and New York: Routledge, 1990.

Philosophy of Nonsense. The Intuitions of Victorian Nonsense Literature, London and New York: Routledge, 1994.

Lecoq Ramond, Sylvie, 'Max Ernst (1891–1976), *Rêves et hallucinations*, 1926. Une acquisition du Musée d'Unterlinden à Colmar', *Revue du Louvre et des musées de France* 41:5–6 (Dec. 1991), 88–90.

Leefmans, Bert M.-P. , '*Das Undbild*: A Metaphysics of Collage', *Collage, New York Literary Forum* 10–11 (1983), 183–227.

Leenhardt, Jacques, 'La pensée archaïsante et les conditions d'une mythologie moderne. A propos de G. de Chirico et L. Aragon', *L'Archaïsme, Elseneur* (Caen) 3 (1984), 158–68.

'L'énigme de l'objet. Propos sur la "métaphysique" chez Giorgio de Chirico et la "mythologie" chez Aragon', in Jacqueline Chénieux-Gendron and Marie-Claire Dumas (eds.), *L'Objet au défi*, Paris: Presses Universitaires de France, 1987, pp. 9–20.

Legge, Elizabeth M., 'Posing Questions: Ernst's *Au rendez-vous des amis*', *Art History* 10:2 (June 1987), 227–43.

Max Ernst. The Psychoanalytical Sources, Ann Arbor and London: UMI Research Press, 1989.

Leiris, Michel, *C'est-à-dire*, Paris: Jean-Michel Place, 1992.

Levy, Silvano, 'René Magritte and Window Display', *Artscribe* 28 (March 1981), 24–8.

Levy, Silvano (ed.), *Conroy Maddox. Surreal Enigmas*, Keele University Press, 1995.

Surrealism. Surrealist Visuality, Keele University Press, 1995.

Lipman, Jean and Richard Marshall, *Art about Art*, New York: Dutton, 1978.

Lydenberg, Robin, 'Engendering Collage: Collaboration and Desire in Dada and Surrealism', in Katherine Hoffman (ed.), *Collage: Critical Views*, Ann Arbor and London: UMI Research Press, 1989, pp. 271–84.

Magritte, René, 'Les mots et les images', *La Révolution surréaliste* 12 (15 Dec. 1929), 32–3.

Ecrits complets, Paris: Flammarion, 1979.

Magritte [exhibition catalogue], London: The South Bank Centre, 1992.

Malet, Marian, 'Leveling: A Fundamental Process in the Poetry of Jean Arp', *Dada/Surrealism* 6 (1976), 40–4.

Mallarmé, Stéphane, *Œuvres complètes*, Paris: Gallimard (Pléiade), 1945.

Man Ray, *Auto portrait* (1963), Paris: Seghers, 1986.

Mariën, Marcel, 'Auto-portrait', *Opus international* 123–4 (April–May 1991), 216.

Matthews, J. H., 'Collage', in *The Imagery of Surrealism*, New York: Syracuse University Press, 1977, pp. 64–116.

Maurer, Evan M., 'Images of Dream and Desire: The Prints and Collage Novels of Max Ernst', in Robert Rainwater (ed.), *Max Ernst. Beyond Surrealism. A Retrospective of the Artist's Books and Prints*, the New York Library and Oxford University Press, 1986, pp. 37–93.

Mead, Gerald, 'A Syntactic Model in Surrealist Style', *Dada/Surrealism* 2 (1972), 33–7.
 The Surrealist Image, Berne: Peter Lang (Utah Studies in Literature and Language 9), 1978.

Mercier, André, 'André Breton et l'ordre figuratif dans les années 20', in *Le Retour à l'ordre dans les arts plastiques et l'architecture, 1919–1925*, St Etienne: CIEREC (Travaux VIII), 1975, pp. 277–316.
 'Aragon et Breton au "Sans Pareil"', in Jean Arrouye (ed.), *Ecrire et voir: Aragon, Elsa Triolet et les arts visuels*, Publications de l'Université de Provence, 1991, pp. 181–90.

Meschonnic, Henri, *Pour la poétique* I, Paris: Gallimard, 1970.

Mesens, E. L. T., 'Que faut-il pour faire un collage?', *Quadrum* 16 (1964), 115–22.

Monnin, Françoise, 'L'art du collage', *La Cote des antiquités* 7 (April 1988), 30–57.
 Le Collage, art du XXe siècle, Paris: Fleurus, 1993.

Monod-Fontaine, Isabelle, 'Le tour des objets', in *André Breton. La beauté convulsive*, Paris: Centre Georges Pompidou, 1991, pp. 64–8.

Murat, Michel, '*Corps et biens*, ou les beaux effets du surréel', *L'Information grammaticale* 24 (Jan. 1985), 36–9 and 25 (March 1985), 36–40.

Murat, Michel and Marie-Pierre Berranger (eds.), *Une pelle au vent dans les sables du rêve. Les écritures automatiques*, Presses Universitaires de Lyon, 1992.

Nadin, Mihai and Vicu Bugarin, 'Collage et métaphore', *Revue d'esthétique* 2 (1970), 131–9.

Naville, Pierre, 'Beaux-arts', *La Révolution surréaliste* 3 (15 April 1925), 27.

N'Goué, Lucienne, 'Ribemont-Dessaignes, Aragon, Giraudoux: le collage ou le texte en relief', *Ecritures, Cahiers de sémiotique textuelle* 1 (1984), 93–105.

Nochlin, Linda, *The Body in Pieces. The Fragment as a Metaphor of Modernity*, London: Thames and Hudson, 1995.

Norris, Margot, 'Max Ernst: The Rhetorical Beast of the Visual Arts', in *Beasts of the Modern Imagination*, Baltimore and London: Johns Hopkins University Press, 1985, pp. 134–69.

Nougé, Paul, *Histoire de ne pas rire*, Lausanne: Age d'Homme (Cistre-Lettres différentes), 1980.

Orenstein, Gloria, '*Nadja* Revisited: A Feminist Approach', *Dada/Surrealism* 8 (1978), 91–106.

Passi, Carlo, '*Nadja* ou l'écriture erratique', *Pleine marge* 10 (Dec. 1989), 83–99.

Payant, René, 'Bricolage pictural: l'art à propos de l'art', *Parachute* 16 (1979), 5–8, and 18 (1980), 25–32.

Pech, Jürgen, 'Mimesis und Modifikation. Fotografische Portraits und ihre

Verwendung im Werk von Max Ernst', in *Max Ernst. Das Rendez-vous der Freunde*, Cologne: Museum Ludwig, 1991, pp. 241–70.

Penrose, Roland, *Scrapbook 1900–1981*, London: Thames and Hudson, 1981.

Péret, Benjamin, 'La nature dévore le progrès et le dépasse', *Minotaure* 10 (1937), 20–1. *Œuvres complètes* II, Paris: Terrain Vague, 1971; IV, Paris: Corti, 1987.

Péret, Benjamin (ed.), *Anthologie des mythes, légendes et contes populaires d'Amérique*, Paris: Albin Michel, 1960.

Péret, Benjamin and Robert Desnos, 'L'enfant planète' (1926), in Desnos, *Nouvelles Hébrides*, Paris:Gallimard, 1978, p. 257; Péret, *Œuvres complètes* IV, Paris:Corti, 1987, pp. 277–8.

Péret, Benjamin André Breton and Robert Desnos, *Comme il fait beau*, Littérature, ns, 9 (1 Feb.–1 March 1923), 6–13; in Breton, *Œuvres complètes* I, pp. 439–40.

Perloff, Marjorie, 'The Invention of Collage', *Collage, New York Literary Forum* 10–11 (1983), 5–47.
The Futurist Movement: Avant-Garde, Avant-Guerre, and the Language of Rupture, University of Chicago Press, 1986.

Piégay, Nathalie, 'Une correction magistrale: *Les Aventures de Télémaque* d'Aragon', *Pleine Marge* 12 (Dec. 1990), 71–7.

Pierre, José, 'Le lyrisme exalté ou refusé: Breton et les dadaïstes zurichois', *Champs des activités surréalistes* 16 (June 1982), 41–57.
L'Aventure surréaliste autour d'André Breton, Paris: Filipacci/Artcurial, 1986.

Poggi, Christine, *In Defiance of Painting: Cubism, Futurism, and the Invention of Collage*, New Haven and London: Yale University Press, 1992.

Prévert, Jacques, *Collages*, Paris: Gallimard, 1981.

Rabaté, Dominique, 'Le surréalisme et les mythologies de l'écriture', in Jacqueline Chénieux-Gendron and Yves Vadé (eds.), *Pensée mythique et surréalisme*, Paris: Lachenal & Ritter, 1996, pp. 105–16.

'Recherches expérimentales', *Le Surréalisme au service de la révolution* 6 (May 1933), 10–24.

Regards sur Minotaure la revue à tête de bête, Geneva: Musée d'Art et d'Histoire, 1987.

Rémy, Michel, 'Le Collage', in *Le Mouvement surréaliste en Angleterre. Essai de synthèse en vue d'une définition du geste surréaliste en Angleterre* [Doctorat d'Etat], Université de Paris VIII, 1984, vol. II, chapter II, pp. 1785–1867.

Rencontres. Cinquante ans de collages [exhibition catalogue], Paris: Galerie Lusman, 1991.

Reverdy, Pierre, *Nord-Sud, Self-Defence et autres écrits sur l'art et la poésie (1917–1926)*, Paris: Flammarion, 1975.

La Révolution surréaliste 1–12, (1924–9); reprint Paris:Jean-Michel Place, 1975.

Reynolds, Dee, *Symbolist Aesthetics and Early Abstract Art. Sites of Imaginary Space*, Cambridge University Press (Cambridge Studies in French), 1995.

Ricardou, Jean, 'Le prisme d'Epsilon', *Degrés* 1:2 (April 1973), d1–9.
'La révolution textuelle. (Rudiments d'une analyse élaborationnelle)', *Esprit* 12 (Dec. 1974), 927–45.

Riffaterre, Michael, 'Semantic Incompatibilities in Automatic Writing', in Mary Ann

Caws (ed.), *About French Poetry from Dada to 'Tel Quel'*, Detroit: Wayne State Univeristy Press, 1974, pp. 223–41.

Rigolot, François, 'Le poétique et l'analogique', *Poétique* 35 (Sept. 1978), 257–68.

Rimbaud, Arthur, *Œuvres*, Paris: Garnier, 1960.

Rodari, Florian, *Collage. Pasted, Cut and Torn Papers*, Geneva: Albert Skira (Editions d'Art), 1988.

Ronca, Felice C., 'The Influence of Rimbaud on Max Ernst's Theory of Collage', *Comparative Literature Studies* 16:1 (March 1979), 41–7.

Rose, Margaret A., *Parody: Ancient, Modern, and Post-Modern*, Cambridge University Press, 1993.

Rosolato, Guy, *Essais sur le symbolique*, Paris: Gallimard (Tel Quel), 1964.

Roughton, Roger, 'Final Night of the Bath', *Contemporary Poetry and Prose* 8 (Dec. 1936), 166.

Rubin, William S., *Dada and Surrealist Art*, New York: Harry N. Abrams, 1968.
 Dada, Surrealism and Their Heritage, New York: Museum of Modern Art, 1968.

Russell, John, *Max Ernst. Life and Work*, New York: Harry N. Abrams, 1967.

Sala, Carlo, 'Les collages de Max Ernst et la mise en question des apparences', *Europe* 46:475–6 (Nov.–Dec. 1968), 131–9.

Salvador Dali. Rétrospective [exhibition catalogue], Paris: Centre Georges Pompidou, 1979.

Sanouillet, Michel, *Dada à Paris*, Paris: Pauvert, 1965; Paris: Flammarion, 1993.

Scharf, Aaron, 'Max Ernst, Etienne-Jules Marey, and the Poetry of Scientific Illustration', in Van Deren Coke (ed.), *One Hundred Years of Photographic History*, Albuquerque: University of New Mexico Press, 1975, pp. 117–26.

Schatzmann, Dr, *Rêves et hallucinations*, Paris: Vigot Frères, 1925.

Schor, Naomi, *Reading in Detail. Aesthetics and the Feminine*, London: Methuen, 1987.

Schwarz, Arturo (ed.), *Le Cadavre exquis, son exaltation* [exhibition catalogue], St-Etienne: Musée d'Art et d'Industrie, 1975.
 I Surrealisti [exhibition catalogue], Milan: Mazzotta, 1989.

Scott, David, *Pictorial Poetics: Poetry and the Visual Arts in Nineteenth-Century France*, Cambridge University Press, 1988.

Sebbag, Georges, *L'Imprononçable Jour de sa mort Jacques Vaché janvier 1919*, Paris: Jean-Michel Place, 1989.

Seitz, William C., *The Art of Assemblage*, New York: The Museum of Modern Art, 1961.

Shattuck, Roger, 'The Mode of Juxtaposition', in Mary-Ann Caws (ed.), *About French Poetry from Dada to 'Tel Quel': Text and Theory*, Detroit: Wayne State University Press, 1974, pp. 19–22.
 'The Alphabet and the Junkyard', *Fragments: Incompletion and Discontinuity*, New York Literary Forum 8–9 (1981), 31–8.

Sobieszek, Robert A., 'Erotic Photomontages: George Hugnet's *La Septième face du dé*', *Dada/Surrealism* 9 (1979), 66–82.

Somville, Léon, 'Pour une théorie des débuts. Une analyse de l'incipit de l'œuvre d'André Breton', in Daniel Bougnoux and Jean-Charles Gateau (eds.), *Le Surréalisme dans le texte*, Publication de l'Université des Langues et Lettres de Grenoble, 1978, pp. 41–57.

Spies, Werner, *Max Ernst Loplop. The Artist's Other Self*, London: Thames and Hudson, 1983.

 Max Ernst. Collages. The Invention of the Surrealist Universe, London: Thames and Hudson, 1991.

Spies, Werner, Sigrid and Günter Metken, *Max Ernst Œuvre-Katalog* [5 vols.], Texas: Menil Foundation and Cologne: Verlag M. DuMont Schauberg, 1975.

Stallybrass, Peter and Allon White, *The Politics and Poetics of Transgression*, Ithaca: Cornell University Press, 1986.

Stamelman, Richard, 'The Relational Structure of Surrealist Poetry', *Dada/ Surrealism* 6 (1976), 59–78.

Steel, David A., 'Surrealism, Literature of Advertising and the Advertising of Literature in France 1910–1930', *French Studies* 41:3 (July 1987), 283–97.

 'Dada-ADAD. Kurt Schwitters, Poetry, Collage, Typography', *Word & Image* 4:2 (April–June 1990), 198–209.

Stokes, Charlotte, 'The Scientific Methods of Max Ernst: His Use of Scientific Subjects from *La Nature*', *Art Bulletin* 62:3 (Sept. 1980), 453–65.

 'Collage as Jokework: Freud's Theories of Wit as Foundation for the Collages of Max Ernst', *Leonardo* 15:3 (1982), 199–204; in Katherine Hoffman (ed.), *Collage: Critical Views*, Ann Arbor and London: UMI Research Press, 1989, pp. 253–69.

 'From the Edges of Floating Worlds: Meaning in Max Ernst's Collages', *Arts Magazine* 61:8 (April 1987), 37–41.

 'The Statue's Toe – The 19th Century Academic Nude as Eros in the Work of Max Ernst', *Pantheon* 47 (1989), 166–72.

Styrsky Toyen Heisler [exhibition catalogue], Paris: Centre Georges Pompidou, 1982.

Suleiman, Susan Rubin, *Subversive Intent. Gender, Politics and the Avant-Garde*, Cambridge, Mass. and London: Harvard University Press, 1990.

Le Surréalisme au service de la révolution 1–6 (1930–3); reprint Paris: Jean-Michel Place, 1975.

Sweeney, J. J., 'Joan Miró: Comment and Interview', *Partisan Review* 25:2 (Feb. 1948), 210.

Sylvester, David, *René Magritte*, London: Thames and Hudson, 1992.

Thomas, Jean-Jacques, 'Collage/Space/Montage', *New York Literary Forum* 10–11 (1983), 79–101.

Todorov, Tzvetan, 'Introduction à la symbolique', *Poétique* 11 (1972), 273–308.

 'Une complication de texte: les *Illuminations*', *Poétique* 34 (1978), 241–53.

Tzara, Tristan, 'Manifeste dada 1918', *Dada* 3 (Dec. 1918).

 L'Invention 1, *Proverbe* 6 (1 July 1920).

 'Le papier collé ou le proverbe en peinture', *Cahiers d'art* 6:2 (1931), 61–74.

 Œuvres complètes I, Paris: Flammarion, 1975.

Umland, Anne, 'Joan Miró's *Collage* of Summer 1929: "La Peinture au défi"?', in *Essays on Assemblage*, New York: MOMA (Studies in Modern Art 2), 1992, pp. 43–77.

Varnedoe, Kirk and Adam Goprik (eds.), *Modern Art and Popular Culture: Readings in High and Low*, New York: MOMA, Harry N. Abrams, 1990.

 High & Low: Modern Art and Popular Culture, New York: MOMA, Harry N. Abrams 1990.

Waldman, Diane, *Collage, Assemblage, and the Found Object*, London: Phaidon Press, 1992.

Warlick, M. E., 'Max Ernst's Alchemical Novel: *Une semaine de bonté*', *Art Journal* 46 (Spring 1987), 61–73.

Wescher, Herta, *Collage*, New York: Harry N. Abrams, 1968.

Williams, Linda, *Figures of Desire. A Theory and Analysis of Surrealist Film*, University of Illinois Press, 1981.

 'Dream Rhetoric and Film Rhetoric: Metaphor and Metonymy in *Un chien andalou*', *Semiotica* 33:1–2 (1981), 87–103.

Wolfram, Eddie, *History of Collage. An Anthology of Collage, Assemblage and Events Structures*, London: Studio Vista, 1975.

Worton, Michael and Judith Still (eds.), *Intertextuality: Theories and Practices*, Manchester University Press, 1990.

Wright, Elizabeth, 'The Uncanny and Surrealism', in Peter Collier and Judy Davies (eds.), *Modernism and the European Unconscious*, Cambridge: Polity Press, 1990, pp. 265–82.

Wright, Patrick, 'Rites and Wrongs', *The Guardian* (10 June 1995), 28.

Zervos, Christian, 'Joan Miró', *Cahiers d'art* 9:1–4 (1934), 11–18.

Index of surrealist collages

The following index lists pictorial and verbal collages referred to in the text and related works. It does not claim to be an exhaustive inventory of surrealist collages.

Measurements are given in centimetres, height preceding width. References are given to publications where works have been reproduced.

Eileen AGAR
Marine Collage (1939)
photographs, engravings, 58 × 41
Whitford and Hughes, London
Arturo Schwarz, *I Surrealisti*, Milan: Mazzotta, 1989, p. 447.

Louis ARAGON
'Suicide' (1920)
Cannibale, 1 (25 April 1920); *Le Mouvement perpétuel* [1920–4], Paris: Gallimard (NRF Poésie), 1970.

Portrait de Jacques Vaché (1921)
pasted papers, leaves, 25 × 19
Isy Brachot, Brussels
Wescher, *Collages*, New York: Harry N. Abrams, 1968, plate 128; Georges Sebbag, *L'Imprononçable Jour de sa mort Jacques Vaché janvier 1919*, Paris: Jean-Michel Place, 1989.

Les Aventures de Télémaque (1922)
Paris: NRF Gallimard.

Le Paysan de Paris (1926)
Paris: NRF Gallimard.

Le Trésor des Jésuites (1928) [with Breton]
Le Surréalisme en 1929, *Variétés* (1929); André Breton, *Œuvres complètes* I, Paris: Gallimard (Pléiade), 1988, pp. 994–1014.

Jean ARP
Papiers déchirés (untitled) (1933)
pasted papers, 27 × 19.5
Öffentliche Kunstsammlung, Basel
Florian Rodari, *Pasted, Cut and Torn Papers*, Geneva: Albert Skira (Editions d'Art), 1988, p. 108.

Antonin ARTAUD and Roger VITRAC
Histoire sans paroles en 9 tableaux vivants (1930)
photocollage
'Le théâtre Alfred Jarry et l'hostilité publique' [brochure]
Opus International 123–4 (April–May 1991), 114–15.

Robert BENAYOUN
Le Printemps sous la cendre (1977)
pasted papers, 24 × 20
property of the artist
Schwarz, *I Surrealisti*, p. 537.

André BRETON
Letter to Aragon (9 Nov. 1918)
pasted papers, manuscript text
facsimile in Georges Sebbag, *L'Imprononçable Jour de ma naissance, 17ndré 13reton*, Paris: Jean-Michel Place, 1989.

'Le Corset Mystère' (1919)
pasted typographical elements
Littérature 4 (June 1919), 7; André Breton, *Œuvres completes* I, p. 16.

Letter to Vaché (13 Jan.1919)
pasted papers, manuscript text
facsimile in Georges Sebbag, *L'Imprononçable Jour de sa mort Jacques Vaché*, Paris: Jean-Michel Place, 1988.

Comme il fait beau! (1923) [with Desnos and Péret]
Littérature, ns, 9 (1 Feb.–1 March 1923), 6–13; Breton, *Œuvres complètes* I, pp. 439–48.

'POEME' (c.1924)
pasted typographical elements, 21.2 × 17
private collection, Paris
Breton, *Je vois, j'imagine*, Paris: Gallimard, 1991, p. 145.
figure 3

Le Trésor des Jésuites (1928) [with Aragon]
see under Aragon

Charles VI jouant aux cartes pendant sa folie (1929)
pasted papers

pasted papers, photographs, typographical elements, texts
Paris: L'Equerre.

Machine à fabriquer des objets dans mon esprit (1937–8) pasted photograph on mirror,
36.8 × 24
Musée d'Art Moderne, St-Etienne
Collages. Collections des musées de province, Colmar: Musée d'Unterlinden, 1990, p. 127.

Jacques BRUNIUS
Collage en neuf épisodes (1942)
pasted papers, 14.5 × 22
Galerie 1900–2000, Paris
figure 12

Max BUCAILLE
Le Double Meurtre (1932)
pasted papers, 24.5 × 26.5
private collection
Collages surréalistes, Paris: Galerie Zabriskie, 1990.

Salvador DALI
Les Accommodations du désir (1929)
pasted papers on oil, 22.5 × 35
Metropolitan Museum of Modern Art, New York
La Révolution surréaliste 12 (15 Dec. 1929), 18; William S. Rubin, *Dada and Surrealist Art*, New
York: Harry N. Abrams, 1968, plate I; *Salvador Dali. Rétrospective*, Paris: Centre Georges
Pompidou, 1979, p. 129.

Le Jeu lugubre (1929)
pasted papers on oil, 41 × 31
private collection, Paris
Rubin, *Dada and Surrealist Art*, plate II; *Salvador Dali. Rétrospective*, p. 151.

Les Plaisirs illuminés (1929)
pasted papers on oil, 23.8 × 34.7
Museum of Modern Art, New York
La Révolution surréaliste 12 (15 Dec. 1929), 29; Diane Waldman, *Collage, Assemblage, and the
Found Object*, London: Phaidon Press, 1992, p. 179.

Les Premiers jours du printemps (1929)
pasted papers on oil, 49.5 × 64
private collection
Salvador Dali. Rétrospective, p. 126.

'Les Pantoufles de Picasso' (1935)
Cahiers d'art 10:7–10 (1935), 208–12; *La Vie publique de Salvador Dali*, Paris: Centre Georges
Pompidou, 1979, pp. 52–4.

Robert DESNOS
Comme il fait beau! (1923) [with Breton and Péret]
see under Breton

'L'enfant planète' (1926) [with Péret]
Desnos, *Nouvelles Hébrides*, Paris: Gallimard, 1978, p. 257; Péret, *Œuvres complètes* IV, Paris:
 Corti, 1987, pp. 277–8.

Marcel DUCHAMP
L.H.O.O.Q. (1920)
rectified ready-made, pencil on print
Museum of Art, Philadelphia
cover [designed by Picabia] for *391* 12 (March 1920); Robert Short, *Dada and Surrealism*,
 London: Laurence King, 1994, p. 56.

Portrait of André Breton (1946)
pasted paper, photograph
cover design for *Young Cherry Trees Secured Against Hares – Jeunes cerisiers garantis contre les
 lièvres* (1946), New York: View Edns.

Paul ELUARD
Les Malheurs des immortels (1922) [with Ernst]
texts, plates reproduced from collages
Paris: Au Sans Pareil.

Répétitions (1922) [with Ernst]
texts, plates reproduced from collages
Paris: Au Sans Pareil.

L'Immaculée Conception (1930) [with Breton]
see under Breton

Les Femmes de Martinique étaient descendues de leur estrade (1933)
pasted papers
Le Surréalisme au service de la révolution 6 (May 1933).

A chacun sa colère (c.1935)
pasted papers, 30 × 26
private collection
figure 11

Le Bon bourgeois (c.1935)
pasted papers
Album Eluard, Paris: Gallimard (Pléiade), 1968, p. 201.

Collage (untitled) (c.1935)
pasted papers
private collection

Hier ist noch alles in der schwebe *(le vapeur et le poisson)* (1920)
pasted papers, pencil, 10.5 × 12
Museum of Modern Art, New York
Ades, *Photomontage*, p. 112; Spies, *Max Ernst. Collages*, plate 160; *Max Ernst*, p. 79.

Le Massacre des innocents (1920)
pasted papers, watercolour, ink on print, 21.5 × 29
Mrs Edwin A. Bergman, Chicago
Spies, *Max Ernst. Collages*, plate 36.

La Petite Fistule lacrymale qui dit tac tac (1920)
gouache, ink on wallpaper, 36.2 × 25.4
Museum of Modern Art, New York
Max Ernst, 1991, p. 73.

The Punching Ball or *l'immortalité de buonarotti* (1920)
pasted papers, gouache on photograph, 17.6 × 11.5
private collection, Chicago
figure 18

La Chanson de la chair (*c.*1920)
pasted papers, gouache, pencil on print, 12 × 21
Musée National d'Art Moderne, Paris
Spies, *Max Ernst. Collages*, plate 40; Ades, *Photomontage*, p. 112; Rodari, *Collage*, p. 79.

Jeune Homme chargé d'un fagot fleurissant (*c.*1920)
gouache, ink on print, 11 × 15.3
private collection, Turin
Spies, *Max Ernst. Collages*, plate 22.

La Santé par le sport (*c.*1920)
photographic elements on photograph, ink
location unknown
photographic enlargement in Kunsthaus, Zurich
Spies, *Max Ernst. Collages*, plate 167; Ades, *Photomontage*, p. 113.

Das Schlafzimmer des Meisters *(la chambre à coucher de max ernst)* (*c.*1920)
gouache, pencil, ink on print, 16.2 × 22
private collection
Spies, *Max Ernst. Collages*, plate 20; Rodari, *Collage*, p. 78.

Tambour du corps de garde à pied de l'armée céleste en-dimanché représenté de face (*c.*1920)
gouache, ink on print, 24.5 × 29
private collection, Holland
Spies, *Max Ernst. Collages*, plate 21.

Dada-Degas (1920–1)
pasted papers, gouache, ink, 48 × 31

Staatsgalerie moderner Kunst, Munich
Spies, *Max Ernst. Collages*, plate 29; *Max Ernst*, p. 81.

Design for an Exhibition Poster (1921)
pasted papers, photographs, gouache, 64 × 49
Museo Civico, Galleria d'Arte Moderna, Turin
Spies, *Max Ernst. Collages*, plate 46.

Les Malheurs des immortels (1922) [with Eluard]
see under Eluard

Répétitions (1922) [with Eluard]
see under Eluard

Portrait de Paul Eluard (1922)
pasted papers, 19.3 × 11.5
Zervos collection, Vézelay
reproduced as frontispiece to *Les Malheurs des immortels*
Collages. Collections des musées de province, p. 104.

Deux enfants sont menacés par un rossignol (1924)
oil on wood with wood construction, 69.8 × 57
Museum of Modern Art, New York
Max Ernst, p. 121; Waldman, *Collage, Assemblage*, p. 131.

Rêves et hallucinations (1926)
pasted papers, 29.7 × 25.4
Musée d'Unterlinden, Colmar
figure 2

L'Esprit de Locarno (1929)
pasted papers
La Révolution surréaliste 12 (15 Dec. 1929), 23; Spies, *Max Ernst. Collages*, plate 266.

La Femme 100 têtes (1929)
collage-novel, plates reproduced from collages, text
Paris: Carrefour.

Nostradamus, Blanche de Castille et le petit Saint-Louis (1929)
pasted papers
La Révolution surréaliste 12 (15 Dec. 1929), 48; Spies, *Max Ernst. Collages*, plate 267.

Jeanne Hachette et Charles le Téméraire (1929)
pasted papers, 24.5 × 20
private collection
La Révolution surréaliste 12 (15 Dec. 1929), 59; Spies, *Max Ernst. Collage*, plate 268.

Rêve d'une petite fille qui voulut entrer au Carmel (1930)
collage-novel, plates reproduced from collages, text
Paris: Carrefour.

Au rendez-vous des amis or Loplop introduces Members of the Surrealist Group (1931)
pasted photographs, papers, frottage, pencil, 50 × 33.5
Museum of Modern Art, New York
figure 19

Loplop présente le Facteur Cheval (1932)
pasted paper, fabric, photographs, pencil, ink, gouache, 64 × 48
Peggy Guggenheim, Venice
Wescher, *Collages*, p. 189; Spies, *Max Ernst. Collages*, plate 75; *Max Ernst*, p. 208; Waldman,
 Collage, Assemblage, p. 155.

Une semaine de bonté (1934)
plates reproduced from collages
Paris: Jeanne Bucher, 1934; New York: Dover Publications, 1975.
figures 13–16, 25

Invitation for exhibition *Man Ray, Peintures & objets* (1935)
pasted papers, 17 × 11.5
figure 21

Invitation for exhibition *Max Ernst* (1935)
photograph, pasted paper
figure 17

L'Habillement de la mariée (The Robing of the Bride) (1940)
oil, 130 × 96
Peggy Guggenheim, Venice
Max Ernst, p. 239.

Paramyths
Beverly Hills: Copley Galleries, 1949; trans. **Paramythes**, Paris: Point Cardinal, 1967.
figures 22 and 23

Théodore FRAENKEL
Femmes qui souffrez (*c.*1920)
pasted typographical elements, 29.5 × 21
private collection
Schwarz, *I Surrealisti*, p. 322.

Une séance historique (*c.*1920)
pasted typographical elements, 29.5 × 21
private collection
Schwarz, *I Surrealisti*, p. 322.

Artistique et sentimental (1921)
pasted papers, typographical elements, 37 × 23.5
private collection, Milan
Ades, *Photomontage*, p. 109; Schwarz, *I Surrealisti*, p. 322.

Georges HUGNET
Le Sang en proverbe (1936)
pasted photographs, typographical elements, 29 × 21
Musée d'Unterlinden, Colmar
figure 24

La Septième Face du dé
plates reproduced from collages
Paris: Jeanne Bucher, 1936.

Les Charmes des saisons (1937)
paper on decalcomania, 34 × 40
José Pierre, *L'Aventure surréaliste autour d'André Breton*, Paris: Filipacci / Artcurial, 1986, p. 82.

Humphrey JENNINGS
Commode and Gâteau de Style (1936)
Les Enfants d'Alice. La Peinture surréaliste en Angleterre 1930–1960, Paris: Galerie 1900–2000, 1982.

Conroy MADDOX
The Strange Country (1940)
pasted papers, 41 × 28
Tate Gallery, London
Silvano Levy (ed.), *Conroy Maddox. Surreal Enigmas*, Keele University Press, 1995, p. 102.

Uncertainty of the Day (1940)
pasted papers, gouache, 15 × 20
property of the artist
Wescher, *Collages*, fig. 210; Ades, *Photomontage*, p. 143.

René MAGRITTE
Le Jockey perdu (1926)
pasted paper, gouache, ink, crayon, 40 × 54
private collection
Magritte, [exhibition catalogue], London: South Bank Centre, 1992, fig. 130.

Le Jockey perdu (1926)
oil, 65 × 75
private collection
David Sylvester, *Magritte*, London: Thames and Hudson, 1992, p. 93

Léo MALET
Le Rêve de Léo Malet (1935)
photocollage, 24.1 × 16.5
private collection, Milan
Jaguer, *Les Mystères de la chambre noire*, p. 94; Krauss, *Amour fou*, p. 107; *The Golden Age of Collage: Dada and Surrealism Eras 1916–1950*, fig. 21.

MAN RAY
Self-portrait (1933)
photomontage
frontispiece to *Minotaure*, 3–4 (Dec. 1933); Ades, *Photomontage*, p. 118.

E. L. T. MESENS
Je ne pense qu'à vous (1926)
rayogram, pasted papers, 30 × 24
Le Surréalisme en 1929, *Variétés* (June 1929); Wescher, *Collages*, fig. 175; Krauss, *L'Amour fou*, p. 48.

Joan MIRO
Danseuse espagnole (1928)
pasted paper, sandpaper, pencil, oil, 105 × 73
Museo Nacional Centro de Arte Reina Sofia, Madrid
Le Surréalisme en 1929, *Variétés* (June 1929); Rubin, *Dada, Surrealism, and Their Heritage*, New York: MOMA, 1968, p. 71; Waldman, *Collage, Assemblage*, p. 169.

Collage-drawing (1933)
pasted papers, pencil, 47 × 62.9
Mayor Gallery, London
Minotaure 5 (Feb. 1934), 44; *The Golden Age of Collage: Dada and Surrealism Eras 1916–1950*, fig. 17; *Regards sur Minotaure*, Geneva: Musée d'Art et d'Histoire, 1987, p. 110.

Collage-drawing (1933)
pasted papers, crayon, pencil, 108 × 70
private collection
Joan Miró [exhibition catalogue], London: Whitechapel Gallery, 1989 [p. 60]; Waldman, *Collage, Assemblage*, p. 173.

Painting based on a collage (1933)
oil, 130.4 × 162.5
Fundació Joan Miró, Barcelona
Jacques Dupin, *Joan Miró. Life and Work*, New York: Harry N. Abrams, 1962, p. 241; *Joan Miró. Paintings and Drawings 1929–41* London: Whitechapel Gallery, 1989 [p. 58].

Preparatory collage for painting (1933)
pasted papers, pencil, 47.1 × 63.1
Fundació Joan Miró, Barcelona
Dupin, *Joan Miró. Life and Work*, p. 114; *Joan Miró. Paintings and Drawings 1929–41*, p. 114.

Collage (Prats is quality) (1934)
pasted papers, pencil, 63.3 × 47
Fundació Joan Miró, Barcelona
figure 9

Paul NOUGE
Carte postale éducative
Le Surréalisme en 1929, *Variétés* (June 1929).

Roland PENROSE
Femme-phare (1937)
pasted postcards, paper
Roland Penrose, *Scrapbook 1900–1981*, London: Thames and Hudson, 1981, p. 100.

The Real Woman (1937)
pasted postcards, paper, 80 × 96
private collection
Penrose, *Scrapbook 1900–1981*, p. 96.

Elephant Bird (1938)
pasted postcards, paper
Victoria and Albert Museum, London
Penrose, *Scrapbook 1900–1981*, p. 95.

Magnetic Moths (1938)
pasted postcards, crayon, pencil, 55.8 × 81.3
Tate Gallery, London
Ades, *Dada and Surrealism Reviewed* [colour plate]; Penrose, *Scrapbook 1900–1981*, p. 94.

Miss Sacré-Coeur (1938)
pasted postcards, paper, oil, 74 × 53
private collection
Wescher, *Collages*, fig. 199; Schwarz, *I Surrealisti*, p. 451.

Letter to Lee Miller
pasted photographs, manuscript text, 24.3 × 32.1
The Golden Age of Collage: Dada and Surrealist Eras 1916–1950, fig. 29.

Benjamin PERET
Comme il fait beau! (1923) [with Breton and Desnos]
see under Breton

'L'Enfant planète' (1926) [with Desnos]
see under Desnos

'**Hier en découvrant l'Amérique**' (1926)
pasted typographical elements
plate from . . . *Et les seins mouraient* . . ., Marseille: Cahiers du Sud, 1929.
figure 10

Collage (untitled) (1929)
pasted papers
frontispiece to Péret, *Œuvres complètes* IV, Paris: Corti, 1987.
figure 5

Roger ROUGHTON
'**Final Night of the Bath**'
Contemporary Poetry and Prose 8 (Dec. 1936), 166.

Georges SADOUL
Portes (c.1925)
booklet (14pp.), pasted papers, postcards, 20.5 × 16
Musée d'Art et d'Histoire, St-Denis
Collages. Collections des musées de province, p. 117.

Max SERVAIS
Bas les pattes (1936)
pasted papers, 25.5 × 33
Collages surréalistes, Paris: Zabriskie, 1990.

Jindrich STYRSKY
La Baignade (1934)
pasted papers on print, 47 × 37.5
private collection, Paris
figure 8

Le Beau Jambon (1934)
pasted papers, 40 × 30
private collection, Paris
Schwarz, *I Surrealisti*, p. 493.

Le Canon et l'enfant (1934)
pasted papers, 36 × 20
private collection, Paris
Le Surréalisme, même 2 (Spring 1957), 110; Schwarz, *I Surrealisti*, p. 493.

Collage (untitled) (1934)
pasted paper on print, 29 × 46
private collection
Minotaure 10 (1938), 32; *Regards sur Minotaure*, p. 170.

Deux belles jambes (1934)
pasted papers, pen, 48 × 35
private collection, Paris
Schwarz, *I Surrealisti*, p. 493.

Le Rêve 1935 (1935)
pasted paper on print
cover for *Bulletin international du surréalisme* (9 April 1935); Sarane Alexandrian, *Breton*, Paris:
 Seuil (Ecrivains de toujours), 1971, p. 94.

La Statue de la liberté (1939)
pasted papers, 32 × 23
private collection, Paris
Ades, *Dada and Surrealism Reviewed*, p. 321; Schwarz, *I Surrealisti*, p. 494.

L'Annonciation (1941)
pasted papers
private collection
La Brèche 4 (Feb. 1963).

Le Cardinal américain (1941)
pasted papers, 41 × 29
private collection
La Brèche 4 (Feb. 1963); Schwarz, *I Surrealisti*, p. 493.

Le Petit Jésus (1941)
pasted papers
private collection
La Brèche 4 (Feb. 1963).

Le Prêtre et l'enfant de chœur (1941)
pasted papers, 29 × 25
private collection, Paris
Schwarz, *I Surrealisti*, p. 494.

Yves TANGUY
Le Phare (c.1926)
pasted paper, matchsticks, cardboard on oil, 67 × 50
private collection
Yves Tanguy. Rétrospective 1925–1955, Paris: Centre Georges Pompidou, 1982, p. 73.

Le Pont (1925)
wire on oil, 40.5 × 33
private collection
Yves Tanguy, p. 69.

Fantômas (1925–6)
oil, cardboard, cotton, 50 × 150
Pierre Matisse Gallery, New York
Rubin, *Dada, Surrealism, and their Heritage*, p. 101.

Albert VALENTIN
Monument aux morts
photocollage
La Révolution surréaliste 12 (15 Dec. 1929), 47.

Index